P9-AOZ-166

10193

STUDIES IN BRITISH ART

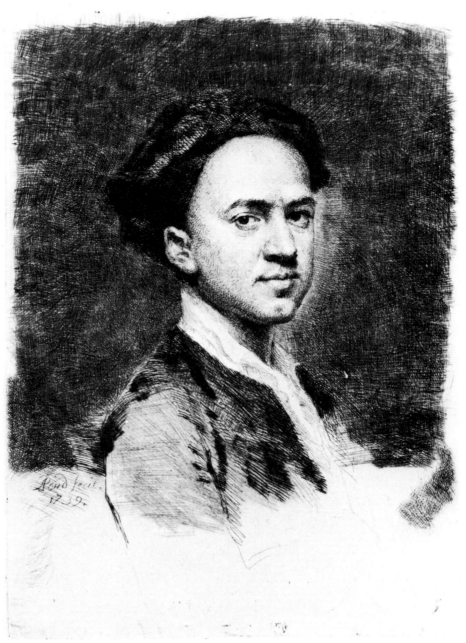

Frontispiece. Arthur Pond, *Self Portrait*, etching and drypoint, 1739. Trustees of the British Museum.

SELLING ART IN GEORGIAN LONDON

The Rise of Arthur Pond

LOUISE LIPPINCOTT

Published for the Paul Mellon Centre for Studies in British Art
by Yale University Press, New Haven and London, 1983

Copyright © 1983 by Yale University.

All rights reserved. This book may not be reproduced, in whole or in part, in any form (beyond that copying permitted by Sections 107 and 108 of the U.S. Copyright Law and except by reviewers for the public press), without written permission from the publishers.

Designed by Caroline Williamson.

Filmset in Monophoto Bembo and printed in Great Britain by
Butler & Tanner Ltd, Frome and London.

Library of Congress Cataloging in Publication Data

Lippincott, Louise, 1953–
 Selling art in Georgian London.

 (Studies in British art)
 Bibliography: p.
 Includes index.
 1. Pond, Arthur, 1701–1758. 2. Art dealers—England—London. I. Title. II.
Series.
N8660.P66L5 1983 707.5'09421 83–40003
ISBN 0–300–03070–3

CONTENTS

LIST OF ILLUSTRATIONS

LIST OF TABLES

ACKNOWLEDGMENTS

During four years of work on this book, I have incurred enormous debts of gratitude to individuals and institutions in the United States and Britain. This study began as a dissertation for the history department of Princeton University under the sympathetic guidance of Lawrence Stone, who has read and reread the manuscript more times than he probably cares to remember. I would also like to acknowledge the contributions of Irving Lavin, Robert Darnton, and Anthony Grafton who will find many of their suggestions incorporated in the text. Support for the research and writing of the first draft was provided by the Committee for European Studies and the Department of History of Princeton University.

A number of institutions and their staffs shared research facilities with patience and generosity. I owe special thanks to Frances Carey, Sheila O'Connell, Angela Wilson, and the late Edward Croft-Murray of the British Museum, David Blayney Brown of the Ashmolean Museum, Oxford, and Maureen Attrill, Keeper of the City Art Gallery, Plymouth. All went out of their way to share information, ideas, and resources with me. The daily assistance of the librarians and keepers of the British Library, the British Museum Department of Manuscripts, the Duke Humphrey Library (Bodleian Library), the Guthrie Room at the National Portrait Gallery (London), the Free Library of Philadelphia, the Philadelphia Museum of Art Library, the Public Record Office, the Victoria and Albert Museum Library, and the Witt Library, Courtauld Institute, is deeply appreciated.

Among the individuals who provided information, photographs, and references, I must mention Christine Armstrong, Brinsley Ford, John Jeff Looney, Tom McCormick, Christopher Mendez, Warren Mild, Ellen Miles, David Moore-Gwyn, Patrick Noon, Ronald Paulson, Ann Percy, Harley Preston, Jules Prown, Leonard Rosenband, and Michael Rosenthal.

Publication of the manuscript would not have been possible without the

unremitting encouragement of Francis Haskell, who also suggested some important revisions. John Nicoll and Caroline Williamson of the Yale University Press and Miss Ruth Keim, valiant typist, got the text from tangled manuscript to elegantly printed form. I am particularly grateful for the support of the Paul Mellon Centre without which this book would probably not have appeared.

Finally, personal thanks are due to my family and friends, who eased my transitions from the twentieth century to the eighteenth, and back again.

I
Introduction

The London art world in 1770 was very different from what it had been fifty years earlier. The 1720s were dominated by foreign imports: artists from Germany, Italy, and France; antiquities and old master paintings from Venice and Rome; prints from Paris and Amsterdam. In the shadow of the continental baroque, the native school of art was distinguished for its technical failings and idiosyncratic mania for portraiture. The weakness of English art was fostered by the disarray of the art world. Artists born and trained in England resented the prestige and success which attended visiting artists from the continent with depressing regularity. Many blamed the debased tastes of English patrons to explain their own lack of popularity, while patrons deplored the crude techniques of local artists which necessitated the importation of fashionable art and artists from abroad. The traditional patronage structure, with artists heavily dependent on the support of individuals, combined with the preference for all things continental, left English artists in limbo. There were, at this time, few alternative routes to the top for those excluded from the generosity of the great. The Painter–Stainers guild, which had organized and protected artists since medieval times, was becoming the province of house painters and gilders, as artists sought to dissociate themselves from trade.

Organized art schools like those of the French Academy did not exist. Artists took apprentices, or students subscribed to informal 'academies' for rare opportunities to draw from casts or the nude. Since the dispersal of Charles I's collection during the Civil War there were no great bodies of art available for study comparable to those in continental churches and palaces. A few artists, spurred on by the successes of the competition, travelled and studied abroad, but many knew of the great works of the past or the trendsetting works of their contemporaries only through prints, copies, or written descriptions.

Painters unable to supplement their deficient training had small chance

of attaining recognition or wealth. Some hired themselves out as studio assistants or drapery painters to Sir Godfrey Kneller, Michael Dahl, and others. Others went to work for the booksellers who controlled the lower echelons of the London art market. They drew illustrations or mass-produced copies of dimly-understood old masters which nevertheless passed as originals in coffee-house auctions. Some found more lucrative roles as dealers, restorers, and copyists of the old masters so much in vogue. A surprising number emigrated to the colonies where inadequate patronage was offset by the benefits of lack of competition. While disappointed painters railed over the English public's deficient taste and patrons lamented their compatriots' lack of skill and sophistication, all agreed that the English art world would benefit from concerted efforts at public education and the establishment of a formal institution devoted to the care and training of a native school of artists.

Fifty years later both the institution and the discriminating audience had been formed. The Royal Academy, chartered in 1768, provided the training and the opportunities for public recognition which had previously been lacking. The Academy provided anatomy lectures and drawing and life classes for qualified students. Travel to Italy was hailed as a necessary stage in a young artist's education and was sometimes paid for by scholarships or sponsors. Public exhibitions and a large commercial print trade enabled a painter to establish his reputation without depending entirely on a few wealthy and well placed patrons. The founding of the Academy also marked the coalition of English painters into a reasonably united body with a vested interest in a native style of painting distinct from continental modes. The landscape, conversation piece, and sporting scene joined the portrait as favored subjects, and the more daring of the younger artists were embarking for the hallowed shores of history painting, which previously had been deemed beyond the reach of English artists and audiences. For the first time in centuries, England's leading artists were Englishmen: Joshua Reynolds, Thomas Gainsborough and Benjamin West, painters; Joseph Wilton and J. F. Nollekens, sculptors; William Woollett and Robert Strange, engravers.

Patrons, in their willingness to support English artists, showed that they, too, had developed independent tastes and overcome Protestant reservations about the veneration of images. With this encouragement the English art world not only reformed, it expanded. What had been marginal occupations in the 1720s bloomed into enormous commercial enterprises. Printsellers, drawing masters, auctioneers, art dealers and art critics flourished and grew rich after 1760, catering more to the public than to the artists they had originally served. Painting and drawing were respectable pastimes for ladies and gentlemen of leisure and were integrated into the standard polite education. No gentleman was fully prepared for polite

society until he could tell a Raphael from a Michelangelo or, better yet, owned an example of each.

The transitional phase between these two periods has not been seriously investigated by historians of art or culture. The art-historical bibliography has been dominated by the assumption that Hogarth was the only English artist of the period worth studying. Numerous analyses of his life, work, and importance have been published, but only C.F. Antal's and Ronald Paulson's have attempted to place his achievements in the contexts of the continental and English art worlds.[1] By all accounts, Hogarth was an exceptional artist and theoretician, the messiah of English art. Scholarly fascination with the intricacies of Hogarth's symbols and meanings, pride in his originality and his staunch advocacy of English painting, and admiration of his technical ability have kept students from asking some significant questions. What concerns and limitations did Hogarth share with other members of the art world? Which of his solutions to problems of patronage, recruitment of labor, and foundation of a national school of art were original, and which were shared with other, less famous artists and entrepreneurs? These questions can only be answered by studies of Hogarth's contemporaries, which are few and far between at present.

Recent doctoral dissertations about Thomas Hudson, Arthur Devis, Joseph Highmore and John Smibert are available, but only Smibert and Allan Ramsay have been seriously treated in published works.[2] These books offer small ground for comparing their subjects with Hogarth, since they are content to identify and catalogue the artist's works, describe his artistic development, and evaluate his achievements with respect to his predecessors, contemporaries, and followers. Ellis Waterhouse's *Dictionary of Eighteenth Century British Painters* indicates both the astonishing number of capable artists active during the period, and the limitations of our knowledge about them.[3] The artists themselves remain dim figures, partly because of the paucity of personal documents surviving from this period, and partly because they are overshadowed by Hogarth's colorful and well-known personality. Very little is known about their patrons, their working methods, or their activities outside the studio. When we think of them at all, it is in Hogarth's terms—as plodding imitators of Kneller or Van Loo, or slaves to decadent Italian and French fashions, or knavish marketers of fakes and copies to gullible 'connoisseurs'.

Hogarth's achievements and attitudes have influenced scholarly treatment of his period as a whole as well as for specialized studies. This is most obvious in the distribution of chapters under the heading 'Art in the Age of Hogarth'; there is one chapter about Hogarth and another about everyone else.[4] Herbert Atherton has attempted to correct the imbalance in *Political Prints in the Age of Hogarth* by refusing to discuss Hogarth at all, but he is one of the very few to err in this extreme.[5] It has been the

consensus of art historians that, excepting Hogarth, the first half of the eighteenth century was a very undistinguished period in British art; including Hogarth, it was an unsettled, trying, and disappointing time for British connoisseurship and patronage.

Cultural historians have slighted the London art world in their studies of Georgian England, perhaps because the dismal scene sketched by art history clashes with their vision of a prosperous, innovative, and self-confident age. Neil McKendrick, John Brewer and J. H. Plumb omit the fine art and print trade from their discussion of commercialism in *The Birth of a Consumer Society*.[6] Yet Mark Girouard, Denys Sutton and Francis Haskell have shown that in the areas of country-house building, garden design and art collecting, at least, English patrons were both extravagant and original.[7] The great iconographic programs uniting architecture, landscape, art and poetry at Stowe, Stourhead and Houghton show that some had assimilated the lessons of the Grand Tour and could bend Italian forms to suit English purposes.[8] The Earl of Shaftesbury's *Characteristicks*, emphasizing the importance of aesthetic appreciation as a way to higher understanding, went through five editions by 1732, indicating that the Renaissance concept of the gentleman as a man of taste had finally penetrated English consciousness.[9]

Nor were these signs of vitality and sophistication confined to the aristocracies of blood and wealth. The world of books and literature expanded rapidly to meet the requirements of middle-class urban dwellers and country gentry in search of news, instruction, and entertainment. The evolution of the newspaper and the novel were creative responses to changing patterns of patronage and demand, as were the 'museums' of freaks, curiosities, and specimens of natural history in London.[10] Novelists, poets, and playwrights enjoyed notoriety and fame if not the profits, which went to their thriving booksellers. New theatres were built, not only in London but also in the provincial capitals, where English actors, singers, and composers competed successfully with the inevitable Italian imports. The market for new products such as fine porcelain, patent medicines, and political souvenirs developed all over England at this time, as did leisure activities such as horse racing, and it has been argued that ever higher levels of consumer demand and participation fueled the Industrial Revolution.[11] Thus in some areas of cultural endeavor, English patrons were active and open minded, artists were innovative and rewarded, and new audiences were discovered and satisfied. Competition from abroad was not always welcomed, but foreign ideas and tastes were assimilated and transformed in the service of English needs.

However, other sectors of English cultural life were declining. Scientific research under the aegis of the Royal Society was drifting into the realms of the fantastic and the ridiculous. Medicine followed science down the

mazier paths of mechanical philosophy. The universities slipped into comfortable somnolence. Another great seventeenth-century body of scholars, the antiquaries, shifted from the practice of strict observation and careful record-keeping to far-fetched speculation and arcane theologies, the change being best illustrated by William Stukeley's early archaeological investigations at Stonehenge and his subsequent imaginative reconstruction of the Druid religion.

The historical view of English culture in the early eighteenth century shows a world in the process of transformation. The court, universities, and professional and learned societies were losing their leadership roles to entrepreneurs and leisured domestic consumers. Art forms and fashions were changing in response to their audiences; art as entertainment, epitomized by the opera and the novel, emerged to challenge intellectual activities as the favorite pastime of the elite. Even collecting, popular in both the seventeenth and eighteenth centuries, changed in purpose and use. Whereas seventeenth-century 'curiosities' were accumulated apparently at random or to support some abstruse cosmological theory, eighteenth-century collections illustrated their owner's taste or provided entertainment for family and friends. There was no reason why the new audiences should be uniquely antipathetic to the visual arts, and it seems eminently likely that art did indeed share in the processes of waning and waxing, adjustment and transformation that make early eighteenth-century culture so complex for the twentieth-century student.

English art is usually placed in its cultural context by lumping Hogarth together with the forces of artistic vitality leading to the formation of the English school in the 1760s, and the rest with the obsolete holdovers from the seventeenth century.[12] These associations are in some measure justified, for Hogarth was a friend of Fielding and Richardson, and exploited the stylistic parallels between his prints and paintings and their innovative novels. The diluted imitations of Lely and Kneller produced by early Georgian portraitists such as Jonathan Richardson can also be compared to the derivative projects of the antiquaries and scientists. However, this neat division of winners from losers is contradicted by other events and relationships in the London art world, and it does not entirely explain the emergence of the classically-minded school of English painters later in the century. There is, for example, the problem of the country-house builders and landscape gardeners who generally preferred Hudson, Pond, Vanderbank, or Van Loo to Hogarth. Nor was Hogarth universally popular in the literary world; Alexander Pope was painted by everyone but him. Finally, Hogarth's art does not satisfactorily link the baroque classicism of the late seventeenth century and the neoclassicism of one hundred years later. Joshua Reynolds acknowledged the precepts of Jonathan Richardson as the source of his artistic ambitions and ideals, while Hogarth, with no

pupils and few followers, had no important successors. Art historical scholarship, by emphasizing the stately succession from one great school or master to the next, has missed significant developments when they occurred on the fringes of the art world.

Any attempt to synthesize 'great man' art history with historians' views of the early eighteenth-century cultural sphere as a whole is doomed to failure. Yet it is highly unlikely that the London art world developed independently from the theatre, literature, and music. Artists were friends and portraitists of writers and actors, they shared the same patrons and joined the same clubs, labored for the same booksellers. Undoubtedly they also shared worries about the impact of censorship, taxation, and war on their fragile economies. If the visual arts are subjected to the same kind of inquiry scholars have directed at literature (for example), perhaps the apparent differences between the art world and other cultural spheres can be resolved, and painters and their patrons will join the writers and readers, the actors, dramatists, and theatre-goers of the eighteenth century.

Coherent sets of questions applicable to the different groups peopling the world of high culture can be derived from relevant sociological and historical issues. From the sociological standpoint, the problems concerning an individual's recruitment into a group, his training, employment, and patrons, are germane to artists, writers, or members of any profession. Moving beyond consideration of the individual, it would be useful to analyze the internal organization of the group itself, and determine its points of contact with other groups and the outside world. Thus one would like to know why and how a young man became an artist and the reasons for his eventual success or failure. His relationships, formal or informal, with other artists and with patrons should be examined and his standing in the community at large should be established.

An investigation of the art world can also proceed along lines of inquiry opened up by historians of eighteenth-century economics, society and ideas. Art was a commercial activity as well as a cultural one, and may have played a significant role in the English economy preceding the Industrial Revolution. How did an artist's or writer's income compare with those of merchants, tradesmen, lawyers, and other members of the middle class? Can we find evidence among art patrons for a growing consumer society? The impact of European wars on the luxury trades is also worth evaluating. Eighteenth-century social issues touched the London art world, too. Originating as artisans or tradesmen, many artists ended their careers as leisured gentlemen; their career patterns reveal the ways and means of eighteenth-century upward mobility. The role of art in society at large—as a means of enhancing social status or political prestige, as a pastime for idle women, as a by-product of the Grand Tour— throws light on the changing activities and interests of many social groups.

The art world was quick to react to new ideas, fashions, and fads. Scholars are just beginning to unravel the complex meanings which eighteenth-century works of art were seen to contain and express. Were particular styles of painting and decorative art, such as the rococo, associated with specific political or social ideologies? Portraits may provide insights into the emergence of British individualism; efforts to promote an English school of art could reflect growing nationalist sentiment. The predominance of classicism and satire in the visual arts must relate to parallel developments in architecture, literature, and other modes of intellectual expression. These interrelated historical factors were as significant in the eighteenth-century London art world as they were important for members of Parliament, the landed gentry, Grub Street writers, or the London poor.

One way to tackle these problems is to use the method of the case study, take the sources as they come, and reconstruct a microcosm of the art world.

Such an opportunity is offered by the body of material relating to the life and career of Arthur Pond, a painter, printseller, and art dealer, whose career in London spanned the years from 1720 until his death in 1758. Pond's name turns up frequently in the scattered sources for early Georgian art and he has been the subject of some tentative articles by modern scholars.[13] However, the most important documents pertaining to his life—his journal and estate papers, preserved in the British Museum—have been generally ignored.[14] Admittedly, Pond was a minor painter, and the quality of his known works probably does not justify the laborious analysis and accounting which this material requires. Perhaps this explains why a superb source for the history of the London art world has lain untouched and unpublished since it entered the British Museum Department of Manuscripts about one hundred years ago.

Pond's journal of receipts and expenses covers sixteen years of his career from August 1734 through November 1750.[15] It is organized on a monthly basis, so that when the book is opened, the receipts and expenses for one month are visible. Each month's accounts are further subdivided into: 1) receipts from portrait painting, art dealing, services, loans, etc. (left hand page, upper half); 2) receipts from printselling (left hand page, lower half); 3) personal expenses (right hand page, upper half); 4) business expenses (right hand page, lower half). Pond rather obsessively recorded every sixpence that entered or left his pocket. About half the time he balanced the month's accounts, leaving one with no great admiration of his arithmetical abilities. There are some gaps in the accounts in the years 1741 and 1743, when Pond may have been travelling, but on the whole they are remarkably complete.

Even so, they present some problems for the analyst. Where Pond's entries can be checked against other sources, such as auction records,

omissions have been found; one is faced with the dilemma of whether Pond forgot to enter his purchase of a Van Dyck portrait at Jarvis's sale in 1740, or, buying it on behalf of another patron, he did not consider it his own expenditure.[16] Then from 1738 to 1744 sales of his prints were handled separately by Charles and Elizabeth Knapton, and it is impossible to determine how much, if any, income he earned from their best-selling engravings during those years. Interpretation of dates also presents problems, because while Pond faithfully recorded the very day he received payment, it often had little or no correlation with the date of commission, completion, or actual sale of a work of art. A portrait commissioned by Princess Amelia in 1744 and paid for in 1748 has been counted as one of Pond's commissions for 1744 and income for 1748.[17] If the commission date cannot be determined—as it sometimes can from records of purchases of materials—it has been counted as part of the payment year. Consequently, deducing Pond's success rate from his income figures has been difficult, given the propensity of English patrons to ignore tradesmen's bills for years. Often, changes in his expenditures both professional and personal have provided a better sense of his relative prosperity. Payments 'on account' have complicated the breakdown of the artist's output and patronage. Many of Pond's best patrons paid up 'on account' once or twice a year, at Christmas or Midsummer, so did patrons making single large commissions which had to be completed over a long period of time, and so too did Grand Tourists running up bills for shipping and customs fees while abroad. Sometimes a patron died without paying his bill, and an heir or executor settled the account. If they can be identified, the various goods and services supplied 'on account' have been sorted into their appropriate categories; nevertheless, 20 per cent of his income cannot be assigned (Tables 7, 8). The figures, compiled with extreme caution by the author, probably require yet more from the reader.

The second volume in the British Museum, which I call Pond's estate papers, is a miscellaneous collection of documents gathered after his death in 1758.[18] It includes a few letters from friends and business associates, extracts from Pond's debt book (present location unknown) showing accounts owing at his death, an inventory of the contents of his house and shop, and annotated catalogues from the sales of his collections of shells and fossils and paintings. Most of the papers were drawn up for the executors of Pond's estate and were probably bound by a later collector.

Both volumes were acquired by the British Museum in 1860 from 'Messrs. Boure', who had bought them at one of three auctions of Dawson Turner's library. Turner (1775–1859), a Yarmouth banker, was a friend and early patron of the watercolorists John Crome and John Sell Cotman; he was also a passionate collector of manuscripts, owning 40,000 at the time of his death. Among these were Pond's books and the bulk of the

manuscripts of George Vertue from Strawberry Hill, which were also acquired by the British Museum.[19] The provenance of the volumes before 1820 (when Turner began collecting manuscripts) is impossible to trace.

These papers, with ancillary material culled from contemporary manuscripts and memoirs and the works of art Pond produced or owned which the author has been able to locate, provide the documentary basis for this study.

Pond offers a suitable introduction to the London art world not only because of the unusually plentiful material about his life, but also because he participated in almost every major trend occurring in the period. He was an enthusiastic admirer of and dealer in Italian art, he promoted public interest in landscape and caricature, he painted hundreds of monotonous portraits, he decorated the stairhalls of country houses and restored the wall paintings in the British Museum, he collected prints, drawings, shells, and 'fossils', he etched and published his own prints, and, just before he died, he thought seriously about retiring and joining the leisured classes he had served most of his life. Among his patrons were the leading figures of the cultural, social, and political worlds—the royal family, the Walpoles, Henry Hoare, Sir Hans Sloane—but he also worked for obscure drapers, small businessmen and actresses. His transactions with other denizens of the art world were numerous; he sold prints to Hogarth, auctioned paintings through Christopher Cock, hired and fired a succession of engravers, gave painting lessons to distinguished ladies and lowly apprentices, and corresponded and traded with assorted connoisseurs, artists, and dealers on the continent. In spite of his numerous activities and modest successes, Pond can be characterized with two words. He was influential and ubiquitous.

Pond emerges as a typical early eighteenth-century English artist who was reasonably successful in most of his endeavors and innovative and significant in some. In many ways a contrast to Hogarth—his championship of Italian art, for example—he still shared the more famous artist's concerns and methods. They were rivals with different aesthetic ideals, but they competed under the same conditions governed by the same set of rules. Their contemporaries rated both highly for their individual achievements and contributions to English art: Hogarth for his invention of comic history painting and his international reputation; Pond for introducing audiences to continental art and for assisting young artists breaking into the London art world. This brief comparison of two contrasting figures suggests that the later eighteenth-century London art world was not constructed entirely upon Hogarth's achievements. Workers such as Pond, encouraging the formation of sympathetic audiences and a trained corps of native painters, also played important roles.

Pond's journal can tell much about how the London art world operated

and changed, but the scantier material concerning his personal life suggests answers to questions about why these changes occurred. His family life, his friendships, and his club memberships strongly influenced the direction of his professional career. His motives were sometimes those of the entrepreneur, sometimes of the artist or of the disinterested promoter of the polite arts. Outside interests such as natural history sometimes weighed in his decisions about commissions or projects. Throughout his life he worked to resolve the conflicts between economic advantage and his social and cultural ambitions, and he can be seen to share the preoccupations of other members of the cultural world: writers, musicians, poets and actors.

Pond in fact begins to resemble the host of better known Georgian cultural figures who combined their creative lives with other professions or entrepreneurial activities. William Hogarth, painter and print publisher, Samuel Richardson, bookseller and author, and Henry Fielding, magistrate and author, come to mind. As examples accumulate, it becomes apparent that only the occasional genius or the independently rich could afford to live by art alone. Specialization was not generally possible in an age when art forms were changing, the audience was expanding but undependable, and stable commercial structures were just beginning to develop. Amphibious characters such as Pond or Samuel Richardson, active as artists and entrepreneurs, could and did make important contributions in both areas. While turning out their own original works, they also developed the commercial structures—the bookshop, the library, the print shop and the exhibition—and the audiences which supported the rising artists of the next generation.

II
Family and Friends

FAMILY LIFE

Arthur Pond was born late in the summer of 1701. He was the third child and second son of John Pond, surgeon, and his wife Mary of London Bridge. On August second he was baptized in the parish church of St. Magnus the Martyr.[1]

The Pond family had recently settled in the parish of St. Magnus. John Pond had married Mary Marshall in 1697, and they first appear in the parish records in February 1698 when a son (also named Arthur) was baptized. During John Pond's lifetime the Ponds used the parish church for baptisms, weddings, and burials, but the family may have had roots outside of London. John Pond owned a copyhold on a piece of land in the Maze, Southwark, just across the Bridge and held a leasehold property in Little Baddow, Essex, usually let out to a tenant farmer at an annual rent of £8.18.6.[2] The chronicler George Vertue—who may not have known him—called John Pond 'a Wealthy Citizen' in 1727.[3] Apart from his land and unspecified savings, Pond left at his death £23.13.0 worth of household goods, some East India bonds, a set of *Spectators*, and so much silver plate that his son hired a coach to move it.[4]

If more of their children had survived infancy, John and Mary Pond would have had a large family. Of the twelve born to them between 1698 and 1722, only five lived into adulthood. The eldest, Arthur I, died in 1700. Deborah born in 1699 survived, as did the third child Arthur. The next son died soon after birth but the three succeeding children William (b. 1704), John (b. 1706), and Roberta (b. 1708) lived. None of the children born after 1709—Mary, Benjamin, George, Susannah, and Mary—reached a second birthday.[5]

As the eldest son of a 'Wealthy Citizen', Arthur Pond may have been destined by his father for a career in one of the learned professions. He was

never formally apprenticed to a tradesman, while his surviving corres-
pondence, Latin dedications, and facility with languages suggest that he
received a good education. At least one of his longtime friends came from
a similar background; John Howard, a lawyer in the Inner Temple, was
the son of William, 'cit. and draper'.[6] Arthur probably attended a grammar
school in or near London, where he must have learned some Latin, and,
presumably, arithmetic and accounting. His exposure to art would have
been minimal except for occasional glimpses of prints displayed at the
booksellers' shops in Saint Paul's Churchyard and the rare paintings in
churches or public buildings. Thornhill's decoration of the dome of St.
Paul's cathedral would have offered him the best introduction to contem-
porary artistic achievements. Given these pedestrian beginnings, it is hard
to imagine how Arthur ever embarked on a career as an artist. However,
by 1720 at the age of nineteen, he had attached himself to the painter John
Vanderbank and entered the London art world.

John Pond apprenticed his second son William to the draper Edward
Holloway in 1719, and William opened his own shop near Aldgate with
partner Thomas Harrison eight years later.[7] He was successful enough to
be able to lend his brother money in the 1730s and to be elected to
responsible posts in his parish of St. Catherine Cree. His property in
Dulwich, where Arthur visited regularly during the summer, became his
family's permanent home and the site of his son's business. In 1743, he
represented the ward of Aldgate in the London Common Council, where
his Jacobite proclivities attracted attention.[8] Twice married, he fathered
four daughters and one son who would become Arthur's principal heir.
William died suddenly at the end of 1745 and was buried in his father's
parish of St. Magnus.[9] His widow retired with some of her children to
Streatham, where she and her youngest daughter died in 1751.[10]

John Pond's third son, also named John, amounted to very little. Like
Arthur, he was never formally apprenticed and he probably travelled on
the continent when he reached the age of twenty-four.[11] However, John
never parlayed these vaguely promising beginnings into an artistic career,
as Arthur was to do. Instead, he was accepting handouts from his older
brother in the 1740s.[12] In 1748 he was married and he probably had
children.[13] John Pond was not financially secure in 1758, for Arthur's will
provided for payment of £350 in debts, established a trust to ensure him
a regular income, and placed the entire estate in the hands of reliable and
disinterested trustees.[14] John's saving grace was his interest in art; he
bought several paintings at the sale of his brother's collections and contin-
ued to frequent London art auctions thereafter.[15]

Closely connected to the Pond family were the Durnfords, pinmakers,
also of London Bridge. Slightly more prosperous than the Ponds, they also
owned leasehold and copyhold land in Essex and Southwark. Richard

Durnford's two eldest sons became pinmakers and one of them, Thomas, was a Jacobite member of the Common Council with William Pond.[16] The other, John, married Arthur Pond's sister Deborah. John and Deborah Durnford became the center of stability for the Ponds after the deaths of William in 1745 and John Pond, Sr. in 1749; by that date theirs was the only established family unit in the younger generation. Another Durnford marriage that would eventually figure in the affairs of Arthur Pond was that of his sister-in-law Susannah to the stationer William Herbert.[17]

As Arthur Pond and his brothers pursued their separate careers, they moved in increasingly disparate social circles. Trembling 'on the brink of matrimony' in 1732, Arthur never quite fell into the life of bourgeois domesticity characteristic of his father and brother.[18] Nevertheless, he maintained close ties with them, as his frequent visits to the family summer haunts at Dulwich, Margate, and Streatham attest. He was a generous godparent to several nephews and nieces, treated his widowed sister-in-law to London plays and Christmas hams, and bailed his brother John out of debt.[19] His sense of responsibility extended to his will, which passed the properties inherited from John Pond Sr. to William's son John, and divided his personal fortune and investments between his improvident brother and his mistress Elizabeth Knapton. The executors of the will, Felix Clay, draper of Aldgate, and John Howard, the family lawyer since at least 1730, also represent Arthur's continuous identification with his City origins, as does his request to be buried at Sanderstead, the home parish of his sister and brother-in-law Deborah and John Durnford.[20]

ENTERING THE ART WORLD

Arthur Pond and other young Englishmen faced many obstacles, real and imagined, to entering the early eighteenth-century London art world. Traditionally, Englishmen had rarely excelled in the visual arts and some thought that they never would; visual insensitivity was held to be a permanent defect in the national character. Two centuries of domination by artists born and trained on the continent supported this supposition. From Holbein in the early sixteenth century to Kneller in the 1700s, it had been foreigners who had commanded the highest prices, painted the most influential persons, and captured most of the knighthoods bestowed on artists in England.

The revocation of the Edict of Nantes and the War of the Spanish Succession had prompted the latest wave of Dutch and French artists and craftsmen seeking peace and prosperity in London. They rapidly filled the large gaps in the London art world which Englishmen were just beginning to discover: printmaking, book illustration, and silver chasing. A Dutch

family, the Vanderbanks, ran the Royal Tapestry Works while Bernard Baron, Claude DuBosc, and the Regnier family set up empires as sellers and importers of prints.[21] Italian and French painters began to leave their native countries in search of patronage, which was no longer so plentiful at home. 'Their notion of [England] is, I reckon, of a cold, dark, dull, dirty country, where there is nothing but money,' wrote James Thomson of the French in 1732.[22] Italian decorators, Swedish portraitists, and French pastellists found work in English country houses while English artists looked on. The increasing mobility of artists, dealers, and tourists also promoted the international trade in old master paintings, another deterrent to a young artist evaluating future patronage. The extravagant purchases of the Duke of Chandos, for example, indicated that the empty walls of stately homes would not be filled by the works of contemporary Englishmen. Lingering Protestant objections to images and reluctance to enter a trade traditionally dominated by foreigners and Catholics may also have been discouraging factors.

In 1715-20 signs of a more prosperous future were not easily read by those outside the art world's restricted geographical and social limits. Jonathan Richardson's treatises were just beginning to be published; their polished arguments supporting the elevated status of the artist and the necessity of an education in aesthetics for every gentleman were not yet widespread. The art academies were divided and short-lived, and James Thornhill had yet to receive his knighthood. Prints and translations of European art treatises were just beginning to affect *retardataire* English tastes; most private art collections were still closed to copyists, engravers, and students. Nor could the average observer have predicted how the audience for art of all kinds would expand dramatically in the ensuing decades.

In such a discouraging climate, few artists of Pond's generation made the transition from schoolroom to studio without a hitch. One exception was George Knapton, who was formally apprenticed to the portrait painter Jonathan Richardson in 1715. George's family had published Richardson's art treatises since 1709, so his parents presumably had some sympathy with his ambitions and other sons to continue the family business.[23] Many others entered allied trades such as coach painting or endured their designated professions until freed from parental control. William Kent ran away from home to become a painter, and John Dyer studied law until his father's death enabled him to enter Richardson's studio. Arthur Pond may have experienced similar obstacles, if his father's failure to apprentice him to a painter is indicative of parental opposition.[24]

The London art world which these young painters sought to enter was a small place geographically and socially. Its physical center was the Covent Garden Piazza 'inhabitted by Painters (a Credit to live there)' and its outer

limits were set within easy walking distance, for few artists owned coaches.[25] Once the fashionable center of town, the Piazza was suffering from decades of neglect exacerbated by the nocturnal revels of visitors to its coffee houses and taverns. Its inhabitants included growing numbers of actresses and prostitutes, and the diminishing numbers of gentry were preparing to flee to the growing West End. Sir Godfrey Kneller had occupied a house on the Piazza from 1682 to 1702, which probably established the area's attraction for his followers. So too did its location beyond the limits of the City of London and the jurisdiction of the antiquated Painter-Stainers guild. In 1726 George Vertue knew eleven artists living on the Piazza, although Kneller had long ago moved to the peace and quiet of Lincoln's Inn Fields. Kneller's new residence marked the eastern boundary; Covent Garden to the south, Leicester Fields to the west, and Long Acre to the north defined the geographical limits of early eighteenth-century artistic enterprise.

Although it helped bring artists into closer proximity with their patrons, for other practical purposes Covent Garden was far from convenient. For example, the best and cheapest color shops were located in Southwark and Shoreditch, and packers and shippers worked down in the City near the Customs docks where foreign shipments arrived. Booksellers and stationers clustered around St. Paul's cathedral. An artist buying supplies, receiving shipments, or negotiating with a bookseller was forced to hire porters, chairmen, or coaches to carry out his basic errands. With most of its patronage centered in the West End, and its supplies based in the east, the art world occupied an ambiguous middle ground.

In many ways the art world's social position was as ambiguous as its geographical location. A very rough estimate of the size of its population can be made from the membership list of Sir Godfrey Kneller's academy between 1711 and 1714. The majority of the eighty-six members were professional artists, most of them painters.[26] These eighty-six comprised the respectable element of the art world, of whom about a dozen would have been well known outside of the Piazza. If another hundred, at the most, is added to account for students, apprentices, dealers, printsellers, and auctioneers, the art world probably contained roughly two hundred people. Most of its members came from rural or tradesmen's families; some had been well educated. Extremes from the upper end of the social and economic spectra were highly visible; although more common, failures were less remarkable.

Sir Godfrey Kneller and Sir James Thornhill lived like the gentry, buying land, holding royal offices, and (in Thornhill's case) sitting in Parliament. In contrast, an abject Mr. Neckins copied portraits at three shillings the head while confined to the Gate House Prison for debt.[27] Adding to the confusion and ambiguity was the large foreign element,

often Catholic or Huguenot. Furthermore, this tiny world was open to outsiders of all ranks who came to sit for portraits, buy pictures, seek work, or peddle their wares. Even in a time and place noted for rapid turnover of population, the art world was fluid and unstable.

An internal structure mixing medieval and modern hierarchies in competition with informal, non-professional clubs compounded the confusion of personnel. Like many other guilds in the eighteenth century, the Painter-Stainers Company was losing prestige, membership, and power. By 1720 it counted none of the leading artists among its members, and it was largely an organization of house painters and gilders. Its gradual collapse cleared the way for experiments with the values and ideals of seventeenth- and eighteenth-century continental academies. In contrast to the guilds, academic theory taught that art was not a trade, that the artist deserved state patronage, and that neither wealth nor background was as important a determinant of an artist's professional status as the hierarchy of the genre which he painted. Thus, in the academic scheme of things, painters were socially distinct from lowly printsellers or art dealers, with the history painter accorded the highest place of all. As abstract, ordering principles, the academic hierarchies were reflected in concrete things like abandonment of the guild, different price scales for the various genres, and new kinds of commissions. However, it would be absurd to imagine that they had much impact on the social organization of the art world before the founding of the Royal Academy in 1768 institutionalized social and professional relations. Secessions from the Kneller academy and its successor run by Thornhill indicate resistance to attempts to impose academic organization upon existing social groupings. Instead, considerations of wealth, age, religion, family background, education, and special interests seem to have been the basis for the alliances within the art world that can still be identified today. Membership lists for the Rose and Crown Club and the Virtuosi of St. Luke cut across most academic hierarchies. The Virtuosi of St. Luke included leading practitioners from various categories of art; in 1720 one finds Sir James Thornhill (history painter), Michael Dahl (portrait painter), Grinling Gibbons (carver), James Gibbs (architect), and John Rowley (mathematical instrument maker), and they were soon to be joined by George Vertue (engraver) and Andrew Hay ('Colletr. of ye Virtu', actually an art dealer).[28] The membership of the Rose and Crown numbered several painters, one lawyer from the Middle Temple, a gem engraver, a seal engraver, a collector, an architect, and a justice of the peace.[29] Many more such clubs must have existed like those which flourished among university students, writers, and politicians.[30] On a smaller scale, foreign origins or family ties influenced the formation of social clusters. Several generations of Lenses, Goupys, Grignions and Vanderbanks formed nearly self-sufficient groups dominating specialized

branches of art. Children, nephews and cousins followed the heads of these families into their field.

Arthur Pond subscribed two guineas to the newly formed St. Martin's Lane Academy in October 1720.[31] This is the earliest documented step in his artistic education, although his name appears among those of John Vanderbank's family and followers, suggesting that he may have been associated with his master some time before the academy was founded. At least twelve of the artists involved in St. Martin's Lane splintered off from Sir Godfrey Kneller's academy, and more had probably been associated with Thornhill's. John Vanderbank led the secession from Thornhill's and became the major subscriber and guiding light of the new academy. He shared responsibility for instructing pupils with Louis Cheron, an aging painter and draughtsman of French origin.

In 1720 John Vanderbank was twenty-six years old and just beginning to make his mark on the English art world. He came from a family of Dutch immigrants who had traditionally made their livings in tapestry manufacture and copper-plate engraving.[32] Among his pupils at St. Martin's Lane were Moses Vanderbank who later entered the tapestry business, and John's cousin Samuel Barker, a tubercular painter of flowers. The Vanderbank family was notoriously addicted to high living and John soon gained a reputation for a spectacular and expensive lifestyle. This (and the academy) met their inevitable ends in May 1724 when,

> Mr. J. Vanderbank, having livd very extravagantly. keeping. a chariot horses a mistres drinking & country house a purpose for her. besides at his Mothers house his painting room. & much encouragement from Nobility & Gentry run so far into debt he was forc'd to go out of England to France. & took with him his *lemon* or wife which he could not be prevailed to part from.[33]

His departure probably brought Arthur Pond's formal art education to a grinding halt. Vanderbank lived in France or, safe from his creditors, in the liberties of the Fleet Prison, until 1727, at which point he returned to his painting career and was soon recognized as a serious painter. Before his premature death in 1738 he was considered the most likely successor to Richardson as London's premier English portraitist.

In most respects Louis Cheron could not have been more different from his colleague. Sixty-five years of age, and a strict Calvinist, he was a most respectable member of the art community. Cheron found more work in England as a draughtsman and illustrator for the booksellers, although he had been a successful painter in the late baroque style in France. His later fame was founded on his 'academy figures', chalk drawings of nudes which were then engraved and collected by students.[34]

Few of the remaining thirty-three subscribers to the St. Martin's Lane

academy were novices. Of the sixteen other members for whom some biographical material can be found, six were over thirty years old and only three were less than twenty. Hans Hyssing (42 years old), George Schrider (38), Louis Laguerre (57) and Alexander Nisbet (63) were all established artists. William Kent (36) and Giuseppe Grisoni (21) had both completed their training in Italy, while Joseph Highmore (28), Bartholomew Dandridge (29) and George Knapton (22) had been studying for some years in London. These painters would have been less interested in the basic training available than in the opportunity to draw regularly from casts or the nude and receive the criticisms of their colleagues.

Among the new entrants to the art world, boasting of little or no formal training, were James Seymour (18), Vanderbank's cousin Samuel Barker, his pupil Arthur Pond (19), William Hogarth, who at twenty-three was still a silver chaser and engraver, John Ellis (19), Joseph Sympson, Jr. and George Hay. Judging from its results, the academy offered students a basic education in the general principles of painting and an introduction to the dry, late baroque style practised by Vanderbank and the older members of the school. Kent and Grisoni may have introduced some modifying Italian influences. However, further development, which was necessary if the student wished to surpass the level of the third-rate, had to come from experience outside the academy.

The shared experience of three or four years at St. Martin's Lane do not seem to have bound Pond and the other younger subscribers together into any lasting association or alliance, although it was a source of professional contacts. Pond's journal reveals that he bought and sold with everybody, but he appears to have cut himself off socially from the group that would gather around Hogarth and Ellis at Slaughter's Coffee House.[35] Joseph Highmore and Stephen Slaughter would supply Arthur's prints to friends in Paris, for example, but Pond and Hogarth developed a professional rivalry which, on Hogarth's side at least, was occasionally tinged with malice.[36] Thus failed an early opportunity to unite the talented members of a new generation into a unified English school of painting.

CLUB LIFE

As his interests diverged from those of his family and the art world split into quarrelsome factions, Pond turned increasingly to his clubs for the organization and advancement of his social and professional life. His journal reveals that between 1735 and 1750 he attended four different clubs regularly; in addition he was elected a fellow of both the Royal Society and the Society of Antiquaries in 1752, and a member of the Royal Society Club in 1757. His clubs—the Roman, the 'D', the Tobacco, the Pope's

Head, and the Royal Society Club—cemented existing friendships, supported his professional ambitions, and became important sources of patronage. Several of his fellows in these clubs also lived in his house and were close friends.

The best documented and probably the most important of these clubs (for Pond) was the Roman Club founded in 1723 and active until 1742. Its founders were Arthur Pond, George Knapton, George's relative Charles Knapton, John Dyer, a Cambridge student named Daniel Wray, and Thomas Edwards, barrister of Lincoln's Inn.[37] These six young men came from similar backgrounds, had done much of their training together, and shared numerous interests and goals. Pond, the Knaptons, and Wray came from prosperous City families. Knapton and Dyer had studied together under the portrait painter Jonathan Richardson, Dyer having abandoned the family profession of law in order to satisfy his desire to paint. Charles Knapton, another scion of the bookselling family, was a landscape painter.[38] George Knapton had attended the St. Martin's Lane Academy with Pond; Wray and Edwards had been friends since childhood.[39]

It was their mutual love of Italian classicism and desire to shine in the world of art and letters which formed the *raison d'être* of the Roman Club, however. As Thomas Edwards wrote to Daniel Wray in January 1723:

> In the meantime, as you know, we have instituted a club, 'Quod felix faustumque sit' etc. I take the liberty of sending you a *petite chançon* which was communicated to us: 'To Florella.' We are as yet in our infancy but we hope in time to render ourselves considerable in the commonwealth of wit and letters, especially when we can have the happiness of your assistance. From as small beginnings as these have risen societies whose names are handed down to posterity with honor, and who knows but this may be the foundation of glorious building.[40]

The members of the Roman Club based their concept of the artist as a gentleman of learning, and the gentleman as a connoisseur and patron of the arts and literature on the theoretical writings and living example of their mentor Jonathan Richardson. In a series of discourses published by the Knaptons between 1709 and 1721, Richardson instructed artists and public alike on the elevated roles of art and the artist, on the socially beneficial effects of training in art and connoisseurship, and on the importance of voyaging to Italy. He predicted,

> ... that if ever the ancient great and beautiful taste in Painting revives, it will be in England: but not till English painters, conscious of the dignity of their country, and of their profession, resolve to do honour to both by piety, virtue, magnanimity, benevolence, and industry; and a contempt of everything that is really unworthy of them.[41]

Even before John Vanderbank's hasty departure for France in 1724, Richardson had probably supplanted him as Arthur Pond's master and mentor, just as the Roman Club replaced the St. Martin's Lane Academy as the formative influence on his career. Thanks to Richardson's encouragement and his friends' examples, Pond completed his artistic education with a voyage to Italy in their company in 1725. In his guidebook *An Account of Some of the Statues, Bas-reliefs, Drawings and Pictures in Italy, &c. with Remarks* (1721), Richardson advocated that, while abroad, English artists and gentlemen should polish their respective educations and develop a mutual respect for the great works of dead and living masters, before returning to London imbued with the skills, knowledge, taste and desire to match the achievements of the ancient Greeks and Italians.[42] Richardson was one of the first in England publicly to advocate foreign travel for young artists, although William Kent and John Smibert, both recently returned from Italy, had improved their painting and increased their patronage as a result.[43] After another year or two of study, painting and versifying, the members of the Roman Club packed their bags and headed for Italy.

Having completed his B.A. degree at Cambridge in 1722, Daniel Wray may have left England within a year of the founding of the Roman Club. Relatively little is known about his Italian trip, except that it exhibits the hallmarks of the conventional Grand Tour. He, John King son of Lord King, and James Douglas, the future fourteenth Earl of Morton, appear to have covered Italy together. Thomas Edwards wrote to Wray at Venice in January 1725/26, at Leghorn in the spring, and at Rome in November, thanking him for his description of Holy Week, an annual highlight of the standard Grand Tour. In 1727 they had reached Turin.[44] In Rome, Wray had his profile cast in bronze by Giovanni Battista Pozzo with a motto suggestive of his character and his future role in the Roman Club: 'Nilactum reputans cum quid superesset agendum.'[45] Douglas, who was to become an important friend and patron of the club—the first of many to be introduced by Wray—had graduated from Cambridge in 1722 like his friend, and shared his scholarly and literary tastes.[46]

In 1724 John Dyer began making plans to head south although he was seriously hampered by lack of funds. On his departure, he narrowly escaped shipwreck off Plymouth and then sailed directly to Italy, possibly ending his voyage at Leghorn, where the merchant firm of Aikman and Company served as agent and post office for peregrinating Roman Club members. Dyer headed south for Rome, living on a slender income from selling his own drawings of ruins and landscapes to fellow tourists.[47] In Rome Dyer soon discovered that he preferred ancient sculpture to contemporary painting: 'I take great pleasure in visiting the statues and reliefs. It is almost my every day's work: it is a pleasure that grows upon me

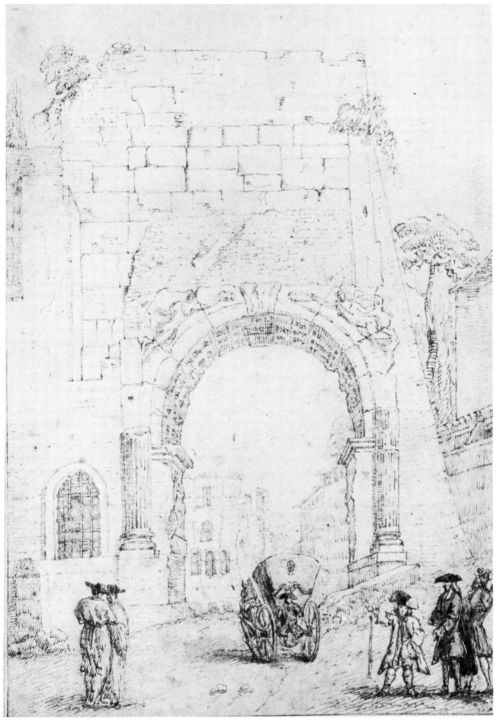

Figure 1. Attributed to Arthur Pond, *A Roman Archway—The Arch of Titus from the Forum, Rome*, pen and ink, *c.* 1725-7. Yale Center for British Art, Paul Mellon Collection.

prodigiously. I don't even wonder that N. Poussin was so fond of them, and called even Rafael an ass to the ancients.'[48] When Rome palled he made expeditions to Tivoli, the Campagna, and Naples, where he was disappointed in the scenery and attacked by bandits.

Dyer's Italian experiences weakened his resolve to become a portrait painter and strengthened his deep-seated preference for a quiet, withdrawn life.

> I have now seen the follies of many distinctions and the greatest heights of people, and can sit me down with much ease, in a very firm opinion that you are happier at Grey House than if you practised all the formalities of greatness in courts and palaces. I have gathered, I thank God, enough of knowledge in painting, to live well in the busiest part of the world, if I should happen to prefer it to retirement.[49]

As he travelled north in the summer of 1725, the reasons for his interest in antiquities shifted. Once they had been subjects for his drawings; in Florence and Ocriculum they became objects for meditation and poetry. For the conventional English tourist, ruins were monuments to timeless virtues, but they reminded Dyer of transience and mortality and they shook his faith in Richardson's doctrine that art could capture and convey eternal truths. He expressed his doubts in 'Written at Ocriculum,' a poetic fragment foreshadowing his poem *The Ruins of Rome* which he would dedicate to the Roman Club.[50] Dyer was back in Leghorn in the fall of 1725 and reached London that winter. There he would make his reputation as a poet and fail as a painter.

Arthur Pond and George Knapton were both in Italy by 1725, travelling together. Thomas Edwards wrote to George Knapton in Rome in the spring of that year, conveying messages to Arthur in his letter.[51] Funds for their travels may have come as gifts or loans from parents, or they may have worked their way south as Dyer had. For Edwards, at least, they were exporting plaster casts from the antique, and shipping them to London via John Pond, Sr. In Rome they caught up with Wray and Douglas, who may have provided some timely business and secured their entrance to aristocratic Roman collections. Letters of introduction from Jonathan Richardson or the travelling art dealer Andrew Hay would also have been helpful. Thanks to his friends, Pond joined Roman antiquarian and artistic circles under the tutelage of Pier Leone Ghezzi. A member of the Accademia di San Luca, Ghezzi held the office of Pittore di Camera to the Pope. He was responsible for the maintenance and care of the papal collections, as well as administration of the mosaic and tapestry factories, and he was the 'decorator in charge' of festivals and monumental constructions. Apart from his official duties, Ghezzi also acted as a line and gem engraver, antiquarian, restorer, agent-collector, caricaturist, and portrait and

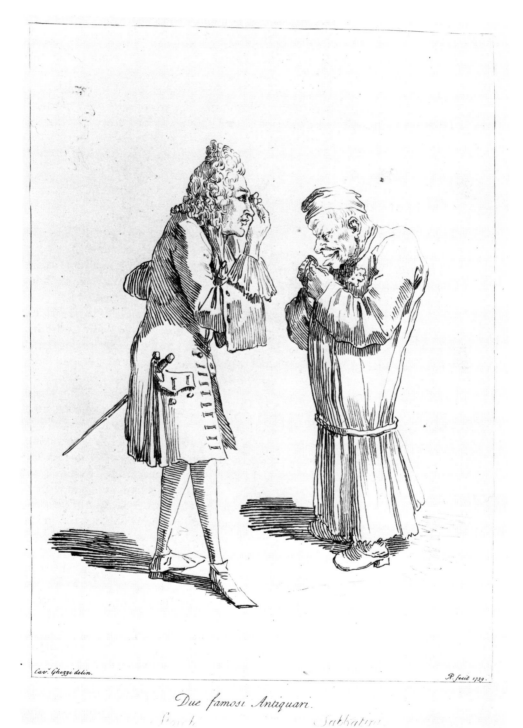

Cav.ᵉ Ghezzi delin.

P. fecit 1739.

Due famosi Antiquari.

Figure 2. Arthur Pond after Pier Leone Ghezzi, *Due famosi Antiquari* [Stosch and Sabbatini], etching, 1739.
Philadelphia Museum of Art, Anthony Morris Clark Bequest.

decorative painter.[52] He was the ideal friend for a young Englishman anxious to join the Roman art world.

Ghezzi was best known for his satiric pen and ink portraits for which every distinguished visitor, artist and connoisseur in Rome seems to have sat. Ghezzi drew several members of Pond's Roman circle. For example, Pond owned a Ghezzi drawing of Dr. Thomas Bentley, nephew of the Oxford scholar Richard Bentley. Thomas arrived in Rome in 1725 to collate Greek manuscripts at the Vatican, and his extraordinary profile soon attracted the caricaturist's attention. A second Ghezzi caricature of two leading members of the Roman art world may have entered Pond's possession at this time. 'The 'Due famosi Antiquari' (Figure 2) were Baron Philip von Stosch, collector, antiquarian, and spy for the British government at the Jacobite court, and Marcantonio Sabbatini, a Bolognese aristocrat, Papal Antiquary, and superintendent of ancient and contemporary buildings.[53] These two would have completed Pond's initiation with shady deals in antique seals, state secrets, and fine arts publications. The center of an international network of artists and connoisseurs, Stosch also supplied useful introductions in Rome; later, he would send artists to London with introductions to Arthur Pond. As the latter's visit to Rome drew to an end, Stosch reported back to the British government, 'Mons.̲ Pond Peintre qui a passe icy quelques annees, et qui est fort attache aux interets du Roy [George II], est party ce matin en compagnie de Dr Elwood Irlandois pour s'y retourner en Angleterre en droiture.'[54]

On his way back to London, Pond stopped in Paris where he met Pierre-Jean Mariette, a collector, printseller, and connoisseur specializing in drawings.[55] Through Mariette he was introduced to the circle of artists and connoisseurs around the financier Pierre Crozat, owner of one of the finest collections of drawings and paintings in Europe. At Crozat's Pond would have experienced French salon life for the first time—'On tenait assez regulierement toutes les semaines des assemblées chez lui où j'ai eu pendant longtemps le bonheur de me trouver, et c'est autant aux ouvrages des grands Maitres qu'on y considerait, qu'aux entretiens des habiles gens qui s'y reunissoient . . .'[56] There one of the topics under discussion in 1727 would have been the recent publication of etchings executed by the connoisseur Comte de Caylus after caricature drawings then attributed to Leonardo da Vinci; some of the originals belonged to Crozat, and Mariette was completing an explanatory pamphlet for publication, which he urged Pond to promote in London.[57] The same team was also engaged on a far more ambitious project, a large volume of chiaroscuro prints reproducing the most famous drawings in French royal and private collections. Completed in 1729, it became the model for the series of prints imitating drawings that Pond and Charles Knapton would execute and publish in London five years later.[58] The French connoisseurs also drew Pond into

their constant and intricate trade in Italian, French, and Netherlandish prints and drawings. Pond and Mariette would correspond for the rest of their lives, bickering respectfully over the quality and attributions of their wares.[59]

George Knapton was the only member to profit directly from the Roman Club's experiment with foreign travel. He used his seven years abroad to study with continental painters, and he came home a humbler and better artist.[60] Furthermore, he exploited his chance to meet and cultivate a new generation of wealthy English gentlemen and aristocrats. The influential Society of Dilettanti, founded in Rome in the early 1730s with George Knapton present, would ally with the Roman Club in an effort to promote the appreciation of Italian art and culture in England.[61]

The Roman Club began to reassemble in London in 1727. Arthur Pond bought the lease on a house in Covent Garden, where he was joined by Wray, Dyer, and Charles Knapton, who between them paid most of the rent.[62] Charles Knapton had married before 1728 when his first child was born.[63] While the rest of the club travelled abroad, he remained at home, minding the shop and redirecting their correspondence to provinces or continent. The club met regularly at Serle's Coffee House near Lincoln's Inn, near the chambers of the fifth member Thomas Edwards.[64] George Knapton and the rest of the Dilettanti returned from Italy in 1732–4; George became the link connecting these Italophile organizations of artists and writers on the one hand, and patrons on the other. Although its members lacked much wealth and influence of their own, they supported each other's literary and artistic productions. John Dyer recognized its importance by dedicating his poem *The Ruins of Rome* (London, 1740) to his fellow members; Arthur Pond also dedicated a print to them 'in the most grateful spirit possible', in 1734.[65]

In January 1741 the club acquired a new member, John Montagu, fourth Earl of Sandwich. At least fifteen years younger than the others, Sandwich had returned from a Grand Tour of the Mediterranean with William Ponsonby (future Viscount Duncannon and Earl of Bessborough) in 1738–9. He brought with him a collection of antique coins, inscribed marble tablets, 'two mummies and eight embalmed ibis's from the catacombs of Memphis ...'.[66] He joined the Dilettanti and the Royal Society immediately thereafter, but his scholarly interests diminished after he joined the Admiralty in 1744. William Fauquier, who had been a member of the Dilettanti since 1736, was a banker and director of the South Sea Company and London Royal Insurance Company; he would be elected a member of the Royal Society in 1748 and of the Royal Society Club shortly thereafter. A prominent London collector, he had employed Pond steadily since at least 1735.[67] Although politics was far from being the club's first

priority, most of their productions exhibit characteristics of the ideology of the political opposition to Sir Robert Walpole. Dyer's poems contrast antique Roman virtue with contemporary English corruption—a reference to the abuse of political patronage. Arthur Pond contributed the frontispiece to Richard Glover's epic *Leonidas* (1737), another veiled attack on the ministry.[68]

The Roman Club broke up in 1742, coincidentally with the fall of Walpole. Charles Knapton died that year; John Dyer, having been ordained in 1741, became vicar of Catthorpe in Leicestershire, and Thomas Edwards retired from his law practice to pursue literary interests at his estate in Buckinghamshire.[69] George Knapton had returned to Italy in 1740 and visited the recently discovered subterranean town of Herculaneum. Nevertheless, the friends remained in close touch with each other. George Knapton sent descriptions of Herculaneum to Pond and Charles Knapton, to be forwarded on to the Royal Society.[70] Daniel Wray continued to live with Pond (the household moved as a unit to Great Queen Street in 1735), to encourage Dyer's poetry, and to find patronage for his friends' endeavors. Thomas Edwards kept his London lodgings at Pond's from 1738 on, although he was there infrequently. Besides providing shelter for his friends, Arthur Pond sent John Dyer painting supplies and prints, and retained Charles Knapton's widow as a business partner, housekeeper and mistress.[71] Pond's journal indicates that Elizabeth and her children lived rent-free in the Great Queen Street house and his friends thought of them as 'Mr. Pond's family'.[72] Even after it ceased to exist formally, the Roman Club persisted as a bond between its former members—aided by their continuing links with the aristocratic Dilettanti.

For a brief spell, Pond may have been a member or associate of the Dilettanti themselves. As a traveller to Italy, a friend of George Knapton, and a shipping agent of several of the founding members, he certainly qualified; his journal reveals that he attended what he described as the 'D' Club up to the end of 1735.[73] At about that date the Dilettanti began to shed their less distinguished members and develop their reputation for boisterously drunken Tuesday night meetings. George Knapton remained with the society in a subordinate role as their designated painter, while the Dilettanti's sculptor Thomas Adye executed commissions for Pond and Thomas Edwards.[74]

Pond joined a third club in the 1730s which differed from the others in being almost entirely political in nature. Its president Ben Bradley had led popular resistance to Sir Robert Walpole's proposed excise tax on tobacco; along with Pond its only other known member was Richard Houlditch, Jr., son of a ruined South Sea Company director, a drawing collector, and a lodger at the Great Queen Street house from 1735 to 1737.[75] His father, Richard Houlditch, Sr., had known Arthur Pond since the latter's student

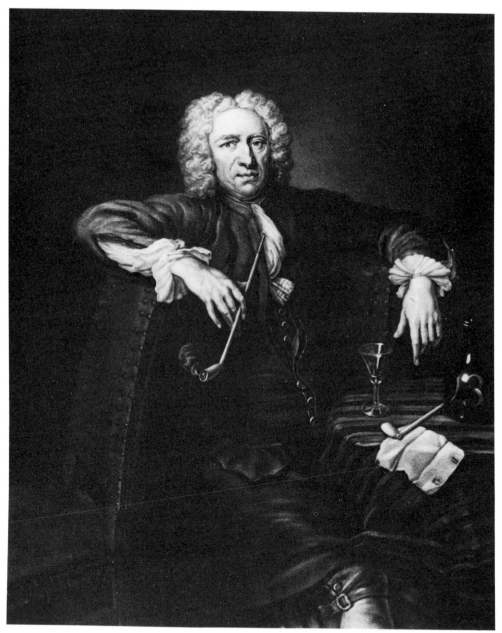

Figure 3. John Faber, Jr. after Arthur Pond, *Benjamin Bradley*, mezzotint, 1737. Trustees of the British Museum.

days in 1722, and in spite of the loss of his fortune in the South Sea Bubble (he had been one of the directors of the Company) and the bankruptcy of Houlditch and Brooks, drapers in Billiter Square, the family lived comfortably in Hampstead.[76] The Tobacco Club, which Pond frequented only from October 1736 to October 1737, had little effect on his artistic production or patronage, as far as can be determined. Its members did commission a portrait of their president which they had engraved in mezzotint and circulated as propaganda.[77] Pond's association with the club ended after the publication of the print (Figure 3).

The dissolution of the Roman Club in 1742 coincided with a hiatus in Pond's life and career. Along with the death or departure of his closest friends, he suffered from a slump in the art market apparently related to the outbreak of the War of the Austrian Succession on the continent. His journal also indicates that he made several long trips away from London and perhaps one expedition to Holland—he had been studying Dutch in 1738-9.[78] Pond's return to London and the revival of his successful portrait painting career in 1744 was soon followed by membership and regular attendance of yet another club. This organization, which seems to have lacked a name during the first ten months of its existence, met weekly until 4 April 1744. It met again on 5 September, and a month later was formally titled the Pope's Head Club, evidently in memory of the poet, who had died the preceding March.[79] If its name can be taken as evidence, the new club shared the old Roman Club's interest in literature, classicism, and mild political commentary; it may also have shared some of its former members: Pond, Edwards, and Wray. However, they had some new associates who are the most likely candidates for places within the Pope's Head. These included Daniel Wray's friend and patron Philip Yorke, writer, antiquary, and son of Lord Chancellor Hardwicke, Philip's brother Charles, a lawyer, and perhaps the Reverend William Warburton and the booksellers John and Paul Knapton. By the late 1740s all were engaged to some degree in Warburton's project of compiling and illustrating various editions of Pope's works to be published by Robert Dodsley and the Knaptons in the late 1740s and 1750s.[80]

Whereas the Roman and Pope's Head Clubs helped solidify Pond's relations with aristocratic patrons, by the 1740s he had also found a group composed almost entirely of wealthy merchants and government office-holders centered in the City of London. These men never organized into a club, but their common social background and their specialized pursuit, the formation of superb personal collections of old master paintings, prints, and drawings, bound them closely to each other and to Pond, who acted as their mentor and advisor. One would guess that they met informally at Christopher Cock's auction rooms in Covent Garden, and at Pond's, where they frequently made purchases together or on one another's be-

half.[81] The center of the group and Pond's close friend was Charles Rogers, a Clerk of the Customs who had inherited an income and a drawing collection to which he dedicated the rest of his life and fortune.[82] Rogers shared his interest with several other Customs House officials: Robert and Horatio Paul and Harry Burrard.[83] Three tradesmen, Robert Mann (a draper whose family relationship with Sir Robert Walpole helped Rogers confirm his appointment to the Clerkship), Charles Lowth (draper of Paternoster Row), and Nathaniel Hillier (merchant in Pancras Lane) were also involved.[84] Other friends drawn into the group included Richard Houlditch, Jr. (whose father had begun as a linen draper), the lawyer John Howard of the Inner Temple, John Barnard, the painter Thomas Hudson, and his pupil Joshua Reynolds.

Beginning in the late 1740s, Arthur Pond also came into contact with scientific circles, thanks to his publication of the engraved illustrations to Richard Walter's *A Voyage round the World ... by Commodore Anson* (London, 1748) and his subsequent interest in shell collecting. Like the old master collectors, the natural historians met on an informal basis. In 1749 Jacob Neilson traded his specialist's knowledge of shells for room and board, and moved into the Great Queen Street house. According to Emanuel Mendes da Costa, a collector who knew them both, Pond and Neilson were intimate friends until Pond, justifiably suspicious of Neilson's relations with Mrs. Knapton, cut him out of his will. Before personal matters intervened, however, Neilson built up Pond's shell collection, and by 1750 Pond was sufficiently involved to begin calling on Sir Hans Sloane.[85]

The sometimes informal but very important relationships Pond developed with eminent collectors and patrons in the 1740s became the key to his election to the Royal Society and the Society of Antiquaries in 1752. Forty-two of his friends and patrons—including members of the Roman Club, the Dilettanti, the Pope's Head, and both collectors' groups—were members of the Royal Society when Pond joined, and about fifteen of his acquaintances could be found in the Antiquaries.[86] The Royal Society Club introduced several more.[87] Pond's acceptability to both groups was enhanced by his magnificent collections of prints, drawings, and shells, and the inheritance of his father's estate in 1749. He appears to have been the only artist of his generation who shared both Societies' then preoccupation with accumulating and organizing strange objects and knowledge in a scientific manner, and who also had the means to exercise it on the grand scale. At the same time, his willingness to share his collections with interested viewers suggests that his lifelong interest in educating public taste had not been entirely subordinated to self-serving ambition.

Before about 1760 clubs such as the Roman and the Pope's Head determined the internal organization of the art world. The guild had

ceased to play a significant role and the resulting vacuum was filled by ephemeral academies and clubs. The clubs were proving to be the stronger and more durable alternative in the first half of the century and gave the period its unique character. Along with those Pond founded or joined, can be listed the Rose and Crown Club (1720–1745), the Virtuosi of St. Luke (1689–1743), the Kit Kat (c. 1700–c.1720), the Slaughter's Coffee House Group (c. 1720–c. 1760), and the Beefsteak (founded 1735). Their names have survived only through chance or thanks to the fame of their associates Kneller and Hogarth. In spite of the conflicts and rivalries which arose among their individual members, the clubs had much in common. They were composed of heterogeneous groupings of artists, writers, publishers, and their patrons; several dabbled in mild opposition politics. All provided favorable climates for creative developments such as the Slaughter's group's promotion of the French rococo style and the Roman Club's championship of classicism. These last two groups also shared an ardent ambition to form and direct the long-desired English school of painting, although they saw it developing along very different courses. They encouraged experimentation, diversity, and controversy, while their common ideals and mixed memberships prevented hierarchical stratification and total fragmentation. Even as Pond and Hogarth waged the war between ancient and modern in their series of prints, Pond's mentor Jonathan Richardson was boring the Slaughter's *habitués* to tears by reading his discourses aloud among the coffee cups. Thomas Hudson contrived to collect the ancients while eating with the 'moderns' in the Beefsteak, and Pond was a careful collector of fine impressions of the Hogarth *Progresses*. Judicious patrons bought conversation pieces from Hogarth and old masters from Pond, and printsellers pirated designs from both with great success. The polemics, the competitive atmosphere, and the drive for excellence and change provided unusual excitement within the London art world—an excitement stimulated by the external public's growing involvement in the art market. The clubs, which effectively brought artists and laymen together, became important sources of patronage, an area where both the guild and the academies had failed.

III
The Search for Patronage

How did an artist just back from two years in Italy, unknown outside the limits of his parents' neighbourhood and the artists' quarter of Covent Garden, find a foothold in the London art market? And, once established, how did he climb to the top?

Arthur Pond's key to success was patronage, a problem which preoccupied every artist of the period up to the founding of the Royal Academy in 1768. The typical patron of the sixteenth and seventeenth centuries, who often took the artist into his household and kept him busy, fed, and clothed, had always been rare in England. By 1720 they were a dying breed, of which the last survivors were the Earl of Oxford (protector of George Vertue) and the Earl of Burlington (William Kent). Most artists were not as fortunate as Kent or Vertue, who admittedly suffered their own kinds of insecurity. As the seventeenth-century system died out, artists lost not only their great patrons, but also their habitual means of finding new ones. The patron's household—where both artist and art works were on display—had functioned as an important point of contact between artist and audience; an eighteenth-century artist living in Covent Garden lodgings had no comparable opportunities for self-display or mingling with the rich and powerful. His relative isolation also made it difficult to maintain contact with patrons living and moving in different social spheres, while impersonal intermediaries such as art dealers, auction houses, and public exhibitions, had yet to evolve beyond a crude stage. Thus an artist like Pond faced an endless process of searching, courting, befriending or discarding series of potential art buyers in the hope that some of them would become steady patrons. The more influential and well-connected these men and women were, the higher his status in the art world would become, and the greater his chances for economic and social success.

The purpose of this chapter is first to identify the kinds of opportunities

Pond and others had for meeting potential clients or showing their work to an interested public, and then see how successful contacts could lead him to previously inaccessible audiences. Pond's case will show that many of the seventeenth-century practices persisted; patrons who also functioned as 'friends' mediating between the artist and an aristocratic audience were still sought after, highly valued, and jealously guarded. However, the means employed to find these 'friends' and exploit their contacts with other potential buyers were distinctly eighteenth-century and reflected the age's particular social character—the leisured status of women, the social and cultural activities of the London clubs, and the role of family ties in the distribution of influence, patronage, and taste. The seasonal congregation of this audience in London, along with the rising population and sophistication of provincial centers and broad improvements in communications in general, expanded the role of gossip and that intangible, reputation, as factors in an artist's strategies for success. Some of the more innovative painters and printsellers like Hogarth and Pond experimented with new commercial techniques, particularly the use of all kinds of print media to reach literate audiences. As a result of these methods, early eighteenth-century English artists discovered a large audience for their work.

Like most of his colleagues, Arthur Pond conducted his business inside his home, which functioned as workshop, exhibition space, and retail outlet. One of his first concerns in his search for patrons was to find a dwelling place in a part of town likely to be frequented by art buyers. His first choice in 1727 was a house formerly occupied by Godfrey Kneller on the Covent Garden Piazza, the center of the London art trade for the preceding twenty-five years.[1] The area's theatres, auction rooms, and market brought a large crowd into the artists' vicinity; people would call in on the painting rooms in the course of a day's shopping or entertainment. Seven years later, Pond, still following in Kneller's footsteps, moved to a large house in Great Queen Street near Lincoln's Inn Fields. This district had recently been settled by two of London's most eminent art collectors, Henry Hoare and Sampson Gideon; it was also the residence of Philip Yorke (Lord Hardwicke) and Lord King. As such it promised to be a profitable hunting ground for patrons, and Pond, who was one of the first painters to move there, was joined within five years by competitors Thomas Hudson, Arthur Devis, Joseph Highmore and James Wills.[2] A patron with other business in the area might easily look in on the artists, too, as the Earl of Egmont did in 1737: 'This morning I visited Lord Grantham, who assured me the King does not go abroad this summer ... I then went to Mr Pond, the painter in Great Queen Street, where my new daughter Percival and my daughter Helena are sitting for their pictures in crayons ...'[3] By the 1740s, Great Queen Street seems to have

rivalled Covent Garden as a center for the art trade, and would certainly have been visited by browsing art lovers and determined shoppers.

Just as important as the location of the house was the physical appearance of its exterior and interior. A fashionable clientele would naturally prefer to enter a stylish, well-maintained house of the type being built in the Lincoln's Inn Fields area at the beginning of the century. Arthur Pond also took care to furnish the public rooms of his house comfortably and well. As soon as he could afford it, mahogany furniture appeared in his parlour, painting room, and bedroom, and the walls were hung with green wool damask. These hangings were then covered—from wainscotting to ceiling, judging from the inventory—with examples of Pond's work: copies from Raphael he had made in Rome, full-length portraits of eminent sitters which displayed his ability to take likenesses, and old master paintings which were the originals of his prints and often for sale. Pond added an extra touch in one of the first floor rooms with a marble chimney piece of his own design carved by Thomas Adye, sculptor to the Dilettanti Society.[4] When the Earl of Egmont entered the house to examine the artist's work, he was intended to be impressed by the display of the artist's skill, taste, erudition, and success. Appearances were so important in making this impression that Pond went into debt in 1735–6 in order to buy the lease on the Great Queen Street house and begin to furnish it.[5]

The great difficulty, of course, was how to induce prospective patrons to enter the house. As far as can be determined, Arthur Pond never hung out a shop sign, the traditional method of proclaiming his trade and inviting interested passers-by to enter. Shop signs were becoming controversial in London at this time, and especially so in the art world as it bridged the distance between the old view of art as a mechanical trade and new aspirations to acceptance as one of the learned and gentlemanly professions. No follower of Richardson was likely to hang out a shop sign, although printsellers and William Hogarth continued to display them. Hogarth seems to have viewed his sign showing Van Dyck's head as a defiant emblem of his allegiance to the old English tradition, and he painted satirical shop signs to mock the new generation's art societies and exhibitions.[6]

The Richardsonian equivalent of the shop sign was intangible—reputation—but like the shop sign, the larger, gaudier, and more telling it was, the more effectively it attracted patrons. In constructing his reputation, Pond sought to emphasize the characteristics distinguishing him from other artists which were also likely to be attractive to patrons. These included his Roman experience, which he stressed by speaking Italian whenever possible, his connoisseurship, which he demonstrated by publishing esoteric prints imitating old master drawings, and his painting skill, which he advertised by publishing prints after his portraits. Later prints

depicting fashionable or important people suggested his association with London's elite and earned him additional social prestige.

Pond's reputation was as ephemeral as the gossip that carried it, but its impact could be considerable. One eighteenth-century commentator placed it immediately after appropriate housing on his list of prerequisites for an artist's success in the fashionable world.[7] In 1727-8 Pond nearly won an important sculpture commission from the East India Company because he 'was mightily commended by report, for his great industry and assiduous studies. abroad'.[8] By 1740 his prints had attracted attention: Mr. Ar. Pond ... has by Collections of drawings prints some books some etchings clare-obscur prints become the greatest or top virtuosi in reputation in London—followd esteemd and cryd up. to be the great undertaker. of gravings paintings &c. &c.—Mr Pond is all in all—.'[9] In the field of portraiture he was especially notable for his work with pastels and color; Mrs. Delaney's statement, '... his coloring in crayons I think *the best* I have seen of any English painter', coincided with a six-year fashion for his portraits in court circles.[10] Later, he was able to half convince the literary world that his services were indispensable for critical success. Thomas Gray joked with Horace Walpole that '*Windsor* and *Eton* might have gone down to posterity together, perhaps appeared in the same volume, like Phillips and Smith, and we might have set at once to Mr. Pond for the frontispieces; but these, alas! are vain reflections.'[11] These are fragments of evidence for what once must have been an impressive, carefully constructed reputation, and they are indicative of the attractions that brought the Earl of Egmont to Great Queen Street.

Most of the patrons who entered the artist's home did so as a result of personal contact with Pond, sight of examples of his work, or conversation with other satisfied buyers. At this time painters rarely employed newspaper advertising, and seem to have regarded it in much the same light as painted shop signs—a medium for printsellers and vulgar tradesmen. The premium on personal contact between buyer and seller survived from the seventeenth century into the eighteenth, but artists now had to manipulate the very different social patterns emerging in urban London. Arthur Pond employed a variety of traditional and new strategies for initiating contact with prospective buyers; these can be summarized as reciprocal business, painting tours, drawing lessons, friends and clubs. Initial contacts, if successful, could then bring in additional business and more clients.

Reciprocal business was the most limited and least satisfying of the strategies available to Pond, but it brought small quantities of regular work. The craftsmen and suppliers who sold frames, glass, linen canvas, and other materials to Pond would occasionally give him commissions or make small purchases. The extent and nature of these purchases seem to have been related to the scale of business Pond gave them, and were

designed to show off the quality of the materials they provided. One of the Gossets, who made elaborate frames at great expense for most of Pond's portraits, ordered a full-length copy of *Rubens' Wife*, a composition which was enjoying an enormous vogue in London in the early 1730s.[12] Presumably Gosset placed the arresting painting in an important frame and hung it in his residence/shop in Newport Street as a sample of his best work. Likewise, Dillingham the glazier wanted prints hand-colored, framed, and glazed with the glass he regularly sold to Pond for the purpose.[13] Pond also traded some business with the drapers who sold him canvas for painting and materials for his own clothes. Stracey Till (partner in William Pond's drapery business) responded to Arthur's purchases of cloth with an order for a portrait.[14] Another draper, Charles Lowth, traded patronage with Pond, but they were drawn together by their mutual interest in old master drawings and antiquarianism.[15]

It was less common for Pond to sell his work to tradesmen in non-art-related professions. For example, he did not receive any orders from his wigmaker Wilkins Perry or Mr. Tourville, the proprietor of the Bull and Gate where he stabled his horse. Once he painted a portrait of his landlord, but only because he lacked the ready cash to pay a quarter's rent.[16] However, he did receive a timely commission from John Howard, the Pond family lawyer, and from Dr. Gally, rector of the parish of St. Giles in the Fields. Howard gave Pond thirty pounds with which to buy draw-ings while in Rome (1725-7).[17] Dr. Gally's order for a portrait of their mutual patron Lord King came just before Pond closed the purchase of the Great Queen Street house located within his cure.[18]

Arthur Pond did very little direct business with his fellow artists, beyond the occasional sale of prints to painters for copying or studying. Those who bought prints in quantity—John Smibert of Boston, Rupert Barber in Ireland, and William Bellers at Oxford—intended them for resale far from London.[19] One of Pond's employees, the engraver Francis Vivares, accepted prints in lieu of wages, but these also were intended for resale.[20] On the whole, artists seem to have been unwilling to use their own display walls to promote the work of living competitors.

The limitations of Pond's business-related patronage are evident when it is compared with the opportunities which opened up with other types of buyers. Not only was the former small in scale, but also it led nowhere. Tradesmen and craftsmen did not spend large sums on art and the same held true for their families and friends. Although glimmers of interest in the fine arts were appearing among small tradesmen and retailers, as buyers they were neither necessary nor sufficient for an artist's success. The most desirable patrons were still the very wealthy merchants and professionals, the gentry, and the court. Pond, however, was unlikely to meet such people in the course of a normal day's business.

The painting tour was a well-tried method of obtaining access to desirable buyers, and it was still favored as a means of launching a young painter's career in the first half of the eighteenth century. Nevertheless, its resemblance to traditional journeymen's tours was declining, thanks to the growth of provincial towns, and the attractions of continental travel. Arthur Pond's trip to Italy after training at St. Martin's Lane functioned like a traditional tour by exposing him to new experiences, methods, and types of patrons. Crucial for his career as a virtuoso, it had little impact on his painting business, and Pond endured several years of obscurity before embarking on another one. His second tour, actually a series of sporadic trips from London to the provinces, was financed by the booksellers John and Paul Knapton.[21] His work for the Knaptons—drawing small copies of portraits of famous historical characters to serve as models for engraved book illustrations—provided entrées to some of the most important collections and aristocratic households in England. It began with orders for copies of portraits from London collections, such as the *Sir Isaac Newton* belonging to Newton's son-in-law John Conduitt, Master of the Mint. Pond copied the painting, then performed ten guineas worth of 'alterations' on other paintings for Mr. Conduitt. He also made an impression on Mrs. and Miss Conduitt, who gave him commissions on their own after John Conduitt's death in 1737.[22] Not only did the *Newton* bring business from the Conduitts, but also it attracted requests for copies from a Mr. Cartlich in 1736 and Sir Thomas Lowther in 1738.[23] Images of Pym, Hampden, Cromwell, and Lord Strafford brought a few more patrons in the same manner.[24]

Pond's real travels commenced in 1737 when Vertue recorded, 'This Summer. Mr. Pond began his circuit in the Country to Noblemen and Gentlemens houses in quest of business. or to Coppy heads in Chiaroscure.—for Knaptons illistrions to be gravd after.'[25] At first he concentrated on the environs of London and the home counties, visiting the royal collections at Kensington Palace, the Middlesex residence of the Duke of Bedford (Woburn) (Figure 4) and the Earl of Essex (Cassiobury) and Lord King's in Surrey.[26] A year later he made stops in Bedfordshire, Suffolk, and then proceeded as far north as Nostell Priory in Yorkshire. There he first copied the head of Sir Thomas More from Lockey's enormous portrait of the More family, then undertook to clean the entire painting at the request of its new owner Sir Rowland Winn.[27] Many of these stops brought more commissions, or introduced Pond to future patrons. All in all, about twenty-five owners of original portraits reproduced in the Knaptons' publication eventually became patrons of Pond, although it is not always certain that the tour was the source of the primary contact. (Lord King had already met Pond on the Grand Tour in 1726, for example). These initial contacts engendered others with the

Figure 4. Attributed to Arthur Pond, *Francis Russell, 2nd Earl of Bedford* (after a portrait at Woburn, formerly attributed to Zuccaro), oil and body color, varnished, *c.* 1737. Ashmolean Museum, Oxford.

family and friends of the original patron; the Conduitts' case is typical of many.

City-born Arthur Pond needed the entrées provided by the Knapton job to make his tour successful, but other strategies for gaining access to country-based patrons could be equally effective. Painters born in the provinces often chose to return to their parents' homes for several years after completing their formal training; in addition to room and board they could count on hospitality and work from their parents' friends and strangers anxious to encourage native prodigies. Arthur Devis, Thomas Hudson, and Pond's friend John Dyer all benefited from contacts made during such 'tours'; Hudson and Devis also found that these patrons could be extremely helpful when they decided to establish themselves in London. Hudson enjoyed a near-monopoly of Devonshire-based London visitors, Devis attracted the Lancastrians, and Allan Ramsay could count on the Scots.[28] Both Arthur Pond and William Hogarth lacked the built-in patronage base provided by provincial origins, and some of the friction between the two may have resulted from competition for business from their native City of London.

The growth of the provincial cities was also helping to reduce the traditional painting tour to obsolescence. Bath could support top-flight portraitists like William Hoare and Thomas Gainsborough, and Pond recommended that one of his pupils begin his career there rather than travel.[29] When his own painting career hit a snag in the early 1740s, he himself seems to have made at least one trip to Bath in search of new clientele.[30] Philippe Mercier in York, William Bellers in Oxford, Thomas Bardwell in Norwich, and John Smibert in distant Boston found adequate patronage for their work, although they continued to rely on London for inspiration and supplies.

Another strategy for attracting patrons that Pond employed successfully was the drawing lesson for private pupils, especially women. This relatively new technique succeeded because women in the upper classes were now receiving better education, including some instruction in the fine arts. Moreover, thanks to the institutionalization of 'pin-money,' they had the funds to spend on their own pleasures or education. They were devoting less time to needlework and domestic management than before, and more to reading, drawing, letter writing, and shopping. Their growing prominence in the art market must have provided an additional incentive for artists to live and work in respectable—if possible, modish—surroundings.

Arthur Pond owed his introduction to court circles to the drawing lessons he gave to Grace, Countess of Dysart in 1734. In themselves the lessons were unimportant, and Pond may not even have been paid for them, but they offered a chance to show off his skills to an influential lady of fashion. Lady Dysart's friends admired her new skills and learned about

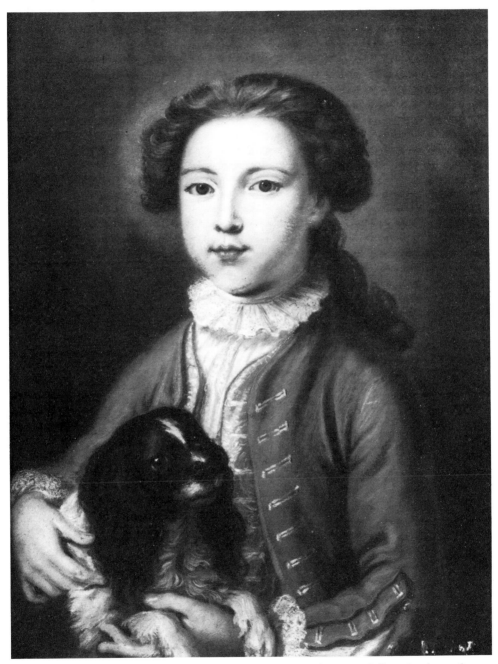

Figure 5. Arthur Pond, *Master John Walker*, pastel, 1736. National Portrait Gallery, London, reference negative.

Arthur Pond. 'Lady Dysart goes on extremely well with her drawings; she has got to crayons, and I design to fall into that way. I hope Mr. Pond will help me too, for his colouring in crayons I think *the best* I have seen of any English painter,' wrote Mrs. Delaney, an intimate friend of Lady Dysart, in 1734.[31] Mrs. Delaney's enthusiasm inspired her correspondent the Duchess of Portland to order a portrait of another mutual friend, Miss Catherine Dashwood. Mrs. Delaney then visited the Dashwood portrait at Pond's before it was completed; it was evidently customary for friends of the sitter to observe and comment on the work in progress.[32] Pond accepted and even welcomed the disruption, since it often brought new patrons or additional business. The Earl of Egmont again: 'This morning I went to Mr. Pond, the painter in Queen Street, to see my daughter Helena sit to him for her picture in crayons. I met my daughter-in-law Percival there, who promised she would sit for me also.'[33] By 1739 Catherine Dashwood's relatives Lady Dashwood, Captain Dashwood, and Robert Dashwood had also sat to Pond, along with some more Percivals. In the meantime, Mrs. Delaney herself took lessons and recommended her uncle Sir Anthony Wescombe and grandfather Lord Lansdowne to Pond.[34]

This intimate female group bonded by sentimental friendship and family ties initiated the rush of fashionable patrons into the Great Queen Street house between 1734 and 1740. Both Mrs. Delaney and Catherine Dashwood held posts as ladies of the bedchamber to Queen Caroline, and with Lady Dysart and the Duchess of Portland they set fashions in dress and taste within the court.[35] Their lead to Pond's was followed by other members of the Queen's retinue: the Countess of Pomfret and the Countess of Hertford (both ladies in waiting) and the Honorable Miss Vane, maid of honor to the Queen and occasional mistress of the Prince of Wales, Lord Harrington, and Lord Hervey.[36] Pond portrayed Princesses Mary and Louisa, the Duke of Cumberland, and the Prince of Orange (for Princess Amelia).[37] Although he was never employed by Frederick, Prince of Wales, Pond sold work to his friends—Lord Archibald Hamilton (husband of another mistress), his brother the Honorable Charles Hamilton, clerk of the Prince's household from 1738 to 1747, and Richard Glover.[38] By 1738 Arthur Pond's fame had swept through fashionable London, and it is impossible to disentangle the social, political, and family ties connecting one of these patrons to another, and thence to Pond. At the height of his popularity the artist was patronized by every court and parliamentary faction; Jacobites, Tories, Walpole Whigs, the 'moneyed interest', and the Leicester House group were all in evidence. Whatever their internal differences may have been, to an outsider such as Pond they displayed impressive conformity in the pursuit of fashion.

Not all of Pond's contacts with female patrons had such far-reaching consequences. Few women spent large sums themselves, but with the right

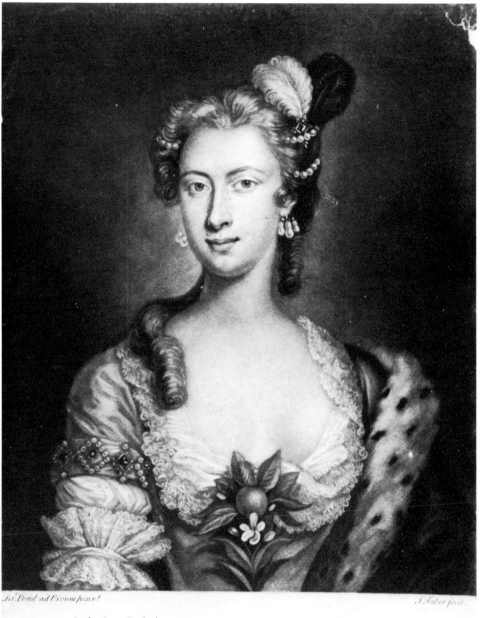

Figure 6. John Faber, Jr. after Arthur Pond, *Her Highness Princess Maria*, mezzotint, *c.* 1740. Trustees of the British Museum.

encouragement their male relations would often disburse enormous quantities. This was the case when Pond began to give drawing lessons to Miss Rhoda Delaval, eldest daughter of a newly wealthy Northumberland gentleman. Pond's reputation was well-established by 1747 when the lessons began, so he was able to charge Miss Delaval the rather steep price of one guinea per session. Over the next ten years he also painted £300 worth of portraits for her father, several more for her mother, and sold £1500 worth of prints (most of his personal collection) to her husband Sir Edward Astley.[39] The family was so taken with Pond that they finally apprenticed one of Rhoda's younger brothers to him, paying a record fee of £300.[40] That the younger son of so prominent a landed family should be apprenticed at so high a price to become a professional, is significant proof of the newly won prestige and status of the artist.

Although women played an impressive role in launching Arthur Pond's career as a fashionable pastel painter, he still looked to men for the bulk of his income, and his clubs seem to have been his main source of primary contact. By guaranteeing continued association between artist and patron, the clubs assisted Pond in his accumulation of a stable, relatively faithful group of buyers and influential 'friends'—no mean accomplishment in times of confusing social and professional changes. As discussed in the chapter above, Arthur Pond joined five clubs in the course of his career: the Roman (1721-42), the Tobacco (1736-7), the 'D' (Dilettanti?, to 1735), the Pope's Head (1745-?), and the Royal Society Club (1757-8). He was also elected to both the Royal Society and the Society of Antiquaries in 1752. Sixty-two of Pond's patrons from the years 1734 to 1750 are known to have belonged to one or more of these organizations, and since membership lists for all but the two Societies and the Dilettanti are incomplete, the figure is much too low. Nor does it account for the families of members who also bought from the artist.

An examination of the general rules and behaviour of the clubs reveals their potential as sources of initial contacts and bases for extensive patronage networks. All of Pond's clubs were founded with the intention of furthering some common interest, be it popularizing Italian classicism, opposing excise taxes, eulogizing Pope, or discussing issues to raise at meetings of the Royal Society. These aims were reflected in their titles—the Roman, the Pope's Head, the Antiquaries—and must have helped Pond at the outset of his career to identify likely patrons. Later, his affiliation with these groups helped prospective patrons identify him. At least four of these organizations met weekly over dinner in a coffee house or tavern; the meals were often accompanied by much drinking and elaborate toasts. Regular members could bring along one or two guests, thus enlarging the pool of possible clients and contacts; Pond met Benjamin Franklin at a meeting of the Royal Society Club as a result of this

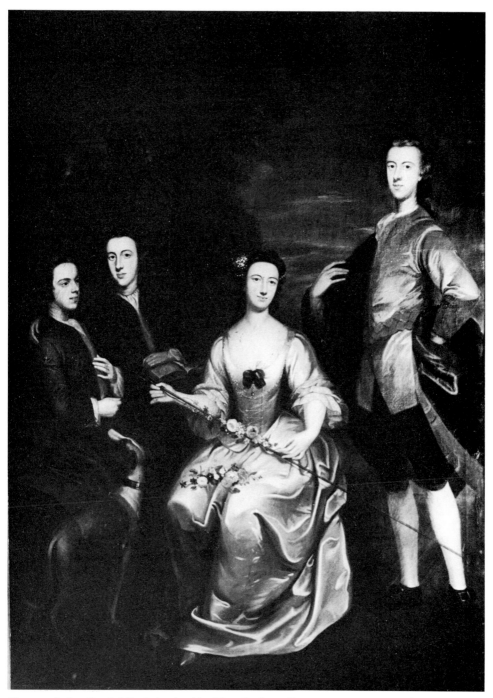

Figure 7. Arthur Pond, *Miss Delaval and her Three Brothers*, oil on canvas, 1749. Witt Library, Courtauld Institute.

practice.[41] No doubt he himself attended other clubs as a guest, thus extending his range even farther. Moreover, the clubs themselves could act as institutional patrons, requesting paintings or prints which bore some relation to their *raison d'être* or ceremonial functions.[42]

For Arthur Pond, the Roman Club was the most important of those active before 1745. Its known members—Daniel Wray, George and Charles Knapton, John Dyer, Thomas Edwards, William Fauquier, and the Earl of Sandwich—bought little or nothing from Pond, but they introduced him to several of his most generous patrons. At some point, probably in Rome, Daniel Wray had introduced Pond to his two travelling companions on the Grand Tour. James Douglas and John King (son of Peter, Lord King) both became steady patrons after their return from Italy although, unfortunately for Pond, King died prematurely in 1739.[43] James Douglas, who became fourteenth Earl of Morton and a fellow of the Royal Society, followed the usual pattern by encouraging relatives to sit to Pond. Morton may also have taken Pond to the soirées of Lady Brown, where eminent Italophiles in London congregated to hear concerts on Sunday afternoons. Subsequently Pond received several orders for portraits from Lady Brown.[44]

George Knapton returned from Italy in 1732 with more useful assistance for his fellow Roman club members. His most important contacts were, of course, the Dilettanti, who organized in Rome several years after Pond had returned to London. Knapton urged these wealthy and for the most part aristocratic travellers to use Pond as a receiving agent for their purchases abroad, and may have persuaded them to include him in their ranks. Pond collected their souvenirs and treasures at the docks, saw them through customs, and arranged for storage or transportation to their ultimate destination. There followed orders to assemble harpsichords and Italian marble tables, and frame antique bas-reliefs.[45] In many cases, Pond's dealings with individual Dilettanti dwindled after their return, since George Knapton had first claims on their patronage. (A club resolution passed in 1741 required every member to sit to Knapton for a portrait in ceremonial robes; later, fines were exacted from those who failed to comply.)[46] However, several enduring and valued buyers remained for Pond. Peter Delmé, owner of the marble tables, gave him several hundred pounds of business while wasting an enormous inheritance; Delmé was assisted in this by his brother John, sister Anne, and brother-in-law Sir Henry Lyddell, another member of the Dilettanti.[47] The Honorable Charles Hamilton and William Fauquier also learned of Pond through George Knapton, and used the former as a shipping agent before giving him more interesting commissions after their return.[48] Also a member of the Royal Society and the Royal Society Club, William Fauquier became a lasting friend, attending Roman Club dinners and entrusting Pond with

the printing of some unflattering caricatures of his neighbours in Kent in the 1740s (Figure 20). Fauquier's in-laws William and Francis Wollaston began to buy from Pond in the late 1730s, then hired Daniel Wray to tutor their children.[49] One Dilettant and collector, the Rev. Thomas Dampier, was limited by his budget to print collecting. However, he was able to introduce Pond to his second club known as the Common Room, another group of scholarly Grand Tourists with expensive interests in classical studies, natural history, and old master drawings.[50] In all, Pond gathered at least eighteen patrons from the ranks of the Dilettanti, including collectors like the Duke of Bedford, General Churchill, and Robert Dingley.[51] The return of the Dilettanti to London between *c.* 1732 and *c.* 1740 coincided with, and no doubt contributed to, the increase of aristocratic patrons led by Lady Dysart and Mrs. Delaney.

Pond's ties with aristocratic salons and the Dilettanti were later reinforced by the addition to the Roman Club of the Earl of Sandwich, an active member of both as well as the Royal Society and the Duke of Bedford's party firmly ensconced in the Admiralty. Several members of the latter, including Thomas Brand, Richard Aldworth (also a member of the Common Room), and Bedford himself, began to buy from Pond after Sandwich's election.[52] Likewise, Sandwich's appointment as one of the Lords of the Admiralty in 1744 strengthened Pond's standing with Bedford, Sir Thomas Frankland, and brought him new buyers Admiral George Anson (also a Yorke protégé), George Grenville, and William Ponsonby (future Viscount Duncannon), all Lords and new patrons. Minor Admiralty officials like Francis Gashry, comptroller of victualling accounts, and Horatio Townshend, commissioner of the victualling office, followed their leaders to Pond's.[53]

The Roman Club also introduced Pond to fashionable literary circles. Through Charles and George Knapton, he met the booksellers John and Paul Knapton, who not only sponsored his successful painting tours, but also ordered portraits, copies, and prints for themselves. Thanks to John Dyer, Daniel Wray, Thomas Edwards, and the Richardsons, Pond received requests for frontispieces and book illustrations from the poet Richard Glover and Lord George Anson. The Jacobite historian Thomas Carte ordered portraits of his heroes the Duke and Marquis of Ormond, subjects of the biography he published in 1736.[54] The poetess Mary Barber sat for her portrait and apprenticed her son to the artist.[55] Soon her great patron the Earl of Orrery developed an interest in Pond, ordering quantities of portraits and prints from him in the late 1730s and 1740s.[56] With the exception of the jobs for Anson and Orrery, these commissions brought more prestige than income, but they substantiated Pond's claims to be the artist of London's literary elite.

In contrast to the Roman Club, whose actual members bought very

little, the later organizations—the Pope's Head and the Royal Society
Clubs—included several of Pond's wealthiest and steadiest patrons. From
Pond's point of view the core members of both groups must have been
Charles and Philip Yorke, sons of Lord Hardwicke. Daniel Wray's friend-
ship with the Yorkes dated back to their collaboration on the *Athenian
Letters* begun in 1737, but it only bore fruit for the others after Hardwicke
was appointed Lord Chancellor with a wealth of patronage of offices and
livings at his disposal. Edwards began to tease Wray about his connection
with the family in 1743, but added, 'I envy you the situation you are in
with respect to these Gentlemen, but at the same time am very thankful
for the share I have in their acquaintance through your hands.'[57] Philip
Yorke was given the lucrative place of Teller of the Exchequer and he
appointed Wray Deputy Teller in 1745.[58] Strategically placed to assist his
friends, Wray obtained good livings for John Dyer, who had taken orders,
invitations to Philip Yorke's country seat at Wrest Park for Thomas
Edwards, and a great deal of business from the Yorkes and their friends for
Pond.[59] Relations between some of the former Roman Club members
and their new patrons were then cemented by the formation of the Pope's
Head Club in 1744 and the addition of Pond and the Yorkes to the Royal
Society Club which Wray had joined in 1743.[60] Wray, Pond, the Yorkes,
and Lord Hardwicke also joined one or both of the learned societies, and
all but Edwards finally became trustees or contributors to the newly-
founded British Museum in the 1750s.[61] Pond might have dined with this
compact but influential group at their various clubs four nights out of
seven; he called on the Yorkes frequently and even stabled his horses with
theirs at the Bull and Gate Inn.[62] His relationship with the Yorkes soon
brought many additional patrons, thanks to the size and wealth of their
family, the number of their friends and dependents, and the prominence
of their political allies.

 The first member of the Yorke family to appear in Pond's journal
accounts was the Marchioness de Grey, wife of Philip Yorke, who re-
quested a portrait in 1740. Lord Hardwicke followed this up with an order
for a copy of a composition by Poussin, and in 1745 Charles and Philip
Yorke stepped in with the first of many orders for paintings, prints, and
other business. Lady Hardwicke and Miss Yorke also figure in the accounts,
along with the Marchioness de Grey's aunt and close friend Lady Mary
Grey, and, after their marriages, the husbands of Margaret Yorke and Lady
Mary, Gilbert Heathcote and Dr. David Gregory (canon of Christ Church,
Oxford).[63] Together the Yorkes and their in-laws provided about £150
worth of patronage for Pond between 1740 and 1750—not as much as
some of Pond's more reckless buyers, but a significant amount when the
family's reputation for stinginess with their personal funds is taken into
consideration.

The Yorkes' many friends helped to compensate Pond for the family's relatively low level of spending. Charles Yorke probably introduced Pond to his good friend Ralph Allen, the famous 'Man of Bath', philanthropist, and innovator in the post office. Allen and his wife became steady patrons from 1749 until Pond's death in 1758; they may also have encouraged him to buy the works of their other protégés Sarah and Henry Fielding.[64] (Like the rest of the Yorke crowd, Fielding seems to have passed through the Bull and Gate Inn, featured in a scene in *Tom Jones*.) Another member of this circle, William Warburton, may have been brought into the Pope's Head Club with the Yorkes. He ordered engraved portraits of Pope for frontispieces to his editions of the poet's works. His literary battles with Thomas Edwards required some adroit maneuvering by the rest of their acquaintance, who managed to maintain simultaneous, but separate friendships with each.[65] Then there was David Papillon, a lawyer and Member of Parliament who had known the Yorkes since their families lived near each other in Dover. Like Pond, Wray, and the rest, he joined the Society of Antiquaries, the Royal Society, and the Royal Society Club. He sat with his wife for a pair of portraits from Pond in 1749.[66] Pond's greatest benefactor in this group, however, was the circumnavigator George Anson, who eventually entered the Yorke family by marrying Lady Elizabeth Yorke in 1748. Pond undoubtedly asked the Yorkes or Lord Sandwich to intercede for him when he wished to paint Anson's portrait in 1744, and they were also influential in Anson's decision three years later to entrust the Knaptons and Pond with the printing and illustration of the authorized account of his historic voyage. Anson, who paid Pond over £700 for the illustrations alone, was his most generous patron by a margin of several hundred pounds.[67]

Among the Yorkes' dependents and political friends, Henry Bromley, Lord Montfort, who managed Philip Yorke's election as MP for Cambridgeshire in 1747, bought heavily from Pond between 1743 and 1748.[68] So, too, did Samuel Shepheard, another Cambridgeshire resident, MP, and friend of Montfort.[69] A former intimate of the Prince of Wales, George Lyttelton switched his allegiance to the Yorkes late in the 1740s and began to patronize Pond at the same time.[70] Thomas Herring, elevated to the See of York through the influence of Hardwicke, returned the favor by supporting their policies and their artist, buying prints from Pond in 1745.[71] Dr. Nathaniel Forster, a scholarly clergyman who owed his preferments to the Yorkes, did the same a year later.[72]

The Yorke network, linked with Pond by the Pope's Head Club, the Royal Society Club, and the learned societies, was the most important source of patrons in the second half of Pond's career. However, he did not rely entirely on the Yorkes; his City collector friends also proved to be well connected in a useful way. Charles Rogers and Robert Mann were

both associates of the Walpole family, and as Horace and his friends returned from Italy and settled down to collecting and connoisseurship, he, Francis Whithed, and his former tutor Edward Weston employed Pond to restore and reline Claudes and Horizontis.[73]

Yet another type of organization which could channel artistic patronage was the philanthropic society. The most famous of these in the early eighteenth century was the Foundling Hospital, which had Hogarth on the Board of Governors and paintings by the Slaughter's group of artists on its walls.[74] Although not a trustee, Pond seems to have been associated with the founders of the Georgia Society, chartered in 1732 to alleviate prison conditions by settling debtors in the colony of Georgia. The Earl of Egmont was their first president, and he probably suggested Pond's name to Samuel Tuffnell, Sir Jacob Bouverie, and General James Oglethorpe, fellow trustees who also bought from the artist in the late 1730s and 1740s.[75] Later, a group of City merchants banded together to form the Magdalen Charity in 1758; the Magdalen project formalized ties between men who already shared business interests and a taste for Arthur Pond's paintings.[76]

This survey of Arthur Pond's dealings with his patrons suggests that an artist who could insinuate himself into the patterns of their daily life was likely to keep them and find new ones—which explains Pond's preoccupation with living and appearing like a gentleman. He was most successful when buyers like the Earl of Egmont and Mrs. Delaney met their friends in his painting room, when he mingled with the Dilettanti at Lady Brown's, or discussed art and poetry with his fellows at the Pope's Head Club. He could rely on family ties, friendships, and other social relations among his patrons to do the rest. In his search for patronage Pond resembled and may even have competed with his friends Edwards, Wray, Dyer, and Knapton, who received places, tutorships, livings, work, and introductions from the very same benefactors. No doubt he suffered many of the insecurities and humiliations experienced by contemporary Grub Street writers and place hunters, but for him, at least, the rewards were obvious. His business did well, and acceptance brought him status; he became known as a gentleman. Furthermore, as a member of the literary clubs and learned societies and an associate of the founders and trustees of the British Museum, he could himself begin to influence trends in English patronage and taste.

Pond and most other painters relied heavily on personal contacts in their searches for patronage, but the rapid expansion of the printed media—books, newspapers, and engravings—opened up new opportunities for impersonal appeals to educated, well-heeled audiences. In general, early eighteenth-century artists were slow, not to say unwilling, to exploit direct newspaper advertising, which they seem to have associated with the lesser trades of bookselling, printselling, and auctioneering. Rather than

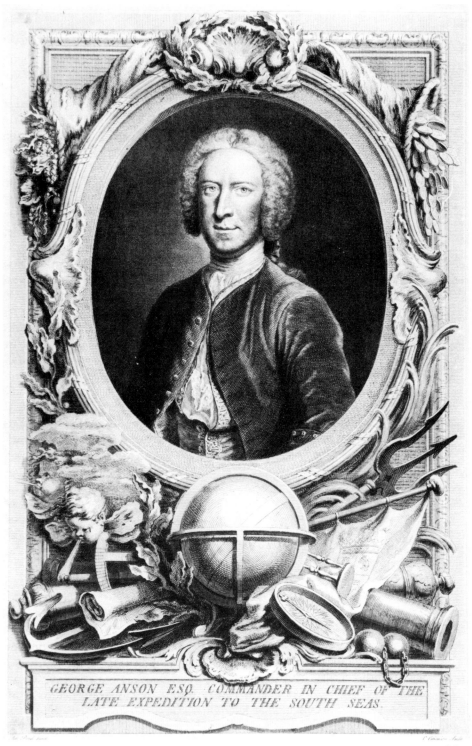

GEORGE ANSON ESQ. COMMANDER IN CHIEF OF THE
LATE EXPEDITION TO THE SOUTH SEAS.

Figure 8. Charles Grignion after Arthur Pond, *George Anson, Esq.*, engraving, 1744. Trustees of the
British Museum.

advertise directly, they disguised their notices as news items destined for the column reporting recent London events. Just before arriving at the obituaries, readers might be informed that Michael Rysbrack or Thomas Hudson was finishing a portrait of some fashionable luminary, which could be seen at their lodgings at stated times.[77] Such notices functioned like printed gossip, which most of them were.

Pond and Hogarth were the only two painters in London to insert legitimate advertisements in the *Daily Advertiser* and other papers, but they were also the only painters with important printselling businesses. Pond limited his notices to announcements of print publication dates and prices, while Hogarth also mentioned lotteries of his paintings; neither violated the proprieties by overtly canvassing for sitters or painting commissions. (This innovation would occur in the provinces around mid-century, when artistic jacks-of-all-trades listed portrait painting in their repertoire of services.)[78] Pond first advertised his prints in 1735 and continued to promote his publications at least until 1751.[79] Unlike Hogarth, he did not open subscriptions through the papers; instead he placed the first ad on the publication date, advertised daily for the next week or so, then posted notices sporadically until the appearance of his next publication. At two shillings per notice in the *Daily Advertiser*, he had a cheap and efficient method of notifying subscribers that their prints were ready, while informing non-subscribers of their availability, price, and location.

It required considerable daring for an artist/printseller to advertise (not to mention publish) prints after his own paintings. Hogarth was perhaps the only painter early in the century to get away with it consistently; his discursive announcements in the *Daily Advertiser* shocked the art world and contributed to his reputation as an eccentric, egotistical genius.[80] At first, Arthur Pond also indulged freely in self-promotion. He boldly advertised his first print of the naval hero George Anson (Figure 8) as 'Engrav'd from an original Picture painted by Mr. Pond, since his return. Sold at Mr. Pond's in Great Queen-Street, near Lincoln's Inn Fields, and by J. and P. Knapton, in Ludgate Street.'[81] His next portrait, showing David Garrick (Figure 9), was modestly launched under the name of one of his employees and advertised with less fanfare. 'This Day is published ... the Head of Mr. Garrick, engrav'd after the original picture painted by Mr. Pond ...'[82] It was this that aroused resentment in some quarters, and the artist must have been stunned when six days later another announcement appeared: 'This Day is publish'd, (Price 1s. 6d) Humbly inscribed to the Ladies, the Tail of Mr. G——CK, engrav'd after an original Painting of Mr. VanderPond. To be had at the Print shops of London and Westminster.'[83] After this lampooning, Pond became far more discreet. He published and advertised his 1747 print of the Duke of Cumberland (Figure 10) under the names of John and Paul Knapton, and subsequent

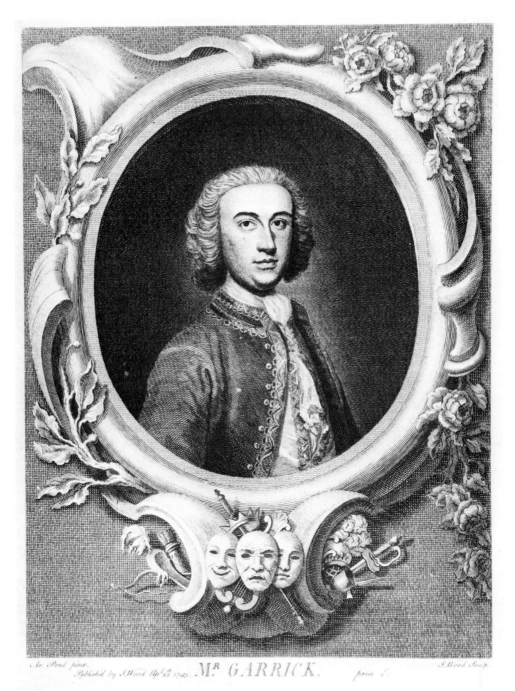

Ar. Pond pinx. J. Wood Sculp.
Publish'd by J.Wood Apl 29 1745. Mʀ GARRICK. price ₤

Figure 9. J. Wood after Arthur Pond, *Mr. Garrick*, engraving, 1745. Trustees of the British Museum.

advertisements for plates of Garrick and the actress Peg Woffington listed commercial printsellers and no publisher whatsoever. Nevertheless, all had been commissioned and distributed by Pond himself, and continued to get his name in the papers.

In themselves, the portrait engravings worked like a printed advertisement. They were especially effective as samples of a painter's best work, which could circulate to an audience of several thousand—an important consideration in an age without public art exhibitions. Their impact can be ascertained from references to occasions when an engraver could make or break a portrait painter's career with the quality of his reproduction.[84] Because of their importance, painters chose the subjects of these showpieces carefully in order to attract attention or appeal to a certain clientele. Pond's princesses, military heroes, actors, and poets had popular appeal while asserting his ties with fashionable and literary circles. They were always engraved by the most skilled practitioner available—John Faber, Jr. in the 1730s, Charles Grignion and J. Wood in the early forties, and James McArdell after 1747.[85] As Vertue sourly commented: 'a head painted printed & published by Pond & gravd by Grignon—of Admiral Anson—this is another project of Pond's to acquire business and reputation—if his pencil or Crayons can't find him sufficient employment'.[86]

Illustrated magazines offered portrait painters another means of reaching patrons indirectly, although sloppy engraving often jeopardized the artists' reputations for producing likenesses. The *London Magazine* and the *Universal Magazine* both featured cheaply engraved portraits of newsworthy persons which were usually taken from the latest prints. Pond's portraits of Pope, Garrick, and Anson, duplicated once in engravings, were incarnated many more times in the pages of these magazines.[87] Like the *Daily Advertiser* the magazines had a large London circulation, but their provincial audiences were also important. Even though circulations were small by twentieth-century standards (perhaps several thousand copies per issue), they represented a significant improvement in terms of speed and range over word of mouth communications.

Readers were also exposed to contemporary art and artists through their consumption of illustrated books. Like single prints, illustrations for a best seller could have the impact of a sizable exhibition, since they exposed the artist's work to several thousand people. Arthur Pond had the good luck to collaborate on several popular successes: Richard Glover's *Leonidas* in 1737, Conyers Middleton's *Life of Cicero* in 1741, the *Heads of Illustrious Persons of Great Britain* appearing between 1736 and 1752, Richard Walter's *Anson's Voyage* in 1748, and Warburton's editions of Pope's *Essay on Man* in 1747.[88] Thomas Gray's ironical comment to Walpole about sitting for a frontispiece by Pond indicates the value of such illustrations for attracting the attention of the reading public, as does the fact that 139

subscribers to these books also patronized Pond at some point in his career. It seems possible that Pond and the Knaptons developed some system for referring interested patrons back and forth to their mutual benefit. Other early eighteenth-century painters helped their careers along by illustrating the best-selling *Hudibras* (Hogarth), Hanmer's edition of Shakespeare (Hayman), and *Pamela* (Highmore).

Arthur Pond's search for patronage closely resembles similar quests carried out by other contemporary artists, writers, place seekers, younger sons, and ambitious ladies of easy virtue. Opinions concerning the role of such patronage in the arts, society, and politics differed in the eighteenth century, as they do today. Critics of the system viewed it as outright corruption; others have argued that it brought stability to a potentially chaotic period in English history. Writers on English paintings from Hogarth in the eighteenth century to John Pye in the nineteenth and Michael Foss in the twentieth have condemned its impact on the visual arts, arguing that only inadequate or misguided patronage could be responsible for the disappointing output of Pond's contemporaries.[89] Their conclusions ignore the fact that Hogarth, operating in a patronage system nearly identical to Pond's, produced art as highly esteemed today as it was by his contemporaries. Furthermore, early eighteenth-century patronage produced some of England's most important authors—Fielding, Pope, Thomson and Dyer, to name a few—indicating that the system itself was not to blame if some mediocrities flourished. The convivial and stimulating atmosphere of the London clubs, where patrons, writers and men of learning gathered, hardly supports the picture of painters as isolated victims of social or political change. Their growing use of the print media reflects a keen awareness of commercial techniques, which they began to exploit with some subtlety. Nor can artists be seen as weak panders to depraved aristocratic or popular tastes, when it is known that many were using their seats on boards of governors, learned societies, and clubs, as well as their access to the popular press, to influence the distribution of patronage and favors to themselves, their friends, and allies.

Given these facts, it might be helpful to re-examine the complaints of William Hogarth and Jean Rouquet which have been almost the only basis for subsequent discussions of the problem of early eighteenth-century art patronage. Both agreed that the uncertainty of public taste—the cycle of fads within elite society—as well as the overwhelming interest in antiquities and old masters, detracted from the patronage of contemporary artists. However, it should be noted that artists, including Hogarth and Pond, while angry or disappointed after their falls from the height of fashion, hardly starved or even suffered any loss of income later. Having contacted important patrons and established their reputations, they settled down to cultivate their friends and buyers who would stand by them

throughout their careers, and who would support projects far beyond the realms of portrait painting. As for antiquities and old masters, artists themselves were among the leading dealers and collectors of the period; one might argue that interest in the newly discovered continental tradition was a point in common rather than a point of difference, between artists and audiences. Still, it is impossible to ignore the fact that English buyers preferred continental subject pictures to English ones, and paid high prices for them. While it sparked resentment in some quarters, this practice does not necessarily prove that patrons were misguided, corrupt, or blind to the virtues of native painters. When some of their imported purchases are compared to English painters' attempts in the same genre, one must conclude that the taste of patrons had outstripped the capabilities if not the ambitions of contemporary English artists. Furthermore, given the important changes occurring in social and domestic life, interior design, and use of leisure time, it is possible that patrons were seeking to fulfill needs or satisfy interests beyond the traditional scope of the existing English school of artists. If second-rate artists did well, it was because demand was outrunning supply, not because of any basic deficiency in the taste of patrons, or the organization of the market.

IV

The Composition of the Market

Arthur Pond's many techniques for finding patrons suggest that his market was not homogenous, but was composed of several levels and varieties of demand, calling for both new and traditional selling strategies. Its confusion was compounded by the paradoxes inherent in Pond's approach and aims; he exploited the newest commercial avenues in his search for the most traditional type of patron. With his discovery of the Yorkes he finally acquired the old-fashioned protector who supplied him with work and introductions in exchange for first call on his services. Such a traditional bargain had also motivated Hogarth's battle for recognition and governed his switch of political loyalties after his appointment to the salaried post of Serjeant Painter to the King. Hogarth was deeply disappointed that his achievements and sacrifice were not also rewarded by the traditional knighthood. Neither artist could rely on his primary patron for his living—an important contrast to the harmony of purpose which had existed between Rubens and Charles I, for example, a century before.

In fact, the traditional patronage system, in which Hogarth still believed, could last just as long as the Court created and controlled demand for art, a prerogative which the later Stuarts and Hanoverians rarely exercised. In abandoning this antiquated market, Pond and others found themselves in a new environment where the nature of demand was shifting and unpredictable. Two of its aspects seem to have taken the early Georgian art world by surprise: its great volume, and its growing preoccupation with the criteria of taste and beauty. Thanks to the Earl of Shaftesbury, Jonathan Richardson, Francis Hutcheson and others, the term 'taste' gained currency. Shaftesbury had proclaimed the appreciation of aesthetic beauty as the first step toward understanding Nature and communing with the Deity; Richardson had described it as the gentleman's route to social success and a necessary precondition for raising English manufactures to competitive levels with continental luxury goods. Rising wealth from

agriculture, finance, and trade, the popularity of the Grand Tour, and the spread of literacy and leisure to new classes of people expanded the population familiar with such novel ideas and willing to put them into practice. Even a shady Grub Street authoress thought she might succeed in the print trade because she had taste.[1] Others prided themselves on their connoisseurship, but the rise of both terms suggests that an individual's estimation of the quality, rarity, and appeal of the product was becoming an increasingly important factor in certain art-buying decisions. During the early eighteenth century, the orientation of these decisions was divided between traditional considerations of patronage and the individual judgment—this seems to most accurately describe the schizoid behaviour of Arthur Pond's buying public.

It is, of course, difficult to determine a patron's orientation (did the individual key on the object or the artist when making a purchase decision?), especially if the individual died 200 years ago and inconsiderately neglected to explain his or her reasoning in writing. However, much can be deduced from a patron's 'track record' at Pond's. One who made significant purchases over an extended time period, relied on credit, and compensated the artist with introductions, special favors, and personal advancement as well as with money, was behaving like a traditional patron. Such a patron, on a large scale, was Peter Delmé, born in 1710 and the eldest son of Sir Peter Delmé, a governor of the Bank of England and former Lord Mayor of London. Peter became a founding member of the Dilettanti during his Grand Tour in the 1730s, a member of Parliament voting with the opposition for twenty years, a famous collector of old master paintings, and—perhaps not unexpectedly—a bankrupt and suicide.[2] His name appears frequently in Arthur Pond's accounts from 1734 to 1750, but their dealings probably began earlier in the thirties and did not end until Pond's death in 1758.

In 1734 and 1735 Pond received and unpacked the crates of pictures and other items Delmé and his friends had collected abroad. He cleaned and framed some of these works, painted portraits of Delmé's sisters, and executed pastel copies after Rosalba Carriera for the house in Grosvenor Square. He was also representing Delmé at auctions and supplying him with choice old master drawings. Delmé himself never sat to Pond for a portrait (Arthur was not famous for the grandeur of his characterizations) but by 1745 his children were old enough to sit for the unpretentious pastels for which the artist was known. Then a commission for a relatively ambitious half-length portrait of Miss Delmé and the cleaning of a Salvator Rosa and a Wouwermans followed in 1746. Delmé also collected prints, among them Pond's publications bound expensively in leather.[3]

The catalogue of Pond's work for Delmé provides further insights into the workings of their relationship. From Delmé's point of view, Pond was

a specialist in old master paintings, first and foremost. His restricted skills as a portraitist caused his patron to bestow commissions cautiously and to prefer Hudson and later Reynolds for portrayals in the grand manner. However, Delmé would buy the odd speciality item if it were of good quality and appropriate to his needs—thus the pastels after Rosalba. (For most copies, Delmé employed the painter Ranelagh Barret.)[4] In return for Pond's numerous and varied services, Delmé paid nearly £400 over seventeen years and offered Pond other assistance too. For example, he permitted Pond to reproduce five old master paintings from his collection as part of the latter's series of landscape engravings (Figure 22). He also brought Pond work from his brother, sister, and brother-in-law. John Delmé bought £40 worth of scagliola busts and disappeared from Pond's accounts; the brother-in-law Sir Harry Lyddell spent twice as much and departed. However, Lady Lyddell, née Delmé, began to imitate her brother's practice, bringing old paintings to Pond for cleaning, and her children and female friends for portraits. Arthur permitted every member of the family to buy on credit, even the disappointing John.[5]

The Delmés offered Pond plenty of business, but relatively little scope for his ambitions. Those with whom he developed a closer personal relationship may have spent less money, but they also provided more challenging and interesting work. Thus John, Lord King, whom Wray and Pond had accompanied to Italy, paid £160 to have a ceiling painted at the family's new house in Ockham, Surrey, designed by Hawksmoor, and asked Pond to buy him a telescope, besides sending him the usual mundane book-binding and family portrait restoration jobs.[6] King's commissions were especially generous in that Pond, in the early 1730s, had yet to master his art or develop a reputation in any branch of painting. A fellow of the Royal Society, Lord King also promoted the career of Daniel Wray. William Fauquier, a fellow member of the Dilettanti, the Roman Club, and the Royal Society Club, employed Pond from 1735 to 1748, primarily to procure old master paintings. His account, much of it on credit and totalling £166, does not record Fauquier's evident sympathy with Arthur Pond's aesthetic interests, nor the unflattering caricature etchings of his neighbours in Kent which Fauquier entrusted to him for printing.[7]

Most of the other buyers in this 'stalwart' group of long-term patrons shared the interests or prejudices of Delmé, King and Fauquier. Similar patterns emerge from the accounts of Henry Hoare (1727, Italian paintings; 1749, portraits of his children; 1745-50, prints; 1753, a decorated ceiling for his new villa in Surrey) and Robert and Uvedale Price (1735-45, old master drawings; 1746, etching tools and materials, and a portrait of Miss Price; 1747-50, more drawings; 1749, a portrait of Mrs. Robert Price and her son Uvedale).[8] They generously lent their collections to the artist to

copy or have engraved, and introduced him to relatives and friends. Some of them were also the benefactors of friends of Pond's. In all, about twenty patrons between 1734 and 1750 conformed to this pattern of ten or more years' association, mixed purchases around or above £50 in value, and distribution of special favors such as invitations, introductions, and sponsorships in clubs. With their close relations they comprised only 5 per cent of Pond's buyers, but—fringe benefits aside—they contributed over 30 per cent of his income.[9] Their business was the source of the artist's financial stability, professional reputation, and social progress.

Who were these stalwarts, and what besides a shared opinion of Arthur Pond's aims and talents did they have in common? Would any similarities in their backgrounds explain the resemblances between their patronage patterns, or were all at the mercy of the limitations of the market? Only two, the Earl of Morton and the Earl of Orrery, were members of the peerage, and they differ from the rest of the group in their Jacobite leanings and predilection for portraits.[10] Lord James Cavendish, a brother of the second Duke of Devonshire, and the Honourable Charles Hamilton sprang from the peerage,[11] but the rest were from the ranks of gentry, learned professions, office holders, merchants, and financiers. Two were baronets and one, Hardwicke, a baron elevated to the peerage in 1754. If members of the House of Lords are included, twelve were active in Parliament, although their terms did not always coincide with their activities in the art market. Only three, Colonel Hodges, Robert Hanby, and Mr. Bridges, have resisted further identification. Jones Raymond, Charles Yorke, the Delmés, William Fauquier, Sir Jacob Bouverie and Richard Houlditch all derived handsome fortunes from their families' successes in law, finance, and government office.[12] They were buying land, running for if not sitting in Parliament, and marrying their children into the peerage. One of their ties with Pond may have been their common origins in the City of London, and a mutual understanding of the social benefits of polite interest in the arts. However, Thomas Barret, Francis Blake Delaval, Sir William Morrice, and the Prices stemmed from established gentry families whose wealth was not outstanding.[13] When compared to the totality of Arthur Pond's buyers, the stalwarts tended to be of higher status, with half ranking as knights or above, as compared to only 20 per cent for the entirety (Table 2).

Other criteria help define the character of the stalwarts further, but still fail to explain their common fascination with Pond. Their age curve resembles that of the patrons as a whole, and seems consistent with that for the English upper classes of the period. Nine of the stalwarts were born between 1700 and 1710, and so belonged roughly to Pond's generation. This generational bulge had a significant impact on Pond's business with them as they graduated en masse from Grand Tour collecting (customs

and ship broking) to furnishing London and country houses (copies), to raising families (portraits), before returning to leisured appreciation of the arts (collecting). All the same, their importance is diluted by the presence of patrons from both extremes of the spectrum — the aged Uvedale Price born in 1680, and Thomas Barret, Charles and Philip Yorke and Rhoda Delaval born in the 1720s.

Much has been made of the role political alignments played in the distribution of art patronage in the early eighteenth century. Can any such role be found for the political inclinations of Arthur Pond's patrons? Arthur himself, from a Jacobitish family but loyal to the Hanoverians, had no special political leanings. Three of his patrons, Orrery, Morton, and Sir William Morrice, were Jacobites; Henry Hoare and Sir Jacob Bouverie were devout Tories, Peter Delmé voted with the City opposition, and Charles Hamilton belonged to the Leicester House set led by the Prince of Wales. Five other MPs among the stalwarts comprised or supported the government of the time. Anson, while befriended by the Yorkes, never evinced any independent party feelings whatsoever. George Lewis Coke did not sit for Parliament, but as a member of the royal household, he can be counted as an administration supporter.[14] Politically speaking, therefore, the stalwarts formed a heterogenous group evenly balancing administration supporters and opposition.

It should be noted, however, that the bulk of the government supporters became prominent in Pond's accounts after the fall of Walpole and the rise of the Pelham administration in 1744. In the case of the Yorkes and Anson, a jump in spending is visible soon after their appointments to government office. All the same, taste seems to have existed independently of political alignment. Or perhaps one might say that an artist's reputation for certain products or services minimized distinctions of this type. Even when one group dominated Pond's accounts, patrons from opposing groups never disappeared, although their buying may have been more selective. Since Pond was famous for his knowledge of the old masters, collectors came to him for advice and restorations regardless of other factors. Briefly in the 1730s he had a reputation for historical portraits; within one week he was paid for portraits of John Pym (for the Whig satirist Charles Hanbury Williams) and the Earl of Ormond (for the Jacobite historian Thomas Carte).[15] Even when he was most closely linked with the opposition-oriented Roman Club, Pond drew a pastel portrait for Sir Robert Walpole and sold prints to his son Horace.[16] One concludes that within such a restricted art market, patrons in need of special products, or searching for high levels of quality, could allow little play to their political inclinations.

Not even shared experience of the Grand Tour entirely explains the fidelity and interests of the stalwart group. Many had indeed begun their collecting and their business with Pond while abroad; the cases of Morton

and King indicate that it could be an important basis for enduring friend-
ship. However, several others had never left England, and consequently
depended on Pond for the education and collecting opportunities they had
missed. This was the case for Philip and Charles Yorke, Rhoda Delaval,
and Charles Rogers, who shared the preferences if not the experience of
Delmé, Hamilton, and Fauquier.

It is primarily in terms of these shared preferences that the stalwart
patrons most closely resemble each other and differ from the bulk of
Arthur Pond's buyers. They return over and over again for products and
services associated with their collections of old masters and contemporary
continental paintings. Only four (20 per cent) concentrated on portraits,
and none bought portraits exclusively They made heaviest use of Pond's
services as an importer, then as a dealer, agent, and restorer of old master
paintings, drawings, and prints. They also bought intelligently at auctions
or while abroad, and fragmentary evidence shows that some very good
purchases were made on Pond's advice or with his active assistance.
Through Pond, Peter Delmé acquired a fine pair of Gaspard Poussin
landscapes at auction in 1738, and he helped Richard Houlditch, Jr. expand
the drawing collection begun by his father.[17] In several instances one can
watch Pond guide and transform the tastes of these buyers as his own
interests shifted from Italian to Dutch art during the 1740s—so, too, their
purchases reveal new emphasis on the Northern Schools. Among those to
make the transition were the Prices, Peter Delmé, and the Yorkes.

From the record of their purchases, it seems safe to conclude that the
stalwarts stuck with Arthur largely because they depended on him for
guidance through the *terra malcognita* of continental art. Their pragmatic
alliance was reinforced by a common intellectual approach to art appre-
ciation espoused by their clubs and learned societies. Dedication to the
improvement of English art via the study of continental masters, concepts
promulgated by Pond's mentor Jonathan Richardson, formed the ideals
of the Roman Club and the Dilettanti which were shared by the Anti-
quaries and the Royal Society under the leadership of Martin Folkes, Dr.
Richard Mead and Sir Hans Sloane. All but three of the stalwarts partici-
pated in one or more of the clubs, and several played key roles in the
founding of such institutions as the Society of Artists and the British
Museum.[18]

Important aspects of the relationship described above hardly survive in
Arthur Pond's accounts. It is nearly impossible to distinguish between
friendship and mere dependence on the basis of expenditure alone. The
exchange of advice and privileged sources of supply for social promotion
through election to the learned societies was not a cash transaction; it is the
stuff of traditional benefactor/beneficiary relations. As will be demon-
strated in a later chapter, Pond deliberately minimized the commercial

aspect of the old master trade, which might have been fabulously lucrative had he been a shade less scrupulous. Instead, he sought to elevate a traditionally sordid business to the high level of polite exchange envisioned by Richardson; his pursuit of ideal beauty would have satisfied Shaftesbury; thus he earned acceptance among gentlemen. In light of the knighthoods bestowed on artists of previous generations, Pond's reward for service— election to the Royal Society and the Antiquaries in 1752—seems a minor accomplishment. Nevertheless, because of declining royal involvement in the arts, and the leading role played by the gentry, politicians, and financiers in cultural life, the F.R.S. may have meant considerably more than Hogarth's title of Serjeant Painter to the King.

At first glance, it seems peculiar that the most advanced and intellectual facet of eighteenth-century taste should be conducted along such traditional lines of mutual personal dependence. However, in England at least, the old master market of the early eighteenth century resembled the portrait markets of preceding eras, with continuous demand for high quality work and only one or two reliable producers or suppliers to fill it. The relative ignorance of most English connoisseurs forced them to rely heavily on the judgment and honesty of their dealer; presumably then, as now, the better one knew the dealer's reputation, sources, and limitations, the easier it would be to make a sound purchase. Pond carefully vetted the works offered to his 'friends', sought out desirable rarities through his international network of contacts and suppliers, and undertook special commissions for them. Thus it was to the patron's benefit in this area of the market as in no other, to cultivate the good will of the entrepreneur, and Arthur Pond, operating in a seller's market, set the most traditional and ambitious terms possible.

The operation of traditional patronage patterns in the old master trade did not stop with Pond and his top-level buyers. As he acquired prestige and status, he too began to dispense patronage, favors, and introductions on behalf of deserving supporters of Richardsonian practices and principles. This is best illustrated by the formation of the City collectors group, including Robert Mann, Charles Rogers, Charles Lowth, Jones Raymond, John Barnard, Nathaniel Hillier, and Christopher Batt—all City merchants or financiers, generally a decade or so younger than Pond, who began collecting old master paintings and drawings under his guidance in the 1740s.[19] They became prominent in the accounts after 1745 and remained friends and allies until Pond's death in 1758, gradually replacing the first generation of stalwarts which had formed in the 1730s. They were especially receptive to the taste for Dutch art which Pond and others were promoting in the latter half of the decade. With these buyers, the exchange of services occurred on a more informal level, as between social equals. Only Christopher Batt and Jones Raymond were big spenders during the

years 1745–51; Pond returned the patronage of the others with orders of suits of clothes and other goods. He dined frequently at their houses, and gradually began to introduce them into his clubs. Charles Rogers owed his election to the Antiquaries to Pond, as may have Charles Lowth, elected in 1756. The addition of this group to the core of second-generation City families among the stalwart collectors made Pond the leading reputable dealer in England, and helped create the impression in Hogarth's mind that the Dutch taste and socially ambitious City collectors were allied in a conspiracy to ruin English art.

On a less esoteric level, the taste for old masters was also spreading among a group who may be roughly defined as 'country house builders', although some were also building in London's rapidly expanding West End. They might spend up to £100 for copies, casts or scagliola busts, but these concentrated purchases rarely led to repeat business. The relative shortage of quality old master paintings suitable for Palladian or rococo interiors in the English market increased the demand for copies, in which Pond did a thriving business (Table 7). During the 1730s his pastel imitations of Rosalba's *Four Seasons* sold well; ten years later he switched to copies of Jean-Etienne Liotard's women in Turkish dress for Lord Duncannon (future Earl of Bessborough) building in London and Kent and his friends.[20] Pond's oil copies of landscapes by Claude Lorrain, Pannini and Poussin which he popularized in engravings were also much in demand as 'chimney pieces' which Samuel Tuffnell bought for his remodelled house in Essex, General Oglethorpe for Cranham Hall, Beeston Long for his house in Suffolk, and Charles Yorke for Painshill.[21] Imitations of a subject with topical aesthetic ramifications by Guido Reni, *Drawing Embracing Coloring*, began to sell late in the 1740s.[22] Georgian scale buildings also needed painted ceilings and staircases. Pond's journal records a large decorative job for Lord King in the 1730s and others for Jones Raymond and Beeston Long in the 1740s; and he covered the ceiling of a room in Henry Hoare's new villa at Clapham in 1752.[23] These commissions fitted into the measured progress of building and decoration which the painter entered after the plasterers and before the upholsterer.

This placed the artist at a disadvantage, for builders, as they reached this stage of construction, often began to worry about funds if they did not actually run out of them. Such a situation seems to have occurred between Pond and his old friend Thomas Edwards, who amused himself between literary skirmishes with William Warburton by building and eventually furnishing his country estate at Turrick. After the usual delays and disasters (a collapsing ornamental plaster ceiling), Edwards commissioned paintings from Pond, then proved generous with complaints and short of money. In 1749 he asked Daniel Wray to prod their mutual friend along, although he had yet to pay for the pictures: 'When Mr. Pond sent word into Bedford-

shire that my Pictures were finished I thought I should find them here at Turrick on my return; I would beg you to desire him to send them by the first opportunity; he has the direction of the carrier.'[24] The date of their arrival at Turrick is uncertain, but the bills for repairing two pictures and rent for eighteen months' lodging were not paid until 1750.[25]

In spite of such irritations, Pond's country house business became quite lucrative, grossing £15 to £100 per customer, although disappointing in that patrons usually did not return after their needs were filled. Thus the pastels for Bessborough were surely intended to complete the arrangement of his originals by Liotard at Stanstead or to duplicate them for another residence. Sir Robert Walpole's lone commission for a portrait of his illegitimate daughter Maria was inspired by his scheme of hanging pastels of his children in the yellow salon at Houghton, and Maria, unlike Horace, had not been to Venice to be portrayed in that medium by Rosalba.[26] The *Four Seasons* functioned as overdoors, the Claudes and Panninis as chimney pieces. Therefore, unless the decorator's interests corresponded with or developed into those of the serious collector, his patronage dried up when his walls were filled.

The primarily decorative roles the copies, wall, and ceiling paintings were designed to fill diminished the challenge to the artist. Original compositions and bravura technique were not required, since most patrons wanted safe solutions to decorative problems, at a reasonable price. Consequently, there existed an enormous market for large, cheap paintings of well-known views or historical subjects, which established painters like Hogarth were understandably loath to supply, and which mediocre artists, lacking familiarity with the originals and adequate skills, could not satisfy. Arthur Pond worked out a compromise, producing quality copies of paintings with which he was familiar as the original dealer, importer, restorer, or publisher. On the whole, however, English artists failed to meet the challenge posed by early Georgian architecture, and patrons turned to dealers and auctions, spending hundreds—sometimes thousands—of pounds for works of varied quality by or after English and continental old masters. Jones Raymond, one of Pond's best patrons, also spent £676 for fifty European paintings at twenty-seven auctions.[27] A collection of annotated sales catalogues, compiled by one of the Great Queen Street lodgers Richard Houlditch, tracks the objects as well as the purchasers of interest to the household between 1725 and 1758. Sixty-two of Pond's patrons spent £17,000 at eighty-nine auctions, or about £275 each.[28] (Since many of the annotations are incomplete, they undoubtedly spent even more.) The same sixty-two spent £2753.10.0 at Pond's.

While accounting for a significant proportion of art buyers' expenditures, auctions also enforced a price structure for the rest of the art world. Spectacular prices were not uncommon, but had little immediate impact

on the fortunes of living painters. In 1758 the Duchess of Portland purchased a putative Raphael for £700, which represented one year's income for Pond.[29] (But this and other such purchases were contributing factors in the coming generation's determination to master history painting and emulate Raphael). The majority of pictures sold at auction were very cheap, going for one to ten pounds each. Some auction buyers seem to have concentrated their funds on one very expensive picture—a 'centre-piece'—and then laid out the rest on cheap 'wallpaper'. The consequence of this practice was to keep low the prices contemporary London subject painters could charge for either their original work or copies. When the sixty-two buyers' 'centerpieces' are excluded, they paid about £14 per picture—roughly what Pond could charge for one of his large copies. Art dealers worked hand-in-glove with the auction houses, often disposing of the accumulations of a continental buying trip at a sale at Cock's. As a portrait rather than subject painter, Pond was not seriously threatened by the dealers' activities or by the competitive frenzy that sometimes visited buyers at auctions, choosing to profit from it instead by dealing and selling through auctions himself. Other portrait painters quietly did the same.

Although the old master and country house trades provided Pond with most of his prestige and interesting commissions, portrait painting was his single largest source of income, significant even among the expenditures of the stalwarts. As portrait buyers, they compounded the defects of a difficult and volatile market. Most of their interest and money was focussed on old master paintings, but the rest of the time they wanted portraits, the nitty gritty of the painter's trade. And, in this field they generally limited their commissions to Pond's areas of strength: small, intimate portraits of women and children. Only the Delavals broke the norm by commissioning full lengths (of the children); only Morton preferred masculine portraits.[30] Fortunately, what the stalwarts' portrait trade lacked in originality and interest, it made up for in numbers and continuity. The men had large families, and, dependent on Pond's expertise in other matters, they returned even after his work had fallen from the vanguard of fashion.

Analysis of the buying patterns of all Pond patrons indicates that most, including the stalwarts, were pushed into the portrait market by forces very different from the decorative or intellectual passions governing the old master trade. Over and over again, important family events—birth, coming of age, marriage, and inheritance—triggered an individual's buying spree at the portrait painter's. One well-documented case is that of the Earl of Egmont, who sat for his first portrait, by Kneller, near the time of his twenty-first birthday. He sat again to Hans Hyssing in 1733, the year he served as president of the Georgia Society and was elevated to the peerage.[31] He entered Pond's life as a consequence of the marriage of his eldest son Lord Perceval in 1738, when he ordered pastels of his daughter

and daughter-in-law, then induced his son to sit also.[32] Finally, Egmont wanted another of himself, but after shopping around several painters (Pond, Wills, and Highmore), he opted for Wills for his own likeness.[33] Such series are not so easily reconstructed for other Pond patrons, but even single commissions can be shown to coincide with landmark family events. Thus General James Oglethorpe, who returned from Georgia, married and settled in a new country house in Essex in 1744–5, commissioned £73 worth of portraits in twelve months.[34] Princesses Mary and Louisa sat for portraits in 1740; the association of their commission with the marriage of Louisa that year is expressed by the discreet orange-blossom Arthur painted in the bodice of her dress.[35] The birth of an heir was another occasion calling for portraits. Even the stalwart Robert Price, attracted to Pond by his reputation as a connoisseur and dealer, requested him to paint a portrait of Mrs. Price and little Uvedale.[36] The phases of childhood were also attracting attention from parents of varied social backgrounds; the eldest sons of the Earl of Orrery, Thomas Walker, Esq., and John Durnford, pinmaker, were hustled off to Pond's before reaching their teens. He depicted each in pastels, holding a King Charles spaniel (Figure 5).[37]

By suddenly and sometimes unexpectedly changing an individual's or family's social status, inheritance could stimulate frantic attempts to catch up with the iconography. Such is the case with Francis Blake Delaval, a retired naval captain who lived quietly before inheriting the recently built, largely unfurnished palace and lands at Seaton Delaval in Northumberland. His response to the problem of empty walls and eleven children was to commission £266 worth of portraits from his daughter's drawing master Arthur Pond, and his wife bought another £35 worth too (Figure 7). When the family began to run out of money in the 1750s, their daughter Rhoda, thanks to her lessons from Pond, could continue to cover yards of canvas with portraits.[38] One finds the same patterns repeated, albeit on a less grandiose scale, by Richard Lloyd on his inheritance of the estate of the dowager Duchess of Winchelsea, and Samuel Shepheard after the death of his father in 1743.[39] Only Charles Rogers, an unmarried orphan, was free to spend his inheritance entirely on old master drawings.

The Earl of Egmont's *Diaries* suggest that he and other portrait buyers brought a relatively special set of expectations and requirements along on their shopping trips. While the Earl was conversant with and appreciative of his friends' old masters, his strongest enthusiasm was reserved for portraits. After the Queen discovered a cache of Holbein drawings in a chest at Windsor in 1735, he pestered her for a year with suggestions that these Tudor portraits might be engraved. As might be expected, Egmont's own art collection consisted of engraved historical portraits extending up into his own time, and described by the Queen as 'curious, and of use when one is perusing a historian'.[40] Her statement, which the Earl found

flattering, can easily be extended to include his attitude towards contemporary portraits, including those of his family. The obsessive concentration on prominent family members, at critical stages in their personal or public lives, coupled with an acceptable monotony of style, pose, and characterization is explicable if patrons such as Egmont destined their portraits to accompany written or oral narratives—in other words they functioned like a rosary for family history, strung up around the halls and galleries of Georgian houses.

This view of portraits as landmarks of family history conditioned patrons' choices of portrait type, medium, and ultimately artist. Thus Arthur Pond drew children on a smaller scale than usual. Young women rarely sat for anything larger than a head and shoulders 'with hands', while a man en route to success in the 1740s and 1750s wanted a half or full length in oils. Samuel Shepheard ordered a full length the year he inherited the family estate, while the frugal Charles Yorke settled for a half length after his appointment to government office substantially increased his income. The concept of 'decorum'—the choice of an appropriate size, medium, and even pose—linked the type of commission to the status of the sitter. This variable could even influence the patron's choice of artist, as when the Earl of Orrery, learning that his wife wanted a portrait, advised, 'Pond will be best for your picture.'[41] Known for his pretty and unpretentious pastels, Pond ended up depicting a large number of women and children, but executed relatively few masculine portraits or large groups in oils. The latter were usually painted by Pond's friends George Knapton and Thomas Hudson, and later by Reynolds.

As the range of examples above suggests, the consumption of portraits was commonplace throughout most prosperous levels of London and provincial society, from princesses to pinmakers. The case of John Durnford indicates that a family portrait would be the first art purchase of an up-and-coming tradesman. These indications are borne out by the overall numbers of patrons buying nothing but portraits from Arthur Pond—155 out of 474 (32 per cent) (Table 1)—as well as the numerous and well-publicized laments of contemporary painters about the dearth of any other demand for their talents. Nevertheless, all depended on the continuous and growing demand for face painting, and even the diversified Pond derived at least half his income from it.

On a very small scale, the eighteenth-century portrait market functioned like a modern commercial market for ephemeral luxury goods. This is evident when Arthur Pond's portrait business is examined in detail and compared to his dealings with collectors. Of the 184 patrons whose purchases included portraits, 117 stayed with Pond for less than twelve months (Table 1). Significantly, several exceptions belonged to the stalwart group, tied to the artist by other mutual interests or old friendships. Portrait

buyers were more apt to shop around as the Earl of Egmont did in 1738, and to place more confidence in their ability to evaluate quality work. Valuing likeness and decorum, they could make their judgments on the basis of their knowledge of the sitter's appearance and social and family status, whereas collectors seeking ideal beauty were dependent on the shaky new 'science' of connoisseurship. Collectors also tended to view their big purchases like speculative investments, destined to increase in value, while portraits, like land, were sold only in emergencies and often at a loss. Since the latter, like court dresses or mourning clothes, were purchased to mark important occasions, they became subject to the laws of fashion rather than finance.

Consequently, the portrait painter had to respond not only to differences in age and status among his sitters, but also to changes in fashion and fashionable taste. The burning question for Pond and his contemporaries was: what are prevailing notions of social decorum, and how can these be best expressed in portraiture? In Pond's case, the prominence of women in family and London life, their leisure and pin money, and the formation of intimate friendships between them as evidenced by the outburst of their correspondence in this period, presented a social opportunity for a painter of his talent. So, too, did the growth of sentimental interest in childhood. He responded with his pastel portraits, which suited his small skills and the private affections of female and domestic life. More than two-thirds of Pond's eighty-eight female patrons bought portraits (as opposed to one

Table 1. Buying patterns, 1734–50

type of purchase	number of buyers	amount spent (£sd)	average individual expenditure (£sd)
paintings only	155	3067.01.0	19.15.0
prints only	136	317.10.0	2.07.0
combination	101	3924.16.3	38.16.0
art dealing[1]	25	501.02.6	20.01.0
restoring	19	83.06.6	4.08.0
miscellaneous[2]	9	17.19.0	1.19.0
unknown[3]	29	708.05.0	24.08.0
	474	8620.00.3	18.03.0

1. includes 'scagliola' sales.
2. includes art supplies, framing.
3. unitemized purchases paid 'on account'.
NB: These figures do not include wholesale print buyers, the Knaptons' payments for illustration jobs, Anson's payment for his illustrations, and apprentice fees.

third of all men), and the sitters consisted entirely of themselves, their female friends, their children, and, on a few occasions, their husbands (Table 2). The entrance of women into the portrait market on a large scale exacerbated its vulnerability to fashion, since few artists managed to extend their relationships with them beyond the purely professional encounter. Women did not join clubs, nor did ambitious professionals have much access to their social circles; the friendship and shared interests which bound Pond and the stalwarts together were not developed easily with a group of aristocratic, poorly educated women. In Arthur Pond's case the only exceptions were two women who seriously pursued 'careers' as amateur painters and relied on him for drawing lessons and supplies: Rhoda Delaval and Mrs. Delaney.[42] Yet even these ladies caused the portrait painter cum drawing master some frustration. Mrs. Delaney experienced several infatuations with portrait painters, one of them Pond. According to her correspondence, she had consulted Hogarth for advice on her drawings as early as 1731. Three years later, she hoped to work in pastels under Pond's supervision, then switched allegiance to Joseph Goupy and Bernard Lens, both professional drawing masters. In 1739 she began regular lessons with Goupy, who had to share time with the harpsichord master. Liking Goupy because he was so 'Modest, quiet, civil, honest, and an incomparable master', she stayed with him until his death induced her to consider Francis Hayman, 'the best master I know of, but am not sure he will teach'.[43] Mrs. Delaney wavered between learning from the fashionable painters of the moment—Hogarth, Pond, and Hayman—and the less talented but more reliable limner-drawing masters.

Mrs. Delaney's behaviour seems typical of most of Pond's female patrons, who form his most predictable and consistent group of buyers. Not only did they concentrate on portraits, but 82 per cent of them (as opposed to 60 per cent of men) made only single purchases (Table 2). Only two, Rhoda Delaval and a widow, Elizabeth Strangways-Horner, spent more than £50, and none exceeded £100.[44] Their homogeneity consists not only of taste, but also of wealth and social background. Pond addressed over half of his female patrons as 'Lady' (indicating husbands ranking as knights or above, or fathers in the peerage) whereas less than a quarter of his male patrons could claim similar status. Others were members of leading families in trade and finance in the City. The two women with lower-middle-class backgrounds were the actress Peg Woffington and Hannah Norsa, daughter of a Jewish tavern keeper and mistress of Sir Horace Walpole. The latter might be considered, in a left-handed way, a member of aristocratic circles. Both conformed in other respects by commissioning pastel portraits of themselves.[45]

If the portrait market enjoyed a high level of demand, it differed significantly from the old master trade not only in its scale and social

composition, but also in the large numbers of practitioners available to satisfy that demand. Ellis Waterhouse's *Dictionary* lists dozens of painters active in London and most of the leading provincial towns;[46] their proliferation testifies to the failure of any early Georgian portraitist to dominate the market and develop a strong artistic personality. (One will grant Hogarth the personality, but not the control.) Therefore, patrons were not compelled to cultivate a reliable portrait supplier, as had been the case in the seventeenth century. On the contrary, they tended to seek either the latest celebrity or an established specialist for each particular need. One finds that Pond painted Lord Anson in 1744, but Hudson and Pingo painted him *c.* 1747, Wandelaar in 1751, Hoare in 1753, Reynolds in 1755, and Cotes in the 1750s or 1760s. The Duke of Cumberland was painted by Jervas, Morier, Amigoni, Highmore, Pond, Rusca, Hudson, Wootton, Reynolds and Gilpin, and sculpted by Rysbrack, Gosset and Cheere. Henry Fox was portrayed by David, Zincke, Pond, Hogarth, Barret, Eccardt, Liotard and Reynolds; Sir Robert Walpole by Rysbrack, Van Loo, Hayman, Jervas, Kneller, Richardson, Wootton, Vanderbank, Gibson, Dahl, Hyssing, Slaughter, Pond, Zincke, Eccardt, Hudson and Heins.[47] Admittedly, these are exceptional cases, but even Daniel Wray, relatively poor and a close friend of the artist to boot, sat to different painters in the 1750s.[48] Few patrons could resist the temptation to see their reflections in different mirrors, and artists had to fight to attract and still

Table 2. Types of buyers: social rank

Rank	number of buyers	amount spent (£sd)	average individual expenditure (£sd)	percentage of buyers active 1 year or less
Peer	49	1288.06.0	25.18.0	
Kt. or Bart.	29	669.06.0	22.09.0	
Esquire	108	2932.06.6	27.04.0	
Professional[1]	51	801.02.6	15.10.0	
'Mister'	148	1818.07.0	12.05.0	
All men	385	7509.02.0	19.10.0	62
'Lady'[2]	44	477.14.0	11.01.0	
'Mrs.'	45	634.18.6	14.06.0	
All women	89	1112.12.6	12.10.0	82

1. Includes military and naval officers, clergymen, and doctors.
2. Includes wives, widows and daughters of peers, and wives and widows of knights and baronets.

more to keep their attention. They offered samples of their work in prints, constructed fashionable reputations, and charged competitive prices. Success was so transient that a fashionable portrait painter had a better chance of raising his prices or attracting new sitters than he did of securing additional business from a previous patron.[49]

One more facet of an already complicated market remains to be explored. This was the print trade, which, deriving its audience from the old master and portrait markets, was still dependent on the booksellers for marketing techniques, sales outlets, and materials. With the auction houses, it was the fastest growing sector of the art world, and one of the most commercial. Arthur Pond began by publishing esoteric prints for the connoisseurs, then plunged into the rapidly evolving general market. Almost half of Pond's patrons (204 out of 474) bought prints from him at one time or another, and even this figure is much too low, since six years of records from 1738 to 1744 (when Charles and Elizabeth Knapton ran the business) are not included in Pond's accounts (Table 1). Nor can the patrons who bought his prints through other retailers be counted or identified. Yet, even with these omissions, numerically the print buyers were the Great Queen Street operation's most important group of patrons, although their individual and overall expenditures (£2.7.0; £317.10.0) were very low by the standards of the collectors or portrait patrons (Table 3). The size and diversity of the audience can be ascribed to the prints' cheapness and their broad appeal to art lovers unwilling or unable to own the original paintings which they reproduced. This was the case for Peter Movillion, a calico printer who seems to have enjoyed a burst of prosperity in 1744-5. That year he took out insurance on his stock in trade valued at £500, purchased some very modest continental paintings at auction, and bought prints of fashionable Panninis at Arthur Pond's for £1. 10. 6.[50] Sold in sets and bound into volumes, the same prints were attractive to the virtuoso and to other students of painting. The great collectors Henry Hoare, Lord James Cavendish, the Earl of Burlington, the Duke of Rutland, Horace Walpole and Dr. Mead bought them as records of their acquisitions (they owned several of the originals) and as aids to connoisseurship.[51] They were regular and discerning buyers of every series that came out. For collectors of contemporary prints, Pond offered special editions on large sheets or India paper which raised their price and increased their rarity.[52] Pond's larger prints could also function as wall decorations after being coloured, framed and glazed at a cost of seven to nine guineas for a set of four. As such, they were especially attractive to learned men with expensive tastes and small pocketbooks, including an erudite group of doctors and clergymen. John Ranby was surgeon to George II and a fellow of the Royal Society, as was Dr. Chauncey (a painting, drawing, and print collector); Dr. Abraham Hall and Dr. Daniel Cox also bought

prints.[53] Their wide-ranging interests and collections in the fine arts and natural history, their support of publications as diverse as Mary Barber's poetry, Middleton's *Life of Cicero*, and *Anson's Voyage* mark the persistence of the seventeenth-century tradition of general learning. This was not the case for the clergymen, whose entrance into the art market resulted from peculiarly eighteenth-century circumstances. The combination of classical education, declining interest in theological controversy, moderate circumstances (John Dyer scraped by on £80 *per annum* in the country; Warburton had £560), and a place in polite society made clerics—the Rev. Nathaniel Forster (a member of the Yorkes' circle), the Rev. John Nicolls (headmaster of the Westminster School), the Rev. Dr. Jenner, the Rev. Mr. Thompson and Dr. David Gregory (canon of Christ Church, Oxford)—frequent buyers of Pond's landscape and ruin prints for study or wall decoration.[54] A few of Pond's clergymen, most notably the Rev. Thomas Dampier, one of the Dilettanti, had accompanied pupils on the Grand Tour, and seem especially to have appreciated Italian landscapes.[55] Their interest in mythologies indicates their engagement in secular life, and declining Protestant prejudice against images.

Artists bought prints to imitate in other media (as the landscapist George Lambert did), to study or to adapt as background details for their original

Table 3. Buyers' average individual expenditures (£sd)

Type of purchase	All buyers	Combination buyers	Buyers active 1 year or less
paintings only	19.15.0	23.02.0	15.06.0
prints only	2.07.0	2.14.0	2.00.0
combination	38.16.0		15.19.0
art dealing	20.03.0	8.09.0	6.11.0
restoring	4.08.0	6.01.0	3.00.0
miscellaneous	1.19.0	9.12.0	1.19.0
unknown	24.08.0	50.00.0	21.01.0
Length of association with Pond			
1 year or less	9.18.0	15.19.0	
1 to 5 years	21.03.0	26.12.0	
6 to 10 years	49.09.0	59.00.0	
more than 10 years	43.06.0	50.06.0	

works. Nineteen professional painters, including William Hoare of Bath, Thomas Hudson, William Kent and John Smibert, purchased prints, as did the leading amateurs Mrs. Delaney, Lady Hertford and William Taverner.[56] Mrs. Delaney promptly lent a friend her Pond prints after Claude Lorrain to copy in pen and ink.[57] These buyers, motivated by specific needs, often bought odd lots of prints at unpredictable times.

The collectors, low-budget cognoscenti, and artists are the most easily identifiable members of the Pond print buyers, but the majority of them may have resembled Mr. Movillion. Many of the unidentifiable 'misters' in Pond's accounts—Mr. Barbarona, Mr. Bingis, Mr. Campfield, Mr. Davy, to name a few—bought one or two prints, spent less than one pound each, and disappeared.[58] Such quick exchanges of cash for a finished, 'mass-produced' product were the most transient and impersonal transactions to be found in the eighteenth-century art market, with the possible exception of auction sales. In some cases, Pond did not even note the name of the print buyer in his journal, and he had no contact whatsoever with buyers at other retail outlets. Some purchases may have been impulsive, and convenient shopping locations and cheap prices may have influenced the buyer's choice. To capture this market Pond and his contemporaries had to abandon the painter's distaste for the commercial techniques of the booksellers: newspaper advertising, distribution through strategically located retail shops, and a continual output of serial publications to attract new patrons and keep old ones on the hook. The emphasis on novelty, volume, and distribution would eventually lift printselling out of the artist's workshop and bookseller's inventory, and into the world of commerce.

In the first half of the eighteenth century, the art market was flooded with new types of patron in greater numbers than ever before. Collectors, calico printers, Grand Tourists, clergymen, aristocratic women, and country house builders sought more—or less—than the conventional portrait. The resulting dislocation between supply and demand produced chaos of a most stimulating and constructive type. The competition between artists and the new art entrepreneurs for the patronage of big collectors and decorators was fierce. Hogarth's feuds with other painters and engravers, and his hatred of auction houses, have been thoroughly documented in his prints and discussed by his biographers; Pond's friend John Smibert accepted Berkeley's invitation to Bermuda in order to escape the cutthroat rivalries of Covent Garden in the 1720s.[59] (Savages and university students were preferable.) Although everyone wanted portraits, there were still more than enough painters to meet the demand. The arrival of various portraitists from the continent increased the pressure (recall Edwards's comment on their view of England as 'a cold, dark place, where there is nothing but money'), as did the tendency of portrait buyers to select artists by the criteria of decorum and fashion.

Such competition opened up the London art market at a time when more patrons were spending more money than ever before. Painters became increasingly sensitive to the forces of supply and demand as their buyers discovered and exploited alternative sources for art. Auctions gave buyers a mechanism for influencing prices and indulging their aesthetic preferences. The effects of the situation were far-reaching. As artists' traditional means of maintaining employment and prices—guilds, gentlemen's agreements, ostracism of foreign artists, and high tariffs on imported art—broke down, the benefactor/client model for patron/artist relations collapsed, too. Competing in an open market, artists formed conflicting, quarrelsome parties, the ephemeral academies, the clubs, heterogenous learned societies, rather than united professional organizations, in their efforts to find stability and impose order on the market. Hogarth complained, but in his refusal to support plans for a royal academy he also acknowledged that the new system (or lack of it) offered better opportunities for experimentation, diversification, and individualistic achievement. In fact, if the collapse of England's somnolent and old-fashioned art world forced Pond and others into desperate measures to appease buyers, it provided a beneficial stimulus for the school of English painters as a whole. Suddenly forced to compete on equal terms with continental artists, past and present, English painters began to imitate, experiment, and improve.

English artists faced further challenges from other luxury trades and leisure activities which were also expanding and reorganizing. The greatest expense in furnishing an eighteenth-century house was not art but upholstery and hangings. On a yard-by-yard basis, silk damask was just as costly as oil on canvas, and the elaborate trimmings were much more. Gold lace for the state bed at Houghton cost Sir Robert Walpole £1200 in 1732, while his four Van Dyck portraits were valued at less than half that sum.[60] On a smaller scale, eight guineas could buy a pastel portrait by Arthur Pond or a finely bred hunting dog for Lady Hertford.[61] Prints and books, both meant to be 'read', competed for the attention of the leisured and the learned. They were competitive in price, similar in purpose and use, and often sold in the same shops.

Art and connoisseurship were gradually incorporated into the daily life of the English upper and middle classes and the structure of the London luxury trades. The problem for English artists was not so much a shortage of patrons or a deficiently educated public as a surfeit of new kinds of buyers with interests and tastes they were unprepared or unable to accommodate. The traditional patron/benefactor was lost in the surge of new customers: women, amateur artists, calico printers, interior decorators. When painters could not meet new demands, they watched their audience turn to art dealers, auctions, imported artists, or even to their own efforts. Hogarth's response was to complain, satirize, and persevere. Pond was

willing to bend with the tide while seeking to maintain high standards. Young artists would seek new solutions to the problems posed by a rapidly changing market. Specialization enabled them to cope with rising numbers of buyers and increase the variety of goods and services available on the market. Persistent efforts to organize painters, establish a central institution to mediate between artists and patrons and subordinate entrepreneurs to their control led to the founding of the Royal Academy in 1768.

V
Painting

In this and the next two chapters, the interaction between changing forces in the London art market and Pond's activities as an artist and entrepreneur are investigated in his three main occupational ventures: painting, print-selling, and art dealing. After emerging from the ingrown world of Covent Garden and rehearsing for an idyllic future as a gentleman-artist while touring Italy, Pond returned to London and was forced to confront the realities of the art market. Some of his initial responses to the situation were discussed in terms of his efforts to establish a reputation and make friends. These adjustments had far-reaching effects on his career and are significant indications of broader trends in the London art world. Pond's artistic activities spanned a period of paradoxical cultural change in England when European models were imitated, criticized, and (in a fit of patriotism) anglicized, while English artists—erstwhile poor relations of European art—cornered a healthy share of the richest national art market in Europe. As a competent artist and first-class opportunist, Pond was quick to identify and adapt to the possibilities that developed between 1735 and 1750; his actions and those of others like him were to have important, unanticipated consequences for the future of English art and artists.

If Arthur Pond is notable for anything in the history of English art, it is for his activities as an art dealer and print publisher rather than his career as a painter. His paintings have disappeared into the cellars and store rooms of country houses and art museums all over England, and the few examples available to scholars suggest that there is little pleasure to be gained from a concerted search for more. From a twentieth-century critic's viewpoint, painting was the least important of Pond's several artistic occupations. This conclusion—borne out by the almost total absence of scholarly interest in the topic—completely reverses the eighteenth century's estimation of his occupational priorities.[1] Until he began to entertain ambitions of passing

as a gentleman late in the 1750s, Pond and others insisted on his primary status as a painter. His insurance policy describes him as a 'limner' (fine artist as opposed to house painter), while correspondence and advertisements always included the term 'painter' in his address.[2] There were good reasons for emphasizing this facet of his career even when his other ventures were just as or more successful. The academic hierarchy of art professionals ranked the painter above all other producers or middlemen, and, as Kneller and Thornhill had demonstrated, it was but a short step up to the landed class. A painter, regardless of his abilities, had more prestige than an art dealer or printseller. Pond's choice of title also reflected economic reality; his revenues from painting accounted for the highest proportion of his art-related income and determined his standard of living and social prestige throughout his career. (Table 7.)

For the purposes of this study, Pond's lack of aesthetic distinction in his chosen field is an asset. His known paintings and the comments of contemporaries indicate that originality, genius and technical brilliance were not factors in his artistic and professional progress, while they support an estimation of his career in terms of calculated responses to current forces in the London art market. As a marginal talent, Pond was vulnerable and responsive to changes in fashion and the status of the competition. His development as an artist, changes in his shop organization and the prices he could command resulted from the constant campaign to establish and maintain a place among the ranks of London painters.

Pond's journal of receipts and expenses covers three phases of his career as a painter. The first, dating from *c.* 1734 to 1740, spans his years as a fashionable pastel portraitist. This period was followed by the slump of 1740-3, during which Pond switched from pastel to oil painting, hired assistants, travelled, and widened the range of subjects and projects he was willing to attempt. Phase three shows him securely established in his new career as an oil painter and copyist specializing in literary portraits and Italianate landscapes.

EARLY SUCCESS

Arthur Pond's efforts to break into the lucrative London portrait market have been described in chapter III above. His search for friends and reputation induced him to travel abroad and around England, study the works of Van Dyck (esteemed as England's greatest portrait painter), and experiment with pastel painting. His new technique gave Pond a competitive edge over established portraitists in London. The suitability of the medium to portraiture had been demonstrated by the continental artists Rosalba Carriera, Maurice-Quentin de la Tour, and Jean-Etienne Liotard,

and English tourists rapidly rediscovered a taste for their work.[3] Relatively few painters in England in the 1730s had mastered the new technique: George Knapton, William Hoare and the Frenchman Delacour. There was, therefore, an English market for pastel portraits which the leading oil painters—Vanderbank, Richardson, Van Loo, Mercier, Rusca, Soldi, and Amigoni—had not exploited. Furthermore 'crayon painting', as it was called in the eighteenth century, was peculiarly appropriate for a young painter with limited means. The technique consisted of drawing with crayons on specially prepared blue paper. The image was built up from a rapidly sketched outline by a series of tones added layer by layer. Bright colors and highlights were added last, after the half-complete drawing had been glued onto a cloth and tacked to a 'straining frame'.[4] The whole was then inserted into a carved and gilded frame, and the fragile surface was protected by a sheet of plate glass, which enhanced the glitter and brilliance of the object.

The pastel medium offered a young painter several advantages over an artist working in oils. A crayon painting was executed like a drawing, that is to say relatively quickly, without tedious delays while the oil-based pigments dried. It could be completed in relatively few sittings, sparing the subject hours of boredom and enabling the artist to execute more portraits in a given space of time. As a result Pond and other crayon painters dominated the market for portraits of children, whose importance as subjects for painters increased proportionately with the amount of parental attention lavished upon them.

If it had survived, Arthur Pond's sitter book would have given a clear picture of the amounts of time and labor involved in completing one of his pastel portraits. However, a rough estimate of his annual output can be

Table 4. Arthur Pond: portrait prices (£sd)★

				size		
dates	medium	head	with hands	kit-cat	half-length	full length
1734–8	crayon	5.05.0	6.16.6	8.08.0		
	oil	6.06.0			16.16.0	
1738–43	crayon	6.06.0	8.08.0			
	oil	8.08.0			12.12.0	16.16.0
1743–8	crayon	7.07.0	10.10.0			
	oil	8.08.0		12.12.0	16.16.0	33.12.0
1748–50	crayon	8.08.0	10.10.0			
	oil	10.10.0	12.12.0	15.15.0	21.00.0	36.15.0

★ Prices do not include frame or glass.

derived from the payments recorded in his journal. In his three busiest years, 1738-40, Pond was paid for between thirty and forty pastel paintings *per annum*. Since he did most of his work in the spring and fall when his clients were in town, he probably averaged over a portrait a week during the season. This was apparently the fastest he could work without loss of quality, for in 1738 (when he was paid for thirty-nine portraits) he raised prices in order to ease demand (Table 4).[5] Pond's relatively high production rate in crayons is evident when contrasted with his output as an oil painter after 1744, when (even with one or two assistants) he was paid for only eighteen to twenty-five portraits each year.

Apart from speed of execution, a second advantage was that pastel paintings were generally cheaper for an artist to produce, and so could compete with works of oil painters in terms of price. Since pastels blended easily, a wide range of expensive pigments was unnecessary. During the 1730s Pond bought most of his 'colours' in small lots, rarely paying more than six shillings per purchase. Prussian blue (discovered in Germany *c.* 1711 and instructions for making it were first published in 1731), flake white, and lake were the only pigments to merit a separate acounting; they were also the most important to the final appearance of the work. White, mixed with all other pigments, provided luminosity; the lake gave warmth to flesh tones, while in the background the blue, a new and fashionable color, offset the warm tones of the subject's face.[6] Although the costs of materials amounted to nearly the same, crayon painters spent little or nothing for additional labor, while oil painters relied on drapery painters and other assistants. Before 1745 Pond employed no assistants and had only one apprentice, the son of poetess Mary Barber.[7] Rupert Barber's responsibilities would have included scraping smooth the sheets of paper for portraits, grinding and mixing colors, affixing the finished works to straining frames, and other peripheral tasks. George Knapton's pupil Thomas King was paid for three months' work at the end of 1735, and David Bellis assisted with occasional restoring jobs.[8] John Dyer, at one time Jonathan Richardson's most promising pupil, may also have helped out once.[9] In all three cases the work involved painting in oils, but Pond's total labor costs between 1734 and 1745 amounted to only £19.12.6. His savings in time and labor were reflected in his prices; his crayons were always one or two guineas (15-20 per cent) cheaper than his comparably sized oils (Table 4).

Employing assistants not only raised a painter's prices and reduced his advantages over others, but also increased his vulnerability to the vagaries of the art market and the competition of other artists. A case in point is that of John Robinson, a talented student of Vanderbank who achieved early popularity by depicting his sitters in Van Dyck costume, launching a fashion which lasted the rest of the century. Robinson was ready to step

Table 5. Distribution of painting costs (£sd)

	1734[1]	1735	1736	1737	1738	1739	1740	1741[2]	1742[3]
cloths	0.12.0	2.17.6	8.01.6	0.15.6	0.09.6	1.17.0	0.15.0	0.03.6	1.04.0
crayon paper		0.04.0		1.00.0					
colors	7.10.0	2.05.0	6.09.0	5.02.0	13.13.6	7.14.0	0.19.6		2.03.0
stretchers	7.16.0	0.03.6	1.13.0		0.10.6	1.11.0	3.05.6		0.17.0
miscellaneous[6]	0.10.0	6.03.6	5.18.6	1.12.6	1.13.6	1.12.6	1.02.0	1.13.0	5.03.6
MATERIALS	16.08.0	11.13.6	22.02.0	8.10.0	16.07.0	12.14.6	6.02.0	1.16.6	9.07.6
Gosset frames		22.01.0	10.10.0	67.10.0	75.19.0	74.15.0	47.05.0	26.00.0	16.04.0
other frames[7]	2.13.0	17.11.6	18.19.0	48.16.6	34.09.0	0.15.0	0.06.0	1.06.6	1.05.0
glass	0.02.6	5.15.6	17.03.0	15.02.6	42.12.6	32.02.0	26.08.0	5.07.0	1.14.0
FRAMING	2.15.6	45.08.0	46.12.0	131.09.0	153.00.6	107.12.6	73.19.0	32.13.6	19.03.0
assistants[8]		4.14.0	4.04.0						4.17.0
Peter Maddox									
David Bellis				2.02.6		1.16.0	0.11.6		1.01.0
LABOR		4.14.0	4.04.0	2.02.6		1.16.0	0.11.6		5.18.0
TOTAL	19.03.6	61.15.6	69.15.6	142.01.6	169.07.6	122.03.0	80.12.6	34.10.0	34.08.6

	1743[4]	1744	1745	1746	1747	1748	1749	1750[5]
cloths		7.07.6	4.04.0	3.08.6	5.01.6	4.07.0	5.01.0	2.19.0
crayon paper				0.01.6	0.03.6		0.01.6	
colors		1.05.6	3.18.6	1.04.0	5.16.6	1.13.0	0.11.6	1.10.0
stretchers		2.13.6	2.00.0	8.03.0	6.11.0	6.09.6	6.07.0	3.12.0
miscellaneous[6]		2.05.0	3.04.0	2.14.0	4.04.0	2.00.6	1.17.6	0.12.0
MATERIALS		13.11.6	13.06.6	15.11.0	21.15.6	14.10.0	13.18.6	8.13.6
Gosset frames	11.00.0	22.10.0	57.06.0	54.12.0	26.06.0	35.10.0	43.09.6	
other frames[7]		1.15.0	6.12.0		9.02.9	18.16.0	3.02.6	1.17.0
glass		8.01.6	3.10.6	13.03.6	9.13.6	0.17.6	1.04.0	3.15.6
FRAMING	11.00.6	32.06.6	67.08.6	67.15.6	45.02.3	55.03.6	47.16.0	5.12.6
assistants[8]		5.17.6	41.11.0	40.19.6	41.09.6	62.18.6	48.03.6	28.18.6
Peter Maddox			2.18.6	4.00.0	1.19.0			
David Bellis				9.04.0	1.06.0	8.01.6		
LABOR		5.17.6	44.09.6	54.03.6	44.14.6	71.00.0	48.03.6	28.18.6
TOTAL	11.00.6	51.15.6	125.04.6	137.10.0	111.11.3	140.03.6	103.17.6	43.04.6

1. August–December only.
2. January, March–May, October–December only.
3. January–October only.
4. April, June–August, November, December only.
5. January–November only.
6. brushes, oil, charcoal, 'laymen'
7. may include some frames for prints
8. Thomas King, Enoch Markham, Thomas Black

into the big time by enlisting the services of London's leading drapery painter Van Haecken, when his competitors threatened to drop the latter if he accepted another client. As a result, Van Haecken refused to work for Robinson and began to paint Van Dyck costumes into the portraits of his other clients; Robinson lost his business and died in obscurity a few years later.[10]

A third advantage of crayon painting was the small size of most works which was fixed by the dimensions of paper and glass available at a reasonable price. The majority of early eighteenth-century pastel portraits show no more than the sitter's head and shoulders; a few also included hands. Technically, therefore, crayon painting was not very demanding on a beginner's anatomical knowledge or his ability to invent imaginative poses. Pond was able to use his basic repertoire of five or six simple poses over and over again, modified by the addition of appropriate details. The pose of *Master John Walker with a dog* (1736) (Figure 5) appears again in reverse in a later portrait of the young Hamilton Boyle (?1748; even the dog is the same); one angled view does nicely for Mrs. Strangways-Horner (1740), Princess Mary (*c.* 1740) (Figure 6), and Ann, Lady Dacre (*c.* 1746). [11] The Princess may be distinguished by her elaborate dress and jewelry. As for the men's portraits in 'three quarter length' (head and shoulders), there is no variation at all. However, it should be noted that eighteenth-century patrons were hardly concerned with monotonous re-petitions, if they even noticed them. At the artist's house they saw a careful and varied selection of portrait types, with a few works in progress; in their friends' and ultimately their own homes they would see one or two, interspersed with the work of other artists. 'Variety' would not be neces-sary in a portraitist's work until voluminous publications of engravings and annual exhibitions gave the public an overview of his career.

The benefits of adopting crayons for Pond were that he was able to paint much more attractive portraits without materially altering the essen-tial aspects of his style. A 'crayon's' appeal stemmed from its bright, clear colors and soft, impressionistic handling of surface detail—a welcome contrast to the stiff, sober, and hard-edged work typical of the same artist's production in oils. Comparison of Pond's earliest attributed oil portrait, *William Hobday* (1732) with a later pastel such as the *Henry Fox* (1737) shows what a difference the new medium could make.[12] Pond's greatest improvements, in handling texture and color, can be ascribed as much to the qualities of the pastels as to his study of Van Dyck. These were the qualities which attracted his first important patrons and distinguished him from the oil painters. When Pond returned to oil painting later in his career, so did his stiff, linear, and boring treatment of drapery and faces (Figure 7).

Finally, the carved, gilded frames and plate glasses protecting the paint-

ings added significantly to their decorative value and novelty. The glass was essential protection for the pastel's dusty surface, but its softening effect on colors and outlines was thought to enhance its overall appearance.[13] Gold frames contrasted splendidly with the richly colored hangings and wall papers which were replacing panelling in English town and country houses, while their carved embellishments linked them firmly with fashionable rococo styles. In commenting on the successes of the London crayon painters, Vertue (who was probably jealous) emphasized the impact these frames had on patrons.

> Crayon painting has met with so much encouragement of late years here. that several Painters those that had been in Italy to study. as Knapton Pond Hoare &c for the practice of painting in Oyl. found at their return that they could not make any extraordinary matter of it, turnd to painting in Crayons and several made great advantage of it. it looking pleasant and coverd with a glass large Gold Frames was much commended. for novelty—and the painters finding it much easier in the execution than Oil colours. readily came into it.[14]

Plate glass was an eighteenth-century status symbol, and its luxurious use in windows, coaches, mirrors, and picture frames proclaimed an owner's wealth and taste.[15]

Judging from his journal, Pond certainly perceived the importance of these embellishments. As his business gained momentum, he relied more and more on the best carvers in London, the Gosset family, whose gilded frames also adorned paintings by Hoare, Hogarth, and others.[16] Pond charged his customers about 50 per cent of the price of the painting for each Gosset frame and a plate glass, and was still unable to meet costs. He seems to have made little or no profit on the glass, and took a loss on the frames. The loss was absorbed in the profits derived from the paintings themselves, but this is the only recorded instance where Pond took a steady loss on *anything*. Evidently the contribution of the frames to the appearance and saleability of his works more than compensated for reduced profits. In addition, competition from George Knapton, James Wills, and William Hoare (who charged about the same as Pond) must have been a factor.[17]

Arthur Pond's success with the new medium can be charted from the payments recorded in his journal. From 1734 to 1737 his annual income from painting rose gradually from £65 to £158, although rising costs for materials and Gosset frames kept his profits below £50. In 1738 his business took off, with gross income tripling and profits amounting to £280. A flood of new patrons and a rise in prices accounted for this wave of good fortune, which lasted into early 1741 (Table 6). It was this accomplishment which provoked Vertue to comment on the crayon painters' arrival in the

art world; apparently earnings of £400 distinguished the noteworthy from the insignificant.

The artist's increasing prosperity was reflected by his more lavish standard of living, the cost of which more than doubled in the late 1730s. Some of the increase was probably due to rising overheads—mahogany furniture for his parlor and painting room where he received sitters, another servant, refreshments for patrons, and transportation of himself and his work in and around London. More expensive clothes, higher grade coal, and wax candles contributed to his prosperous image. He also spent more on the theatre, coffeehouses, and books, and began to invest in a personal collection of old master prints and drawings. His enjoyment of personal comforts and his accumulation of a 'nest egg' were tied to his rising success as a painter, although his profits from painting rarely covered his total living expenses. The differences would be made up by his print and dealing business.

Table 6. Painting income, profits, and standard of living (£sd)

year	income[6]	costs[7]	gross profit	living expenses
1734[1]	105.14.0	19.03.6	86.10.6	101.00.0
1735	58.01.6	61.15.0	−3.13.6	102.10.0
1736	110.08.6	69.15.6	40.13.0	252.03.6
1737	286.13.6	142.01.6	144.12.0	247.14.0
1738	449.05.0	169.07.6	279.17.6	309.14.0
1739	440.19.0	122.03.0	318.16.0	288.09.6
1740	325.13.6	80.12.6	245.01.0	276.10.0
1741[2]	131.13.0	34.10.0	97.03.0	96.11.0
1742[3]	108.17.6	34.08.6	74.09.0	244.10.0
1743[4]	61.10.6	11.00.6	50.10.0	10.15.6
1744	347.16.0	51.15.6	296.00.0	335.02.6
1745	517.15.6	125.04.6	392.11.0	342.02.0
1746	455.01.6	137.10.0	317.11.6	291.07.6
1747	348.12.0	111.11.3	237.00.9	357.04.0
1748	430.10.6	140.13.6	289.17.0	370.08.0
1749	514.14.6	103.17.6	410.13.6	375.14.0
1750[5]	179.18.6	43.04.6	136.14.0	389.16.0

1. August–December only.
2. January, March–May, October–December only.
3. January–October only.
4. April, June–August, November, December only.
5. January–November only.
6. Includes income from sales of frames and glass.
7. Includes costs of frames and glass.

REORGANIZATION, 1740–3

Throughout his career, Pond was never able to compete with the foreign-born portrait painters resident in England. The 1730s had been dominated by Van Loo, Mercier, Amigoni, Rusca, Soldi, and Dahl, whose stranglehold on the market for contemporary oil paintings was contested by a few members of the generation of English painters born in the seventeenth century—Richardson, Vanderbank, Hogarth and (briefly) Smibert. At the beginnings of their careers, Pond, Knapton, Hoare, Ramsay, Robinson and Hudson did not compete so much as seek the peripheral markets which existed for specialized products or were located outside of London. Or they worked as drapery painters and assistants in hopes of inheriting some business. Some had just achieved a relatively comfortable accommodation with the *status quo* when the London art market collapsed in 1740–1.

The coincidence of several events, not all of them limited to the art world, threw the world of 'virtu' into disorder. One of the most important was the outbreak of hostilities with France in 1740–1, which hampered Grand Tourists and art dealers abroad, and foreign artists working in England. From the safety of Massachussetts, John Smibert wrote Pond, 'I am sorry the State of the Virtu is at so low an ebb. if the arts are about to leave Great Britain I wish that they may take their flight into our new world that they may, at least remain in some part of the British dominions.'[18] Rusca's last visit to London ended in 1740, Amigoni had departed for the continent in 1739, Mercier went to work in the provinces, and Van Loo was gone by 1742.[19] Soldi lost some of his glamour when imprisoned for debt in 1744.[20] The older generation of English painters also began to leave the scene. Ill health forced Jonathan Richardson to retire in the early 1740s, John Vanderbank died from overindulgences in 1739, and Michael Dahl died in 1743. Furthermore, an older generation was giving way in political and economic life. The fall of Walpole in 1742 brought new men to power, and new groups of artists rode in on their coattails. The people Pond and his friends had assiduously cultivated since the 1720s entered office, inherited estates, and attained positions from which they could help their friends. The future suddenly opened up for the painters of Pond's generation.

Pond's journal shows that the transition from a crayon painter's to an oil painter's career at a time of political and economic crisis was not an easy one, even when the competition had providentially vanished. Smibert's comment, 'Your act. of the state of painting and the Painters with you shows a very fickle temper and is no recommendation of your great town,'[21] suggests that new patrons posed new problems, not all of them welcome. Pond's painting income dwindled from £326 in 1740 to £131

in 1741, £107 in 1742, and a miserable £54 in 1743 (Tables 6, 7). Like the European painters he found it expedient to absent himself from London for five months in 1741, two months in 1742, and eight months in 1743.[22] During one of these absences he may have visited Bath under the aegis of his friend and patron Charles Yorke.

Several factors contributed to the many difficulties Pond experienced between 1740 and 1743. Anti-French sentiment and the fear of Jacobitism helped to depress many continental tastes and fashions on which Pond had

Table 7. Distribution of art-related income (£sd)

	1734[1]	1735	1736	1737	1738	1739	1740	1741[2]
portraits	43.07.0	27.06.0	68.05.0	115.11.0	225.15.0	226.16.0	239.08.0	105.00.0
copies	15.15.0	15.15.0	25.04.0	14.14.0	84.00.0	100.16.0	17.17.0	
decorative ptg.	40.00.0			127.19.0				
total	99.02.0	43.01.0	93.09.0	258.04.0	309.15.0	327.12.0	257.05.0	105.00.0
dealing	21.00.0	71.05.0	66.09.6	206.12.0	21.09.0	96.10.0	48.04.6	10.10.0
scagliola		37.05.6		43.01.0	46.10.6	41.09.6	20.09.6	2.02.0
restoring		17.00.0	10.10.0		12.12.0	21.16.0	1.01.0	
appraising				8.08.0	3.03.0		2.02.0	
commissions								
shipping	11.03.0	10.10.0	18.19.6					
total	32.03.0	136.00.6	95.19.0	258.01.0	83.15.0	159.15.6	71.17.0	12.12.0
prints		10.17.6	31.11.6	14.15.0	7.07.0	9.00.0		2.02.0
coloring								
binding		5.13.0	0.05.0		0.05.0	0.09.0	5.05.0	
portfolios		0.03.6	0.10.6	0.07.0				
Knaptons		21.00.0		8.08.0	7.07.0	62.10.0	64.02.6	
Anson								
private plates				20.00.0		2.03.6		27.16.6
total		37.14.0	32.07.0	43.10.0	14.19.0	74.02.6	69.07.6	29.18.6
frames & glass	6.12.0	14.01.0	15.12.6	27.15.0	128.14.6	109.12.0	67.19.6	26.04.0
packing		0.19.6	1.07.0	0.14.6	10.15.6	3.15.0	0.09.0	0.09.0
total	6.12.0	15.00.6	16.19.6	28.09.6	139.10.0	113.07.0	68.08.6	26.13.0
apprentices		15.00.0	15.00.0	15.00.0	15.00.0			
lessons								
art supplies		1.01.0						
total		16.01.0	15.00.0	15.00.0	15.00.0			
on account	30.01.0	280.12.0	310.14.0	130.09.6	57.10.6	134.08.6	122.04.6	130.04.0
TOTAL	167.18.0	528.09.0	564.08.6	733.14.0	620.09.6	809.05.6	589.00.6	304.07.6

1. August–December only.
2. January, March–May, October–December only.
3. January–October only.
4. April, June–August, November, December only.
5. January–November only.

traded for years. Then, he may have worried that the election of his Jacobite brother and brother-in-law to the Common Council in 1743 would jeopardize his politically moderate position and his association with the Yorkes. Another factor in his former success, the novelty of pastels, had faded after five years in the London spotlight. No longer a technical secret known only to Italian travellers, crayons were fast becoming the favorite medium for novices, amateurs, and female portraitists. Most importantly, however, young English painters flocked to London to fill

1742[3]	1743[4]	1744	1745	1746	1747	1748	1749	1750[5]
80.17.0	50.08.0	295.01.0	280.01.0	231.06.0	156.07.0	296.02.0	372.15.0	136.10.0
12.12.0	6.06.0	10.10.0	108.03.0	78.15.0	143.02.0	70.07.0	26.05.0	29.08.0
			52.10.0	50.00.0			20.07.6	
93.09.0	56.14.0	305.11.0	440.14.0	360.01.0	299.09.0	366.09.0	419.07.6	165.18.0
5.05.0		89.13.6	19.09.0	22.19.0	90.04.0	59.06.0	33.14.0	66.16.6
		2.02.0	7.07.0		3.03.0	12.00.0	0.15.0	
		18.13.0	11.09.6	31.03.6	12.04.0	16.16.6	19.04.0	35.16.6
		4.04.0						
	6.06.0	3.13.6	3.18.6	18.10.0				15.00.0
							3.01.0	
5.05.0	6.06.0	118.06.0	42.04.0	72.12.6	105.11.0	88.02.6	56.14.0	117.13.0
2.02.0		8.07.0	85.18.0	104.05.3	95.09.0	131.12.0	82.13.0	43.12.3
			18.15.0	7.07.0	12.12.0	10.10.0	21.00.0	1.08.6
			0.08.0	0.08.0	1.08.6		1.12.6	
10.10.0		52.10.0	29.04.0		21.00.0		89.12.0	183.10.0
			100.00.0		260.00.0	344.05.0		
			0.14.6		7.07.0			
12.12.0		60.17.0	234.11.6	112.00.3	396.16.0	488.13.6	193.05.0	230.03.3
14.00.0	4.07.6	40.10.6	75.17.6	89.15.0	49.03.0	64.01.6	89.14.6	13.13.0
1.08.6	0.09.0	1.14.6	1.14.0	5.05.6			5.12.6	0.07.6
15.08.6	4.16.6	42.05.0	77.01.6	95.00.6	49.03.0	64.01.6	95.07.0	14.00.6
							210.00.0	
		27.06.0	5.05.0		16.16.0	15.15.0	9.09.0	
		2.08.6	0.13.6	2.04.0	3.18.6	1.15.0	11.06.6	7.07.0
		29.14.6	5.18.6	2.04.0	20.14.6	17.10.0	230.15.6	7.07.0
15.10.0	167.14.0	14.10.0	87.07.0	115.19.0	65.09.6	36.19.0	120.08.0	101.11.0
142.04.6	235.10.6	571.03.6	887.16.6	757.17.3	947.03.0	1061.14.6	1115.16.0	636.12.9

the vacuum left by the departed foreigners, and began a competition as fierce as that of the 1720s. Allan Ramsay, who had returned from Italy in 1738, settled permanently in London in 1743. Hudson returned from near exile in Devonshire in 1740 and settled near Lincoln's Inn; Hogarth began to form his school at the new St. Martin's Lane Academy. On the sidelines, George Vertue kept score: 'since Mr. Vanlo, painter left England the most promising young Painters make most advances possible to be distinguisht in the first class—of those that make the best figure Hymore. Hudson Pond Knapton Ramsey Dandridge Hussey Hogarth Wills'.[23]

In order to 'make the best figure', Pond had to demonstrate his proficiency as an oil painter and take on some important commissions from influential clients. As usual he managed, by painting and then publishing three crucial portraits. These were the *Garrick* of 1743 (published in 1745, which drew the newspaper spoof of its advertisement), the *Anson* of 1744, and a half length of the Duke of Cumberland (*c.* 1745; published 1747) (Figures 8, 9, 10). Garrick's well-known features offered Pond a chance to demonstrate convincingly his ability to take a likeness, while the portraits of Anson and Cumberland, Britain's military heroes of the mid-1740s, appealed to nationalist sentiments while they were still high. Significantly, Pond chose to present masculine images—a change from the published princesses of the 1730s—and the elaborate composition of the *Cumberland* suggests his ambitions for the grand commissions in the grand style. The Anson and Cumberland engravings may also have signalled the end of the artist's association with opposition politics, since their appearance coincides with the death of the Roman Club and the inauguration of the Pope's Head, recasting the old organization in a format acceptable to the office-holding Yorkes.

STABILITY, 1744–50

The prints and the sponsorship of the Yorkes launched Pond on his second career as a painter in oils. In 1743 he raised prices for the first time since 1738, and a sixfold increase in earnings and a tidy £312 profit rewarded his optimism the next year. From 1744 to 1750 Pond earned between £350 and £550 *per annum*, with profits averaging about £100 less than earnings (Tables 6, 7). In 1748 he raised prices once again but was unable to match the prices awarded his top competitors. His annual cost of living crept up from £300 to close to £400 (Tables 4, 6), and finally in 1750 he was secure enough to cut back on his painting business in order to pursue new interests in shell and fossil collecting. By this time, Hudson's fees were 30 per cent higher than Pond could command.[24] His gradual withdrawal from 'competitive' painting after 1750 gracefully acknowledged the

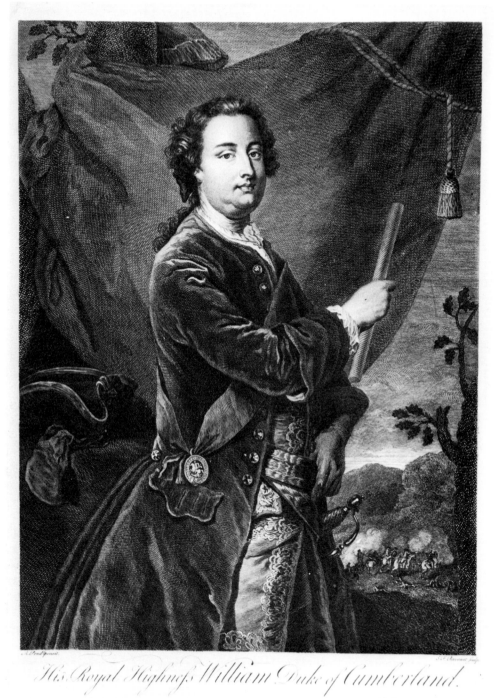

His Royal Highness William Duke of Cumberland.

Figure 10. S.F. Ravenet after Arthur Pond, *His Royal Highness William Duke of Cumberland*, engraving, 1747. Trustees of the British Museum.

superiority of Hudson, Ramsay, Knapton and Highmore in the portrait trade, and cleared the way for his growing social and intellectual ambitions.[25]

In attempting to fill the shoes of departed continental painters before 1750, Pond faced a wider range of demand from his patrons than he had had to meet previously as a pastel painter. He was asked to paint larger portraits—'with hands', kit-cat, half length and whole length—to fill the walls of Georgian-scale houses. Some of these portraits were ordered in suites, requiring the artist to relate each to the others for a unified decorative effect. Pond also received commissions for decorative painting of ceilings and stair halls, which called for full-length figures, realistic or imaginative landscapes, and historical or allegorical themes. As a pastel painter Pond had executed copies after allegorical heads by Rosalba Carriera not much different from his standard portraits. After 1744 buyers wanted copies of Poussin's *Dance of Human Life*, Pannini *Ruins*, and landscapes by Rembrandt and Claude Lorrain, inducing Pond to work in areas far beyond the scope of his training (and, one suspects, abilities). In the absence of continental artists, Pond was also given a larger role in the care and maintenance of private collections of European paintings, reflected in his rising income from picture restoring. As an oil painter, Pond painted bigger, more difficult, and more diverse kinds of pictures than ever before, which explains why his income rose as productivity (in terms of number of pictures per year) declined.

The change to works in larger scale in the oil medium forced Pond to revise his working methods. Probably for the first time since his days at St. Martin's Lane Academy, he faced the problem of depicting the human figure. The life size, full-length portrait proved especially difficult. In 1742 Pond bought 'Balls for Layman 2:6' (the jointed wooden figure which sat in for the human subject) and a 'little Woman Dol' for £3.14.0; in 1744 and 1749 he bought two more 'laymen', one of which may have been for use by his pupils.[26] Clothing was simulated by draping swatches of expensive silks 'to paint after' over the layman.[27] A second challenge consisted in modelling and coloring in oil paints. Pastels had been simple and straightforward to apply and blend, whereas oil paints were notoriously changeable. Every painter had his jealously guarded recipes for flesh tones and transparent glazes for modelling and shadows, and Pond soon began to seek his own. In addition to Prussian blue, lake, and flake white, which had been the mainstays of his pastel coloring, he bought brown pink, 'verdigrease', vermilion, 'terra vert' and the mysterious 'Purple brown red' as well as 'Turpentine and Mastick for Varnish'.[28] Varnish served as a vehicle for some glazes, but it also replaced glass as a form of surface protection. The attractive softening and greenish tint lent by glazing had now to be achieved through varnish, too.

NON SIBI SED TOTI

R.M.

Figure 11. Arthur Pond, *Dr. Richard Mead*, etching, 1739. Trustees of the British Museum.

Along with his techniques, Pond had to change some artistic allegiances. His pastels exhibited dependence on the work of Rosalba Carriera, but her example could be of little help to an oil painter, and her influence on Pond diminished after 1740. Van Dyck was, of course, the ultimate model for most Georgian painters, and his effect on Pond had been visible in the 1730s. However, portraiture in the Van Dyck style was monopolized by Robinson at first, and after his decline by Hudson, Knapton, and Ramsay. None of Pond's securely attributed portraits shows the sitter in Van Dyck dress or with the magnificent architectural settings of the latter's aristocratic full lengths. The Cumberland portrait raises the possibility that Pond was looking to the recently departed Van Loo (and his audience) for ambitious portrait commissions; a later portrait of Alexander Pope (1747) certainly exhibits careful study of the French painter's work.[29]

However, on one of the rare occasions when he allowed his ambitions to outstrip his skills and his audience, Pond sought to develop portraiture in the style of Rembrandt. His interest in the Dutch painter had risen by 1739, when he bought his first work by the master, a *Woman Bathing* now in the National Gallery, London[30] (Figure 12). Pond's self-portrait of the same year (frontispiece), an etching, is Rembrandtesque both in its use of drypoint and in the depth (relative to Pond's other work) of the characterization. However tentative these early works seem today, they were, in 1740, beyond the comprehension of one of England's most advanced connoisseurs. Pond's famous attempt in the Rembrandt style, the etched profile of Dr. Richard Mead (1739) was a dramatic failure, suppressed at the request of the doctor himself (Figure 11). Vertue thought it made the doctor resemble 'an old mumper as Rhimebrandts heads usually do', and concluded that Rembrandt's appeal was limited to the virtuosi.[31] Nevertheless, Pond persevered, selling a painted version of the Doctor's profile to the Earl of Orrery in 1744. Two years later the Doctor relented and bought one for himself.[32] Pond's two best patrons of the 1740s and 1750s, the Yorkes and Delavals, did develop likings for Rembrandt, as did the City collectors.[33] Thomas Hudson, a member of the collectors' group, began to imitate Rembrandt portraits in 1747, and the most famous Rembrandtian portrait, the *Self-Portrait with a bust of Michelangelo* (Royal Academy of Arts), would be painted by Joshua Reynolds, a second generation member of their circle and the owner of the *Woman Bathing* which had inspired Pond forty years earlier.

As an oil painter Pond not only adjusted his style and technique to suit the market, but also had to revise his business outlook, since the costs of producing an oil were different from those for crayon painting. Although Pond paid about the same overall sum for materials for oils and crayons, these costs were distributed differently (Table 5). Cloths, costing one shilling and sixpence for a '$\frac{3}{4}$ size' (for the standard head and shoulders

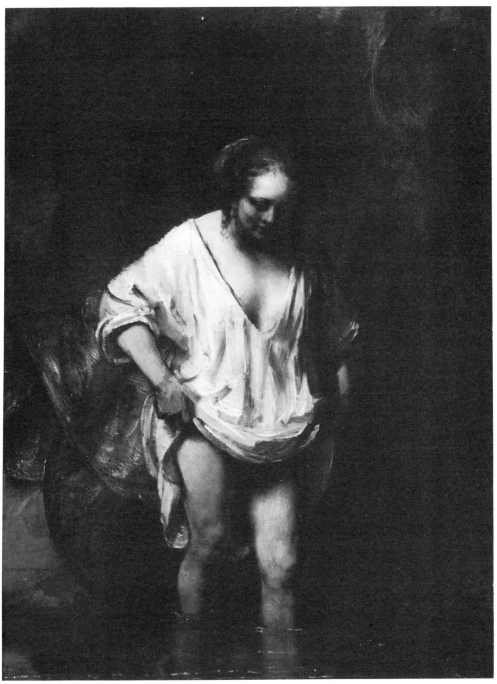

Figure 12. Rembrandt van Rijn, *Woman Bathing*, oil on panel, 1655. The National Gallery, London.

portrait) were considerably more expensive than the cheap blue paper used for crayons.[34] Cloths for larger portraits or copies cost in the five to ten shilling range. Fortunately, after 1744 Pond managed to spend less on pigments, although he was using more varieties than before. This saving was not due to the fact that he was using smaller quantities or cheaper pigments, but because he had started to avoid the commercial color shops like Mr. Powel's in St. Martin's Lane (which he had patronized in the 1730s). In 1739 he bought Antonio Neri's *L'arte vetraria* (Florence, 1612) an important source of recipes for artists' colors.[35] Then he purchased pigments in bulk at the sales of painters' effects; in 1747 he acquired £4 worth of fine lake from Jonathan Richardson's estate, for example.[36] Occasionally he bought supplies from David Bellis, the picture restorer and colorman, but most of his pigments probably came direct from the colormakers, whose odoriferous workshops were located across the river in Southwark or north of the City in Shoreditch. In 1743 John Smibert asked Pond to send him several pounds of Prussian blue 'that may be had cheapest of ye maker M Mitchell at Hoxton who you may send to by a peny post letter or a Porter'.[37] Pond was still avoiding the color shops in 1757, when he complained, 'I could not under a fortnight get any flake white without going to ye colour shops, who sell it dear.'[38] The cost of the third essential element of oil painting, the stretching frames, did not differ significantly from that for similar frames which supported crayon paintings. They continued to be manufactured by Weston the carpenter, who also crated finished works for transportation and carried out the alterations and repairs on the Queen Street house.

The cost of framing an oil painting was much less than that for a crayon, and in this area Pond was able to make important savings. Since the surfaces of oils were protected from water, dust, and other hazards by layers of varnish, glazing was unnecessary, eliminating an expense to the artist of £20 to £40 a year. The frames themselves were also cheaper in later years, although Pond continued to rely heavily on the Gossets. Whereas framing alone had cost Pond over £100 in 1737 and 1738 and £75 in 1739, after 1744 it never exceeded £60 (Table 5). Better yet, he began to make a profit on frames for the first time in his career, an indication of his new professional sense of security. Apparently Pond was ordering fewer and simpler frames and charging the same prices; the ultra-expensive 'gold architrave frames' disappeared from his accounts along with the crayon portraits. The use of simpler moldings, occasionally painted black rather than gilded, may have been part of the Rembrandt style of the 1740s.

The biggest difference between oils and pastel paintings from Pond's point of view must have been that the former could not be profitably attempted without one or more competent assistants. After 1744 he steadily

employed two or more trained helpers, and in 1749 he began to take on apprentices. Their wages, amounting to between £30 and £60 a year comprised the difference between the costs of producing oil and crayon paintings (Table 5). None of these assistants or pupils became great or famous painters, but it can be argued that Pond made some contribution to English painting as an employer rather than producer.

Pond was never in the league to hire Van Haecken, but made do with his friend's pupil and his own former part-time helper Thomas King, beginning in 1744. From December 1744 to December 1748 King dominated Pond's painting business as chief assistant and reigning eccentric. According to contemporary chroniclers, King was a bohemian in an age when artists usually resembled respectable tradesmen. He resided in Covent Garden, consorted with actors and other low characters, and spent his earnings with carefree abandon. His biographers refer vaguely to his portraits of theatrical characters, but remembered him squandering earnings from a 'job in the country' on a lavish apartment and footman whom he could keep less than a month. He was also 'dissipated'.[39]

King's reputation for working only when financial necessity compelled him is substantiated by his record with Pond. He often worked only two or three weeks each month, forcing his employer to seek interim help before giving up on him altogether. His earnings, which work out *pro rata* to two or three shillings a day, were well below the standard one-half to one guinea suggested by the 1747 *London Tradesman* although they may have been supplemented by room and board at the Great Queen Street house.[40] Pond usually paid King three or four times a month in installments of ten shillings and six pence. Such payments seem to have been based on quantities of work done, rather than *per diem* or per hour; one of the few specific descriptions of a payment to King in the journal reads, '£1:1:0 which makes £2:2:0 in full for Claude.'[41] This payment schedule would have given Pond some control over his erratic assistant's working habits. King earned between £25 and £40 for a year's work: wages well below the potential for a drapery painter and comparable to those for a journeyman house painter or colorman. His responsibilities—which are rarely specified in the journal—probably included laying the ground on portrait canvases and doing much of the painting of nonessentials, such as drapery and backgrounds. A few years later he was also paid for decorative painting at Beeston Long's country house and for copying landscapes by Claude Lorrain.

King was apparently adequate for most of Pond's major painting jobs, but as the latter's business expanded he needed another assistant in his painting room. Since, for some unknown reason, the artist did not take another apprentice until 1749, he began to train one of his domestic servants to execute tasks that could be done in the shop or required his

direct supervision. Peter Maddox had been in Pond's employment from June 1742, but only began to work in the painting room in February three years later. One of the sidelines of the printselling business which Pond had taken over in January 1745 was the sale of hand-colored, framed prints; it became Peter's task to color views of ruins and landscapes at the rate of two shillings and six pence per print. Pond charged his customers one guinea for the service. After a year Peter was skilled enough to assist Tom King on the project at Beeston Long's house and do some minor restorations on old master paintings.[42] In this manner he supplemented his annual wage of five guineas with two to four pounds earned as a shop assistant, before quitting Pond's in the spring of 1747.

Peter Maddox was replaced by Enoch Markham, an obscure painter whose only known work is a copy of someone else's portrait of Jonathan Swift.[43] Markham took over Peter's responsibilities as a shop assistant, coloring prints at a fee of seven shillings and six pence per print. After a few months he was able to ask for and receive a raise of three shillings, before graduating to more difficult tasks. When the unreliable Tom King was indisposed to work, Markham earned two guineas for copying Dr. Mead's Pannini, one guinea for 'painting Mr. and Mrs. Bridges', and seven shillings and six pence for 'dead coloring' (i.e. underpainting) Pond's copies after Liotard and Guido Reni. In September 1747 he was sent to execute a commission at Langley for Jones Raymond, when he was paid by the day rather than by the job. Pond gave him £1.7.6 for eleven days' work and paid for his food and lodging separately.[44] Together Markham and King solved most of Pond's labor problems for 1747.

When he raised prices again in 1748, Markham and King were assisted by another drapery painter, Thomas Black, and the colorman and painting restorer David Bellis. Black was a sober and reputable specialist who was still with Pond at the latter's death in 1758, and unlike the others, he started out on a *per diem* wage.[45] For his first three months (during the height of the London season) he received four shillings and eight pence a day paid once a week. As business slowed down during the summer, his wage dropped to four shillings, at which it appears to have stayed for at least another year. A schedule of Pond's payments to his assistants indicates that Black began as a substitute for Markham in the summer of 1748, and was rehired on a more or less permanent basis after Pond ceased to employ either King or Markham in the summer of 1749. From that time on Pond relied solely on his one assistant and a succession of apprentices as he reorganized his painting business around a more reliable work force.

The history of Pond's experience with hired assistants reveals the improving status of English painters in the London art world. As his business improved, Pond paid higher and higher wages to increasingly competent and reliable artists, all of them English. In contrast to the piteous Mr.

Neckins of the 1720s, these young painters assumed heavier responsibilities as their experience grew. Of Pond's three assistants, two—King and Black—later embarked on independent painting careers. In both cases their stints with Pond helped them over the rough transition between their initial training (King at Knapton's, Black at the second St. Martin's Lane Academy) and their careers as full-fledged painters. They gained an income, technical training, and exposure to the manners and methods of a fashionable portraitist. Noted for his unusual generosity to young artists, Pond may also have introduced them to prospective clients; he certainly did this for his apprentices. In return, these young assistants executed the dullest and most time-consuming tasks connected with oil painting for relatively small sums. Although their work could not compete with Van Haecken's, neither did their wages, and Pond never spent more than sixty pounds a year for the services of two or three painters.

Like the assistants, Pond's apprentices traded cheap labor for training, experience, and introductions. However, their relationship with their master was considerably more formal, bound by a written or unwritten set of articles and guaranteed by the payment of fees or a capital sum to the artist. In addition to instruction Pond provided food and lodging and sometimes clothing. Between 1734 and his death in 1758 Pond trained three apprentices, of whom two served their full terms and went on to modest careers as portrait painters. Rupert Barber worked under Pond for five years from 1735 to 1739. His apprenticeship was not registered with the Inland Revenue Office, but its terms, deducible from Pond's journal, were very easy. The boy's mother paid fifteen pounds a year, and no premium or capital sum was required.[46] Pond's low rates appear to have resulted from several causes: his friendship with Mary Barber dating back to 1730; his marginal status in the London art world (he was just beginning to be successful with crayon painting); and the relatively low status of the painter's trade in general during the 1730s. Judging from Mary Barber's report to Jonathan Swift on her son's progress in 1736, Pond scrupulously fulfilled his obligations as a teacher. 'My son, who is learning to paint, goes on well and, if he be in the least approved of, he may do very well at Bath; for I never yet saw a painter that came hither fail of getting more business than he could do, let him be ever so indifferent.'[47] Rupert may indeed have essayed the Bath portrait market, but by 1743 he had returned to his native Ireland, where he was befriended by Pond's patroness and one-time private student Mrs. Delaney. There he worked as a miniature and enamel painter, engraved a few book illustrations, and experimented with glass making.

The terms of Pond's later apprenticeship contracts reflect his improved status as a successful oil painter and the growing possibilities envisioned for young English artists. The articles (which may or may not have existed

in Rupert Barber's case) were drawn up by the Pond family lawyer John Howard, and formally registered with the Inland Revenue Office. Although the articles themselves have not survived, we do know that Pond extracted substantial sums from his apprentices' hopeful parents: £200 from Frances James for her son George in 1749 and £300 for George Delaval five years later. These were top fees for an English painter in the first half of the century.[48] While the terms of the agreements suggest that more was at stake in 1749 than had been earlier, there were several important similarities between Pond's first and subsequent apprentices. In all cases Pond knew the boys' parents long before the question of apprenticeship came up. George James's father was a printer/bookseller Pond had dealt with intermittently in the 1730s, while George Delaval was a younger son of Pond's patron Francis Blake Delaval and a brother of the amateur Rhoda. Since familiarity appears to have been a factor in the choice of master for an apprentice, the predominance of English rather than continental artists in the 1740s facilitated the recruitment of the next generation of English painters. Furthermore, George Delaval's apprenticeship indicates that portrait painting was no longer an occupation for 'mechanics' but was now suitable for the younger sons of gentlemen as well. Delaval died before finishing his term at Pond's, but George James followed the course plotted for Rupert Barber, becoming a minor Bath portraitist. Like Thomas Black he was elected an associate member of the Royal Academy after its founding in 1768. James had the good luck to inherit money from his grandfather, marry a wealthy woman, and retire; unfortunately he elected to settle at Boulogne-sur-mer where he died during the Terror.[49]

Pond's journal tells even less about his apprentices' responsibilities and merits than it does about those of his assistants. If any of these painters had become fabulous artists rather than simply competent professionals, Pond's methods as a recruiter, trainer, and employer would require further research and analysis. However, it appears to have been the quantity rather than quality of those he assisted, and the level of his concern rather than the manner of his teaching, which prompted the respect of his contemporaries and biographers, and won him a reputation as a friend and benefactor of young artists. Pond's sponsorship of English painters had several important consequences. His own achievement of comfortable professional and social status encouraged others to enter the art world by demonstrating the improving future for native-born painters. Unlike their masters, the students and apprentices of the late 1740s did not experience the hardships and jealousies characteristic of the preceding decades; they met instead a sophisticated and wealthy audience willing to encourage a national school of artists. By training apprentices and employing English artists, Pond helped break the pattern of continental dominance in portrait, decorative, and history painting. With George Knapton and Thomas

Hudson, who trained the likes of Francis Cotes and Joshua Reynolds, he exerted a stronger influence on subsequent English painters than did Hogarth or Highmore, who had no known followers. The studios of these three friends became the breeding ground of the English painters who dominated the second half of the century. Joshua Reynolds, the apprentice of Hudson, began in the same manner as Rupert Barber and George James, and built his career on the models of Richardson, Hudson and Pond.

VI
Dealing and Collecting

The economics of the early eighteenth-century commerce in antiquities and old masters is not at issue; it could be an immensely lucrative trade, with profits in the vicinity of 100 per cent for astute or unscrupulous dealers and collectors. The unanswered question is whether the importation from abroad of hundreds of paintings, sculptures, prints, drawings, and antiquities stimulated or depressed the native school of art. The issue had first been raised in England when the Earl of Shaftesbury likened aesthetic appreciation to the philosopher's search for truth and stated that the highest form of artistic beauty was to be found in history painting rather than portraits.[1] His aesthetic, an integral part of his larger attack on revealed religion, made the lack of history painting in England an issue of concern to philosophers, moralists, deists, and nascent virtuosi as well as to artists. The most obvious solution was to import history paintings from abroad. The debate dropped to a lower and hotter level when William Hogarth and Jonathan Richardson redrew the lines of battle on practical rather than moral and religious grounds. Both were anxious to promote an English school of painting equal to the greatest of Greece, Rome, or the Renaissance, but they differed radically on the contributions which the connoisseurship of old masters could make toward its formation. In a series of treatises Richardson outlined the benefits to be accrued from collecting continental history painting—improved public taste and morals, more sophisticated artists, competitive manufactures, and growth of the tourist trade—while Hogarth used satirical prints and *The Analysis of Beauty* to express his opinion: it debased taste, threatened the livelihood of English artists, and signalled an irreversible decline in national prestige. Modern scholars have tended to honor Hogarth's position and muddy the waters further by applying nineteenth- and twentieth-century aesthetic standards to discussions of eighteenth-century taste. The examination of Arthur Pond's career as a dealer and collector, which was based on Richardson's

theories and example, offers an opportunity to determine the validity of Richardson's side of the question. It will also assist in looking beyond the irrelevant question of whether the collectors received value for money in order to evaluate the impact of the trade on the art world as a whole: how dealing and collecting advanced or detracted from the formation of the English school of painting.

Before plunging into the description of Arthur Pond's distinguished career in this field, one must recognize that the old master trade was organized very differently from that of the eighteenth-century painter. The most obvious difference between the two is that the painter was producing objects, while the dealer or collector was essentially a middleman. Some of these acquisitive types were literally treasure hunters, digging subterranean tunnels through the ruins of Herculaneum or ransacking the tombs of ancient Romans and Etruscans. Others purchased devotional masterpieces from financially distressed monasteries and churches, and mythological scenes from distressed clerics and noblemen. Estate sales were the third major source of art treasures. Once objects entered the market, they passed from hand to hand, rarely sharing wall space with the hallowed family portraits much beyond the lifetime of their purchaser. Collections in the process of formation were never static; a connoisseur upgrading his holdings would be buying and selling simultaneously. While family portraits passed to the heir along with land, house, and heirlooms, many collections were sold at the owner's death to realize money for the estate. Distinctions between producers and consumers in the old master trade are therefore very difficult to make, since most of those involved behaved sometimes like speculators and entrepreneurs, and at others like pure collectors. Pond himself never separated in his accounts works bought for his collection from those bought for eventual resale. Furthermore, he was constantly selling 'cast-off drawings' and prints as his holdings expanded and improved. In this chapter one cannot talk easily of artists and patrons. We have instead virtuosi and connoisseurs playing an expensive game of international 'hot potato'.

The terms 'virtuoso' and 'connoisseur' were used frequently in the eighteenth century to denote gentlemen interested in the fine arts, and their meaning is as ambivalent as the trade itself. Shaftesbury had called the virtuosi the 'refin'd *Wits* of the Age . . . the Lovers of *Art and Ingenuity*; such as have seen *the World*, and inform'd themselves of the *Manners* and *Customs* of the several Nations of EUROPE, search'd into their *Antiquitys*, and *Records*; consider'd their *Police*, *Laws* and *Constitutions*; observ'd the Situation, Strength, and Ornaments of their *Citys*, their principal *Arts*, Studys and Amusements; their *Architecture*, *Sculpture*, *Painting*, *Musick*, and their Taste in *Poetry*, *Learning*, *Language*, *and Conversation*.' The Earl also noted the existence of a lower form of virtuoso who, turning from the

proper study of mankind, squanders his attention on lower forms of life such as shell-fish, or who becomes so preoccupied with the rarity of things that he devotes his energies to pursuing monsters instead of beauty and truth.[2] The latter type was clearly in Lord Chesterfield's mind when he warned his son to avoid 'those *minuties*, which our modern virtuosi most affectedly dwell upon ... All these sorts of things I would have you know, to a certain degree; but remember, that they must be only amusements, and not the business of a man of parts,' thus indicating the ambiguity.[3] Chesterfield would have preferred his son to become a 'connoisseur', capable of appreciating the arts on a philosophical level even if he could not always tell the work of one Italian painter from another. Jonathan Richardson had employed the word in 1719 as part of his campaign to rescue polite interest in the fine arts from the *minuties* and atheists, and it was soon current in London and abroad.

These changes in terminology were tied to developments in art dealing and collecting which occurred before 1760. In the first decades of the eighteenth century virtuosi and collectors were thought not only to be dull but also subversive, as being Catholics, atheists, Jacobites, spies or homosexuals.[4] However, several patriotic, protestant Englishmen began to collect paintings while fighting or travelling abroad; Colonel (later General) Guise and James Brydges (the future Duke of Chandos) come to mind. Their example, coupled with increasing familiarity with foreign collections through the Grand Tour, did much to calm traditional suspicions and spark a positive fashion for art collecting. The 1720s and 1730s can be characterized as a time of enthusiastic importation of continental art, encouraged by theoretical publications, acts of Parliament, and foreign tourism. During this period there developed a commercial network controlled by London virtuosi who began to exploit and eventually to replace the continental artists and agents who had previously dealt directly with English collectors.

DEALING

The source of Pond's interest in the old masters was undoubtedly Jonathan Richardson, mentor of the Roman Club and owner of one of the finest drawing collections in London. Richardson's theories and arguments in favor of art collecting and connoisseurship, which would inform his follower's endeavors in this field, appeared in published form in 1719, two years before the founding of the Roman Club and three years before Pond's first recorded auction purchase.

Jonathan Richardson's *Two Discourses* containing 'An Essay on the whole Art of Criticism as it relates to Painting' and 'An Argument in

behalf of the science of a Connoisseur' made art collecting and appreciation both respectable and practicable.[5] Citing no philosopher more controversial than John Locke (a clergyman), the essays popularized a philosophic rationale for the new pastime which comfortingly combined old ideas derived from earlier art treatises with the language of the early enlightenment. And whereas Shaftesbury had valued art appreciation, Richardson showed one how to do it.

Discussing the art of criticism, Richardson argued that connoisseurship transcended the learned recognition of an artist's distinctive style (the province of the virtuoso or artist) to encompass a broader understanding of the aesthetic and philosophical principles embodied in a work of art. These principles could be discerned by anyone with a classical education and a trained eye after systematic examination of the painting or sculpture in question. Richardson's suggested method resembled those of contemporary naturalists observing and classifying nature to reveal the order of the universe (a comparison Shaftesbury rejected); and Richardson certainly had their investigative models in mind when he claimed that connoisseurship was a science. To emphasize the definitive and measurable results of his method, he developed a table or chart from which the connoisseur was able to rate (on a scale from zero to twenty) the beauty and sublimity of a work of art.

Having established the claims of connoisseurship for a gentleman's interest and support, in the second essay Richardson described the practical benefits which individuals and the nation as a whole would derive from the new science. Connoisseurship filled a gentleman's leisure time pleasantly and instructively, and was infinitely superior to other notorious 'Criminal, Scandalous, and Mischievous' activities. The manufactures of the lower orders would also benefit from the study of recognized masterpieces, and artisans and tradesmen might become more polite, too. In addition to reforming manners, connoisseurship would contribute to England's wealth, status, and power by encouraging traffic in the art market and the efforts of local painters. The Italian example proved that the formation of great collections would attract foreign tourists and assist in the training of native artists, so that 'not only our Paintings, Carvings, and Prints, but the Works of all our other Artificers would also be proportionably Improved, and consequently coveted by Other Nations . . .'. Richardson also felt that the skilled painter's potential as national money-maker was not yet fully appreciated. 'I have observ'd heretofore, that there is no Artist whatsoever, that produces a piece of work of a value so vastly above that of the Materials of Natures furnishing as the Painter does; nor consequently that can Enrich a Countrey in any Degree like Him . . .'.[6] He hoped that his practical as well as his theoretical arguments for connoisseurship would legitimize public interest in the fine arts and the growing

economic activity which necessarily accompanied it. These developments would in turn raise the level of achievement of the English school of painting. As a final argument, collectors would benefit financially from the exploitation of a growing art market as a means of capital investment.

> If Gentlemen were Lovers of Painting, and *Connoisseurs*, many Summs of Money which are now lavish'd away, and consum'd in Luxury would be laid up in Pictures, Drawings, and Antiques, which would be, not as Plate, or Jewels, but an Improving Estate: Since as Time and Accidents must continually waste, and diminish the Number of these Curiosities, and no New Supply (Equal in Goodness to those we have) is to be hop'd for, as the appearances of things at present are, the Value of such as are preserv'd with Care must necessarily encrease more and more: Especially if there is a greater Demand for them, as there Certainly will be if the Taste of Gentlemen take this turn . . .[7]

Two years after the publication of the *Discourses* an Act of Parliament made connoisseurship cheaper and more rewarding for the public, and transformed dealing from a shady artist's sideline into a potentially lucrative trade. It was pushed through Parliament in 1721 by Mr. Broderick (the owner of a Titian, a Rembrandt, a Gaspard Poussin and a Van Eyck). By changing the basis of the tax from value to size, the act significantly reduced fraud and lowered the customs duties imposed on imported works of art. George Vertue noted its impact on the market almost immediately.

> This Gentleman [Mr. Broderick] it was that brought a Bill into the house of Commons. to pass an Act for importing of pictures into England paying according to the size. from 10 shillings each picture to four pounds the most. when as before it was ad Valorem. & caus'd great roguery & false swearing & prevented the best. or very good pictures to come in the Custom mounting so high. & instead of that Copies were brought in & sold for originals & the Curious decievd. & since this Act already many good pictures are brought in. & few Copies. since this twelvemonth.[8]

The great collectors Henry Hoare, Sir Robert Walpole, Sir Paul Methuen and General Guise were among the first to benefit from Broderick's Act, importing their foreign purchases early in the 1720s.

Although he was involved simultaneously in dealing and collecting from 1722 until his death 1758, Pond acted primarily as a middleman (dealer and agent) during the years preceding 1740. He was involved in the London art market even before he had finished his training under John Vanderbank. In 1722 he is known to have attended two sales of painting collections: Mr. L. Crosse's sale where he purchased a drawing either by or after Annibale Carracci, and Mr. Van Huls's where, acting as an agent

for the collector Richard Houlditch, Sr., he successfully bid for a Van Dyck portrait.[9] Assisting in the formation of important early collections of drawings, prints, and paintings, Pond contributed to others' realizations of Richardson's ideas while eking out his own shaky finances. Before his trip to Italy in 1725, Pond's involvement in the old master market centered around the auctions which he would have followed through advertisements in the newspapers. Sales like the one he attended on the behalf of Richard Houlditch were usually held at the house of the collector (especially if it was an estate sale), while entrepreneurs like the bookseller John Bullfinch preferred to offer their goods at a coffee house or tavern, the Green Door being a favorite.[10] Not yet an authority on painting, Pond would have earned small commissions from well-known collectors who hoped to keep prices low by not bidding in person. He could also have collected fees from auctioneers or consignors to the sales by driving up the bidding on selected works, a fairly common but dubious practice which a follower of Richardson would probably have preferred to avoid.

Pond's serious commercial activities began in Italy in 1725–7. There he refined his knowledge of 'hands'—the identification of the author of a

Table 8. Distribution of art-related income, %

	painting	dealing	printselling	framing	teaching	on account
1734[1]	59	19		4		18
1735	8	26	7	3	3	53
1736	16	17	6	3	3	55
1737	35	35	6	4	2	18
1738	50	13	2	23	3	9
1739	40	20	9	14		17
1740	44	12	12	11		21
1741[2]	34	4	10	9		43
1742[3]	65	4	9	11		11
1743[4]	24	3		2		71
1744	53	21	11	7	5	3
1745	50	5	26	8	1	10
1746	48	9	15	13		15
1747	32	11	42	6	2	7
1748	35	8	46	6	2	3
1749	38	5	17	8	21	11
1750[5]	26	19	36	2	1	16

1. August–December only.
2. January, March–May, October–December only.
3. January–October only.
4. April, June–August, November, December only.
5. January–November only.

work of art from its composition, style, and manner of execution—under the tutelage of Ghezzi, Stosch, and Sabbatini in Rome, and Mariette in Paris. Along with the Roman print publisher Johann Frey and the Venetian virtuoso Anton Maria Zanetti, they would remain important sources of information and works of art after Pond's return to London.[11] They also probably introduced Pond to the special opportunities open to a needy artist in Rome. One source of income could be found by luring tourists to the studios of Italian painters or the shops of dealers; a sale or commission resulted in a kickback for the intermediary. There is no way of knowing whether Pond exploited his Roman Club friends—especially the wealthy Wray, Morton, and King—in this manner, but it is possible. The practice gradually hardened into custom over the following years, so that the upright John Russell was ostracized by the Roman art community for refusing to 'put off pictures upon them [tourists], at an exorbitant price' in 1743.[12] Pond was also earning money by acting as the agent for collectors back in England. The family lawyer John Howard had given him £30 with which to procure Italian paintings, sculptures, prints, and drawings. Their final accounting reveals that Pond spent about £27 on pen drawings, four landscape paintings, four ivory heads by Pozzo, and four sets of prints from Johann Frey.[13] Another £2. 5. 7 was spent on customs duties. Pond's commission, which was not specified, would have been included in the cost of the object to the buyer. He and George Knapton also bought plaster casts for their friend Edwards.

Pond was also buying works of art on his own account for eventual resale in London. Comparison of the prices he paid for John Howard's commissions and the prices similar works rated at London auctions late in the 1720s suggests that not including duties and freight charges Pond may have made a 100 per cent profit on most imported paintings. Since paintings usually travelled rolled up without frames, freight charges were probably quite small. His father, by receiving shipment, saved him the high cost of an agent. Even with import costs amounting to 20 per cent of value, Pond must have done handsomely out of the Italian landscapes he sold to Henry Hoare for the decoration of Stourhead in 1727.[14]

Back in London in the summer of 1727, Pond would have concentrated on establishing himself as a portraitist. However, his difficulties in breaking into the painting market compelled him to fall back on his skills as a virtuoso. The importance of these skills for his financial situation can be discerned from the first four years covered in his journal of receipts and expenses—years preceding his success as a crayon painter. Between 1734 and 1738 Pond consistently augmented his income by selling more than he kept for himself. Significantly, the only other period of his career when he had a positive balance from art dealing came in 1743-4, when his portrait business was once again in trouble (Table 9). The journal shows that in the

1730s Pond was importing prints from Florence and Rome for sale, but was also disposing of objects—such as another ivory by Pozzo—which he had acquired abroad.[15]

With the exception of several paintings, most of the objects which Pond sold were small (prints, drawings, ivories) and of relatively low value. Thus while the figures of Pond's transactions as a dealer and buyer seem low, as compared to his income from painting they represent a large volume of works of art. The low figures and small balances also conceal handsome profit margins of 100 or 200 per cent. Not all of Pond's art purchases were destined for the market; many entered his collection and did not contribute to his income. A clearer indication of the returns on his investments can be obtained from the transactions concerning specific works identified at the times of purchase and sale. One such is a sketch by the Baroque painter Castiglione, which Pond bought from George Knapton for the sum of £1. 11. 6 in March of 1740 and sold to Lord James Cavendish a month later for five guineas.[16] Such profits combined with low overheads to make art dealing a welcome resource for the young

Table 9. Dealing and collecting (£sd)

year	sale of objects	purchase of objects	balance
1734[1]	21.00.0	1.04.0	+ 16.16.0
1735	71.05.0	35.00.6	+ 36.04.6
1736	66.09.6	0.15.0	+ 65.14.6
1737	206.12.0	18.04.0	+188.08.0
1738	21.09.6	30.19.6	− 9.10.0
1739	96.10.0	121.04.0	− 24.14.0
1740	48.04.6	108.18.6	− 60.14.0
1741[2]	10.10.0	5.01.0	+ 5.09.0
1742[3]	14.17.6	5.05.0	− 9.12.6
1743[4]	0	0	
1744	89.13.6	7.02.6	+ 82.11.0
1745	19.09.0	30.13.6	− 11.04.6
1746	22.19.0	37.06.0	− 15.02.0
1747	90.04.0	173.02.0	− 82.18.0
1748	59.06.0	68.14.6	− 9.08.6
1749	33.14.0	44.10.6	− 10.16.6
1750[5]	66.16.6	36.03.6	+ 30.13.0

1. August–December only.
2. January, March–May, October–December only.
3. January–October only.
4. April, June–August, November, December only.
5. January–November only.

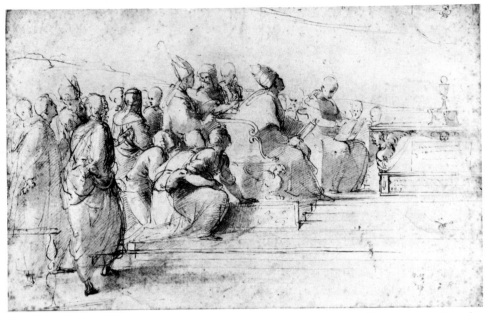

Figure 13. Raphael, *Study for the left-hand lower part of the 'Disputa'*, pen and brown ink with wash, heightened with white (sold from Arthur Pond's collection, Langford's, 3 May 1759, lot 64). Trustees of the British Museum.

artist. His only costs would be commissions to agents and shipping and customs fees, which were low for works on paper. The charges for several volumes of the *Museum Florentinum* (books of prints sold at £4 each) were less than £1 in 1735.[17] As with crayon painting Pond was relatively independent of the need for hired labor and able to respond to trends in the English art market, since inventories were easier to change than his own painting styles. However, the quality of the works he offered, and the manner in which he sold them, were the crucial factors in his rise to the top of the trade.

From the beginning, Pond handled works of high quality. His journal mentions paintings, prints, and drawings by Rembrandt, Claude Lorrain, Castiglione, Borgognone, Passeri, Swanevelt, and Carlo Maratta, artists in large demand throughout the century, as they still are today. His emphasis on quality is also suggested by the surviving works known to have passed through his hands or entered his collection (Figures 12, 13, 14, 15, 17). The prints after drawings, reproducing works he owned or sold to other collectors as well as those belonging to friends, confirm his reputation for connoisseurship (Figures 15, 16, 17). Even though Pond specialized in genuine works by big-name artists, a comment by the connoisseur Pierre-Jean Mariette implies that by continental standards, at least, he was not always able to find their best work. 'Il a gravé une suite de planches d'après des dessins de maitres italiens, qui auroit eu sans doute un meilleur succes s'il eut fait choix de meilleurs originaux.'[18]

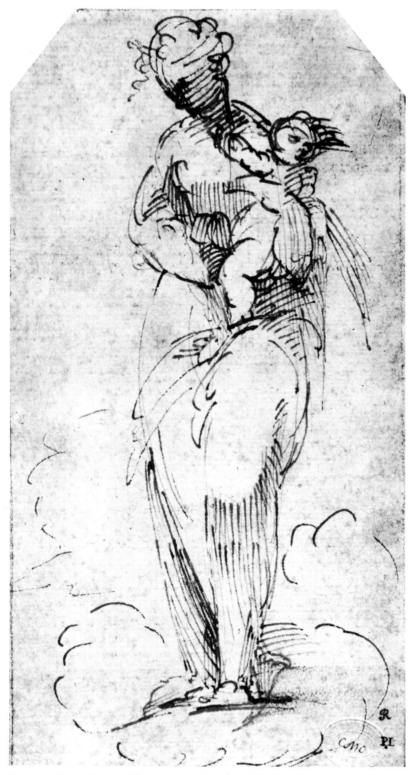

Figure 14. Parmigianino, *The Virgin standing on clouds holding the Child*, pen and black ink. Trustees of the British Museum.

Mariette may have been critical, but Pond's English clients were less exacting. For one thing, the market was considerably smaller in London than on the continent and, having developed later, offered less of a selection. For another, Pond gave buyers the equivalent of a written guarantee of authenticity, an important consideration for those who thought of art as an investment. He was in the habit of 'christening' drawings by inscribing the word 'true' and his signature on the back.[19] Extant drawings bearing Pond's 'baptism' include Salvator Rosa's *Three Studies for a seated Figure* (Paris, Louvre), Rembrandt's *Cottage near the Entrance to a Wood* (Metropolitan Museum of Art, Robert Lehmann Collection), Rembrandt's copy after Mantegna of *The Calumny of Apelles* (British Museum, Department of Prints and Drawings), Parmigianino's *Virgin standing on Clouds, holding the Child* (British Museum, Department of Prints and Drawings) (Figure 14), and Pietro da Cortona's *Nymphs carving on Trees* (Pierpont Morgan Library, New York). These and most other of his attributions have withstood the test of two and a half centuries of scholarship.

Pond's relatively unusual practice paid off as English collectors became increasingly disillusioned with the copies and fakes they unwittingly purchased abroad. (In Rome in the 1730s Italians and English émigrés were setting up 'factories' which manufactured antique gems and seals, old master drawings, and Renaissance paintings for tourists.)[20] Wiser collectors were beginning to prefer less spectacular acquisitions from reputable virtuosi. Pond, with his guarantees, his knowledge gained on the spot in Italy, and his contacts with impeccable continental agents, could claim to be a safe source. His reputation as such, combined with discreet publicity from his print publications, brought him to the top of his field at the end of the 1730s. Having 'dipt into the Connaissance of Virtu in ogni genere— [Mr. Pond] has by Collections of drawings prints books some etchings clare-obscure prints become the greatest or top Virtuosi in London— followd esteemd and cryd up. to be the great undertaker. of gravings paintings &c &c.—Mr. Pond is all in all.'[21]

Pond's business in objects of virtu was undoubtedly the most prestigious and in the long run the most important of his activities as a middleman, but it was not necessarily the most lucrative. He was also earning money by selling imitation marble busts acquired from a French entrepreneur in Italy and shepherding tourists' crates through customs to their ultimate destinations in town or country houses (Table 7). In both endeavors his powers of connoisseurship were less useful than his familiarity with international shipping, customs officials, and bills of exchange.

Pond bought the scagliola busts from a French sculptor living in Rome, Pietro Berton, and took easy profit when he sold them to his patrons. Berton shipped the heads of gods, emperors, and philosophers to London

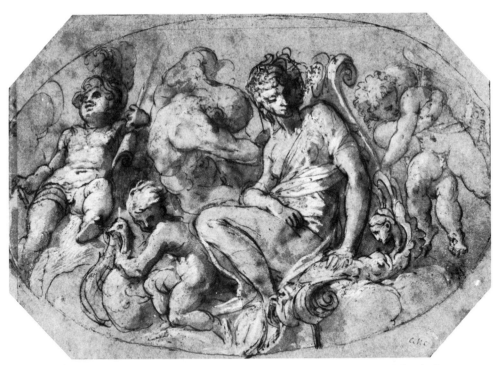

Figure 15A. Jacopo Bertoja (formerly attributed to Parmigianino), *Venus in her chariot*, pen and brown wash on blue paper, heightened with white. Trustees of the British Museum.

Figure 15B. Arthur Pond after 'Parmigianino', *Venus in her chariot*, etching and woodblocks, 1736. Trustees of the British Museum.

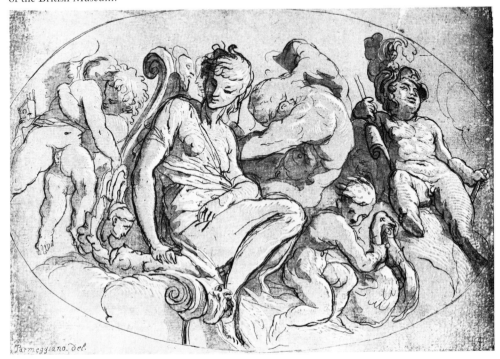

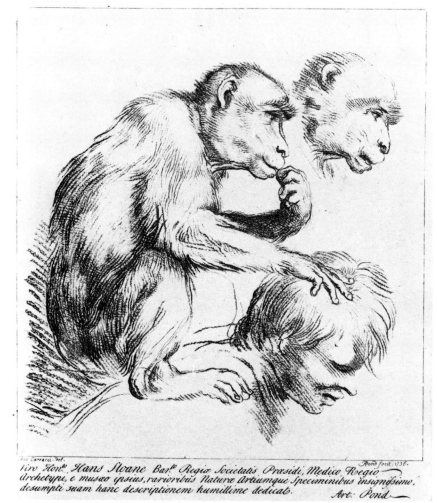

Figure 16. Arthur Pond after Annibale Carracci, *Study for 'Man with a monkey'* (from a drawing now in the British Museum), etching, 1736. Trustees of the British Museum.

and Pond paid for the items, shipping, and insurance with a series of bills of exchange drawn on local merchants with international connections—Aikman and Company at Leghorn, Fagnani in Rome, and Meyer and Company (probably also in Rome).[22] He then employed a London mason named Constantine to fix the heads on pedestals before they were sold to individual buyers; the accounts are unclear about whether the fee of two or three shillings a head also covered making or buying the pedestals. The

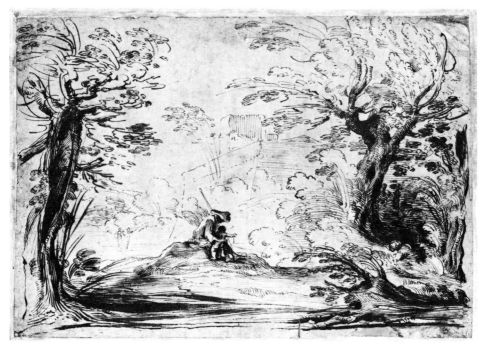

Figure 17A. Guercino, *Landscape with a man and boy seated on a hillock*, pen and ink. Trustees of the British Museum.

Figure 17B. Charles Knapton after Guercino, *Landscape with a man and boy seated on a hillock*, etching, 1735. Trustees of the British Museum.

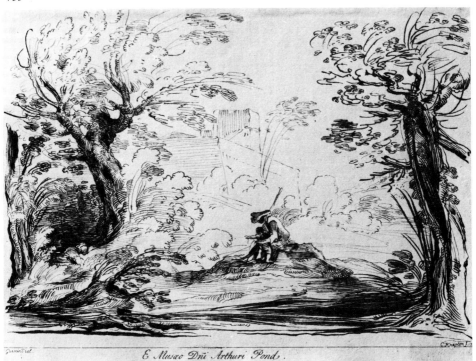

E Musæo Dñi Arthuri Pond.

'scagliola account', as Pond called it, was most active before 1739 and fell off sharply in 1740. Pond revived it briefly in 1743 with a shipment valued at £10 but sales were low for the rest of the decade and he closed out the business.

Pond's career as an art shipping agent resembled his scagliola trade in that it, too, was concentrated in the years before 1740 and reaped substantial profits. Between 1735 and 1741 Pond laid out up to £50 *per annum* on shipping fees, insurance premiums, customs duties, and packing costs for objects bought and imported by his English clients abroad. Whereas maximum annual costs later in his career never exceeded £5, this indicates a dramatic change in his professional position, for after 1744 Pond left such menial tasks to hungrier artists. Again the vagueness of the journal of receipts and expenses prevents exact calculation of Pond's earnings as an agent. His travelling clients often ran up bills and then paid 'on account' for the total when they returned to London, so that specific services—or purchases as opposed to services—cannot be separated out. Payments on account, which may have included a few painting commissions, supplied 30 per cent of Pond's income between 1734 and 1738 (Table 7).

Analysis of one fairly well-documented account does, however, give an idea of the sums which could be spent and earned in this unglamorous aspect of the art trade. The Honorable Charles Hamilton was in Rome in 1732 and back in London by 1736 when he settled his account with Pond. He had evidently been shipping his purchases to London long before 1735 when he sent Pond £40 on account. Between receipt of this payment and the final settlement, Pond spent £35 on customs duties and porters. Hamilton's final payment, which also covered restretching and framing some pictures and 'piecing Hamilton's harpsichord', amounted to £64. 3. 6—generous compensation for services worth about £10 plus the interim duties. Two years later Hamilton employed Pond again, and this time the transaction can be traced from beginning to end. Acting through Pond, Hamilton purchased a painting by the Dutch artist Steenwick from an English divine in Paris, Dr. Hickman. Hamilton gave Pond twelve guineas to pay for customs, restretching and framing the canvas, and delivering the picture to his home after its arrival in London. These costs came to £6. 3. 6, so Pond earned six guineas commission on a painting which cost Hamilton £9. Another job from Hamilton followed a month later, this time involving four marble busts shipped to London on the *Golden Eagle*. Pond received £27, spent £6. 12. 5 on insurance, £0. 16. 6 on freight, £7. 17. 8 on 'Duty Entry &c,' and £1. 18. 4 transporting the busts around London, and was able to keep £10 for himself.[23]

Charles Hamilton's account shows that in spite of Broderick's Act the costs of importing works of art, especially if one or more middlemen were employed, could be extremely high, sometimes approaching the value of

the object in question. This explains why, in the 1730s, the list of Pond's patrons or clients in this area is dominated by the wealthy, the aristocratic, and the spendthrift. Along with Hamilton, Pond was importing works for the extravagant Delmé family, the banker William Fauquier, and Sir Daniel Molineux. The Duke of Marlborough, the Earl of Oxford, Henry Hoare the banker, Sir Anthony Wescombe, the merchant Sir Jacob Bouverie, Sir Thomas Hanmer, and General Dormer were buying prints and drawings.[24] Two founding members of the Dilettanti, Messrs. Denny and Turner, seem to have found the pace too hot after their return to London; having paid for shipping their treasures home they retired quietly from the Society and the art market.[25]

In spite of the easy profits and prestige he earned as a virtuoso, Pond never considered it to be his primary occupation, especially when his portrait business was going well. Between 1735 and 1750 his middleman activities contributed only 10 per cent of his overall income, and it was significant only at times when his other enterprises were doing badly. The profits were incidental to his interest in connoisseurship, and unimportant in relation to other income; this may also have been true for Hogarth's friend John Ellis, Samuel Scott, George Knapton, Thomas Hudson, and later Joshua Reynolds.[26] For less successful or dedicated artists, however, the virtuoso's trade was an attractive alternative to dead-end careers painting lowly tradesmen or churning out copies or illustrations for the booksellers. Andrew Hay and Christopher Cock were two of Pond's associates who founded successful businesses by importing or selling continental art in the 1720s and 1730s.

Andrew Hay had studied portrait painting under Sir John Medina before entering 'the trade' in about 1725. His new occupation would have been especially appealing after Broderick's Act passed in 1721, and also in light of the competition among portraitists which was to drive John Smibert to Bermuda a few years later. Hay held his first known sale in Covent Garden in 1725 and was thenceforward constantly on the move between the continent, London, and his native Edinburgh in search of pictures, busts, bronzes, prints and drawings for his frequent sales in London. Vertue recorded that at the time of his retirement in 1745 Hay had been to Italy six times (twice making the trip across the continent on foot) and fourteen times to France. He was finally able to settle in Edinburgh permanently after twenty years in business, richer by several thousand pounds.[27] Dr. Bragge, another hardy traveller, contined in Hay's footsteps in the 1740s and 1750s.[28]

In contrast to the respectable Hay, Christopher Cock, the founder of London's first art auction house, had been a marginal character from the start. Possibly related to the printseller and auctioneer John Cock (d. 1714), Christopher called himself a painter in his 1725 insurance policy, but had

long been involved in shady business connected with old master paint-ings.[29] The best known scandal of his making concerned his restoration of some 'Raphael' cartoons for the Duke of Chandos; Chandos brought a lawsuit against Cock when he found that the heads of the principal figures had been excised from the designs and allegedly sold on the London market. Cock retorted that the cartoons had been damaged before he accepted the job (a previous restoration had been carried out by the Duke's footman), and the situation was further complicated when several aristo-cratic connoisseurs fled to the country or developed serious illnesses rather than testify to the authenticity of the 'Raphaels'.[30] Patrons of the auction house, which opened *c.* 1726, were advised to buy cautiously. During the late 1720s and 1730s Cock's sales were drawn from the collections of travelling dealers like Hay, continental speculators testing the London market, and unprepossessing estate sales, making it extremely difficult for buyers to assure themselves of the authenticity of the lots. According to Hogarth—and the sale catalogues confirm this—many of Cock's wares were copies, forgeries, or misattributed paintings masquerading as genuine old masters. Nevertheless the auctions prospered, in part because audiences preferred copies of history paintings to lesser examples of autograph work.[31]

Alongside the full-time professionals like Hay, Bragge, and Cock, de-veloped a team of 'semi-pros', English travellers, merchants, diplomats, and fugitives from justice who assisted friends or sought extra income by trading in art. Pond was closely associated with one, Dr. Hickman, the 'bearleader' of the Duke of Kingston in Paris, between 1735 and 1740.[32] After Hickman's departure, Pond started dealings with a banker, Mr. Selwin of the rue de la Jussiene. Between 1743 and 1746 Pond earned handsome commissions from the banker for sales of works by Federico Barocci, Kierinx, and Rubens.[33] Mr. Jemmeneau, merchant, post office official, and future consul at Naples, provided lodgings in Leghorn for the Roman Club in the 1720s and Zuccarelli landscapes for Pond in 1739,[34] while Horatio Paul, who fled England after killing his opponent in a duel before witnesses, exported works from Paris in the 1750s.[35] Charles Rogers, Paul's friend and correspondent, took his offerings to Pond for evaluation and eventual sale. '... Mr. Pond proposes to dispose of as many among his friends as he can; for which purpose it will be necessary to have them left some time at his House ... May I venture to tell you Mr. Pond's Opinion of your German Masters & your Vandycks particularly? Viz, altho' your Prices may be given for a few of them to complete sets, yet he is afraid they will not be given in general for them.'[36] Foreigners residing in London like the musician Francesco Geminiani (an importer of works by Chardin and Watteau) also contributed to the influx of objects destined for the English market.[37]

Early in the 1740s the old master market had been disrupted by the international situation and by some strategic deaths and retirements, much as had the portrait painter's, and with similar results; trade came increasingly under the control of specialized English entrepreneurs after 1745, while the audience became more discriminating and more numerous. As 'the greatest or top Virtuosi in London', Arthur Pond was in the thick of the trade's transition from pariah status to acceptance as a respectable occupation within the art world.

Hostilities with France which culminated in war in 1743 and the Jacobite rebellion two years later limited the importation of continental art and drove some foreign-born art dealers out of London. Smibert's remark to Pond about the flight of the arts from England and the bad condition of 'ye Virtu' alluded to the old master trade as much as to portrait painting. Another comment shows the new hesitation which preceded decisions about intercontinental shipping and refers to the collapse of the market. 'I have for a long time intended to send for ye pictures, but delayed on act. of the war, which as there is no appearance of being over, think it now best to have them over here [Boston] again, for as you long ago wrote me you had sold none of them, nor thought it likely you should.'[38] Pond's journal supports Smibert's pessimistic appraisal of the early 1740s: both the scagliola trade and his activities as a shipping agent ground to a halt. Although Pond may have been relieved to end the latter service, his efforts to revive the scagliola trade later suggest that its interruption was unwelcome to him.

During the decade dealers and agents found that imprisonment in or expulsion from hostile countries could augment the usual hazards of international travel and transport in the eighteenth century. Both Philippe Mercier and Hubert Gravelot, artists and importers of French painting, fled London. Their English counterpart in Paris, the engraver Thomas Major, was thrown into the Bastille 'for political reasons' in 1746, curtailing his trade in prints and drawings with English collectors.[39] The suspicions of Jacobitism directed against artistic Scotsmen with international connections may have encouraged Andrew Hay to retire the year of the Rebellion, but auction catalogues indicate that other entrepreneurs—Samuel Paris, Dr. Bragge, and Mr. Blackwood—cancelled or suspended their activities also.[40]

The obstacles to art importing in the 1740s encouraged concentration on the London auctions, which entered a period of increased prosperity. Although there appear to have been fewer sales in the years between 1743 and 1749 than in the preceding and succeeding periods, they were distinguished by works of high quality and reassuring provenances. The deaths of many of the leading English art collectors within ten years of each other helped shift the focus of the trade from new imports to recirculation

of works of art already in England. The Earl of Oxford died in 1741 and his collection was sold a year later; Michael Dahl's collection went up for sale in 1744; Mary Edwards's in 1746. A year later Jonathan Richardson's holdings came on the market, as did the Duke of Chandos's paintings. In February 1748 Charles Rogers wrote, '... Virtu never flourished more than now; greater prices were never given for Prints & Drawings; the Town seems mad after them, 'tis well you are out of the infection, for the Frenzy is to be avoided as you would a Pickpocket.'[41]

Other collectors were encouraged by the success of these sales to offer their own treasures, as Richard Houlditch had in 1744. After spending over £100 at the 1747 Richardson drawing sale, Pond put part of his own specialized print collection on the block at Cock's in 1748. Advertised as 'A very valuable and well-chosen collection of prints and books of prints' with no reference to the name of the owner, most failed to meet their reserve price and were bought in.[42] Most probably, a wary audience was reluctant to pay top prices for cast-offs, even from one of the finest collections in the country.

Paintings were always popular, however, and Cock's profits from their sale began to attract criticism and competitors. Hogarth attacked Cock in *The Battle of the Pictures* (1742), an engraving which pits the armies of history paintings stacked beneath his walls against an array of Hogarth's moral subjects. A year or two later Cock had his first imitator, when Mr. Ford at Raphael's Head in the Haymarket added art works to his accustomed sales of houses and estates. Richard Houlditch noted a sale of paintings at Ford's in 1744, and Pond bought drawings from him in 1748.[43] Another estate auctioneer, Aaron Lambe opposite the King's Arms Tavern in Pall Mall, sold prints in 1740 but was not as firmly entrenched as either Cock or Ford.[44] A third art auction house, Prestage's, opened in 1752, and after 1754 at least ten important painting sales were held in London every year.[45]

As mentioned in chapter IV above, Pond's patrons bought frequently at auctions and spent substantial sums there. The combination of low prices for mediocre works and increasing numbers of valuable masterpieces attracted the modestly financed as well as the rich collectors. One of the most important contributions of the sales, therefore, was the involvement of growing numbers of customers in the London art market. The auctions also offered unusual opportunities to view works of art, since it was customary to place the objects offered for sale on exhibition for several days before the event actually took place. These exhibitions were well advertised in the newspapers and the admission was free or cheap—usually about a shilling. As a result, many pictures and other objects could be seen easily by the interested public and, of course, artists—who would not

otherwise have been admitted to private collections without a letter of introduction or ticket procured from an influential 'friend'.

The general public's growing familiarity with auctions is indicated by the success of Samuel Foote's theatrical farce *Taste*, acted at the Haymarket for the benefit of the painter-turned-actor Jemmy Worsdale in 1752.[46] Satirizing the antics of unscrupulous dealers and their pretentious clients, it exposed the shams and snobberies of the auction houses to a very mixed audience. When he reflected on the public response to his play, Foote was pleasantly surprised by his audience's understanding (although it was by no means complete) of the elitist pastime. One scene in *Taste* shows that in auction rooms, artists and collectors rubbed shoulders and discussed the works on view, educating many of the passers-by at the same time. Proximity offered a virtuoso like Pond a chance to display his skills and demonstrate the science of connoisseurship to an appreciative audience. His services were soon in much demand from collectors who wanted prospective purchases thoroughly 'expertised' before they were bought.[47]

The decline of foreign competition in London in the 1740s enabled Pond to develop yet another artistic sideline dependent upon his virtuoso's training. The Duke of Chandos's misadventures with Christopher Cock explain why collectors were anxious to find knowledgable and reliable restorers for their prize paintings. Before 1738 Pond's income from art restorations stemmed from his survey of country houses for the Knaptons; most of his jobs were unexciting family portraits. However, as his reputation grew and competition dwindled, he was entrusted with increasingly valuable paintings; two Claudes belonging to Lord James Cavendish in 1738, a Nicolas Poussin in 1747 for Horace Walpole, and works by Carlo Maratta and Cignani for Henry Hoare in 1749. At his death in 1758 he was engaged in repairing the wall paintings by Charles de la Fosse in Montagu House for the trustees of the new British Museum.[48] Charging one guinea for a standard cleaning, Pond earned between £10 and £35 each year after 1743. Much of the work was actually done by assistants and once even by his servant Peter Maddox in 1747. A colorman, David Bellis at the White Bear in Longacre, was given the difficult job of relining old canvases or 'piecing out' pictures to fit their new locations, earning about half a guinea for each picture.[49] If Pond did any work on these jobs at all, it must have been the inpainting (which required faithfully matching the original artist's colors and brushwork) for which his specialized knowledge of hands would have been invaluable. Pond's accounts also mention varnish for history paintings and landscapes, indicating that he catered to the taste for 'brown' pictures popular in the 1740s with connoisseurs enamored of Dutch painting.[50] In fact, Pond's collecting propensities suggest that he was perhaps one of the leading exponents of the new taste. His practice of

varnishing elicited another satiric print from Hogarth, the *Time Smoking a Picture*.

Having established himself as London's leading virtuoso in the 1740s, Arthur Pond gradually withdrew from the more commercial aspects of the trade, which he had practiced in the 1730s, in favor of projects which allowed full scope for his expertise: authenticating pictures at sales or in collections, and restoring. His transition had resulted from several factors: the growth of the London art marketplace, his successful painting career which brought him a better income, and his adherence to Richardson's association of gentlemanly behaviour with connoisseurship. Writing mainly for the leisured class, Richardson had said little about the role or status of the virtuoso; it was left to Pond to demonstrate that, if less than a gentleman, the virtuoso was more than just a merchant. His highly specialized knowledge and analytical skills which could be hired on a consultative basis rather like a doctor's or lawyer's suggest comparison with a learned profession rather than a trade.

THE COLLECTOR

As a collector Pond demonstrated in real life the validity of Richardson's arguments in favour of connoisseurship, reaping the aesthetic, social, and economic benefits his mentor had promised. He had been buying for himself as early as 1722, but his serious collecting began in the late 1730s, as his painting business improved. Like Richardson, Pond was interested in drawings, then believed to be the most telling indices of an artist's 'hand' and thought processes (Figures 13, 14, 15, 17). They were also cheaper to buy than paintings and easier to keep in a crowded London dwelling.[51] Beginning in about 1735, Pond began to develop his own special field, artists' prints, particularly those of Rembrandt. These were prints executed directly on the plate by artists (usually painters), rather than copied from a drawing or painting by an engraver of reproductive prints. Like drawings they recorded the artist's mind and hand at work; they were easier to obtain and the market less competitive. Pond got his best examples from the Dutch engraver Jacobus Houbraken, a collaborator on the Knapton 'Illustrious Heads', only after dedicated pursuit. In 1738–9 he took Dutch lessons in preparation for brief trips to Holland to coordinate production of the 'Heads'. Houbraken parted with his best impressions, acquired at the Six sale, only after Pond appealed to their friendship and offered extremely high prices. The Parisian dealer Gersaint remarked especially on Pond's acquisition of a rare impression of *Peter and John at the Gate of the Temple* and drew the continental observer's inevitable conclusion: 'when they [the English] enter into any kind of Curiosity, if it is impossible for them to

satisfie it with Money, which they are not very frugal of on these Occasions, they testifie so great Regret that we are indeed forced to refuse them nothing'.[52] Pond acquired a print 'of Burgo Master Six by Rembrandt' for £2. 6. 6, the Hundred Guilder print for £3. 11. 0 in 1738, and another £18 worth from Houbraken in 1740.[53] These formed the nucleus of a collection which even the exacting Mariette called '(un) des plus parfaits et des plus nombreux' of Rembrandt's work. In comparison, Pond's other acquisitions paled to 'un assez beau cabinet d'éstampes et de dessins' which apparently could not compete with continental collections.[54]

The growth of the collection can be traced best through Pond's insurance records, furniture buying, and auction catalogues. His first policy, dated 1733, insured his household goods and furniture for £200 and his clothes for £100.[55] Some of the coverage was for paintings valued at £150 which Pond was holding for Smibert, so his own collection was presumably still quite small. He maintained the £300 valuation until 1748, although Smibert's paintings were out of the house by 1744; they had been stolen by Pond's framemaker.[56] The purchase of 'a deal press to hold my prints' in 1735 and the shift to a negative balance from art dealing in 1738 mark the beginnings of his serious collecting (Table 9). Negative balances from 1738 to 1742 and from 1745 to 1749 suggest that his heyday as a collector corresponded to his most prosperous years as a portraitist.

The year 1748 was a watershed for the print and drawing collection; it had expanded enormously as the result of large purchases at Richardson's sale in 1747 (£149) and the auction of Sir Thomas Frankland's collection in February 1748 (£32).[57] Pond's anonymous sale of prints the same year probably consisted mainly of discards after a systematic weeding to make room for the new purchases, while prices and buyers' interest still seemed high. In July he took out a separate insurance policy for the prints and drawings, valuing the total at £1000.[58] Assuming that the value was related to the collection's size and quality, he owned the largest such accumulation insured by the Sun Fire office. Indication of the relative size of his holdings can be obtained from the insurance policies of some of his friends: Dr. Jenner's books and prints were valued at £250 in 1745, William Powlett's books at £50.[59] Pond's collection competed in scale and value with those of the aristocratic connoisseurs: General Dormer's library valued at £2000 and Sir Anthony Wescombe's insured for £1000.[60] Pond continued to accumulate prints after 1748, but sold the collection to Edward Astley—husband of his former drawing pupil Rhoda Delaval—in 1756 for £1400.[61] When Astley sold it in 1760, the auction required nineteen days and consisted of 1550 lots of prints and books of prints—meaning that the collection probably contained about 10,000 individual works, the majority of which had belonged to Pond.[62]

Auction records show that Pond bought paintings sparingly, and his

estate inventories suggest that he kept very few of them for his own enjoyment. Most of the canvases and pastels in his house at the time of his death were his own copies after Italian paintings or replicas of commissioned portraits.[63] The only important oil in his possession in 1758 was the splendid *Woman Bathing* by Rembrandt, which was purchased by Joshua Reynolds at Pond's sale and is now in the National Gallery, London (Figure 12).[64] Its informal subject, painterly handling and tonal coloring conflicted with most eighteenth-century interiors. To quote William Gilpin, 'If a picture does not please the sight, it is fitter for a painter's chamber, or a curious cabinet, than for a saloon or a drawing room.'[65]

Pond's collecting activities entered a second phase after 1745, when he added shells and 'fossils' to his range of aesthetic and scientific interests. Exotic shells had been included in collections of art and curiosities since the sixteenth century, but had been disdained by the Earl of Shaftesbury. Nevertheless, as a result of his and others' admiration of natural beauty, and with the South Sea explorations of Pond's era, shell collecting enjoyed a new vogue. Grotto-builders and manufacturers of shell work (often aristocratic ladies like the Countess of Hertford and Mrs. Delaney) were incorporating shells into the current fashions in architecture, landscape gardening, and the decorative arts.[66] As a result, the 'shell trade' proliferated rather as had the commercial art trade, with shell dealers beginning to advertise in the papers in the late 1740s, and a shell auction house opening in the 1750s.[67] Naval officers returning from the Pacific or Caribbean did a brisk trade in 'tygers', 'sauce boats', 'false admirals', 'spindles', 'wild musics', 'flea-bitten volutes', and other rare molluscs. Pond's involvement in the shell trade appears to have stemmed from his work for the publication of George Anson's South Sea adventures; not only the glamour, but also the challenge of finding and classifying the most beautiful and the most rare must have appealed to him. Furthermore, he probably perceived similarities between Jonathan Richardson's 'scientific' methods of classifying art objects according to author and quality, and Linnean systems for categorizing specimens of natural history. The latter he may have learned from Emanuel Mendes da Costa, a merchant, shell collector, correspondent of Linnaeus, and author of a *Natural History of Fossils* (1752) which Pond owned. Like Pond, da Costa combined an appreciation of the fine arts (he was known as a connoisseur of antique silver jewelry) with scientific interests, and—not coincidentally—both were elected to the Society of Antiquaries in 1752.[68] The same combination of interests in natural history and fine arts appeared in several of Pond's other patrons and acquaintances: the Duchess of Portland (who began with shells and switched to paintings), Mrs. Delaney and John Dyer (vice versa), and some members of the club known as the Common Room.[69] However, it was not automatic, and Francis Wollaston expressed certain Shaftesburian reservations to their

mutual friend Charles Rogers in 1750. 'I hope and suppose you are by this time recovered from the fatigue such tasteless people as we are undergo on seeing a large collection of shells. But perhaps I am now talking disrespectfully to one of the Virtuosi themselves; perhaps the same thing may have led you into that way which at first drew in Mr. Pond ... What would you say were I to treat your Prints in the same Manner?—You would very rightly despise me: for in them there is some design, some expression & life. beiseides [sic] the great art of the Master by whom it was done.'[70]

Like his collection of artists' prints, Pond's accumulation of shells and fossils became known for its comprehensiveness and high quality. Still modest in size in 1750, it grew rapidly during the next nine years. In 1755 Charles Rogers reported, 'Our Friend Mr. Pond is engaged in a new Pursuit, the Ornamenting his Cabinets with the most beautiful Woods, but without neglecting his other elegant Acquisitions; so that his Collections may be now justly ranked with the most considerable.'[71] By 1757 John Dyer could rank his holdings with the the famous hoard of Sir Hans Sloane, the foundation collection of the British Museum:

> Sofal's blue rocks, Mozambic's palmy steeps,
> And lofty Madagascar's glittering shores,
> Where various woods of beauteous vein and hue,
> And glossy shells in elegance of form,
> for POND'S rich cabinet, or SLOAN'S are found.[72]

Pond's shells required 643 lots at the sale in 1759 and included several thousand individual specimens. The catalogue also lists six large pieces of mahogany furniture in which the collection was stored, and a library of twenty-six books on shells and fossils.[73]

Arthur Pond's artistic career began to benefit from his collecting by the late 1730s. Its impact was most quickly discernible on his own art with the publication of the *Prints in Imitation of Drawings* in 1735-6 and a series of etched portraits—all private plates—executed in 1739. The latter works, including a profile of Dr. Mead and a self-portrait, reveal the effects of his study of Rembrandt prints (Figure 11, Frontispiece).[74] They are densely etched, enhanced with dry point, and—in contrast to Pond's oil portraits—present convincing character studies. Pond's portraiture also benefited from the study of Van Dyck, whose work he would have known from the prints he collected in the 1720s and 1730s. Several examples of that artist's work had also passed through Pond's hands, and one or two (probably copies) were still in his possession at his death in 1758.[75] George Vertue credited Pond's subsequent success in the portrait business to this study of Van Dyck: 'Mr. Ar. Pond painter by drawing and studying after painting the heads of Vandyke &c. and crayon painting from the life ...

has so much improvd himself since a few years and his return from Italy ...'[76] The collection was clearly a source of inspiration for his rare innovations in the fields of portrait painting and printmaking.

Pond's art and shell collections also helped improve his social and economic standing in London, beginning in 1740 with his recognition as the town's leading virtuoso. As he gradually dropped the commercial aspects of his pursuit to concentrate on connoisseurship and accumulation, he earned growing respect for his knowledge, discernment, and public spirit. His shell collection, and probably also his art collections, were open to interested members of the public, who commented on his generosity.[77] His transition from commercial trader to learned collector was finally recognized with his elections to the Royal Society and the Society of Antiquaries in 1752.[78] Although neither group led the scholarly or aesthetic vanguards in the first half of the century, inclusion in both distinguished Pond from other members of the art world and vindicated Richardson's allegation that one could earn an entrée to polite circles by collecting art. As a member of the Royal Society Pond stood on equal footing (intellectually, at least) with his aristocratic patrons—Lord Hardwicke, Lord James Cavendish, and others.

As his own collection grew in importance, Pond's relationships with private collectors began to change. Whereas in the 1730s he had functioned as a middleman, ten years later he was an important member of a circle of connoisseurs of Dutch art, several of whom would join the Society of Antiquaries. The group was composed of wealthy tradesmen and merchants and a few country gentlemen: Christopher Batt, Esq. of Kensington, Jones Raymond of Leadenhall Street (a director of the East India Company), Robert Mann, Charles Rogers, Nathaniel Hillier, the artist Thomas Hudson, Charles Lowth, John Barnard, and Richard Houlditch. Pond's journal refers to visits to Batt and Raymond once or twice a week, irregular calls on Rogers, and numerous business transactions with all of them.[79] With Pond's assistance the group began collecting Rembrandt drawings, prints, and paintings in the 1740s, along with occasional small works by Italian masters. Christopher Batt opted for paintings, purchasing *Tobit and the Angel* in 1748 and two more Rembrandts in 1750. Pond also sold Rembrandts and landscapes by other Dutch painters to Jones Raymond.[80]

Pond was able to communicate more than just his enthusiasm for Rembrandt to these collectors. Both Jones Raymond and Robert Price experimented with etching in the late 1740s, buying paper, copper plates, and tools from the artist.[81] Charles Rogers embarked on a dedicated study of old master drawings, finally publishing his own prints after drawings which should be seen as a continuation of Pond's endeavors in the field.[82] Through this group Pond's interests and taste would be communicated to

the next generation: Hudson and Rogers would have interested the young Reynolds in collecting and Rembrandt. Pond's City collectors may very well have been the 'circle of Virtuosi' to whom Hudson introduced the young painter in the 1740s.[83] This small core of collectors was one of the sources for the passion for Dutch painting and landscape which spread through England later in the century.

Reacting yet again against a successful trend in the London art world which he perceived as harmful to his own interests, Hogarth ridiculed middle-class collectors of Dutch art in prints from *The Rake's Progress* and *Marriage à la Mode*, as well as in *Time Smoking a Picture*. However, his golden opportunity for showing up Pond's circle came in 1752. The famous story—Thomas Hudson's purchase of a 'Rembrandt' print etched by Hogarth's friend Benjamin Wilson, and Hogarth's subsequent triumphal banquet where Hudson and others were served a roast papered over with 'Rembrandts'—is vague only concerning the number of connoisseurs taken in by the hoax. All sources agree that Hudson was the principal victim, but according to Whitley, Pond and other members of his circle were among the twenty-three guests disillusioned at the dinner.[84] They had their revenge after Hogarth published *The Analysis of Beauty* in 1753. Charles Rogers could write complacently, 'The Town is not I think divided in its Opinion concerning his Performance, for the Unlearned confess they are not instructed, and the Learned declare they are not improved by it. . . . Mr. Wills is sorry any one of the Profession should derogate so much from it as to print such stuff as Mr. Hogarth has done; . . .'[85]

Some of the fringe economic benefits of art collecting have been discussed along with Pond's activities as a commercial trader and agent. The sale of objects and earnings from services to collectors when other sources of income dried up helped Pond to survive the difficult periods in his career as a painter. Over the long run, his collections functioned as a safe and rewarding capital investment which appreciated in value before being sold in 1756–9. In that three-year period Pond or his estate realized more than £3500 from the sale of his paintings, prints, drawings and shells, and the figure would be higher if the revenues from the sale of his cast collection were known. Given the vagueness of the journal entries, it is impossible to offer more than a guess about the significance of the figure in terms of return on initial investment. The journal shows that between 1734 and 1750 Pond bought on average £40 worth of objects *per annum*; if these expenditures are calculated for the twenty-five-year period when Pond was actively collecting, his initial investment would amount to roughly £1000 on collections which realized more than twice the sum. The 150 per cent estimated return does not take into consideration the additional income generated from the sales of unwanted objects (perhaps worth another £1000 over twenty-five years) and the casts.

The importance of the art and shell collections to the artist's finances is evident when considered in the context of Pond's personal estate at the time of his death in 1758. In his will Pond listed specific bequests of money to his friends and family amounting to £3,645.[86] These bequests were fully funded from the sales of the painting, print, drawing, and shell collections, and more remained from sales of the casts,[87] and perhaps £1000 in South Sea annuities which Pond inherited from his father in 1749 but does not mention in his will. Pond's only other property apart from clothes and furniture were his lease on the Great Queen Street house (worth £150) and the properties in Essex and Surrey also inherited from his father. The collections, therefore, embodied the savings from thirty years in the art world.

In the course of becoming London's leading virtuoso and connoisseur, Arthur Pond not only advanced his own career but also vindicated Jonathan Richardson's theories about the pleasures and usefulness of art collecting, and established it as a respectable pastime for English art lovers. The benefits of this occupation for Pond have been described above: improved painting style and technique, a source of images for his prints, extra income in bad times and a safe capital investment in good ones, and an important ingredient in his reputation. The extent and quality of his art and shell collections earned him admission to the Society of Antiquaries and the Royal Society, a distinction accorded no other artist of the period.

However, Pond's contributions to the old master trade were as great as the benefits he derived from it. He was one of the first to adopt Richardson's principles of 'scientific' connoisseurship, thus placing the tricky problems of attributing works of art on a sound intellectual and professional footing. The new method, which borrowed analytical and comparative techniques from the natural sciences, made art collecting and connoisseurship the most intellectually advanced occupations in the London art world. It is also the only one of Pond's endeavors which has withstood darkening by time; his attributions are still accepted by modern scholars, and prints or drawings from his collections are highly valued. Attributions of paintings and drawings continue to be made on the basis of distinctive motifs or mannerisms, discerned after lengthy examinations and comparison with similar works.

The imposition of intellectual order on the attribution of art objects began to revive confidence in the art market and stimulate interest in collecting and connoisseurship. Those who had mastered Richardson's techniques and were familiar with genuine works had the confidence and tools for making their own decisions about an object's authorship, quality, and market value. Less confident souls could avail themselves of an expert opinion, or select works which had been authenticated by a responsible

dealer. Art buyers were encouraged to look with their eyes and their minds and base judgments on their own observations.

The spread of the Richardsonian method of connoisseurship had momentous consequences for the future of the London art world. Most obviously, it was instrumental in the formation of an audience capable of examining and appreciating art—something new in eighteenth-century England. It also forced English viewers to come to grips with works far more complicated than portraits, thus breaking down their traditional resistance to genre and history painting. Finally, the study of the old masters was given an important place in artists' educations, encouraging them to master and surpass the greatest achievements of the past.

VII

Printselling

Along with his own paintings and the works of the old masters, Arthur Pond sold prints which he executed and published himself. His journal, therefore, records the internal development of the printseller's trade in the early eighteenth century, and his many surviving prints reveal the process by which an artist-entrepreneur estimated and influenced English taste in art. The quantities of remaining material—documents and objects—permit a detailed examination of the relationship between the rapid commercialization of the print trade and subsequent cultural change.

Like portraits and old master paintings, prints presented special difficulties and opportunities for the artist and entrepreneur. There were several different processes for making and printing the original block or plate, all current in the eighteenth century and all employed by Arthur Pond. The most traditional was the woodcut, executed by carving out the design drawn on a block of wood, thus leaving the image in raised relief. The block would then be inked and printed (with minimal pressure) on a sheet of paper and could produce thousands of impressions. The other processes—engraving and etching—consisted of incising the lines of the image *into* a copper plate; the engraver cut into the plate with special tools, while the etcher 'bit' his lines into the plate by immersing it in a bath of acid. In the eighteenth century both processes frequently were employed on the same plate, since etching saved time and labor while engraving supplied sharpness and detail. A new refinement on the engraving technique known as mezzotint engraving had been introduced into England late in the seventeenth century. The mezzotinter used a 'rocker' to pit the surface of his plate uniformly, then polished the areas he wished to appear light or white. Mezzotints have a velvety quality very different from the linearity of the other intaglio techniques and are especially suitable for dramatic contrasts of light and dark. Completed copper plates were inked, then wiped dry, leaving ink only in the incised grooves or pits. When the plate

and a sheet of good quality damp paper were run through a rolling press at high pressure, ink was forced out of the plate onto the paper, printing the design. Although copper plates were easier to make than woodcuts of comparable quality and could produce more finely detailed or atmospheric images, they were less durable and required frequent maintenance. By 1720 all of the processes outlined above had undergone numerous refinements and variations, but were in essentials very similar to the methods of the sixteenth century.[1]

Although plates could be made, printed and published by one person, the step-by-step method of printmaking encouraged specialization and division of labor in the large printshops which had existed in Italy and the Netherlands since the sixteenth century. Often one artist drew the design, an engraver or block cutter transferred it to the plate or block, a printer pulled the prints, and a printseller sold the prints to the public. The publisher might be any one of the principals involved in the process, or perhaps the owner of the original being reproduced, or an outside entrepreneur such as a bookseller. In a few establishments some or all of the activities were concentrated under one roof, but for the most part tasks were 'put out' to workers operating in their own shops or homes. In Arthur Pond's case, for example, original paintings and blank copper plates were carted to the engraver's house, the finished plates were sent off to the printer and the paintings returned to their owners, and the prints and plates finally returned to Pond's Great Queen Street house where the former were sold. Printselling presented many of the commercial problems attendant upon bookselling: supervision and control of the scattered phases of production and slow return on initial investments in labor and materials, with success ultimately dependent on the entrepreneur's original choice of the painting or manuscript to be reproduced. In the production of engraved book illustrations, the two occupations actually overlapped.

Arthur Pond's prints were his only works whose subjects he chose himself. As a portrait painter he depicted the subject of his patron's choice; as an art dealer he was restricted to the preferences of long-dead patrons and artists, further limited by their availability on the market. Prints allowed him to select original models which he considered most important, interesting, or beautiful, and so reveal much about his own tastes. However, as a multiple image, the print had to appeal to hundreds of patrons, forcing Pond to consider public taste as well as his own when determining his subjects. When he entered the trade in 1735, the gap between Pond's interests and those of his audience was demonstrably large. There followed an extraordinary dialogue of the deaf, with Pond on one side of the counter offering mute images and his audience on the other communicating through patronage. Ten years later both sides had reached a satisfactory and mutually profitable understanding.

PRINTSELLING

During the first quarter of the eighteenth century, the London booksellers dominated the print trade, just as they controlled art dealing and auctions. Theirs was virtually the only demand for subjects other than portraits; their histories, novels, and texts needed maps, diagrams, and illustrations. Only two printshops of any magnitude existed in London at this time. Thomas Bowles and John Overton ran successful family businesses dating back to the late seventeenth century.[2] Their inventories featured illustrations for chapbooks, maps, topical prints, and portraits. Fine arts publishing (i.e. reproductive prints of works by contemporary or old masters) was in the hands of a few beleaguered portrait engravers and several foreigners—usually French—who moved to London to escape continental competition and censorship laws. The key figure in the introduction of the continental-type, fine arts print shop was Claude DuBosc, an engraver who had first come to England in 1711 to assist Nicolas Dorigny with the engraving of the Raphael Cartoons at Hampton Court. DuBosc settled in Covent Garden and opened his own printshop, selling imported French engravings and his own works taken from portraits, battle scenes, and the occasional old master. His career culminated with the publication of an English version of Bernard Picart's *Religious Ceremonies* in 1733, with plates by a group of young French engravers who followed their master's example by opening shops in London.[3] When Arthur Pond entered the print trade in the 1730s, the fine arts branch was dominated by the French, and mediocre English engravers hacked away at portraits and plates for the booksellers. In 1732 William Hogarth opened the assault on this unsatisfactory situation with the *Harlot's Progress*, whose unconventional subject and fine execution met rapidly with success.

Hogarth's efforts in the name of English engravers and printsellers were soon seconded by Pond, who challenged the French entrepreneurs on their own ground of reproductive fine arts prints. Unlike Hogarth, who always worked as an independent artist/publisher, Pond modelled his own activities after those of Pierre Crozat and the Comte de Caylus in Paris, Johann Frey in Rome, and Jacobus Houbraken in Amsterdam, all of whom featured quality reproductions of old master history paintings. He had seen the French and Italian operations during his tour of the continent in 1725-7, and learned of the Dutch shop in the course of his work with the Knapton booksellers in the 1730s.

Pond's first publication, the *Prints in Imitation of Drawings*, appeared in London in 1735 and 1736 (Figures 15, 16, 17). They sought to emulate the immensely successful *Recueil Crozat*, a series of reproductive prints by the connoisseur and amateur etcher the Comte de Caylus and the wood engraver Nicolas Le Sueur. Pond's friend Mariette had assisted in selecting

the original Italian old master drawings from Pierre Crozat's collection and written learned commentaries on the artists of the works reproduced.[4] The French example and the influence of the Roman Club led by the drawing collector Jonathan Richardson encouraged Pond to continue the emphasis on Italian originals. Pond initiated and controlled the English version of the *Recueil* with the assistance of his friend and lodger, the landscape painter Charles Knapton. Together they etched seventy plates after drawings belonging to themselves, their friends, and eminent connoisseurs who allowed them access to their treasures—Dr. Mead, Sir Hans Sloane, General Campbell, Sir Anthony Wescombe. The portrait painter Pond concentrated on forty figure studies, while Knapton did the thirty landscapes. Two wood engravers, William Pennock and a man named Davis, cut the pearwood blocks which imitated the colored shadings of the original drawings' ink washes.[5]

Pond's journal of receipts and expenses shows that in their initial venture he and Knapton had not yet set up an independent printshop. When it came time to print their plates they had no reserves of paper, but bought heavily from a London stationer (William Herbert, a distant relation of Pond's by marriage) and a French paper maker, Josias Johannot, an importer and manufacturer of high quality paper suitable for copper plate printing. Johannot and his family resided in Pond's original parish of St. Magnus in London.[6] Nor did Pond and Knapton own a printing press, an omission which cost them £48 in payments 'to Wyatt for printing' and 'to Wyatt, for beer'.[7] Wyatt accounted for about 45 per cent of Pond's costs on the project; printing and paper together comprised 75 per cent of his total outlay.

High costs would not have been such a problem if the prints had sold well. Pond announced the opening of a subscription for the first set of twenty in the *Daily Advertiser* in January 1734/5, and published them on 2 April the same year. In April 1736 the subscription for the second set opened, but 'Complete Sets of those publish'd last Year' were still 'to be had at the same Place'.[8] Pond priced the sets at a guinea apiece, meaning that he had to sell at least 100 sets or 4000 prints to recoup his initial expenses. This did not happen for ten years (Table 7). Pierre-Jean Mariette, who had collaborated on the *Recueil Crozat*, claimed that Pond's version failed because he selected relatively undistinguished designs which did not compare with the quality of those in the French publication.[9] Comparison of Pond's prints with the original drawings also suggests that the reproductions were not especially accurate, reversing compositions and altering details (Figure 15).[10] But although quality may have been an issue on the continent, it is not clear that such considerations were decisive with the English public. Informed critical response was generally positive in London.[11] Most of the collectors represented in the sets subscribed, as

did William Kent, the Earl of Burlington, Mary Edwards, Robert Din-
gley, Mr. Prideaux, William Lock, Sr., and Horace Walpole, Jr. So did
several artists and printsellers: Pond's friend George Knapton, William
Bellers, and Claude DuBosc. The Roman Club, mentioned in several
dedications on the prints, also subscribed. Judging from the list of pur-
chasers of the prints before 1740, drawing connoisseurs in England bought,
but there were simply not enough to support the project beyond this.

Sales outside this select group suffered because of the prints' limited
visual appeal and specialized function. The sketchiness of the images must
have perplexed unsophisticated browsers who did not share the connois-
seur's preoccupation with 'hands', while their irregular sizes and unfinished
appearance rendered them most unsuitable for framing. Cryptic dedica-
tory inscriptions in Latin and obscure, unidentified subject matter increased
their difficulty for the layman. The prints also did not appeal to professional
or amateur copyists seeking ready-made compositions to borrow.

The *Prints in Imitation of Drawings* bore all the hallmarks of a pretentious
but amateurish production, an ambitious, commercially unsound plunge
into printselling. Pond was not to attempt such esoteric projects on such a
large scale again. Instead, he entered a commercial alliance with the Knap-
ton booksellers of St. Paul's Churchyard. The founder of the business
James Knapton died in 1736, leaving his thriving and reputable firm to
two sons who had been his partners for several years. A relatively colorless
but capable publisher, John Knapton would be elected Master of the
Stationers' Company in 1742, 1743 and 1745. Paul, a patron of the arts and
a friend of Warburton, must have supplied some of the flair, although
events would prove he lacked discipline and business sense.[12] These two
young men were either brothers or cousins of Pond's friends George and
Charles Knapton, and together the five were to publish several of the
largest and most successful series of prints of the early eighteenth century.

The partnership developed not only from the failure of the *Prints in
Imitation of Drawings*, but also from the relationship the five worked out in
the course of a massive book illustration project, the portrait heads for Paul
de Rapin Thoyras' *History of England*. The project (which will be discussed
in detail later in the chapter) required the collaboration of several artists
working in England, Houbraken's workshop of engravers in Holland, and
the printing and bookselling operation in London. Arthur Pond and
George and Charles Knapton collected historical portraits for the first
phase of the project and may also have assisted with the printing and
maintenance of the engraved plates. In return, the Knaptons offered the
printing presses and commercial expertise which had been lacking in the
Great Queen Street operation. Further stimulus for the partnership must
have come from a change in customs duties in 1737-8 which increased by
20 per cent the cost of engraved copper plates imported from the continent.

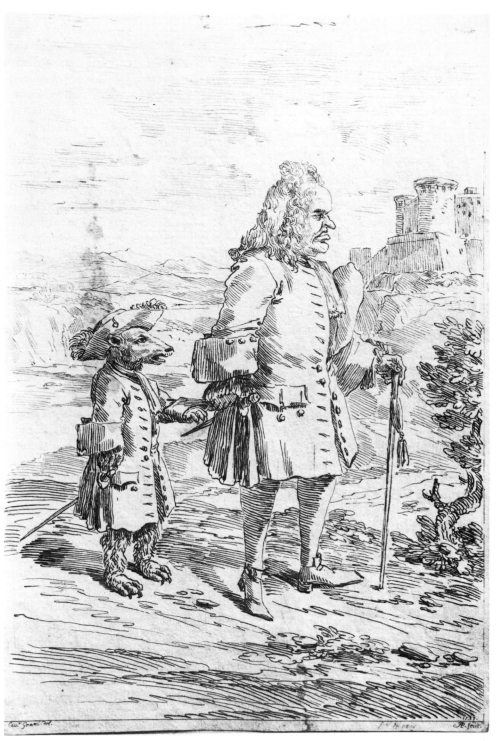

Figure 18. Arthur Pond after Pier Leone Ghezzi, *The Bearleader* (from a drawing now in the British Museum), etching, 1737. Trustees of the British Museum.

As the Knaptons explained in an advertisement to their subscribers, the extension of customs duties on 'worked copper' to cover engraved plates seriously interrupted their schedule for the 'Houbraken Heads' and forced them to raise prices.[13] An English workshop suddenly became economically desirable, whereas up to that date the sophisticated and efficient continental shops—especially those in Paris and Amsterdam—had the competitive edge.

Although no document concerning the agreement between the booksellers and the artists survives, the arrangement appears to have gone into effect in the fall of 1737. Pond's payments to Wyatt ceased in July and in December of that year he bought a 'Rolling stone', presumably for a press.[14] Vertue noted that there were several presses in the Great Queen Street house by 1741 as the partnership's output increased dramatically.[15] Another was added in 1746, again in anticipation of increased production. No doubt, their main purpose was the printing of book illustrations, which Charles Knapton had undertaken by 1740. All appear to have been supplied by the Knaptons, since Pond's only expenses consisted of paying the joiner to put them together, and contributing to the 'handsel', their ceremonial 'christening'.[16] In return, the Knaptons received a portion of the prints pulled, which they sold for their own benefit. Newspaper advertisements indicate that the booksellers carried every Pond and Charles Knapton publication including the *Prints in Imitation of Drawings*, the only series completed before the deal was made.[17]

The divisions of responsibility between Pond and the Knaptons render reconstruction of the workshop's daily operations extremely difficult. The roles of Charles, George and John and Paul Knapton were important but can be deduced only from omissions in Pond's accounts. Analysis is also hampered by the gaps in the journal between December 1741 and December 1744, although the prints themselves and newspaper advertisements are occasionally informative. All sources indicate that Pond was the chief instigator and guiding light of the Great Queen Street fine arts publications. According to the journal entries, he was responsible for locating and obtaining the works of art for the engravers to copy. The original old master drawings or paintings usually belonged to his acquaintances or patrons, or had once passed through his hands. Pond also bought the copper plates and paper for printing and supervised the engravers. Charles Knapton and his wife Elizabeth managed the book illustrations, printed the completed plates, and may have handled sales at the Great Queen Street house. Elizabeth also mounted the prints which patrons wished to have bound together or framed.[18]

Pond's first project after the disappointing *Prints in Imitation of Drawings* consisted of two sets of caricature prints (Figures 2, 18, 19). He began them in 1736, before the partnership with the booksellers was established, but

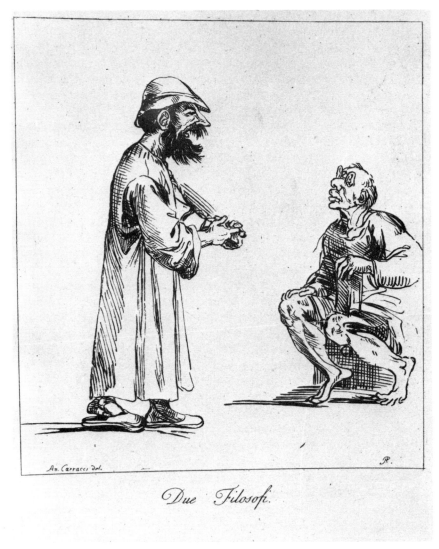

Due Filosofi.

Figure 19. Arthur Pond after Annibale Carracci, *Due Filosofi*, etching, *c.* 1736-40. Trustees of the British Museum.

did not finish the series until 1742.[19] Their character reflects the transition in outlook resulting from the commercial alliance with the Knaptons. Like the *Prints in Imitation of Drawings*, the caricatures were probably inspired by a Crozat/Caylus/Mariette publication, the *Têtes de Caractères* after originals then thought to be by Leonardo da Vinci, which Mariette had urged Pond to promote in England as early as 1730.[20] Pond's caricature prints

also continued to imitate the drawing styles of the original artists who included Italian draughtsmen like the Carracci (Figure 19), Guercino, Pier Francesco Mola, and Pier Leone Ghezzi (Figures 2, 18). In this case, however, the hilarious or grotesque portraits justified and depended on the accurate reproduction of the caricaturists' drawing methods. The unification of drawing style and meaning gave the caricature prints a coherence and visual impact lacking in the *Prints in Imitation of Drawings* and must have been a major reason why the new publication caught on so quickly with the London audience. Their timely appearance—contributing to the popularization of caricature drawing as a form of polite entertainment—was also helpful.

Early sales of the prints, which had been etched by Pond and printed by Charles Knapton, were handled by Charles and Elizabeth Knapton and were not recorded in Pond's journal. However, a positive response may be inferred from their numerous imitators and the vehemence of Hogarth's reaction. When the sets were completed in 1742, Henry Fielding attacked caricature and burlesque as debased forms of 'character painting' and comedy in his preface to *Joseph Andrews*.[21] Hogarth illustrated Fielding's argument in a print entitled *Characters & Caricaturas* 'quoting' directly from Pond's caricatures and the *Têtes de Caractères* which he contrasted—unfavourably—with his own work and the Raphael cartoons.[22] Later he selected the most popular caricature from Pond's series, *The Bearleader* (Figure 18), for his first plate in *The Analysis of Beauty* and an attack on 'those who have already had a more fashionable introduction into the mysteries of the arts of painting'.[23]

Hogarth's opposition could not slow the growth of interest in caricature stimulated by Pond's publications. Tourists who had learned the art in Italy or from Pond's prints began to etch their satires, which then spread far beyond the drawing room. The banker, Dilettant, and frequent patron, William Fauquier gave his plates of *Miss Turner* (1743) (Figure 20) and *Mrs. Young of Eltham* (1746) to Pond for printing.[24] Fauquier probably distributed his designs to his friends for their private amusement, but another patron, George Townshend, adopted the caricature technique for his satires on the Duke of Cumberland intended for general sale, and from that time on caricature was an essential component of English satirical prints.[25]

The *Caricatures* were the last plates intended for commercial sale which Pond etched himself. The later projects were designed to exploit the facilities offered by the Knaptons and place the Great Queen Street operation on a par with continental enterprises. After obtaining the necessary presses, Pond and Knapton hired skilled professional engravers capable of reproducing Italian old master landscape paintings on copper. The *Italian Landscapes* were published between 1741 and 1746 (Figures 21, 22); like the

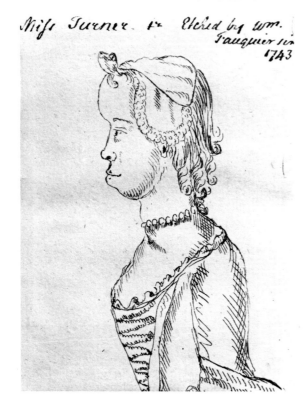

Miſs Turner. & *Etched by Wm.*
Fauquier in
1743

Figure 20. William
Fauquier, *Miss Turner*,
etching, 1743. Trustees of
the British Museum.

Caricatures they were initiated by Pond, who selected the original works and paid the costs of the first 'number' containing four prints.[26] Soon afterward all references to the project disappear from his journal, and it seems likely that Pond—busy with his portrait painting career—turned control over to his partner, who is named on the prints as the publisher. When Charles Knapton died in the fall of 1742 his widow was granted administration of his estate and continued to publish the landscapes, but under Pond's name.[27] She remained in the Great Queen Street house and eventually became Pond's housekeeper and mistress as well as his business partner. Pond reassumed responsibility for the publishing business in 1745, but Mrs. Knapton continued to print and sell their plates.

With the hiring of professional engravers the Great Queen Street operation could approach the continental shops in quantity and quality of production. Many—Chatelain, Vivares, Canot, Muller, Fougeron—had been trained abroad but settled in England when they found better opportunities for work in London. Pond was one of the first to employ them and their growing numbers of English pupils, James Mason, John Wood, and Charles Grignion.

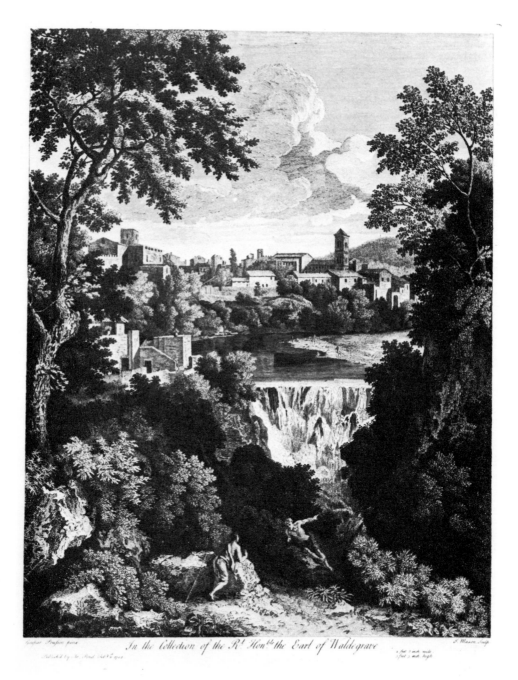

Gaspar Poussin pinx.

In the Collection of the Rt. Honble. the Earl of Waldegrave

J. Mason Sculp.

Publish'd by Mr. Abrd. Febry. 2d 1744.

Figure 21. James Mason after Gaspard Poussin, *The Falls of Tivoli* (after a painting now in the Wallace Collection, London), engraving, 1744. Trustees of the British Museum.

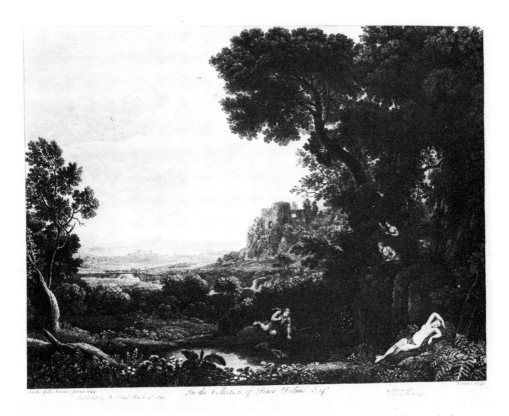

Figure 22. Francis Vivares after Claude Lorrain, *Landscape with Narcissus and Echo* (after a painting now in the National Gallery, London), engraving, 1743. Trustees of the British Museum.

The engravers presented many of the managerial problems which Pond also experienced with his painting assistants. Jean-Baptiste Chatelain, the best of the French landscape specialists, was every bit as extravagant and unreliable as the drapery painter Thomas King. Like King, Chatelain worked only when necessity compelled him, and then 'if by accident he earned a guinea, he would immediately go to a tavern, and lay at least half of it out on a dinner'. This was not as unusual as Chatelain's obsessive belief (based on a dream) that Oliver Cromwell's treasure was buried in his Chelsea house. According to his biographer Joseph Strutt, 'He was so prepossessed by this idea, that he used to spend whole days, lying upon his face, listening if by the shaking occasioned by the carriages passing to and fro, he could hear the chinking of money. Sometimes he would work in pulling up the floors, searching behind the wainscot, and removing walls, in quest of this hidden treasure till he so blistered and bruised his hands, he

could not work for a considerable time.'[28] In general Pond and Knapton preferred less eccentric employees. Vivares, Wood, Mason, and Muller were competent, reliable, and seem to have had few ambitions beyond earning enough to start their own printshops or publishing ventures. Advertisements in the daily newspapers indicate that most of them had initiated independent publications or opened shops by the late 1740s, while continuing to engrave plates for other publishers: Pond and Knapton, Thomas Smith, and John Boydell.[29] They formed the foundation of the school of English reproductive engravers which would dominate the international print trade in the second half of the eighteenth century.

Requiring a directed north light for their work the engravers preferred to cut the plates in their own dwellings. In order to maintain control over production, Pond paid them by output rather than on a day-by-day basis. Fees could vary according to the size of the plate and the complexity of the subject, but they started very low. One of the first engravers Pond approached for the project, Andrew Laurence, turned down the offer because the wages were even lower than those he earned in J.P. Le Bas's workshop in Paris.[30] In 1740 Pond paid Chatelain and Vivares twelve guineas for the first four plates of his *Landscapes*, or three guineas per plate. The payments were distributed according to the amount of work each engraver did; thus Chatelain received two guineas for executing most of one plate, while Vivares got nine for three complete plates and fifteen shillings for finishing Chatelain's.[31] Pond also kept an eye on the quality of the work by pulling prints from the plates at several stages of completion, marking up the proofs to indicate changes and corrections for the engravers.[32] As a result, the *Italian Landscapes* were called 'the most curious and elaborate Artfull works of the kind done in England', and set new standards for native landscape engravers.[33]

The appearance and format of the forty-four *Italian Landscapes* were the key to their commercial success. Unlike the *Prints in Imitation of Drawings* and the *Caricatures*, they offered finished compositions and matching sets of complementary views at manageable prices. Each number containing four prints of uniform size, cost five shillings, and appeared roughly every three months, keeping the series in the public eye. Such prices were competitive with those Hogarth asked for his *Progresses*—yet another instance where Pond and Hogarth were offering similar products to their audience. A single 'number' of prints could be framed for wall decoration; it also offered plenty of material for copyists from Mrs. Delaney and friends working in watercolors, to George Lambert and Pond himself painting imposing chimney pieces for country houses.[34] The high market and aesthetic values placed on the original paintings by Gaspard Poussin and Claude Lorrain, and the publicity accorded the aristocratic collections from which they were drawn, also contributed to the saleability of the

prints. Pond was never able to expand the repertoire of artists represented beyond these two superstars, in fact. An experiment with the eighth set (1744) containing prints after Filippo Lauri, Salvator Rosa, Borgognone and Rembrandt was never repeated. The long Latin dedications which had weighted down the *Prints in Imitation of Drawings* were replaced by a simple credit line—for example, 'In the Collection of Her Grace the Duchess of Portland'. Taken individually the landscape prints deployed more of the basic elements for audience appeal than any previous Pond and Knapton fine arts publication.

It is only when the *Landscape* prints are viewed as a group that the persistence of Pond's essentially serious purposes becomes apparent. Taken together, the prints form a comprehensive survey of the authentic works by Claude and Poussin to be seen in England, and so were a valuable tool for connoisseurs and artists struggling to sort the good from the bad in collections, sales, or their own work. Their intended didactic function is borne out by the engravers' meticulous attention to details such as foreground vegetation and the inclusion of the original paintings' dimensions with the publication information. Connoisseurs and collectors bought each number as it came out or, after the set was completed, acquired all at once. For five shillings Pond would have the work bound into a volume which is still the earliest and most valuable reference work on Italian landscapes in eighteenth-century English collections.[35] Purchasers initially attracted to the prints by the fashion for Claude and Poussin may have found themselves drawn unwittingly into connoisseurship.

Because Charles or Elizabeth Knapton kept the records of the sales of the *Landscapes* until 1745, the nature and size of their early audience is difficult to define. However, it was large enough to ensure that publication would continue for five years. The tenth and eleventh numbers, the first for which both cost and sales figures are available in the journal, each sold out the first printing of about 200 impressions in two months and earned back expenses within one year.[36] Earlier numbers had the advantage of novelty and freedom from imitators and may have done even better. In contrast to the *Prints in Imitation of Drawings*, the *Landscapes* were a commercial as well as aesthetic success.

While their attractive format certainly assisted sales, so too did the different marketing techniques Pond and Knapton adopted for the new publication. If they did offer a subscription, it was not advertised. Instead, as the prints appeared number by number, each was accompanied by saturation advertising in the *Daily Advertiser*. In their length, detail, and persistence, the notices resembled those of the booksellers when announcing a major publication, rather than the brief listings customary for prints. The only other printseller to exploit newsprint to such a degree was William Hogarth; perhaps Pond and Charles Knapton hoped to match his

Figure 23. J.S. Muller after Giovanni Paolo Pannini, *Roman Antiquities No. 3: Basilica of* Trustees of the British Museum.

Antoninus, Temple of Fortuna Virilis, Mausoleum of Hadrian, Medicean Vase, engraving, 1746.

success by adopting his and the booksellers' methods. They also emulated the larger commercial operations by selling much of their output to other retailers. These middlemen bought cautiously at first, then waded in enthusiastically as their patrons responded. John Smibert wrote from Boston, 'The smal sett I have sold and desire you will send 5 setts of the 7 numbers on the smal paper which with the sett already received will amount to eight guineas allowing the 20 per cent for those who sell them again. its probable more will sell but we will try them first ...'[37] James Regnier, a Huguenot émigré turned printseller in Newport Street, Westminster, carried the *Landscapes* along with the fine reproductive prints, illustrated books, and art treatises he imported from Paris. So did four purveyors of popular prints, John Tinney in Fleet Street, Joseph Sympson in Drury Lane, Mary Overton in Fleet Street and Henry Overton at the White Horse without Newgate.[38] Located all over London, these retailers distributed the *Landscapes* far beyond the circle of connoisseurs who frequented the Great Queen Street house. More than half of Pond's sales of the tenth number were to these retailers.

Even before the *Italian Landscape* set was complete, Pond launched his fourth major publication, the *Roman Antiquities* (Figure 23). Its appearance, coinciding with his return to portrait painting in oils, shows Pond again correctly anticipating and adapting to the art market's revival after its 1743 collapse. The *Antiquities* developed further the decorative and 'popular' characteristics of the previous set and achieved the *juste milieu* between Pond's learned approach to Italian painting and his audience's genteel familiarity with the fine arts. They would become the model for Pond's two final projects, the *Large Dutch* and *Large Italian Landscapes*.

Pond increased the decorative potential of the *Antiquities* at the expense of their usefulness to the connoisseur. His most obvious concession in this direction was the limitation of the number of prints in the series to five. The *Antiquities* are not a visual catalogue of Pannini's work in England, nor do they accurately represent the major Roman monuments. Four of the compositions are pastiche assemblages of famous ruins in picturesque groupings. The fifth shows the 'inside of the Pantheon', a subject which had been successfully engraved fifteen years earlier and was tacked onto Pond's series as an afterthought.[39] The marketability of Pannini and the Pantheon had already been demonstrated by the souvenir hauls of English tourists, just as interest in the Claudes and Poussins had been stimulated by high auction prices. Pond also followed the *Landscapes* by giving the dimensions of the original painting with a restrained credit line for the owner. Furthermore, each monument depicted was identified with a caption; all previous prints had been published without titles, whether or not their subject matter was significant.

The five *Antiquities* form a thematic and visual unit suitable for room

decoration, and, measuring eighteen by twenty-four inches each, were large enough to 'carry' a wall as a painting could. At a patron's request, Pond's shop assistants hand-colored, framed, and glazed these prints at a cost of £1.11.6 each. Of the 544 individual impressions Pond sold to retail customers between 1745 and 1751, eighty-one were colored and framed in the shop; many more were colored and framed at home by the frugally minded. According to the journal, no one asked to have these attractive prints bound into portfolios.[40]

The identification of the monuments of the *Roman Antiquities* suggests that Pond sought to enhance their appeal through associations with contemporary literature and fashions outside the realm of fine art. The ruins would, of course, have been popular subjects with Grand or armchair tourists. They were also favored by clergymen with strong classical and antiquarian tastes. Furthermore, the prints may have derived additional impact from the political connotations of Italian classical culture during the years surrounding the fall of Walpole. Pond's Roman Club had been loosely associated with the parliamentary opposition to Walpole since the 1730s. One of its members, John Dyer, published a poem entitled 'The Ruins of Rome' in 1740 as Walpole's control of Parliament weakened.[41] Amidst his melancholic reflections on Rome's decaying grandeur corrupted by luxury and cowardice, Dyer scattered numerous references to the state of Walpolian England. Pond's *Antiquities* depict several tourists apparently engaged in similar reflections, surrounded by the monuments which had occasioned Dyer's poem. Although Walpole fell two years before Pond published the first *Antiquity*, Rome's past continued to be a powerful political metaphor, and the prints may well have been bought because of a perceived political message.

Marketed in the same manner as the *Landscapes*, the *Roman Antiquities* were an immediate commercial success. Smibert reported from Boston, 'ye View from Greenwich & Antiquities by P. Panini please more here than ye others and I hope some number of them wil sell'.[42] Pond's initial investment in the plates amounted to about £25 each: £20 to Johann Sebastien Muller for engraving, approximately £1 for the plate itself, and £3 to £5 for paper. (Muller's high fee resulted from the *Antiquities'* surface area—double that of the *Landscapes*—and a shortage of skilled workmen following the return of several French engravers and their pupils to France in 1744–8. The shortage would continue throughout the century; by 1786 James Mason could command £100 for a similar plate, while a history engraver charged several times that sum.) The five *Antiquities* cost Pond about £125, and he recouped his expenses within a year of publication of the *Interior of the Pantheon*, the last of the series (even when figures for sales of *No. 1* before 1745 are lacking). Again his sales were almost equally divided between wholesale (54 per cent) and retail (46 per cent) customers.[43]

Hogarth reacted against the success of the *Antiquities* in Plate I for his aesthetic treatise, *The Analysis of Beauty*.[44] Depicting a statuary's chaotic yard, Hogarth mimicked the eclectic groupings of sculpture, architectural elements, and tourists of the Pannini compositions. Two of the sculptures from the *Antiquities*, the 'Farnese Hercules' and the 'Belvedere Torso', reappear in the statuary's yard, while the arrangement of buildings in the background recalls the placement of the 'Basilica of Antoninus' and the Temple of Fortuna Virilis in *Roman Antiquities No. III* (Figure 23). 'Figure 1' in the scene's border reproduces Pond's *Bearleader* caricature as a representation of continental contempt for English tourists' dull aesthetic sensibilities. Hogarth intended the plate to contrast the 'unnatural' tastes developed by tourists and learned connoisseurs with the 'natural' sources preferred by himself and the best classical sculptors.

In his reactions against the earlier *Caricatures* and the *Roman Antiquities*, Hogarth was attempting to draw distinctions between Pond's work and his own. Evidently he was concerned about the similarities between their respective publications which were causing confusion (character vs. caricature), or—worse yet—cutting into his business. In terms of format, decorative appeal, quality, relevance to contemporary interests, and sales methods, the *Roman Antiquities* and Hogarth's 1745 publication *Marriage à la Mode* (which used the anti-Pond *Characters & Caricaturas* as its subscription ticket) were about equal.

Such eighteenth-century quarrels have obscured the important fact that Pond and Hogarth employed the same formula for selling reproductive fine arts prints to the English public. Both produced sets containing four to eight prints unified by theme and composition, relevant to contemporary interests, large and rich enough to decorate the walls of a Georgian-scale room, after known original paintings by name artists. Hogarth developed the format first in the *Harlot's Progress*; Pond's projects converged toward it in the late 1730s and early 1740s. With the *Roman Antiquities* he proved that the 'Progress' format could be adapted for any type of reproductive print. He followed the *Antiquities* with two pairs of landscapes by Dutch painters and four large plates after Claude Lorrain and Gaspard and Nicholas Poussin.[45] While the Italian landscapes combined the most successful aspects of earlier publications, Pond widened his range with the Dutch sets. In the first pair published in 1744 he included an English scene: Peter Tillemans's *View from One-Tree Hill in Greenwich* (Figure 24), then in the collection of the Earl of Radnor. It may have been one of the earliest eighteenth-century English views featured in a print as a work of art rather than topography. The second pair containing a *Moonlight* by Aert van der Neer (Figure 25) and a *Firelight* by Rembrandt (both published in 1751) contrasted scenes illuminated by artificial and natural light. The special aesthetic and technical problems moon- and

Figure 24. J. Wood after Peter Tillemans, *The View from One-Tree Hill in Greenwich*, etching and engraving, 1744. National Maritime Museum, London.

firelight raised for the artist would fascinate the next generation of English painters, Joseph Wright of Derby in particular. Pirates and imitators soon capitalized on the formula Pond and Hogarth had worked out. In 1746 Vivares offered his own version of 'Four perspective Views of the most considerable Antique Ruins, in or near Rome', which sound suspiciously close to Pond's project. However, Vivares also opened a subscription for 'four of the principal English ruins' to accompany them; he was to make his reputation with these sets of picturesque English views engraved for the publisher Thomas Smith of Derby.[46] Hundreds of such series, including several copies or imitations of the originals by Pond and Hogarth, were listed in the 1775 *Catalogue of Prints* published by Sayer and Bennet, by then one of London's largest printselling firms.[47]

The proliferation of engraved views and reproductions begun by Pond must be considered in light of the loopholes in the so-called Hogarth Act of 1735, which granted copyright protection to certain reproductive engravings. According to Vertue, the Act protected the engraver only if he was also the inventor of the original composition.[48] It did not cover engravers who worked from old master paintings or actual buildings, statues, or views. Other engravers could and did copy their prints legally, although they sometimes faced 'hazard & law suits' in muddy situations. As a result, reproductive old master, portrait, view, and topographical prints flourished after the breakthroughs of the 1740s, becoming cheaper and more plentiful as the century progressed, while prints after contem-

porary works became more expensive and less accessible to the general public.

The prosperity enjoyed by the London reproductive print trade beginning in the 1740s is reflected in the increasing importance of print sales in Arthur Pond's income (Tables 7, 8). Before publication of the *Italian Landscapes* began in 1740, Pond earned between £2 and £36 *per annum* from sales of his prints—largely the *Prints in Imitation of Drawings*. The prints accounted for 1 to 5 per cent of his income but his failure to recover his outlay eliminated net profits. Presumably from 1741, and certainly from 1745 on, Pond (and/or Knapton) gained between £50 and £200 a year from print sales which contributed, on average, 12 per cent of his total income. From 1745 to 1748, his most productive years as a publisher as well as a painter, print sales supplied up to 20 per cent of income and far exceeded art dealing in its economic importance. Since sales depended on a constantly changing inventory, the lull after 1748 when few new prints appeared caused income to drop to 7 per cent.[49] Unlike his increasingly commercial competitiors in the business, Pond retailed few prints by other publishers and so faced declining business as a consequence of his own declining output.

Arthur Pond's remarkable success with the new format and sales methods for reproductive prints from old masters was not an isolated event, although after Hogarth's it is the earliest one documented. The cumulative example of the 'Progresses' and the Italian views inspired an outburst of publications of views, genre, and literary subjects by English engravers. Vertue was decidedly impressed by the number of such projects under way by December 1744, when he wrote, 'this year or this time the most remarkable for works done or doing in Engraveing—in England—mostly undertaken as Pond began with sketches of Drawings—graved then Landskips Pousin and others'.[50] Vertue also singled out Hogarth's *Marriage à la Mode* and projects by Highmore, Samuel and William Buck, W.H. Toms, Thomas Smith, and Francis Vivares, as well as the Knaptons' new edition of the 'Houbraken Heads'. Although most undertakers were also retailers, they began to rely increasingly on the wholesale trade for the distribution and sale of their goods. The old firms carried growing numbers of fine arts reproductive prints bought wholesale from Pond, Thomas Smith of Derby, and other publishers. The list of retailers carrying Pond's *Italian Landscapes* and *Roman Antiquities* expanded to include an old Overton associate Robert Sayer, and Peter and Mary Griffin. Their new businesses were located along Fleet Street, halfway between the traditional publishing center at St. Paul's Churchyard and the artists' district around Covent Garden and Lincoln's Inn Fields.[51] They were joined by many others who filled the back pages of the *Daily Advertiser* with announcements of new shops and new projects. Engravers and importers also

Figure 25. Francis Vivares after Aert van der Neer, *Moonlight*, engraving, 1751. Trustees of the British Museum.

expanded the retail side of their trade, including publications by other Englishmen in their inventories and hiring and training English assistants to increase their own output. John Tinney, Joseph Sympson, W.H. Toms and Francis Vivares were able to enlarge their shops once the boom was under way. The most successful entrepreneur of this type was John Boydell. A pupil and assistant of Toms, Boydell earned a fortune from his cheaply engraved views, was elected an alderman of London, and exerted a major influence on the course of English art through his selection of original English works for publication and exhibition in his Shakespeare Gallery.[52] He deserves ranking with Wedgwood and Boulton as one of England's heroic entrepreneurs.

By the late 1740s print publication had increased at such a rate that retailers could maintain a varied and up-to-date inventory without engaging in production at all, though—as the case below demonstrates—the living was marginal at this early date. Laetitia Pilkington, an Irish

adventuress, had parlayed friendship with Jonathan Swift and a meagre talent for verse into a checkered Grub Street career. When her literary aspirations met with disappointment, she begged fifteen guineas from a patron and opened a pamphlet shop. But, 'having met with a very great Bargain of Prints, which were sold under Distress, and having some Knowledge in that Way, I resolved also to deal in them; so, having decorated out my Windows with them to best advantage, early on Monday morning entered on my new Employ'. Laetitia made a satisfactory living buying and selling prints until her clothes were stolen and her landlord confiscated her inventory in lieu of a quarter's back rent.[53] While hers is hardly an inspiring tale, it does indicate that the printselling trade was no longer the province of specialists, and was more widespread after 1745 than even the newspapers or Vertue indicate.

Commercial expansion depended ultimately on the growth of the audience for reproductive prints. Pond's journal indicates that his patronage not only increased in the 1740s but also became socially and economically more diverse.[54] The purchasers of his *Prints in Imitation of Drawings* had been almost without exception connoisseurs, antiquaries or artists. His later customers, forty to sixty every year, comprised a more varied group—calico printers (Mr. Movillion), school masters (Rev. Thomas Dampier) and physicians (John Ranby) were now intermingled with the social and cultural elites. Hogarth sought to widen the audience further with prints such as the *Industry and Idleness* series aimed at merchants and their apprentices. Like Pond, he modified his subjects for simpler tastes, but it is doubtful that either entrepreneur sold many prints to the lower middle class. That market would eventually be cultivated by Sayer, Boydell, and Darley, who made further drastic concessions to popular tastes and pocketbooks.

BOOK ILLUSTRATION

During the early eighteenth century, book illustration equalled printselling in importance as a market for artists' and engravers' skills and a means of stimulating public interest in the arts and literature. Almost every major English artist of the period worked for the booksellers at some stage of his career, and if his designs appeared in a best seller, he was guaranteed an audience of several thousand readers. (Collaboration also benefited the booksellers who found that quality illustrations increased sales.) William Hogarth, Francis Hayman, and Joseph Highmore—as well as Arthur Pond—first drew public attention by designing illustrations for books which proved to be best sellers.[55] Working with historical or literary texts, they found one of the few commercial outlets available for their own

historical or imaginative compositions. But in spite of these unusual op-
portunities, the commercial and aesthetic limitations imposed by the book-
sellers prevented artists from remaining happily for very long in this
branch of the profession. Production schedules were tied to the publication
of texts, forcing designers and engravers to work hurriedly and sloppily.
Regardless of time pressures, plates were often crudely worked, either
because of the limitations of the engraver, or because the bookseller's large
run necessitated a durably cut plate that could be touched up easily. Pay
for such work was usually low. Finally, ownership of the plate and profits
from the illustrations passed to the publisher, be it a bookseller or a private
patron. This made little difference to the engravers who jobbed for both
print- and booksellers, but it prevented established printsellers like Pond
and Hogarth from undertaking more than one or two such projects during
their careers.

As a result of his 1737 partnership with the Knapton booksellers, Arthur
Pond assisted with two of their most ambitious book illustration projects,
and his agreement with George Anson to undertake the illustrations to
Walter's *Voyage round the World* ... was also probably connected with
the Knaptons' publication of the text for the work. Having little imagin-
ative or creative skill himself, Pond treated book illustrations like repro-
ductive prints—which many of them actually were. As a result, his projects
would exert more influence on subsequent painters and printsellers than
on English book illustration. His emphasis on quality and his ability to
meet deadlines, coupled with the Knaptons' predilection for historical
subjects and patronage of some of the best contemporary draughts-
men and designers, led to the prototypical model for later English
history painting: the production of major historical compositions for the
purpose of public display and the sale of reproductive engravings after
them.

The first of Pond's jobs was illustrating the numerous editions, contin-
uations, and supplements to Rapin's popular *History of England*, first pub-
lished in English translation by James Knapton in 1725. It was not illus-
trated at all until 1733 when George Vertue proposed engraving
appropriate historical portraits. That year Vertue drew up an agreement
with James's heirs John and Paul Knapton which gave him full artistic
control, while 'all the prints from these plates to be publish & sold for our
joint interest, as well by me as them in every way or manner we coud'.[56]
The Knaptons announced the subscription for the Vertue 'Heads of the
Kings of England, and of several Famous Persons' in the *Daily Advertiser*
in August 1733, and publication began in December. Engraved in a dry
and fussy late baroque style, the portraits with elaborate allegorical sur-
rounds were sometimes pedantic, sometimes amusing, and often dull.
Thanks to their novelty and antiquarian merit, and to the popularity of

the text, they sold well, although Vertue fell far behind the publication schedule, requiring two and a half years to complete the series.[57]

In order to forestall competition and please subscribers anxious to bind text and illustrations together, it was essential for Vertue or any illustrator to keep pace with publication of the text. Within three weeks of the Knaptons' announcement of the subscription, rival printsellers had advertised their own sets of plates for Rapin. Claude DuBosc offered portrait heads 'engraved by the most celebrated Masters in Paris', and Henry Overton adapted some old plates 'relating to King Charles I' to the new publication by printing them on paper the same size as that of the text.[58] Meanwhile, the Knaptons sent four plates to Bernard Picart in Amsterdam for completion and anxiously promised subscribers in notices in the *Daily Advertiser* that 'the rest will by engrav'd with all the Expedition the Nature of the Work will admit'.[59]

Vertue's deadline problems encouraged the Knaptons to found a more efficient workshop to execute the illustrations to their sequel to Rapin. In March 1736 they opened the subscription for Nicholas Tindal's *Continuation of Mr. de Rapin Thoyras's History of England, from the Revolution to the Accession of George I*, and a year later announced another set of portrait 'Heads of the Most Illustrious Persons of Great Britain'.[60] Vertue's original agreement with the Knaptons did not extend to the new publication, to which he contributed only nine of the eighty plates. The disappointed engraver argued,

> Surely no person of true honor upon considering such constant practises can say that the Business of Portrait Engraver is the practice of Mr. J[ohn] or P[aul] Knapton, Mr. [George] Knapton face painter Mr. [Charles] Kn[apton] Landskip painter Mr. P[ond] painter or Mr. Gra[velot] or any of their agents in England
>
> all these persons that have now got into this affair—by artifice.
>
> ... I have lately found one artifice made use off seeing I have access to many persons of distinction who will, or do yet, countenance my borrowing pictures to engrave, saying that I keep them too long to Engrave whereas they can draw a picture in a few days and return it again.
>
> as this copy of theires is soon done so they send it away to be gravd, and another expedient is. one or two or three of them are imployed to draw the heads another or two draws the ornaments about it. one graves the head or face. another the draperys and ornaments another the writing so this to every plate is employed five or 6 hands.[61]

Arthur Pond, who had assisted sporadically on the project since 1735, began to travel around England copying historical portraits in the fall of 1737, the probable date of his business agreement with the Knapton

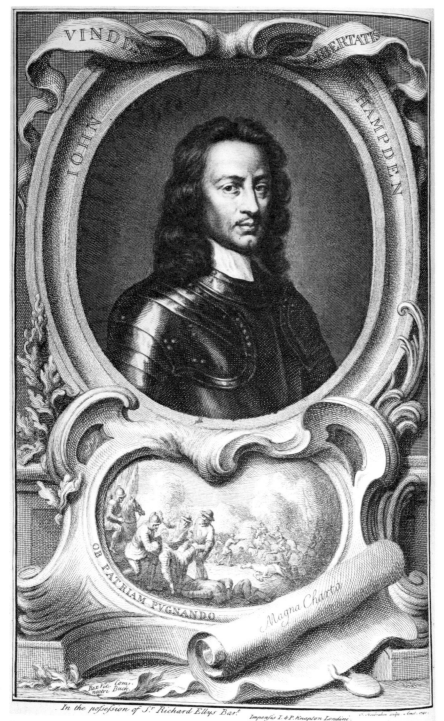

Figure 26. Jacobus Houbraken after an unknown artist, *John Hampden*, engraving, 1740. Philadelphia Museum of Art, Library.

booksellers. So, apparently, did George and perhaps Charles Knapton.[62] Most of the ornaments were drawn by Hubert Gravelot, a French draughtsman working in London. At least one of the plates, that of John Hampden, was drawn and designed by Arthur Pond with the assistance of Wray and Edwards, who quibbled happily over the correct arrangement of their hero's attributes. 'In the meanwhile Pond will be at work upon the head of the Great Hambden and we must have some ornament for it, I can think of nothing at present but the Pilius & dagger lying upon Magna Carta ...', wrote Edwards in November 1739. The Great Queen Street iconographers Gravelot, Pond, and Wray dreamed up something rather different (Figure 26), provoking Edwards to complain, 'Why did you not tell me what Ornament you have thought of for my Heroe [sic]? The Chicanerie you mention if there be any is on your side. I spoke from the heart.'[63]

The portraits and designs were then sent to Amsterdam, where Jacob Houbraken turned them into finished engravings.[64] The end product, a strange mixture of archaic portraiture, baroque allegory, and decorative rococo exuberance, was nevertheless more attractive and sophisticated than anything achieved by Vertue, and Gravelot's designs have been credited with popularizing the rococo style in England. The format became a popular model for many portrait engravings by other publishers, who offered expensive likenesses embellished 'in the Manner of Houbraken' in the late 1730s and 1740s.[65] Pond imitated the format in a 1744 portrait of Lord Anson and the 1745 Garrick (Figures 8, 9), as did Hogarth in his self portrait with his dog Trump, palette, burin, and other attributes. Perhaps because Houbraken was given most of the credit for the plates' attractive appearance, the Knaptons continued to employ him even after the rise in customs duties of 1737–8 reduced or eliminated the cost advantage of the Dutch workshop.

The selection of the eighty 'Houbraken Heads' had been keyed to the contents of Tindal's Continuation. However, the popularity of the prints—which could be purchased separately from the text—outdistanced the sales of the book on which they had initially depended, and inspired the Knaptons to issue another publication, this time designed around the prints. In December 1742 they announced the publication of Thomas Birch's Lives and Characters of eighty Illustrious Persons of Great Britain 'whose Heads are engraven by Mr. Houbraken and Mr. Vertue, proper to be bound up with the same ...'. Three months later they embarked on Volume II of the 'Illustrious Heads' which they would continue to publish until 1751.[66]

Arthur Pond assisted with the project until its completion. He continued to supply the drawings on which the likenesses were based, using the opportunity to publicize his own portraits of Alexander Pope and Sir

Robert Walpole. One of the plates for Volume II, the *Jane Seymour*, was engraved in whole or in part by Pond's employee James Mason (Houbraken's services must have been unavailable in 1746). Pond also supervised the recutting of the plates when they wore down after numerous printings; one concludes that after Charles Knapton's death he bore much of the responsibility for seeing the project through.[67]

Together, Rapin's and Tindal's histories and Vertue's and Houbraken's 'Heads' stimulated interest in collecting English portrait heads. The Earl of Egmont had shown them to the Queen as early as 1736.[68] Horace Walpole began to collect in the 1740s, at which date it was still an unusual hobby. However, by 1759 the antiquary Joseph Ames was confident enough of the audience to publish *A Catalogue of English Heads: or, an Account of about Two Thousand Prints Describing what is peculiar to each ...*, and Granger's biographical list of heads in several collections appeared ten years later. By 1770 Horace Walpole was complaining that the growth of interest—even among the 'ignorant'—was driving up prices and inspiring engravers to publish portraits of marginal characters to fill out constantly expanding sets.[69] Portrait prints—which had risen to prominence on the backs of literary histories—became best sellers in their own right.

The transition from historical portraiture to depictions of historic events in illustrations or prints was not an easy or simple one. Renderings of past or contemporary events were rarely seen in early eighteenth-century England, the only real exception being imported French or Dutch engravings of important battles. Historical events were usually memorialized by portraits of the leading characters involved, maps, or emblematic prints. The concept of representing English heroes in action developed from several eighteenth-century stimuli: exposure to old master paintings depicting historical or mythological events, Hogarth's moral subjects showing contemporary life, and the popularity of several contemporary and historical British heroes whose picturesque adventures merited visual exploitation. One of these popular heroes—succeeding the Duke of Marlborough and preceding the enthralling cast of heroes and villains from the '45 rebellion—was the circumnavigator George Anson.

Anson had set out from England in the fall of 1740 with six unseaworthy ships, an army of decrepit soldiers, and instructions to sail around the world. En route, he was to harry Spanish ships and settlements along the South American coast before capturing the treasure-laden Manila galleon in the China Seas. After mutinies, shipwrecks, naval battles, and wrangles with the Chinese bureaucracy, Anson accomplished his nearly impossible task and returned to England via the Cape of Good Hope, two years after the Admiralty had given him up for dead. The booty from the Manila galleon, amounting to over one million pounds in spices, trade goods, and precious metals and gems, was the richest ever taken by an English commander.[70]

His exploits were celebrated in the newspapers, songs and prints—including Pond's engraved portrait of the commander in a Houbraken-style surround published soon after his return in 1744. Surviving members of the crew began to write their memoirs, and drawings and prints of their encounters with sea lions and Polynesian cannibals began to circulate in the printshops.[71] In the wake of these accounts, some verging on the fabulous themselves, Anson decided to issue an authorized narrative of the voyage drawn from his own logs and ghost-written by one of the officers from the expedition. The task of printing and selling this hot commercial property was given to John and Paul Knapton, probably thanks to the influence of Sandwich and the Yorke family who were in-laws of Anson and members of the Pope's Head Club with Pond and the Knaptons. In January 1745 the Knaptons announced in the papers that the narrative was going to press with a full subscription, and nine months later Anson made the first down payment to Pond for the maps and illustrations to accompany the text.[72]

Pond probably owed this extremely desirable commission to the same influences and associations which brought the Knaptons the printing job. His reputation as a publisher of landscape prints would have encouraged Anson's belief in his suitability. He was, however, hired independently of the booksellers, and was paid directly by Anson in a series of large installments between September 1745 and July 1748 when the text and illustrations were published together in a single bound volume. The original drawings by Percy Brett, a member of Anson's crew, would have been supplied by Anson. Since he had complete control of the project and supervised every aspect of it, Pond's journal shows how an entrepreneur tackled a major job.

Forty-two pages of illustrations accompanied the completed text. Several of these pages bore more than one image and were composed from two or more plates. Other large illustrations had to fold out. Eight enormous charts and plans were printed on fine India paper so their numerous folds would not add unnecessary bulk to the volume. Arthur Pond built the team of engravers of these plates around the core of men he had trained to work on his Italian views. John Wood and James Mason executed most of the large views calling for their established talents for landscape. Johan Sebastian Muller, engaged simultaneously on the *Roman Antiquities*, engraved at least six of the 'sea pieces', including the relatively ambitious *Burning of Payta*. However, in order to keep up with the publishing schedule, Pond had to hire lesser engravers to supplement their work. Nicolas Fougeron, Pierre Charles Canot, and Markus Tuscher contributed between one and three plates each.[73] Fougeron and Canot, as members of the school of French immigrant engravers in London, would have been introduced to Pond by Chatelain or Vivares (if not by their illustrations

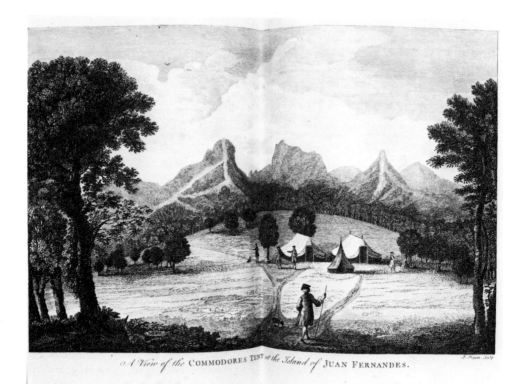

A View of the COMMODORES Tent at the Island of JUAN FERNANDES.

J. Mason Sculp

Figure 27. James Mason [after Percy Brett], *A View of the Commodore's Tent at the Island of Juan Fernandes*, engraving, 1748. British Library.

for other booksellers), but Tuscher was an artist/architect of pretension who had arrived in London from Rome with introductions from Pond's old acquaintances Stosch and Ghezzi.[74] Most of the illustrations can be assigned to these six engravers, but several—crude, unsigned, and not mentioned in the journal—might conceivably have been executed by Pond himself. For the elaborate charts which required a specialist, and the portrait of Anson for the frontispiece, Pond called upon the team which had assisted with the Rapin illustrations. Richard W. Seale had engraved the maps for Rapin's *History* and George Knapton and Houbraken collaborated on the portrait.

The Anson plates cost Pond £168.9.0 for labor and materials. This comes to about £4 per page, and slightly less per plate. The engravers were paid by the plate, with the fee varying according to the size and difficulty of the image. Some of the cruder cuts by the lesser engravers cost about £2, while Seale's large plan of Acapulco and vicinity cost eleven guineas. The finished plates were printed at the Great Queen Street house by Elizabeth Knapton, who received £200 from Pond for the job. Pond bought the paper in bulk from Mr. and Mrs. Watkins, stationers in

London, for £144. The actual printing began some time in the fall of 1747 and was completed in May 1748 when the book appeared and Mrs. Knapton was paid in full. Pond, who had received a total sum from Anson of £703 for the job, kept nearly £200 for himself.[75] This was not as large a fee as it appears when prorated over nearly four years.

When compared to the *Italian Landscapes* executed by many of the same engravers, the Anson illustrations appear relatively naive and crude. This was not the fault of the engravers, who in most instances worked from drawings by members of the ship's crew under Anson's stipulation of unvarnished accuracy. Book illustration also posed a different set of technical problems for the reproductive engraver; plates had to be cut deeply and simply to produce the thousands (as opposed to hundreds) of images required by the large number of subscribers. Nevertheless, Pond and his employees worked hard to bring the illustrations up to the high standards for which the Great Queen Street operation had become known. Some of the designs presented problems which were given standard solutions taken from paintings or reproductive prints. J.S. Muller imitated Dutch marine paintings to add some zest to the technically accurate but dull renderings of sea battles. The Knapton/Houbraken portrait of Anson and Seale's charts followed the conventional formats worked out for Rapin, while two views organized like classical landscapes, showing *A View of the Commodore's Tent at the Island of Juan Fernandes* (Figure 27) and *The Watering Place at Tenian*, might be subtitled 'Claude Lorrain in the South Seas'. Although the Anson illustrations could not approach the artistic quality of other Pond and Knapton projects, several thousand were sold to subscribers to the *Voyage*. Their success may have helped to convince the Knaptons that a market existed for English historical scenes as well as for English historical portraiture.

In any case, the final Knapton publication relating to English history was a projected series of fifty prints 'representing the most memorable Actions and Events, from the Landing of Julius Caesar to the Revolution'. The series synthesized elements from all of their previous book illustration and print publications; events were drawn from Rapin, with an eye to Anson-like heroism, and a brief text like Birch's for the *Illustrious Heads* was to accompany each plate. Subjects were selected to please several audiences. '... In the choice of subjects, care will be taken that they be, first Important, or interesting; secondly, Striking or such as will make Good Pictures; thirdly, So different from each other, as to afford an agreeable Variety.'[76] Like the *Landscapes* and the *Roman Antiquities* they were conceived in decorative sets which could be bought piecemeal for furnishing, or as an instructive whole for binding.

English History Delineated was published jointly by the Knaptons and another leading London bookseller, Robert Dodsley. For both, a series of

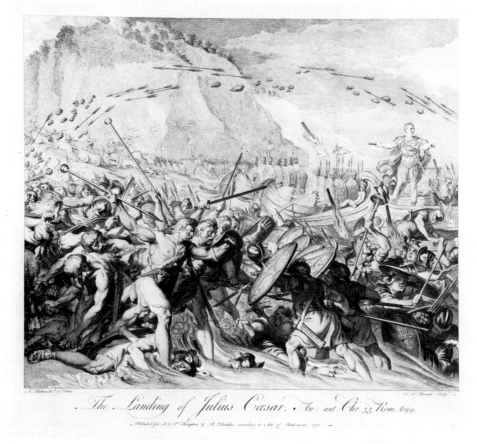

The Landing of Julius Cæsar. An: ant Chr 55 Rom. 699.

Published for S.&P. Knapton & R. Dodsley, according to Act of Parliament 1751

Figure 28. S.F. Ravenet after Nicholas Blakey, *The Landing of Julius Caesar*, engraving, 1751. Yale Center for British Art, Paul Mellon Collection.

fine arts prints more or less independent of a text was a novel undertaking and depended heavily on the assistance of the artists and engravers involved in the project. These men, Francis Hayman, Simon Francois Ravenet, Nicholas Blakey, Charles Grignion and L. G. Scotin, had illustrated books for both publishers and were skilled in depicting the human figure in action. Arthur Pond undoubtedly had a part in conceiving and planning the series, and probably oversaw the printing and maintenance of the plates, which were in his shop at the time of his death.[77] Ravenet, one of the engravers, seems to have coordinated the activities of the draughtsmen and printmakers. Ravenet failed to manage the workmen with Pond's skill. At least one draughtsman viewed his commission as a subsidy for a history painting of monumental proportions (Figure 28). His ambitions,

set out in a letter to Robert Dodsley, helped delay publication of the first
set for one year.

> As you are not of my profession you can't be so sensible as my Self of
> the difficultys to be met with in a Subject of the consequence of the
> Landing of Caesar. For my part I take it to be of so important an
> undertaking that I realy beleive it would require a year to paint a picture
> of it of a reasonable Size, of which time I would bestow upwards of two
> thirds of Scheming and making my Studdys, for I should not desire
> above three or four months to paint it in as many feet square as I have
> drawn it in inches.[78]

Blakey may well have painted his masterpiece, but only a modest drawing
fifteen by eighteen inches was exhibited at the Knaptons' shop as an
inducement to subscribers in 1751. The first set of prints was the only one
published.[79] Soon after its appearance, John and Paul Knapton went
bankrupt, apparently as a result of financial mismanagement over a long
period of time.[80] Although publication of the completed plates continued,
neither Pond nor the Knaptons initiated large scale printselling projects
after 1751. The Dodsleys, undergoing a change of management with the
retirement of Robert, dropped out of the print trade altogether.[81]

Prints and book illustrations played an important role in the develop-
ment of the early eighteenth-century art world. Unlike paintings, they
were numerous, cheap, accessible, and responsive to rapid shifts in public
tastes. Artist-entrepreneurs like Pond and Hogarth were among the first
in England to exploit these special characteristics to further their own
careers and create a favorable atmosphere for the growth of a native school
of painting. Their prints and illustrations introduced artists and audiences
to a range of subjects—classical, landscape, caricature, genre, history—
practically unknown outside the restricted circles of connoisseurs which
would become prime material for painters and draughtsmen later in the
century. By merging continental workshop methods with the commercial
techniques of the booksellers, they created profitable businesses which
could maintain high standards of quality. The subsequent proliferation of
printshops, along with the opening of fine arts auction houses, completed
the process of separating the art and book trades which had begun in the
1720s.

One wonders, however, if the two trail blazers realized they were
paving the way for printselling empires. In the anarchic atmosphere of the
London art world before the founding of the Royal Academy, the print-
sellers, with their commercial alliances and close contact with the public,
were in the best position to shape and profit from its growing interest in
art collecting, drawing, and connoisseurship. Nicholas Blakey realized this
in 1751; the fact burst upon the art world ten years later when John Boydell

published *The Destruction of the Children of Niobe*, a print which made the painter Richard Wilson famous and the publisher rich.[82] Thereafter, painters sought to regain control of the business, excluding engravers and printsellers from membership in the Royal Academy, and themselves publishing prints after their own works, which were increasingly designed to appeal to popular tastes. Some failed and some succeeded, but it was the print market which first encouraged them to paint on speculation rather than command, and to broaden their subjects beyond the traditional limits of aristocratic portraiture.

VIII
Conclusion

On 10 May 1757, Arthur Pond wrote to John Moffat in Boston, 'The word Painter is not necessary in my direction, & I may leave off.'[1] Evidently he was well enough known in London to do without the identifying label; he may also have been considering retirement in order to devote his time to his collections, the newly-founded British Museum, and some well-deserved leisure. Although he would continue to work sporadically until his sudden death from a fever in September 1758, Pond had reached, if not passed, the peak of his fame. By 1760 his reputation had begun the slide from 'Mr. Pond . . . is all in all' to near oblivion. This is not unexpected, given that Pond's importance for subsequent generations of artists and scholars lay not in his paintings, but in his life and activities, and—ultimately—the cryptic entries in his journal of receipts and expenses. He has been rendered more obscure, and at the same time more useful to the scholar, by his very lack of artistic importance; examination of his life and work usually reveals the typical rather than the exceptional. The known facts about him match and illuminate the surviving fragments of information remaining for his contemporaries. In this character as a successful and typical artist-entrepreneur, Arthur Pond serves as the touchstone for a more positive view of the early eighteenth-century London art world than generally has prevailed.

For his own and the succeeding generation of the art world, Pond's significance lay in the fact that he was both English and successful. His example, coupled with those of Hogarth, Hudson, and others, vindicated Jonathan Richardson's early vision of a rising English school and was instrumental in its realization. In competing with foreign artists, Pond demonstrated to patrons that native painters could produce quality work and deserved their encouragement. As a prominent painter and connoisseur, he attracted pupils, followers, imitators and competitors who would form the internationally famous school of artists, engravers, and entrepre-

neurs of England's great age of painting. His position within learned and
gentlemanly circles contributed to the formation of social distinctions
between artists and tradesmen, a crucial step preceding the founding of the
Royal Academy. Simply by succeeding, Pond demonstrated the validity
of Jonathan Richardson's theoretical program for the creation of an
English school of art.

His prints and collections also continued Richardson's policy of fami-
liarizing English artists and audiences with the continental painters, de-
mystifying their work to the point where Joshua Reynolds could argue
that every artist should master and experiment with the various excellen-
cies of the great artists of the past. Slavish adoration of Raphael and
Michelangelo could then be replaced by sophisticated visual allusions to
their work, incorporated into strikingly independent compositions. An
audience versed in connoisseurship and familiar with recognized master-
pieces was prepared to appreciate these developments. Pond, therefore,
was a leading member of the generation who made great advances in the
social and professional status of English artists, and in the formation of an
intelligent, discerning audience.

Yet at the same time that Pond and his friends advocated professional
change, they also ensured the continuity of the mainstream of baroque
classicism in English art from Van Dyck to Richardson to Joshua Rey-
nolds. Pond was one of many portraitists who occasionally dressed the old
baroque postures in flimsy rococo dresses, while his prints from Claude,
Poussin, and Pannini and his own collections made fewer concessions to
the vagaries of fashion. Reissued throughout the eighteenth century, the
prints became the most enduring and influential statement of his aesthetic
values. As a Richardsonian classicist, Pond was grounded not only in a
classical style, but also in a philosophy of painting—one which valued high
ideals and sublime concepts above prettiness, and learning above topicality.
The themes of technical competence and restraint, learning, and idea—
themes stated in Richardson's essays, then exemplified in Pond's collections
and prints—were finally enshrined in Joshua Reynolds's *Discourses*, the
great statement of English academic theory. In discussing the imitation of
Nature (on which Pond's rival Hogarth prided himself), Reynolds wrote:
'The wish of the genuine painter must be more extensive: instead of
endeavoring to amuse mankind with the minute neatness of his imitations,
he must endeavor to improve them by the grandeur of his ideas; instead of
seeking praise, by deceiving the superficial sense of the spectator, he must
strive for fame, by captivating the imagination.'[2] Reynolds placed himself
squarely in the theoretical tradition of Richardson and Pond; it is no
coincidence that his own writings are titled after Richardson's 1719 pub-
lication.[3]

However, Pond was not merely a passive exponent of Richardson's

master plan. His ventures into commercial book illustration and printsell-
ing, surely not envisioned by his mentor, suggest his commitment to art
for a wider public—those who could spare the occasional shilling for
luxury. In this respect Pond matched William Hogarth in the search for
new audiences: together they launched a reproductive print trade that
would dominate the international market after 1760, and open up popular
markets for the fine arts. Building on the repertoire and audiences Pond
and Hogarth had accumulated, John Boydell, Robert Sayer, and others
completed the transformation of print publishing from an artist's sideline
into a distinct enterprise with a balance from exports alone thought to be
worth £60,000 a year.[4] Their exploitation of contemporary artists soon
had them at war with Reynolds and the history painters, but their patron-
age and the revenues from mass sales of reproductive prints made history
painting famous and commercially rewarding after about 1760. While
Pond and his friends may never have attempted history painting them-
selves, their achievements in related professional fields paved the way for
Reynolds's generation.

The re-emergence of Arthur Pond and his friends from two centuries of
obscurity raises some questions about past and present estimations of the
London art world as it existed before 1760. Hogarth's polemical attacks on
his contemporaries must be re-examined, now that some information on
his targets' lives, work, and friends is available.[5] For example, his rivalries
with Pond, revealed in his prints, seem to have originated not from their
differences (which were minor) but from their similarities. Born in the
City of London, trained together at St. Martin's Lane, competitive portrait
painters and venturesome printsellers, friends of writers, men of learning,
and politicians, dedicated to the promotion of English art and artists, they
seem to have differed mainly on the role of imported art in the develop-
ment of a new school of painting.[6] Their approaches to the problems of
patronage—using friends, clubs, and other social connections to procure
buyers—were also similar and probably characteristic of most painters of
the period. While Hogarth had the edge in terms of talent and originality,
his high prices and occasionally eccentric behavior often worked in favor
of his competitors, especially in the volatile and socially-oriented portrait
market. In this context Hogarth sounds less like a messiah denouncing false
prophets, and more like a painter defending his share of the market.
Concerning the effects of connoisseurship of old master paintings on artists
and audiences, he may actually have been wrong; Reynolds criticized him
sharply for failing to master the tradition before attempting his own
history paintings.[7]

Furthermore, Hogarth's views on the early eighteenth-century art au-
diences are probably too pessimistic. Art buyers' preferences for portraits
and old masters did not spring solely from ancestor worship or ignorant

vanity; in Pond's case one can argue that they were satisfying specific iconographic needs within the strengths and limitations of the market. In addition, the popularity of drawing lessons and the willingness of gentlemen to apprentice their sons to the trade indicate a new respect for the artist's skills and profession. While ignorant or fashion-conscious patrons still abounded, many more were becoming interested in art as a means of personal enjoyment or self-improvement. Hogarth seems not to have noticed that the generation of buyers born after 1720, spending large sums on collecting old and contemporary masters, demonstrated discrimination and flair. Nor were artists entirely at the mercy of their audience. Their positions within clubs and learned societies gave them considerable impact on the development of taste and the distribution of patronage, as Pond's and Hogarth's histories demonstrate. The audience's heterogeneous composition did indeed cause difficulties and confusion, but it also stimulated artists to attempt new styles or formats in order to attract and keep public attention. Its sheer size supported the development of the commercial print trade which in turn provided many of the financial opportunities for the new school of history painters.

However, while the art market certainly grew, its popular character should not be overestimated. Hogarth's prints have been described as 'popular', but he seems to have intended only one set for an audience of tradesmen.[8] Still, in terms of size, quality, and price, Hogarth's prints are extremely close to Pond's and must have appealed to a similar audience. Pond's print buyers were more varied than his 'combination', portrait, or old master patrons, but tradesmen were still relatively few and far between. The 'popular' market was served by the cheap, pirated versions offered by a lower class of printsellers, whom Hogarth sought to drive out of business with his 1735 copyright act.

Arthur Pond is important not only as a precursor of Reynolds and a rival of Hogarth, but also because the documents of his life have permitted examination of the issues relevant to both which have been beyond the usual scope of the critic or cataloguer. The end result has been the recreation of the London art world's working environment—the same environment in which Hogarth flourished and fulminated and Reynolds began his illustrious career. It does not closely resemble the place described in much of the subsequent literature. In Pond's art world, a customs duty levied on worked copper was probably more important for his printselling career than Hogarth's well-publicized copyright act. Art dealing was less a murky trade than a commercial vehicle supporting the introduction of enlightenment concepts into aesthetics and connoisseurship. Among the leaders of the art world, portrait painting was providing the financial wherewithal towards higher ends—the creation of an English school of painters capable of working in the 'Grand Style'. Artists and patrons alike believed that the

great future for English painters first envisioned by Jonathan Richardson in 1715 was just over the horizon. The battles, controversy, and competition between factions of artists and patrons which erupted in the late 1740s and 1750s stemmed not from despair, but from a sense of the enormous stakes offered by the booming market for art in England.

From the new perspective granted by Pond's journal accounts, Hogarth's relative position within the London art world appears to have been neither as detached nor as superior as that controversialist may have wished. Nor do Joshua Reynolds and the history painters appear to have sprung full-formed from a vacuum created by Hogarth's death in 1764. Pond and his contemporaries had built up a solid professional and commercial base on which the later eighteenth-century art world would thrive.

Repopulating the art world with its 'lesser men' restores some of its richness—the controversy, the sense of discovery and purpose—and it is no longer the cultural wasteland envisioned by most nineteenth- and some twentieth-century scholars. The very close links between the fields of painting, art dealing, and printselling are reforged, unifying the art world's uneven progress towards such disparate achievements as the founding of the Royal Academy, the success of Boydell's Shakespeare Gallery, and the evolution of a small bookselling firm into Sotheby's art auction house. The period becomes a time of diversity, experiment, assimilation, specialization, and change—an exciting, if difficult transition between the moribund school of Sir Godfrey Kneller and the not-so-sudden maturity of the 'English school' under the leadership of Sir Joshua Reynolds.

A larger and livelier art world fits more comfortably into the context of early eighteenth-century English culture as a whole. Artists' connections with other cultural figures—scholars, poets, scientists, and publishers—were formed and strengthened by their participation in the booming book and print trade and membership in London's numerous clubs. Members of London's cultural scene were bound together even more tightly by the patronage system that operated universally, distinguishing its beneficiaries for their social and political affiliations as well as for their talents and learning. All of them experienced the unsettling transition from the 'great man' patronage of the preceding century to commerce with a larger, heterogeneous audience.

Like literature, drama, horse racing, and tourism, the fine arts trades expanded and commercialized to meet demand from a growing, cultivated audience. The growth of the market encouraged the specialization among producers which followed; painters founded the Royal Academy excluding the engravers and printsellers, who subsequently began to develop large-scale production techniques and mass audiences. The London art world participated wholeheartedly in eighteenth-century England's

commercialization, growing from a weak provincial offshoot of the continental school of painting and the English book trade into a highly specialized, internationally respected aesthetic and commercial enterprise.

NOTES

NOTES TO CHAPTER I

1. C.F. Antal, *Hogarth and His Place in European Art* (London, 1962); Ronald Paulson, *Hogarth: His Life, Art, and Times*, 2 vols. (New Haven and London, 1971).

2. Ellen Miles, 'Thomas Hudson (1701-1779): Portraitist to the British Establishment', 2 vols. (Ph.D. dissertation, Department of the History of Art, Yale University, 1976); Richard Saunders, 'John Smibert (1688-1751): Anglo-American Portrait Painter', 2 vols. (Ph.D. dissertation, Department of the History of Art, Yale University, 1979); Alison Shepherd Lewis, 'Joseph Highmore: 1692-1780' (Ph.D. dissertation, Department of Fine Arts, Harvard University, 1979); Ellen G. D'Oench, *The Conversation Piece: Arthur Devis and His Contemporaries* (exhibition catalogue, New Haven, 1980); Henry Wilder Foote, *John Smibert, Painter* (New York, 1969); Alastair Smart, *The Life and Art of Allan Ramsay* (London, 1952).

3. Ellis Waterhouse, *The Dictionary of British 18th Century Painters in oils and crayons* (Woodbridge, 1981).

4. See for examples Ellis K. Waterhouse, *Painting in Britain 1530-1830* (London, 1962); Joseph Burke, *English Art 1714-1800* (Oxford, 1976); Richard T. Godfrey, *Printmaking in Britain, A General History from its Beginnings to the Present Day* (New York, 1978).

5. H.M. Atherton, *Political Prints in the Age of Hogarth* (Oxford, 1974).

6. Neil McKendrick, John Brewer, and J.H. Plumb, *The Birth of a Consumer Society. The Commercialization of Eighteenth-Century England* (London, 1982).

7. Mark Girouard, *Life in the English Country House. A Social and Architectural History* (New Haven and London, 1978); Denys Sutton, 'Aspects of British Collecting, Part I', *Apollo* 114, no. 237 (November 1981); Francis Haskell and Nicholas Penny, *Taste and the Antique* (New Haven and London, 1981).

8. Ronald Paulson, *Emblem and Expression, Meaning in English Art of the Eighteenth Century* (Cambridge, Mass., 1975), chapter 2.

9. Stanley Green, *Shaftesbury's Philosophy of Religion and Ethics. A Study in Enthusiasm* (Ohio University Press, 1967), p. xi.

10. Ian Watt, *The Rise of the Novel* (London, 1957); Richard D. Altick, *The Shows of London* (Cambridge, Mass. and London, 1978), chapters 1, 2.

11. McKendrick, Brewer, and Plumb, *Birth of a Consumer Society*.

12. Paulson, *Emblem and Expression*, for example. Paulson brilliantly traces the transformation of English art as it shifted from reliance on symbol to use of psychology and expression to transmit essentially literary meanings. He sees Hogarth's *Progresses* as essential

in the process, but ignores the important contributions made by Van Loo, Chardin, and others in the fields of portraiture and conversation pieces. The significance of the fashion for the French style of psychological portraiture in the 1740s has been discussed by Waterhouse in 'English Painting and France in the Eighteenth Century', *Journal of the Warburg and Courtauld Institutes* 15 (1952), pp. 122–35.

13. H.M. Hake, 'Pond's and Knapton's Imitations of Drawings', *Print Collector's Quarterly* 9 (1922), pp. 324–49; Sir Charles Holmes, 'Some Neglected English Masters', *Burlington Magazine* 60, no. 351 (June 1932), pp. 300–7; A.C. Sewter, 'A Portrait by Arthur Pond', *Burlington Magazine* 77, no. 449 (August 1940), pp. 63–4; H.R. Hicks, 'Caricatures by Pietro Leoni Ghezzi (1674–1755), engraved by A. Pond (1705–1758)', *Apollo* 42, no. 246 (August 1945), pp. 198–200. Sources for the biographical information in these articles are the *Dictionary of National Biography*, s.v. Pond, Arthur; Horace Walpole, *Anecdotes of Painting in England; with some account of the principal painters ...*, 4 vols., ed. Rev. James Dallaway (London, 1876), s.v. Pond, Arthur.

14. The only published reference to the Pond papers I have found (outside the B.M. catalogue) is in W.T. Whitley, *Artists and their Friends in England* (1928, reprint New York, 1968).

15. B.M., Add. MS 23724. Arthur Pond. Journal of Receipts and Expenses 1734–1750.

16. V. & A., MS 86.00.18–19. (Richard Houlditch, Jr.), Sale Catalogues of the Principal Collections of Pictures ... Sold by Auction in England ... 1711–1759, 1:59.

17. B.M., Add. MS 23724, ff. 104, 107.

18. B.M., Add. MS 23725. Papers illustrative of the works of Arthur Pond, Engraver & Painter, including particulars of various kinds left by him at the time of his decease & the sale catalogues of his effects 1745–1759.

19. Sydney D. Kitson, 'Notes on a Collection of Portrait Drawings Formed by Dawson Turner', in *Walpole Society*, vol. 21 (Oxford, 1932–3), pp. 67–104.

NOTES TO CHAPTER II

1. London, Guildhall Library, MS 11361. Parish Register of St. Magnus the Martyr 1557–1720 (Baptisms and Burials), f. 91.

2. *Calendar of Marriage Licenses issued by the Faculty Office 1632–1714*, ed. George E. Cockayne and Edward Alexander Fry. *The Index Library*, vol. 33 (London, 1905), p. 148. P.R.O., PROB 11/767 (22 January 1749). Will of John Pond of London Bridge, Surgeon.

3. George Vertue, *Note Books 3, Walpole Society*, vol. 22 (Oxford, 1934), p. 37.

4. B.M., Add. MS 23724. Arthur Pond, Journal of Receipts and Expenses 1734–1750, f. 161.

5. Guildhall Library, MS 11361, ff. 86, 90, 91, 92, 93, 94, 95, 96, 97, 98, 100, 166, 170, 172, 174, 175, 176; Guildhall Library, MS 11362. Register Book of Marriages, Baptisms & Burials of the United Parishes of St. Magnus the Martyr & St. Margaret New Fish Street from September 1712 to December 1812, entry of baptism 14 April 1722, burial 14 January 1724.

6. P.R.O., IR 17/22/2952. Index of Apprentices Names in the Apprenticeship Books of the Inland Revenue Department 1710–1762, s.v. Howard, John. Another friendship which may date back to his childhood was Arthur's with Felix Clay, a draper who opened his shop 'next the Magpye Tavern without Aldgate' in 1724 (Guildhall Library, MS 11936. Sun Fire Insurance Company Policy Registers, 1710–c.1900, vol. 18, no. 33567, 28 October 1724). Clay and Howard acted as the executors of Arthur's will (P.R.O., PROB 11/841 (Middlesex) 30 October 1758. Will of Arthur Pond.).

7. P.R.O., IR 17/31. Index of Apprentices Names, s.v. Pond, William; Guildhall, MS 11936. Sun Fire Registers, vol. 24, no. 42259 (29 July 1727).

8. Eveline Cruickshanks, *Political Untouchables. The Tories and the '45* (New York, 1979), p. 141.

9. William's family history is reconstructed from Guildhall Library, MS 17833. Register Book of the Parish of St. Katherine Coleman, London from 25 March 1666 to 13 September 1741, baptisms 14 February 1734, 13 May 1739, 1 August 1740; Guildhall, MS 17834 (vol. I). Register Book of the Parish of St. Katherine Coleman, London from the 13 September 1741 (Baptisms 1741–1812), 7 January 1742, 1 June 1744; Guildhall, MS 11362. Register Book of . . . the United Parishes, burials 3 January 1746.

10. *The Parish Registers of Sanderstead, Co. Surrey.* Transcr. and ed. W. Bruce Bannerman (London, 1908), p. 30.

11. Philadelphia, Free Library, John Frederick Lewis Collection of Engravers' Letters, vol. L-M, f. 83. Pierre-Jean Mariette to Arthur Pond, 3 August 1730.

12. B.M., Add. MS 23724, ff. 123–82.

13. Ibid., f. 158.

14. P.R.O., PROB 11/841. Will of Arthur Pond. The trustees were John Howard and Felix Clay (see note 6).

15. *A Catalogue of the Genuine and Entire Collection of Italian and other Pictures of Mr. Arthur Pond, Late of Great Queen-Street, Lincoln's-Inn Fields, Deceas'd.* (London: Langford, March 8–9, 1759), annotated copy bound into B.M., Add. MS 23725. Papers Illustrative of the works of Arthur Pond, Engraver & Painter, including particulars of various kinds left by him at the time of his decease & the sale catalogues of his effects 1745–1759, ff. 22–28; John Pond attended Michael Rysbrack's sale in 1764 (Ellen Miles and Jacob Simon, *Thomas Hudson 1701–1779 portrait painter and collector*, exh. cat., Iveagh Bequest, Kenwood, 1979, fig. 8).

16. Cruickshanks, *Political Untouchables*, p. 141.

17. The Durnford family births and burials can be found with those of the Ponds in the parish registers of St. Magnus (see notes 1 and 5). Other information from P.R.O., PROB 11/835 (February 1758). Will of John Durnford, Citizen and Pinmaker of London.

18. Oxford, Bodleian Library. MS 1007. Thomas Edwards, Letter Book 1720–1733, p. 111. Nor did Pond have children. J.T. Smith in *Nollekens and His Times* (1828) ed. W. Whitten, 2 vols. (London and New York, 1917) 1:306–8, records an encounter with a John Pond claiming to be the son of John 'Horse' Pond (a stable keeper and publisher of a racing sheet) and a grandson of Arthur. 'Horse' was said to have a sister immortalized for her equestrian exploits in *The Idler* (Samuel Johnson, *The Idler and the Adventurer*, ed. W.J. Bate, John M. Bullitt, and L.F. Powell (New Haven and London, 1963) p. 19n), thus giving Arthur two children. However, Musgrave records that a William Pond, editor of the *Sportsman's Calendar*, died in 1779, and was followed by his widow 'the horse racer' in 1786. (Sir William Musgrave, *Obituary Prior to 1800. . .*, vol. 5, ed. Sir George Armytage. *Harleian Society* 48 (London, 1910), p. 59,) 'Horse' and his wife or sister may have been children of Arthur's brother John. If they had been illegitimate children of Pond and Elizabeth Knapton, it seems likely they would have been provided for in his will.

19. B.M., Add. MS 23724, passim.

20. P.R.O., PROB 11/841. Will of Arthur Pond; *Parish Registers of Sanderstead*, ed. Bannerman, pp. 30–3, 51.

21. Baron and DuBosc appear constantly in the Vertue *Note Books* 1–6, *Walpole Society*, vols. 18, 20, 22, 24, 26, 30 (Oxford, 1930–50). Their importance and that of the Regniers can be inferred from their frequent notices in the *London Daily Advertiser* after *c.*1730 and their entries in the Sun Policy Registers (Guildhall, MS 11936); they were the only printsellers before *c.*1745 (with the exception of the Bowles Family) to have stock and property meriting fire insurance. For the Vanderbank tapestry makers, see Edith A. Standen, 'Studies in the History of Tapestry: Some Exotic Subjects', *Apollo* 113, no. 233 (July 1981) 44–54.

22. *James Thomson (1700–1748) Letters and Documents*, ed. Alan Dugald McKillop (Lawrence, Kansas, 1958), p. 83.

23. P.R.O., IR 17/24/3380. Index of Apprentices' Names, s.v. Knapton, George.

24. P.R.O., PROB 11/767. Will of John Pond. In the document, John Pond states, 'Whereas I have fully advanced my late Son William Pond and my Son John Pond but have not as Yet any ways advanced my Son Arthur Pond ...' implying that he had not apprenticed him.

25. Vertue, *Note Books* 3:30.

26. Vertue, *Note Books* 6, *Walpole Society*, vol. 30 (Oxford, 1948–50), pp. 168–9.

27. The sad history of Mr. Neckins is laid out in scattered entries in B.M., Add. MS 19929. Memorandum Book of John Bullfinch 1701–1728. Mr. Neckins was employed by Bullfinch to draw copies of portrait heads to be bound into extra-illustrated histories.

28. B.M., Add. MS 39167 B. Minutes of the 'Virtuosi of St. Luke', 1698–1743, ff. 84–5.

29. Vertue, *Note Books*, 6:32–4.

30. John Timbs, *Club Life of London, with anecdotes of the clubs, coffeehouses, and taverns* (London, 1866); R.J. Allen, *The Clubs of Augustan London* (Cambridge, Mass., 1933); Neil McKendrick, John Brewer and J.H. Plumb, *The Birth of a Consumer Society. The Commercialization of Eighteenth-Century England* (London, 1982), pp. 203–62.

31. Vertue, *Note Books* 6:170–1.

32. Hans Hammelman, *Book Illustrators in Eighteenth-Century England*, ed. T.S.R. Boase (New Haven and London, 1975), pp. 79–86.

33. Vertue, *Note Books* 3:20.

34. Hammelman, *Book Illustrators*, pp. 24–6.

35. See Mark Girouard's articles on the Slaughter's group in *Country Life* 139 (13 January 1966), pp. 58–61; (27 January 1966), pp. 188–90; (3 February 1966), pp. 224–7.

36. B.M., Add. MS 23724, f. 14; Elizabeth Johnston, 'Joseph Highmore's Paris Journal, 1734', in *Walpole Society*, vol. 42 (London, 1970), p. 92.

37. Ralph M. Williams, *Poet, Painter, and Parson: The Life of John Dyer* (New York, 1956), pp. 39–40.

38. B.M., Add. MS 23084. George Vertue, MS Note Book, ff. 68–9 refers to Charles Knapton as a landscape painter.

39. *DNB*, s.v. Edwards, Thomas; Wray, Daniel. Williams, *Poet, Painter, and Parson*, p. 39.

40. Williams, *Poet, Painter, Parson*, p. 39.

41. Jonathan Richardson, *The Theory of Painting* (first published 1715, reprinted in *The Works of Jonathan Richardson*, Strawberry Hill, 1792), p. 95.

42. Jonathan Richardson, *An Account of Some of the Statues, Bas-reliefs, Drawings and Pictures in Italy, &c. with Remarks* (London, 1722), pp. vii–viii.

43. Henry Wilder Foote, *John Smibert, Painter* (New York, 1969), chapter I.

44. Oxford, Bodleian Library, MS 1007. Edwards, Letter Book, pp. 66, 70, 83–5, 93.

45. Michael Jaffe, *Cambridge Portraits from Lely to Hockney* (exhibition catalogue, London, 1978), cat. no. 80. The motto in English reads, 'Not considering anything done, whilst anything remained to be done.'

46. *DNB*, s.v. Douglas, James (fourteenth Earl of Morton).

47. Williams, *Poet, Painter, and Parson*; Rev. Robert Aris Willmott, ed., *The Poetical Works of Mark Akenside and John Dyer* (London, 1855), part 2, pp. v–l.

48. Willmott, ed., *Poetical Works ... of John Dyer*, part 2, p. vii.

49. Ibid., part 2, p. viii.

50. Ibid., part 2, pp. 18–21, 23–40, The dedication appears in the notice of the poem's publication listed in the *London Daily Advertiser*, no. 2843 (Wednesday, 5 March 1740). Wray and Edwards had given Dyer material assistance by editing the poem and finding a publisher. Williams, 'The Publication of Dyer's *Ruins of Rome*', *Modern Philology* 44 (1946–1949), 97–101.

51. Oxford, Bodleian Library, MS 1007. Edwards, Letter Book, p. 59.

52. Anthony M. Clark, 'Pier Leone Ghezzi's Portraits', *Paragone* 14, no. 165 (1963), pp. 11–21; Ulrich W. Hiesinger and Ann Percy, eds., *A Scholar Collects: Selections from the Anthony Morris Clark Bequest* (exh. cat., Philadelphia Museum of Art, October 1980–January 1981), pp. 111–12, 118–21.

53. Lesley Lewis, *Connoisseurs and Secret Agents in Eighteenth-Century Rome* (London, 1961); same author, 'Philip von Stosch', *Apollo* 85, n.s., (May 1967), pp. 320–7.

54. P.R.O., State Papers Foreign, SP 85, vol. 16. Walton Letters, Rome (1 March 1727). My thanks to Brinsely Ford for this reference.

55. Pierre-Jean Mariette, 'Abécedario de P.J. Mariette et autres notes inédites de cet amateur sur les arts et les artistes', 6 vols., *Archives de l'art français*, vols. 2, 4, 6, 8, 10, 12 (Paris, 1857–8), vol. 4, pp. 197–8.

56. Pierre-Jean Mariette, *Description sommaire des dessins des grands maistres d'Italie, des Pays-Bas et de France du cabinet de feu M. Crozat, avec des réflexions sur la manière de dessiner des principaux peintres* ... (Paris, 1741), p. xi; quoted in Rosaline Bacou, *Le Cabinet d'un grand amateur P.-J. Mariette 1694–1774* (exh. cat., Paris, Musée du Louvre, 1967), p. 17.

57. Samuel Rocheblave, *Essai sur le Comte de Caylus. L'homme—l'artiste—l'antiquaire* (Paris, 1889), pp. 144–60; M.-J. Dumesnil, *Histoire des plus celebres amateurs francais et de leurs relations avec les autres: Pierre-Jean Mariette 1694–1774* (Paris, 1856), pp. 12–42. Philadelphia, Free Library, Lewis Collection, vol. L-M, f. 83.

58. Hiesinger and Percy, eds., *A Scholar Collects*, pp. 116–18.

59. Mariette, 'Abécedario', vol. 2, *Archives de l'art français*, vol. 4, pp. 353–4. Undated letter to Mariette from Dr. Hickman outlining Pond's complaints about a drawing sent by Mariette.

60. Vertue, *Note Books* 3:62.

61. Lionel Cust and Sidney Colvin, *History of the Society of Dilettanti* (London, 1898), p. 4.

62. Williams, *Poet, Painter, and Parson*, p. 39. Williams is confused about the date that the Club moved to the Great Queen Street House; Pond's journal (B.M., Add. MS 23724, ff. 6–21) confirms that Charles Knapton and Wray were with him in both residences in 1734–5.

63. *The Registers of St. Paul's Church, Covent Garden, London, vol. 1, Christenings 1653–1752*, ed. Rev. William H. Hunt (London, 1906), pp. 218–27, 238. The first child, a son named Charles, was followed by Elizabeth in 1731 and another Elizabeth in 1734.

64. Williams, *Poet, Painter, Parson*, p. 39; Bryant Lillywhite, *London Coffeehouses* (London, 1963), s.v. Serle's indicates that it was a favorite meetingplace for literary types and lazy law students.

65. V. & A., Department of Prints and Drawings, no. 12652. Arthur Pond after Raphael, *Seven Playing Boys* (etching). The original drawing (now at Christ Church, Oxford) belonged to Jonathan Richardson. The inscription in full reads: 'Nobilibus, Politis, Doctis Viris, qui in Sodalitium vere Romanum coiere, in Ordinem Cl. Singulari beneficio cooptatus, Arth: Pond Gratissimo, quo potest, animo hanc Typum dedicat.' Williams, 'The Publication of Dyer's *Ruins of Rome*', p. 101, n.

66. *DNB*, s.v. Montagu, John (fourth Earl of Sandwich); John Cooke, 'Memoirs of the noble author's life', in *A voyage performed by the late Earl of Sandwich round the Mediterranean in the years 1738 and 1739. Written by himself* ... (London, 1799), p. iii.

67. Cust and Colvin, *Dilettanti*, p. 8; *An Alphabetical List of the Royal Society* (annual broadsides) copies in the Guildhall Library, London.

68. Richard Glover, *Leonidas, A Poem* (London, 1737).

69. Charles Knapton's death is recorded in P.R.O., PROB 6/118 (October 1742). Grants of Administration for Middlesex.

70. *The Philosophical Transactions of the Royal Society of London ... abridged*, vol. 8 (1735–1743), (London, 1809), pp. 437–8.

71. Edwards's payments for lodgings, with very small sums added for coal and food, indicate that he was rarely in London (B.M., Add. MS 23724, ff. 57, 79, 95, 120, 152, 176; For Dyer, see ibid., f. 137.) The most explicit discussion of Pond's relationship with Elizabeth Knapton occurs in B.M., Add. MS 29867. Emmanuel Mendes da Costa: Anecdotes and Notices of Collectors, s.v. Pond. (My thanks to Edward Croft-Murray and Sheila O'Connell for sharing this information with me.)

72. B.M., Add. MS 23724; Oxford, Bodleian MS 1012. Thomas Edwards, Letter Book 1752–1756, pp. 7, 212.

73. B.M., Add. MS 23724, ff. 8–21.

74. Cust and Colvin, *Dilettanti*, pp. 4–8; B.M., Add. MS 23724, ff. 47, 59, 64, 75, 89, 115; Oxford, Bodleian MS 1009. Thomas Edwards, Letter Book 1738–1742, pp. 162–3, 200–1, 216.

75. F.M. O'Donoghue and Henry M. Hake, *Catalogue of Engraved British Portraits preserved in the Department of Prints and Drawings in the British Museum*, 6 vols. (London, 1909–25); s.v. Bradley, Ben. Joseph Ames, *A Catalogue of English Heads: or, an Account of about Two Thousand Prints Describing what is peculiar to each* (London, 1758), p. 15. Houlditch's involvement in the club is based on a caricature formerly in the B.M., Department of Prints and Drawings, Personal and Political Satires, No. 2011. *A Smoking Party* (anonymous etching, now lost) recorded in Frederic George Stephens, *Catalogue of Prints and Drawings in the British Museum*. Division I. *Political and Personal Satires*, 4 vols. (London, 1870–83), cat. no. 2011, p. 865.

76. 'Richard Houlditch, Esq. his Particular Inventory . . .', *Inventories of Goods of Directors of the South Sea Company* (London, 1721); P.G.M. Dickson, *The Financial Revolution in England: A Study in the Development of Public Credit* (New York, 1967), p. 119; Frits Lugt, *Les Marques de Collections de dessins & d'estampes . . .* (Amsterdam, 1921), p. 415 (L. 2214, 2215). Lugt and others have confused Houlditch senior and junior, both important drawing collectors. The Houlditch sales of 1744 and 1760 listed in Lugt as Houlditch Sr. are actually from the collections of his son.

77. B.M., Add. MS 23724, ff. 42, 58.

78. Ibid., ff. 47–50, 69.

79. Ibid., ff. 101–3, 108–91.

80. William K. Wimsatt, *The Portraits of Alexander Pope* (New Haven and London, 1965), cat. no. 43.3, pp. 190–92 for listings of the editions of the *Essay on Man* embellished by Warburton's notes and Pond's portraits. Their great project was *The Works of Alexander Pope Esq. In Nine Volumes Complete . . . together with the commentaries and notes of Mr. Warburton* (London, 1751).

81. B.M., Add. MS 23724, f. 115 (Rogers and Paul).

82. See John Nichols, *Literary Anecdotes of the 18th Century; Comprizing Biographical Memoirs of William Bowyer . . . 9 vols.* (London, 1812–1815), 3:255–57; (Julian Stock *et al.*), *An Exhibition of Old Master and English Drawings and European Bronzes from the Collection of Charles Rogers and the William Cotton Bequest* (exhibition catalogue, London, Sotheby's, 1979). Charles Lowth became a regular patron in 1745 (B.M., Add. MS 23724, ff. 116–80).

83. Robert Paul, deputy director of the customs, elected F.R.S. 1725; his son Horatio fled England in 1751 and became an art dealer (Stock *et al.*), *Exhibition*, p. 7. Harry Burrard, official in the customs office 1731–40, M.P. for Lymington 1741–78 (Romney Sedgwick, *The History of Parliament: The House of Commons 1715–1754* 2 vols. (London, 1970), s.v. Burrard, Henry). His letter to John Howard mourning Pond's death is preserved in the estate papers, B.M., Add. MS 23725, f. 10.

84. For Charles Lowth, see Guildhall Library, MS 11936, vol. 65, no. 94585 (7 April 1743), vol. 84, no. 114561 (22 December 1748); his collection of prints and drawings was sold at Langford's in January 1767 (Frits Lugt, *Repertoire des Catalogues de Ventes Publiques intéressant l'art ou la curiosité*, The Hague, 1937, vol. 1, no. 1585). Hillier began buying from Pond in

1747 (B.M., Add. MS 23724, f. 141) and was a regular member of the group by 1751 (Plymouth, City Museum and Art Gallery, Cottonian Collection. Correspondence of Charles Rogers D.37). Musgrave, *Obituary*, vol. 3. *Harleian Society* vol. 46 (1900), p. 217. A manuscript inventory of his drawing collection is preserved in the British Museum, Department of Prints and Drawings. For Robert Mann, see (Stock *et al.*), *Exhibition*, p. 6.

85. B.M., Add. MS 29867, s.v. Pond, Arthur; Add. MS 23724, f. 160; Add. MS 23725, f. 15. Neilson was not entirely cut from Pond's will, but inherited a paltry £25, the smallest sum mentioned (P.R.O., PROB 11/841, Will of Arthur Pond).

86. *An Alphabetical List of the Royal Society* (annual broadsides, 1724-58) copies in the Guildhall Library; *A List of the Society of Antiquaries, from 1717 to 1796; in chronological and alphabetical order* (London, 1798).

87. Sir Archibald Geikie, *Annals of the Royal Society Club. The Record of a London Dining-Club in the Eighteenth and Nineteenth Centuries* (London, 1917).

NOTES TO CHAPTER III

1. Greater London Council, *The Parish of St. Paul Covent Garden, The Survey of London*, vol. 36 (London, 1970), pp. 91, 95, 97.

2. London, Guildhall Library, MS 11936. Sun Fire Insurance Company Policy Registers, 1710-*c*.1900, vol. 83, no. 113091 (6 August 1748, Hudson); Ellen G. D'Oench, *The Conversation Piece: Arthur Devis and His Contemporaries* (exhibition catalogue, New Haven, 1980), p. 13; John Perceval, first Earl of Egmont, *Diary*, 3 vols., *Historical Manuscripts Commission*, vol. 31 (1920, 1923), 3:127. I am grateful to Warren Mild for bringing the references in the *Diary* to my attention.

3. Perceval, *Diary* 2:127.

4. B.M., Add. MS 23725. Papers illustrative of the works of Arthur Pond, Engraver & Painter, including particulars of various kinds left by him at the time of his decease & the sale catalogues of his effects 1745-1759, ff. 15-16; B.M., Add. MS 23724. Arthur Pond, Journal of Receipts and Expenses 1734-1750, f. 59; Rupert Gunnis, *Dictionary of British Sculptors 1660-1851*, revised ed. (London, 1964), s.v. Adye, Thomas.

5. B.M., Add. MS 23724, ff. 16, 17, 18, 19, 20.

6. Ronald Paulson, *Hogarth: His Life, Art, and Times*, 2 vols. (New Haven and London, 1971), 1:340, 423. If Arthur Pond had had a shop sign, it would have been mentioned in his insurance policy or his newspaper advertisements.

7. Jean Rouquet, *The Present State of the Arts in England* (London, 1755), p. 39.

8. George Vertue, *Note Books* 3, *Walpole Society*, vol. 22 (Oxford, 1934), p. 37.

9. Ibid., p. 105.

10. *The Autobiography and Correspondence of Mary Granville, Mrs. Delaney*, ed. Lady Llanover, 3 vols. (London, 1861), 1:485.

11. *Horace Walpole's Correspondence with Thomas Gray, Richard West and Thomas Ashton*, ed. W.S. Lewis, George L. Lam and Charles H. Bennett, *Yale Edition of Horace Walpole's Correspondence*, vols. 13-14; (New Haven, 1948 *et seq.*), vol. 14, pp. 26-7.

12. B.M., Add. MS 23724, f. 20.

13. Ibid., f. 148.

14. Ibid., f. 82.

15. Lowth bought steadily from Pond between 1745 and April 1750, although his name first appears in the journal in December 1739 (B.M., Add. MS 23724, ff. 69, 116-81).

16. B.M., Add. MS 23724, f. 162.

17. Ibid., f. 2.

18. Ibid., f. 6.

19. Ibid., ff. 115 (Barber); 8, 14, 15, 34, 57, 100, 113, 114 (Bellers); 120, 165 (Smibert). Walter George Strickland, *A Dictionary of Irish Artists* (Shannon, 1969), s.v. Barber; B.M.,

Add. MS 23095. George Vertue. Memorandum Book 1715–1751, f. 18; Henry Wilder Foote, *John Smibert, Painter* (New York, 1969).

20. B.M., Add. MS 23724, f. 175; Vivares opened his printselling business by 1749. *London Daily Advertiser,* no. 5745 (3 June 1749).

21. B.M., Add. MS 23724, ff. 67, 72. Numerous payments from Charles Knapton between the years 1735 and 1742 may have been either for rent, or in connection with the illustrating project.

22. Ibid., ff. 22, 40, 75.

23. Ibid., ff. 22, 50.

24. Ibid., ff. 51, 53, 72.

25. Vertue, *Note Books* 3:79.

26. B.M., Add. MS 23724, ff. 21, 39, 41.

27. Ibid., f. 63; Add. MS 23725, f. 13.

28. Ellen Miles, 'Thomas Hudson (1701–1779): Portraitist to the British Establishment', 2 vols. (Ph.D. dissertation, Yale University, 1976); Alastair Smart, *The Life and Art of Allan Ramsay* (London, 1952); D'Oench, *Conversation Piece.*

29. Strickland, *Irish Artists,* s.v. Barber.

30. There is no direct evidence that Pond actually visited Bath. However, gaps in his Journal indicate that he was frequently out of London between 1740 and 1743, while many of his patrons of the period lived or owned property in the town.

31. See note 9, above.

32. *The Autobiography . . . of Mrs. Delaney* 1:485.

33. Perceval, *Diary* 2:364.

34. B.M., Add. MS 23724, ff. 15, 46, 62, 63; Pond's portrait of Lord Lansdowne was sold 28 March 1974 by Leo Spik, Berlin, lot 285.

35. *The Autobiography . . . of Mrs. Delaney* 1, passim.

36. B.M., Add. MS 23724, ff. 16, 18, 33, 92.

37. Ibid., ff. 68, 73, 104, 111, 147.

38. Ibid., ff. 16–141 (Charles Hamilton), 47, 65, 70, 74 (Glover).

39. Ibid., ff. 100–82; Horace Walpole, *Anecdotes of Painting in England;* [1760–1795], eds. Frederick W. Hilles and Philip B. Daghlian (New Haven and London, 1937), p. 204; Francis Askham (pseud. J.E.C. Greenwood), *The Gay Delavals* (London, 1955), passim.

40. P.R.O., Apprentice Index. IR 17/15/1564.

41. Sir Archibald Geikie, *Annals of the Royal Society Club* (London, 1917), p. 60.

42. For example, the Tobacco Club ordered mezzotint prints after Pond's portrait of their president Ben Bradley (B.M., Add. MS 23724, ff. 42, 58).

43. B.M., Add. MS 23724, ff. 62, 70, 85, 151, 163 (Morton); Lord King's name appears in the Journal sixteen times between August 1734 and January 1739 (ff. 6–58); John Nichols, *Literary Anecdotes of the 18th Century; Comprizing Biographical Memoirs of William Bowyer . . . and Biographical Anecdotes of a Considerable Number of Eminent Writers and Ingenious Artists,* 9 vols. (London, 1812–15), 2:441.

44. B.M., Add. MS 23724, ff. 62, 69, 81; for Lady Brown, see *DNB,* s.v. Brown, Sir Robert.

45. B.M., Add. MS 23724, ff. 14–33.

46. Lionel Cust and Sidney Colvin, *History of the Society of Dilettanti* (London, 1898), p. 64.

47. B.M., Add. MS 23724, ff. 14–164 (Peter Delmé); 7–9, 11, 14, 18 (John Delmé); 57, 62 (Lyddell); 151, 161, 172 (Anne Delmé, future Lady Lyddell and Baroness Ravensworth); for Peter Delmé, see Romney Sedgwick, *The History of Parliament: The House of Commons 1715–1754,* 2 vols. (London, 1970), s.v. Delmé, Peter; E. Beresford Chancellor, *The History of the Squares of London Topographical and Historical* (London, 1907), pp. 27–30.

48. B.M., Add. MS 23724. Charles Hamilton's name occurs in the Journal eighteen times between f. 17 and f. 74; Fauquier's twenty-six times between f. 17 and f. 154.

49. Ibid., ff. 41, 59, 61, 158; *DNB*, s.v. Wollaston, Francis.

50. *DNB.*, s.v. Stillingfleet, Benjamin. Stillingfleet, William Windham, Richard Ald-
worth, and Robert Price (all Pond patrons) were also members. Aldworth and Dampier
knew and corresponded with the Earl of Sandwich, another Roman Club member and
Dilettant.

51. B.M., Add. MS 23724, ff. 24 (Dingley); 79, 104 (Churchill); 128, 157 (Bedford). Other
members of the Society who patronized Pond: Thomas Anson, Robert Coke, Mr. Degge,
Mr. Denny, Lord Duncannon (third Viscount Bessborough), Viscount Galway, Simon,
first Earl Harcourt, Robert D'Arcy, fourth Earl of Holderness, George Knapton, Sir
Brownlow Sherrard, Sewallis Shirley, William Strode, William Turner, Charles Hanbury
Williams.

52. B.M., Add. MS 23724, ff. 128, 157 (Bedford); 127, 157 (Brand); Add. MS 23725, f. 12
(Aldworth).

53. Daniel A. Baugh, *British Naval Administration in the Age of Walpole* (Princeton, 1965),
pp. 55, 59, 74. B.M., Add. MS 23724, ff. 120, 137, 145, 149, 153 (Anson), 181 (Grenville),
122, 124 (Duncannon), 129 (Gashry), 104, 157, 162 (Townshend).

54. Eveline Cruickshanks, *Political Untouchables. The Tories and the '45* (New York, 1979),
pp. 23–4; *DNB.*, s.v. Carte, Thomas; B.M., Add. MS 23724, f. 52.

55. B.M., Add. MS 23725, f. 22; Add. MS 23724, ff. 14, 15, 21, 28, 39, 62, 65; *DNB.*, s.v.
Barber, Mary.

56. B.M., Add. MS 23724, ff. 63, 101, 102, 103, 122, 156. Mary Barber's *Poems on Several
Occasions* were published in London in 1734, prefaced by a letter addressed to the Earl of
Orrery. Mrs. Barber also knew the Countess of Dysart, addressed in two of the verses, and
Mrs. Delaney, who later assisted her son Rupert with his painting career in Ireland
(*Autobiography . . . of Mrs. Delaney* 3:116 and passim.).

57. Oxford, Bodleian Library, MS 1010. Thomas Edwards, Letter Book 1742–1747, p. 44.

58. Philip C. Yorke, *The Life and Correspondence of Philip Yorke Earl of Hardwicke Lord High
Chancellor*, 3 vols. (Cambridge and Chicago, 1913), 1:213; *DNB*, s.v. Wray, Daniel.

59. Ralph M. Williams, *Poet, Painter, and Parson: The Life of John Dyer* (New York, 1956),
p. 123; *DNB*, s.v. Edwards, Thomas; *The Sonnets of Thomas Edwards* (Los Angeles, 1974),
introduction by D.G. Donovan.

60. Geikie, *Royal Society Club*, pp. 11–12, 27, 38, 40.

61. *DNB*, s.v. Yorke, Philip (first Lord Hardwicke); Yorke, Philip (second Lord Hard-
wicke); Yorke, Charles; Wray, Daniel; Edwards, Thomas. Arthur Pond was hired
to clean and restore the wall frescos at Montague House for the Museum's opening
(Edward Croft-Murray, *Decorative Painting in England 1537–1837*, 2 vols. (London 1970),
2:320).

62. B.M., Add. MS 23724, ff. 152–82 (Appleyard); Yorke, *Life and Correspondence of Philip
Yorke . . .*, 2:586.

63. Joyce Godber, 'The Marchioness Grey of Wrest Park', *Bedfordshire Historical Society* 47
(1968).

64. B.M., Add. MS 23724, ff. 112, 164; John Kerslake, *Early Georgian Portraits*, 2 vols.
(London, 1977), vol. 2, plate 15; Benjamin Boyce, *The Benevolent Man. A Life of Ralph
Allen of Bath* (Cambridge, Mass., 1967), pp. 167, 169, 178, 241 for Allen's involvement
with Yorke, Pond and the Knaptons.

65. Yorke, *Life and Correspondence of Philip Yorke . . .*, 1:203.

66. Ibid., 2:556–98; *An Alphabetical List of the Royal Society* (printed broadsides, Guildhall
Library, 1724–1758); *A List of the Society of Antiquaries, From 1717 to 1796*; (London, 1798);
Geikie, *Royal Society Club*, p. 9; B.M., Add. MS 23724, f. 167.

67. B.M., Add. MS 23724, ff. 137, 145, 149, 153.

68. Sedgwick, *The House of Commons*, s.v. Yorke, Philip (second Lord Hardwicke); B.M.,
Add. MS 23724, ff. 97, 102, 113, 122, 152.

69. Sedgwick, *The House of Commons*, s.v., Shepheard, Samuel; Guildhall, MS 11936, vol. 83, no. 112332-4 (3 June 1748); B.M., Add. MS 23724, ff. 95, 120, 154.

70. Sedgwick, *The House of Commons*, s.v., Lyttelton, George; B.M., Add. MS 23724, f. 127.

71. Yorke, *Life and Correspondence of Philip Yorke* ..., 1:422-3; B.M., Add. MS 23724, f. 113.

72. Yorke, *Life and Correspondence of Philip Yorke* ..., 2:560; B.M., Add. MS 23724, f. 124.

73. *Horace Walpole's Correspondence with Sir Horace Mann*, 11 vols., ed. W.S. Lewis, Warren Hunting Smith and George L. Lam, *The Yale Edition of Horace Walpole's Correspondence* vols. 17-27 (New Haven, 1954-71), 11:passim; *DNB*, s.v. Weston, Edward; B.M., Add. MS 23724, ff. 145, 156.

74. Benedict Nicolson and John Kerslake, *The Treasures of the Founding Hospital* (Oxford, 1972), pp. 20-32.

75. Perceval, *Diary* 2; B.M., Add. MS 23724, ff. 36, 101 (Bouverie); 104, 105, 106, 116 (Oglethorpe); 110, 115 (Tuffnell).

76. The patrons in question are John Barker, Robert Dingley, and Ralph Allen. John Chaloner Smith, *British Mezzotinto Portraits*, 4 vols. (London, 1883), 1:209, 2:741; B.M., Add. MS 23724, ff. 24 (Dingley); 20, 116, 134 (Barker); Boyce, *The Benevolent Man*, p. 263.

77. Rouquet, *Present State*, p. 80: *London Daily Advertiser*, no. 116 (17 June 1731), for example.

78. See, for example, the advertisement of John Warwell in *The Bristol Journal* (20 November 1756). I am grateful to Jeff Looney for supplying me with this reference.

79. *London Daily Advertiser*, no. 1247 (27 January 1734 O.S.), etc.

80. Vertue, *Note Books 6*, *Walpole Society*, vol. 30 (Oxford, 1951-2), p. 134.

81. *London Daily Advertiser*, no. 4335 (14 September 1744).

82. Ibid., no. 4457 (29 April 1745).

83. Ibid., no. 4462 (4 May 1745).

84. Rouquet, *Present State*, pp. 82-3.

85. John Faber, Jr. after Pond, *Benjamin Bradley*, mezzotint, 1737; John Faber, Jr. after Pond, *Princess Mary* and *Princess Louisa*, mezzotints, *c.* 1740; Charles Grignion after Pond, *George Anson*, engraving, 1744; J. Wood after Pond, *David Garrick*, engraving, 1745; S.F. Ravenet after Pond, *William Augustus, Duke of Comberland*, engraving, 1747; James McArdell after Pond, *David Garrick*, mezzotint, 1748; James McArdell after Pond, *Peg Woffington*, mezzotint, 1750.

86. Vertue, *Note Books 6*:199, 202.

87. The portrait of David Garrick appeared in the *London Magazine* (1749) opposite p. 282 (London, National Portrait Gallery, Guthrie Room, s.v. Garrick); Anson's in the *Universal Magazine* (1748) (F.M. O'Donoghue and Henry M. Hake, *Catalogue of Engraved British Portraits preserved in the Department of Prints and Drawings in the British Museum*, 6 vols. (London, 1909-25), s.v. Anson, no. 2); Pope's portrait in the *London Magazine* (O'Donoghue and Hake, *Engraved British Portraits*, s.v. Pope, no. 57).

88. Richard Glover, *Leonidas, a poem* (London, 1737); Conyers Middleton, *The History of the Life of Marcus Tullius Cicero*, 2 vols. (London, 1741); Richard Walter, *A Voyage round the World in the Years MDCCXL, I, II, III, IV by George Anson* (London, 1748); W.K. Wimsatt, *The Portraits of Alexander Pope* (New Haven and London, 1965), cat. no. 43.3, pp. 190-2.

89. William Hogarth, *The Analysis of Beauty*, ed. Joseph Burke (Oxford, 1955); John Pye, *The Patronage of British Art, an historical sketch* (London, 1845); Michael Foss, *The Age of Patronage: The Arts in Society 1660-1750* (London, 1971). The best study of early eighteenth century art patronage is Mark Girouard's series of articles on the St. Martin's Lane/ Slaughter's group in *Country Life* 139, (1966) pp. 58-61, 188-90, 224-7.

NOTES TO CHAPTER IV

1. Laetitia Pilkington, *Memoirs of Mrs. Laetitia Pilkington, Wife to the Rev. Mr. Pilkington*, 3 vols. (London, 1748, 1749, 1754) 2:240-1.

2. Romney Sedgwick, *The History of Parliament: The House of Commons 1715-1754*, 2 vols. (London, 1970), s.v. Delmé, Peter; Lionel Cust and Sidney Colvin, *History of the Society of Dilettanti* (London, 1898), p. 8.

3. B.M., Add. MS 23724. Arthur Pond, Journal of Receipts and Expenses 1734-1750, ff. 7, 48, 50, 60, 75, 114, 126, 163; V. & A., MS 86.00.18-19. (Richard Houlditch, Jr.), Sale Catalogues of the Principal Collections of Pictures ... Sold by Auction in England ... 1711-1759, 1:275.

4. George Vertue, *Note Books*, vol. 3, *Walpole Society*, vol. 22 (Oxford, 1934), pp. 112, 113, 117.

5. B.M., Add. MS 23724, ff. 62, 151, 172 (Lyddell); 9 (John Delmé).

6. Ibid., ff. 20, 24, 40, 55, 58.

7. Ibid., ff. 32, 57, 82, 89, 122, 127.

8. Kenneth Woodbridge, *Landscape and Antiquity: Aspects of English Culture at Stourhead 1718 to 1838* (Oxford, 1970), pp. 22, 38; B.M., Add. MS 23724, ff. 129, 137, 140, 149, 156, 159, 160, 165, 176 (Hoare), 44, 57, 69, 70, 72, 114, 125, 127, 128, 161 (Price).

9. Income from twenty-one 'stalwarts' and their immediate families amounted to £2550.08.6.

10. *DNB*, s.v. Douglas, James, fourteenth Earl of Morton; Boyle, James, fifth Earl of Orrery. B.M., Add. MS 23724, ff. 62, 70, 85, 151, 163 (Morton), 63, 101, 102, 103, 122, 156 (Orrery).

11. Two Lord James Cavendishes existed in the early eighteenth century. One, a brother to the second Duke of Devonshire, died in 1751; the other, a son of the Duke, died in 1741 and has usually been cited as the collector. However, Lord James bought continuously from Pond from 1735 to 1749, suggesting that the former should be identified as the collector. B.M., Add. MS 23724, ff. 18, 25, 32, 36, 52, 62, 73, 113, 126, 127, 152, 153, 164. Sedgwick, *History of Parliament*, s.v. Hamilton, Charles.

12. Sedgwick, *History of Parliament*, s.v. Raymond, John (alt. spelling Jones); Yorke, Charles; Delmé, Peter; Bouverie, Jacob. For Fauquier and Houlditch, see Ch. II above.

13. George Edward Cockayne, *The Complete Peerage of England, Scotland, Ireland ... extant, extinct or dormant*, s.v. Dacre (Barret-Lennard, seventeenth Baron); Sedgwick, *History of Parliament*, s.v. Delaval, Francis; Morrice, William; *DNB*, s.v. Price, Robert.

14. *London Daily Advertiser*, no. 6247 (16 January 1751) Obituary.

15. B.M., Add. MS 23724, ff. 51 (Williams), 52 (Carte).

16. Ibid., ff. 17 (Horace Walpole), 77 (Sir Robert Walpole).

17. V. & A., MS 86.00.18-19, 1:275 (Andrew Hay's Sale, 1738, 'lot 166 A Landscape, and Figures, G. & N. Poussin, 40.19. Pond. Delme').

18. See Ch. VI below.

19. For reciprocal patronage with Charles Lowth, see Ch. III, n. 15; with Mann, B.M., Add. MS 23724, ff. 151, 152, 153; Pond's calls on Christopher Batt began August 1745, on Raymond they began May 1739 but did not become frequent until August 1745. Ibid., ff. 63, 119.

20. Pond sold 'Seasons' to Sir Francis St. John and Colonel Hatton in 1738; to Sir Harry Lyddell, Thomas Lewis, and Sir William Morrice in 1739. Lord Duncannon bought copies after Liotard in 1745 and 1746, followed by the Duke of Rutland and the Duchess of Bedford in 1746. B.M., Add. MS 23724, ff. 49, 55, 57, 59, 69, 78 ('Seasons'), 122, 124, 128 ('Turk women').

21. Purchasers of copies after Italian landscapes were: Lord Hardwicke (Poussin) in 1742; Dr. Gregory (Pannini) in 1743; John Knapton (Claude) in 1744; Samuel Tuffnell (Pannini),

General Oglethorpe (two Claudes) and Robert Copley (Claude) in 1745; Hans Stanley (Claude) and Beeston Long (Pannini) in 1746; Mr. Smith (Pannini) and Mrs. Delaney (Claude) in 1747; Mr. Delahaise (Poussin) and Mr. James Henkell (Claude) in 1748; Robert Doughty (Claude) in 1750. B.M., Add. MS 23724, ff. 88, 97, 107, 115, 116, 117, 123, 124, 138, 148, 157.

22. Purchasers of 'Drawing and Coloring': Mr. Knox and James Calthorpe in 1747; George Montgomery in 1748; Captain Beckford in 1749. B.M., Add. MS 23724, ff. 144, 146, 151, 166.

23. For King, see n.6 above; B.M., Add. MS 23724, ff. 144, 160 (Raymond), 120, 121, 124, 126 (Long).

24. Oxford, Bodleian Library. MS 1011. Thomas Edwards, Letter Book 1747-1752, pp. 143-4.

25. B.M., Add. MS 23724, ff. 173, 176.

26. For Duncannon, see n. 21 above. B.M., Add. MS 23724, f. 77; Horace Walpole, *Ædes Walpolianae*, 2nd ed. (London, 1752), p. 52 describes the contents of the salon. The portrait of Maria Walpole is still at Houghton.

27. V. & A., MS 86.00.18-19, passim.

28. Ibid., passim.

29. Ibid., 2:100.

30. B.M., Add. MS 23724, ff. 115, 161 (Delaval), 70, 85 (Morton).

31. John Kerslake, *Early Georgian Portraits*, 2 vols. (London, 1977), s.v. Egmont.

32. B.M., Add. MS 23724, ff. 40, 46.

33. John Perceval, first Earl of Egmont, *Diary*, 3 vols. *Historical Manuscripts Commission*, vol. 31 (London, 1920, 1923) 3:127, 146.

34. Thaddeus Mason Harris, D.D., *Biographical Memoirs of James Oglethorpe, Founder of the Colony of Georgia* ... (Boston, 1841), p. 278; B.M., Add. MS 23724, ff. 104-6, 116.

35. B.M., Add. MS 23724, f. 73.

36. Ibid., f. 161.

37. *Master John Walker* was paid for in July 1736 (B.M., Add. MS 23724, f. 27); sold Sotheby's, London, 27 January 1960, lot 104. In October 1737, Pond was paid five guineas 'Bro. Durnford, Jacky's pic: Crayons.' Ibid., f. 42. *Hamilton Boyle* (present location unknown) is reproduced in *The Orrery Papers*, ed. The Countess of Cork and Orrery (London, 1903) 2:21. It may have been one of six pictures purchased by the Earl of Orrery in 1748 (B.M., Add. MS 23724, f. 156).

38. Francis Askham (pseud. for J.E.C. Greenwood), *The Gay Delavals* (London, 1955); B.M., Add. MS 23724, ff. 115, 161 (F.B. Delaval), 104, 176 (Mrs. Delaval), 100, 101, 102, 104, 105, 106, 115, 136, 138, 139, 140, 150, 151, 153, 162, 163, 164, 176 (Rhoda Delaval). Rhoda's work is still in the possession of the family at Doddington Hall, Lincs. Portrait heads by Rhoda are let into a canvas with figures and background by Van Haecken, the London drapery painter.

39. Sedgwick, *History of Parliament*, s.v. Lloyd, Richard; B.M., Add. MS 23724, ff. 145, 146. For Samuel Shepheard, see Sedgwick, op. cit., s.v. Shepheard, Samuel; the death of his father is recorded in *London Daily Advertiser*, no. 4034 (22 December 1743); B.M., Add. MS 23724, ff. 95, 120, 154.

40. Perceval, *Diary* 2:297.

41. *Orrery Papers* 2:164-5.

42. For Rhoda Delaval, see n. 39 above. B.M., Add. MS 23724, ff. 17, 29, 115, 132, 134, 138, 152, 173 (Mrs. Delaney, formerly Pendarves).

43. *The Autobiography and Correspondence of Mary Granville, Mrs. Delaney*, ed. Lady Llanover, 3 vols. (London, 1861), 1:283, 485, 609; 2:505.

44. B.M., Add. MS 23724, ff. 72, 101 (Mrs. Horner, total expenditure £66.14.6); Rhoda Delaval spent £98.04.6 on drawing lessons, art supplies, and one portrait.

45. *Horace Walpole's Correspondence with George Montagu* ..., 2 vols., ed. W.S. Lewis and Ralph S. Brown, Jr., *The Yale Edition of Horace Walpole's Correspondence*, vols. 9, 10 (New Haven and London, 1949) 1:109n. B.M., Add. MS 23724, f. 102 (Norsa); *DNB*, s.v. Woffington, Margaret; B.M., Add. MS 23724, f. 107 (Woffington). Her portrait is now in the Garrick Club, London.

46. Ellis Waterhouse, *The Dictionary of British Eighteenth Century Painters in oils and crayons* (Woodbridge, 1981).

47. Kerslake, *Early Georgian Portraits*, s.v. Anson; Cumberland; Fox, Henry; Orford, first Earl of.

48. London, National Portrait Gallery, Guthrie Room, s.v. Wray, Daniel.

49. Jean Andre Rouquet urged the ambitious portrait painter to 'paint everybody possible at great speed' in order to take advantage of the protection of a powerful friend or woman of quality. Rouquet, *The Present State of the Arts in England* (London, 1755), p. 39.

50. London, Guildhall Library, MS 11396. Sun Fire Insurance Policy Registers, vol. 74, no. 104113 (3 June 1745): V. & A., MS 86.00.18–19, 1:416–19.

51. B.M., Add. MS 23724. See, for example, entries for 1746 (ff. 123–34) when all were buying.

52. Special large paper increased the cost on one number (four prints) of the *Italian Landscapes* by sixpence; buyers included Mann and Rogers (B.M., Add. MS 23724, ff. 143, 153). One number of the same prints on India paper raised the price from five to seven shillings (ibid., f. 114).

53. *DNB*, s.v. Ranby, John; *A Catalogue of the extensive, valuable, and superb Collection of Prints, Books of Prints, Drawings, and Miniatures, selected from Various Cabinets ... of Charles Chauncey, M.D., F.R.S. and F.S.A.* (London, 1790); Dr. Charles Peters was one of the physicians to George II (Helen Sard Hughes, *The Gentle Hertford, Her Life and Letters* (New York, 1940), p. 210). B.M., Add. MS 23724, ff. 118, 126 (Ranby), 113, 115, 122, 126, 137, 140, 149, 152, 156, 164, 167, 173, 177 (Chauncey), 126 (Hall), 151 (Cox).

54. Ralph M. Williams, *Poet, Painter, and Parson: The Life of John Dyer* (New York, 1956), p. 117; *DNB*, s.v. Warburton; Benjamin Boyce, *The Benevolent Man: A Life of Ralph Allen of Bath* (Cambridge, Mass., 1967), p. 189 (Forster); Guildhall MS 11936, vol. 48, no. 75899 (17 January 1737) lists Nicoll as headmaster; the Rev. Charles Jenner, rector of Buckworth, also kept a house in London and a collection of books and prints valued at £250 (ibid., vol. 50, no. 77476 (28 June 1738); For Dr. Gregory, see James Byam Shaw, *Paintings by Old Masters at Christ Church, Oxford*, 2 vols. (London, 1967) 1:16n. B.M., Add. MS 23724, ff. 124 (Forster), 158 (Nicoll), 120 (Jenner), 123 (Gregory and Thompson).

55. Cust and Colvin, *Dilettanti*, p. 249; *DNB*, s.v. Stillingfleet, Benjamin; B.M., Add. MS 23724, ff. 122, 127, 134, 145, 155.

56. B.M., Add. MS 23724, ff. 113, 116, 138, 148 (Lambert), 160, 161 (Hoare), 112 (Hudson), 33 (Kent), 119, 120, 139 (Smibert); 33 (Hertford), 112, 115, 123, 126, 131, 132, 135, 137, 148, 150, 152, 154, 156, 170, 173, 174, 179 (Taverner). For Mrs. Delaney, see n. 44, 45 above.

57. *Autobiography of ... Mrs. Delaney* 2:412.

58. B.M., Add. MS 23724, ff. 24 (Barbarona), 134 (Bingis), 111 (Campfield).

59. Henry Wilder Foote, *John Smibert, Painter* (New York, 1969), pp. 35–6.

60. John Fowler and John Cornforth, *English Decoration in the Eighteenth Century* (Princeton, 1974), p. 84; Walpole, *Ædes Walpolianae*, p. 52.

61. Hughes, *Gentle Hertford*, p. 278.

NOTES TO CHAPTER V

1. Most of Pond's eighteenth-century biographers—if they did not forget his painting career altogether—were very moderate in Pond's praise. Twentieth-century scholars have

been misled by a traditional attribution to Pond of a portrait of Peg Woffington in the National Portrait Gallery, London. Comparison of the London portrait with McArdell's mezzotint after Pond shows little similarity between the two, and the attribution has recently been changed to 'unknown artist'. The original Pond pastel of Woffington is now in the Garrick Club, London (C.K. Adams, *A Catalogue of the Pictures in the Garrick Club* (London, 1936) no. 308). The difficulties this portrait has caused are evident in Sir Charles Holmes, 'Neglected English Masters', *Burlington Magazine* 60, no. 351 (June 1932), pp. 300–7 which dismisses Pond as a sloppy and inconsistent follower of Kneller on the basis of four portraits, three of which were painted by other artists. In contrast, A. C. Sewter discovered a legitimate Pond portrait in 1940, and felt the artist deserved further study. Horace Walpole, *Anecdotes of Painting in England; with some account of principal painters . . .*, ed. Rev. James Dallaway, 3 vols. (London, 1876), s.v. Pond; Pierre-Jean Mariette, 'Abécedario de P.J. Mariette et autres notes inédites de cet amateur sur les arts et les artistes', 6 vols., *Archives de l'art français*, vols. 2, 4, 6, 8, 10, 12 (Paris, 1857–1858), 4: 197–8; John Kerslake, *Early Georgian Portraits*, 2 vols. (London, 1978), vol. 2, no. 899; A.C. Sewter, 'A Portrait by Arthur Pond', *Burlington Magazine* 77, no. 449 (August 1940), pp. 63–4.

2. London, Guildhall Library, MS 11936. Sun Fire Insurance Company Policy Registers, vol. 37, no. 60289 (28 May 1733). Letters addressed to 'Mr. Arthur Pond, Painter', etc. are included in the estate papers, as is one of Pond's dated 1757 stating he wished to drop the appellation. London, British Museum, Add. MS 23725. Papers illustrative of the works of Arthur Pond, Engraver & Painter, including particulars of various kinds left by him at the time of his decease & the sale catalogues of his effects 1745–1759, ff. 3, 5, 50.

3. Peter Lely and John Greenhill drew pastel portraits for English patrons in the late seventeenth century.

4. Edward Mead Johnson, *Francis Cotes* (Oxford, 1976), p. 5. A pupil of Pond's friend George Knapton, Cotes would have learned a crayon technique very similar to Pond's.

5. B.M., Add. MS 23724. Arthur Pond. Journal of Receipts and Expenses 1734–1750, ff. 46–58.

6. Rosamund D. Harley, *Artists' Pigments c. 1600–1835* (London, 1970), pp. 120–4, 65–9.

7. B.M., Add. MS 23724, ff. 14, 21, 28, 39, 62, 65. Pond had known Mary Barber since 1730, when he subscribed to her *Poems on several occasions* (London, 1730).

8. B.M., Add. MS 23724, ff. 18–22, 85–91 (King), 37, 39, 45 (Bellis).

9. Ibid., ff. 19, 20 lists small payments to Dyer along with King's wages.

10. George Vertue, *Note Books* 3, *Walpole Society*, vol. 22 (Oxford, 1933–4), pp. 124–5.

11. For Walker and Boyle, see Ch. IV, n. 38 above. Mrs. Strangways-Horner paid for her portrait (now in the Melbury Collection, no. 31) in March 1740 (B.M., Add. MS 23724, f. 72). The portrait of Princess Mary with that of her sister Louisa, was paid for 15 April 1740 (ibid., f. 73). For Ann, Lady Dacre, see A. C. Sewter, 'A Portrait by Arthur Pond', *Burlington Magazine* 77, no. 449 (August 1940), 63–4.

12. Attributed to Arthur Pond, *Portrait of William Hobday* (1732), sold at Sotheby's (London) 26 July 1978, lot 103; *Portrait of Henry Fox* (now Collection of Viscountess Galway), paid for November 1737 (B.M., Add. MS 23724, f. 43).

13. Otto Kurz, 'Varnishes, Tinted Varnishes, and Patinas', *Burlington Magazine* 104 (February 1962) 56–9.

14. Vertue, *Note Books* 3:109.

15. Letter writers often commented on the lavish use of plate glass in windows of houses and coaches. Plate glass was insured separately from other stock-in-trade by tradesmen; also by houseowners. Henry Furnese insured the glass windows of his house for £200, while its furnishings were valued at £1000. Guildhall, MS 11936, vol. 26, no. 46037 (1 November 1728).

16. Three Gossets were active in London in the early eighteenth century, all of them wax-modellers and frame-makers. Isaac and Gideon were nephews of Matthew Gosset in

Poland Street; there was also a James Gosset working in both trades in Berwick Street, Soho in 1763. Gideon made frames for Gainsborough, Hogarth, and Hoare, and may also have made them for Pond. E.J. Pyke, *A Biographical Dictionary of Wax Modellers* (Oxford, 1973), s.v. Gosset; Thomas Mortimer, *The Universal Director; or the Nobleman and Gentleman's True Guide to the Masters and Professors of the Liberal and Polite Arts and Sciences …* (London, 1763), p. 12; Ambrose Heal, *The London Furniture Makers from the Restoration to the Victorian Era* (London, 1953), s.v. Gosset.

17. In 1738, William Hoare charged £5.5.0 for a crayon head, framed, and £8.8.0 if the frame had glass. Alison Shepherd Lewis, 'Joseph Highmore: 1692–1780' (Ph.D. dissertation, Harvard University, Department of Fine Arts, 1975), pp. 324–5.

18. Henry Wilder Foote, *John Smibert, Painter* (New York, 1969), pp. 85–6.

19. E.K. Waterhouse, 'English Painting and France in the Eighteenth Century', *Journal of the Warburg and Courtauld Institutes* 15 (1952), pp. 125–6; John Ingamells and Robert Raines, 'A Catalogue of the Paintings, Drawings, and Etchings of Philip Mercier', in *Walpole Society*, vol. 46 (Oxford, 1976–8), p. 4; Alastair Smart, *The Life and Art of Allan Ramsay* (London, 1952), pp. 13–40; Vertue, *Note Books* 3:87, 100.

20. J. Ingamells, 'Andrea Soldi—I', *Connoisseur*, vol. 185 (March 1974), 192–200.

21. Foote, *Smibert*, p. 87.

22. Pond's Journal shows gaps in the accounts during these years suggestive of absences from London. Pond may have been travelling around England some of the time, combining work for the Knaptons with other business as in the 1730s. He may also have sought work in Bath, or gone abroad to Holland. B.M., Add. MS 23724, ff. 83–99; see chapter VI, below.

23. Vertue, *Note Books* 3:117.

24. Ellen G. Miles and Jacob Simon, *Thomas Hudson 1701–1779 Portrait painter and collector* (exhibition catalogue, Kenwood, 1979) not paginated.

25. By 1751 Allan Ramsay was able to charge £12.12.0 for a head, as opposed to Pond, who asked £10.10.0 in 1750. In 1752 Ramsay claimed to have earned £1000 from painting, and although Pond's income was just as high, only about half came from painting. Lewis, 'Highmore', pp. 324–5.

26. B.M., Add. MS 23724, ff. 89, 90, 100, 165.

27 Ibid., ff. 15, 128, 155.

28. Ibid., ff. 62, 115, 122, etc.

29. Jacobus Houbraken after Arthur Pond, *Alexander Pope*, engraving, 1747. Plate 28 of Thomas Birch, *The Heads of Illustrious Persons of Great Britain*, vol. 2 (London, 1752).

30. B.M., Add. MS 23724, f. 63.

31. Vertue, *Note Books* 3:125–26.

32. B.M., Add. MS 23724, ff. 102, 132. Perhaps these may be identified with the two portraits now in the Royal College of Physicians, London. Gordon Wolstenholme, ed. and David Piper, *The Royal College of Physicians of London. Portraits* (London, 1964), pp. 284–7.

33. Oxford, Bodleian Library, MS 1011. Thomas Edwards, Letter Book 1747–1752, p. 267. Rhoda Delaval and her husband Edward Astley supported another Rembrandt imitator, Thomas Worlidge, and they bought Pond's print collection, the largest holding of Rembrandt in England.

34. B.M., Add. MS 23724, ff. 105, 107, for example.

35. Ibid., ff. 62, 63. Not only cheapness, but shortage of materials due to interrupted trade with France may have encouraged Pond to make his own colors.

36. Ibid., ff. 9, 138. Powel is mentioned in J.T. Smith, *Nollekens and His Times* (1828), 2 vols., ed. W. Whitten, (London and New York, 1917), 1:35.

37. Foote, *Smibert*, p. 86.

38. B.M., Add. MS 23725, f. 50.

39. Edward Edwards, *Anecdotes of painters, who have resided or been born in England, with critical remarks on their productions* (1808, reprint London, 1970), s.v. King, Tom.

40. R. Campbell, *The London Tradesman* (1747) facs. ed. (New York, 1969), pp. 95–107; B.M., Add. MS 23724. Pond's purchase of a 'feather bed for Mr. King' suggests room and board may have supplemented his wages.

41. B.M., Add. MS 23724, f. 152.

42. Ibid., ff.91–142.

43. F.M. O'Donoghue and H.M. Hake, *Catalogue of Engraved British Portraits preserved in the Department of Prints and Drawings in the British Museum*, 6 vols. (London, 1909–25), s.v. Swift, Jonathan (after Markham).

44. B.M., Add. MS 23724, ff. 136–68.

45. Edwards, *Anecdotes*, s.v. Black.

46. See n. 7 above.

47. Walter George Strickland, *A Dictionary of Irish Artists* (Shannon, 1969), s.v. Barber, Rupert.

48. P.R.O., IR 17. Apprentice Index, IR 17/23/3106 (James), IR 17/15/1564 (Delaval). Other artists charged in the region of £100 to £175 for a five to seven year apprenticeship. Lewis, 'Highmore', p. 328.

49. Edwards, *Anecdotes*, s.v. James, George.

NOTES TO CHAPTER VI

1. Anthony Ashley Cooper, third Earl of Shaftesbury, *Characteristicks of Men, Manners, Opinions, Times*, 3 vols. (4th ed., London, 1727).

2. Ibid., 3:156–7.

3. Quoted in John Fowler and John Cornforth, *English Decoration in the Eighteenth Century* (Princeton, N.J., 1974), p. 25.

4. See Lesley Lewis, *Connoisseurs and Secret Agents in Eighteenth Century Rome* (London, 1961).

5. Jonathan Richardson, *Two Discourses* (London, 1719); Lawrence Lipking, *The Ordering of the Arts in Eighteenth-Century England* (Princeton, 1970), pp. 113–21.

6. Richardson, *Discourses*, part 2, pp. 41–52.

7. Ibid., part 2, p. 47.

8. Vertue, *Note Books 3, Walpole Society*, vol. 22 (Oxford, 1934), p. 9.

9. V. & A., MS 86.00.18. (Richard Houlditch, Jr.), Sale Catalogues of the Principal Collections of Pictures . . . Sold by Auction in England . . . 1711–1759, p. 207, lot no. 173; George Vertue, *Note Books 1, Walpole Society*, vol. 18 (Oxford, 1930), p. 107.

10. B.M., Add. MS 19929. Memorandum Book of John Bullfinch 1701–1728, ff. 148–51 lists the expenses and arrangements for such a sale (of illustrated books) at Powell's Coffee House in November 1705. The early auction catalogues listed in V. & A., MS 86.00.18–19 cover numerous sales at the Green Door.

11. Correspondence between Pond and Mariette after the former's return to London is indicated by reference to a letter between the two dated July 1727, in B.M., Dept. of Prints and Drawings, *A Complete Series of Exhibition Catalogues of the Society of Artists of Great Britain . . .* (Anderdon Gift), vol. I, p. 314; see also Ch. III n. 57 above; later their mutual friend Dr. Hickman served as an intermediary, see Pierre-Jean Mariette, 'Abecédario . . .', *Archives de l'art français*, vol. 4, pp. 353–4. Pond also executed small commissions for Zanetti and continued to buy prints from Frey. B.M., Add. MS 23724. Arthur Pond. Journal of Receipts and Expenses 1734–1750, f. 27. Frey's price list, with updated inventory and prices is among Pond's 'estate papers', B.M., Add. MS 23725. Papers illustrative of the works of Arthur Pond, Engraver & Painter, including particulars of various kinds left by him at the time of his decease & the sale catalogues of his effects 1745–1759, f. 83.

12. (John Russell), *Letters from a Young Painter Abroad to his Friends in England* (London, 1748), p. 231.

13. B.M., Add. MS 23725, f. 2.

14. At the Duke of Portland's sale and Mr. Van Huls' sale, both in 1722, small Italian histories and landscape paintings were making prices between £10 and £40. The variations in price were dependent on size and subject matter as well as the reputation of the artist. V. & A., MS 86.00.18, pp. 6–11, 201–10. Pond's sale to Hoare is mentioned in Kenneth Woodbridge, *Landscape and Antiquity: Aspects of English Culture at Stourhead 1718 to 1838* (Oxford, 1970), p. 22.

15. B.M., Add. MS 23724, ff. 16, 17, 25.

16. Ibid., f. 73.

17. Ibid., f. 16.

18. Mariette, 'Abécedario . . .', *Archives de l'art français*, vol. 8, pp. 197–8.

19. J. T. Smith, *Nollekens and His Times* (1828), 2 vols., ed. W. Whitten (London and New York, 1917), 1:381–3. The Cortona drawing in the Morgan Library has been inscribed in this manner. A typical inscription, along with Pond's *paraphe* and collector's stamp for prints is reproduced in Frits Lugt, *Les Marques de Collections de Dessins & d'Estampes* (Amsterdam, 1921) no. 2038.

20. A factory for the production of 'antique' seals is described in Brinsley Ford, 'Thomas Jenkins, Banker, Dealer, and Unofficial English Agent', *Apollo*, 99 (1974) 416–25.

21. Vertue, *Note Books* 3:105.

22. B.M., Add. MS 23724, ff. 15–17.

23. Ibid., ff. 16, 17, 29, 30, 38, 40, 42, 47, 61, 63, 65–67.

24. Ibid., ff. 7–10 (Delmé); 31, 32, 74, 75, 92, 116 (Fauquier); 52, 54, 60 (Molineux).

25. Lional Cust and Sidney Colvin, *History of the Society of Dilettanti* (London, 1898), p. 8.

26. Their purchases on their own behalf or for patrons are recorded throughout V. & A., MS 86.00. 18–19. Scott acted as bidder and agent for Lord Anson. Hudson's purchases are discussed in Ellen Miles and Jacob Simon, *Thomas Hudson 1701–1779 Portrait Painter and Collector* (exhibition catalogue, Kenwood, 1979), not paginated. Reynolds's buying in: Timothy Clifford, Anthony Griffiths, and Martin Royalton-Kisch, *Gainsborough and Reynolds in the British Museum* (exh. cat., London. 1978) pp. 61–74.

27. Vertue, *Note Books* 3: 13–14, 125.

28. V. & A., MS 86.00.18–19 records sales of Bragge's collections in 1742, 1743, 1744, 1749, 1750, 1751, 1753, 1754, 1756, and 1757. According to B.M., Add. MS 23724, Pond bought infrequently from Bragge (f. 162).

29. Vertue, *Note Books—Index, Walpole Society*, vol. 29 (Oxford, 1940–2), s.v. Cock, Christopher. London, Guildhall Library, MS 11936, Registers of the Sun Fire Insurance Company, vol. 20, no. 36382 (22 July 1725), vol. 46, no. 72090 (c. November 1726). Obituary in *London Daily Advertiser*, no. 5591 (12 December 1748).

30. C.H. Collins Baker and Muriel I. Baker, *The Life and Circumstances of James Brydges First Duke of Chandos* (Oxford, 1949), pp. 84–91.

31. For example, Pond's patron Ralph Allen preferred copies of great classical and biblical subjects to less 'meaningful' originals. Themes of moral and political virtue were prominently displayed by Sir Robert Walpole, Lord Temple, Henry Hoare, and other politicians and men of affairs. Benjamin Boyce, *The Benevolent Man. A Life of Ralph Allen of Bath* (Cambridge, Mass., 1967), p. 104; Ronald Paulson, *Emblem and Expression. Meaning in English Art of the Eighteenth Century* (Cambridge, Mass., 1975), chapter 2.

32. B.M., Add. MS 23724, ff. 14, 40, 60, 61, 62, 74. On one occasion the artist Joseph Highmore visiting Paris in 1734 served as their intermediary. See Elizabeth Johnston, 'Joseph Highmore's Paris Journal', in *Walpole Society*, vol. 42 (Oxford, 1970).

33. B.M., Add. MS 23724, ff. 98, 103, 112, 129, 130.

34. B.M., Add. MS 23095, George Vertue. Memorandum Book 1715–1751, f. 25; *London*

Daily Advertiser, no. 3723 (24 December 1742); auction catalogue, Langford's, March 1768 in Frits Lugt, *Repertoire des Catalogues de Ventes Publiques . . .*, 2 vols. (The Hague, 1938), 1:no. 1768.

35. (Julian Stock *et al.*), *An Exhibition of Old Master and English Drawings and European Bronzes from the Collection of Charles Rogers and the William Cotton Bequest* (exhibition catalogue, London, 1979), Introduction.

36. Plymouth, City Museum and Art Gallery, Cottonian Collection. Transcripts of Letters to or from Charles Rogers. D.23A. Charles Rogers to Horatio Paul, 7 May 17 [. .].

37. Pierre Rosenberg, *Chardin 1699–1779* (exhibition catalogue, Paris, Cleveland, Boston, 1979), p. 74.

38. Henry Wilder Foote, *John Smibert, Painter* (New York, 1969), p. 85.

39. Ian Maxted, *The London Book Trades 1775–1800* (Folkestone, Kent, 1977), s.v. Major, Thomas.

40. V. & A., MS 86.00.18–19. Paris stopped operations in 1745; Bragge suspended sales between 1744 and 1749, as did Blackwood. Paris was active as early as 1722. Frank Simpson, 'Dutch Paintings in England before 1760', *Burlington Magazine* 95, no. 599 (Feb. 1953) pp. 39–42.

41. Plymouth, City Museum. Cottonian Collection. Transcripts of Letters. D. 6. Charles Rogers to Charles Wollaston.

42. Lugt, *Les Marques de Collections . . .*, 1:no. 2038.

43. *London Daily Advertiser*, no. 5591 (December 1748); V. & A., MS 86.00.18, pp. 408–9; B.M., Add. MS 23724, f. 150.

44. *London Daily Advertiser*, no. 2214 (February 1737); no. 2870 (April 5, 1740); Lambe was evidently the son of the book and printseller John Bullfinch and was assisting him with auctions as early as 1705, B.M., Add. MS 19929, ff. 148–51.

45. V. & A., MS 86.00.18–19 first lists sales at Prestages in 1752.

46. Samuel Foote, 'Taste; a Comedy, in two acts As performed at the Theatre Royal Drury Lane', in *The Works of Samuel Foote, Esq.*, 3 vols. (London, 1830; reprint, New York, 1974), 1.

47. Pond was employed in this capacity by one of the Delmés in 1748 and by Lord Hardwicke in 1754. V. & A., MS 86.00.18, pp. 275, 63, 64.

48. The jobs for Cavendish, Walpole, and Hoare are listed in B.M., Add. MS 23724, ff. 52, 138, 165. The British Museum project is listed with other unfinished accounts in B.M., Add. MS 23725, f. 13. See also Edward Croft-Murray, *Decorative Painting in England 1537–1837*, 2 vols. (London, 1970) 2:320, referring to the history of the painting and Pond's bills for the restoration now in the British Museum.

49. Guildhall, MS 11936, vol. 41, no. 63881 (21 May 1734). He worked for Pond off and on between 1737 and 1750. In April 1737, Pond paid Bellis £1.1.0 for lining two pictures. Eleven years later Bellis charged £3.12.0 for '3½-lengths to whole' and 17 shillings for 'lining Ld. Campden'. B.M., Add. MS 23724, ff. 37, 151, 155.

50. B.M., Add. MS 23724, ff. 127, 138.

51. Arthur Pond's drawing collection, highly esteemed in its time, has been difficult to reconstruct, since he had no collector's mark such as those employed by Jonathan Richardson (Lugt 2183, 2184), John Barnard (Lugt 1419, 1420), Thomas Hudson (Lugt 2432), Charles Rogers (Lugt 624, 625, 626). The 'baptism' (Lugt 2038) appears only on drawings seen by Pond and is no use in indentifying the drawings he kept; none of the drawings from his 1759 sale bears a mark. Discussion of his skill as a drawing connoisseur and collector awaits reconstruction of the collection itself.

52. Plymouth, City Museum, Cottonian Collection. 269. drawer 4. Charles Rogers, 'Estimation of Prints', in *Art Lists*. Translation by Charles Rogers.

53. B.M., Add. MS 23724, ff. 11, 49, 74.

54. Mariette, 'Abécedario . . .', *Archives de l'art français*, vol. 8, pp. 197–8.

55. London, Guildhall, MS 11936, vol. 37, no. 60829 (28 May 1733).

56. Foote, *Smibert*, p. 387.

57. B.M., Add. MS 23724, ff. 138, 149.

58. Ibid., f. 154. On 8 July 1748, Pond took out 'Insurance on Prints & Draw £1000', paying a premium of £1.7.6.

59. London, Guildhall, MS 11936, vol. 73, no. 101972 (6 April 1745); vol. 52, no. 80700 (21 June 1739). Powlett's collection grew to 131 paintings by the time of his death in 1757 when its value would have been considerably higher than £50.

60. Ibid., vol. 41, no. 63992 (15 June 1735); vol. 22, no. 40916 (23 March 1726). Most eighteenth-century print and drawing collections were bound or kept in portfolios, and were considered to be parts of libraries of manuscript and printed material.

61. Horace Walpole, *Anecdotes of Painting in England (1760–1795)*, ed. Frederick W. Hilles and Philip B. Daghlian (New Haven and London, 1937), p. 204.

62. *A Catalogue of the Genuine, Entire and Well-known Collection of Etchings and Prints by Masters of the Greatest Eminence, Purchased by Sir Edward Astley, Bart. of Mr. Arthur Pond . . .* (London, Langford's, 20 March–25 April 1760), annoted copy in the British Library.

63. V. & A., MS 86.00.18, pp. 59, 69, 90, 196, 305, 388, 416, lists seven purchases of single paintings between 1740 and 1751, not including paintings Pond bid for on the behalf of other collectors. A few other purchases listed in B.M., Add. MS 23724 were quickly sold. The remaining pictures, most of very low value, are listed in *A Catalogue of Genuine and Entire Collection of Italian and other Pictures of Mr. Arthur Pond . . .* (London, Langford's, 8–9 March 1759), in B.M., Add. MS 23725, ff. 21–8. A number of the Italian pictures in the sale actually belonged to other owners.

64. Pond bought the painting in May 1739 ('A Naked Woman of Rembrandt . . . 7.0.0.' and it was sold to Reynolds at Pond's estate sale in 1759 for £16.5.6. The purchase is recorded in the annotated sales catalogue (see note 75 below) and in V. & A., MS 86.00.19, f. 170.

65. Quoted in Fowler and Cornforth, *English Decoration*, p. 235.

66. See Helen Sard Hughes, *The Gentle Hertford Her Life and Letters* (New York, 1940); *The Autobiography and Correspondence of Mary Granville, Mrs. Delaney*, ed. Lady Llanover, 3 vols. (London, 1861). Mrs. Delaney was collecting shells as early as the 1730s. Her serious work in shells did not begin until the late 1740s, after her marriage with Dr. Delaney when she gained access to local shells in Ireland.

67. Jane Martin's shop 'At the Golden Key in Marybon-street near the Hay-Market, Piccadilly', was the first to carry a large selection of shells as advertised in the *London Daily Advertiser* no. 5133 (26 June 1747); Benjamin Pitt, a virtuoso in shells and fossils (d. 1755) opened a shell auction house in London in 1749 or 1750. *Autobiography and Correspondence of Mary Granville, Mrs. Delaney*, 3:332n; *London Daily Advertiser*, no. 5738 (May 1749).

68. P.J.P. Whitehead, 'Emanuel Mendes da Costa (1717–91) and the *Conchology, or natural history of shells*', *Bulletin of the British Museum (Natural History)*, Historical series, 6, no. 1 (29 September 1977).

69. Horace Walpole, *The Duchess of Portland's Museum*, introduction by W. S. Lewis (New York, 1936), p. 5.

70. Plymouth, City Museum, Cottonian Collection. Transcripts of Letters, D.10. Francis Wollaston to Charles Rogers, 21 January 1749/50.

71. Ibid., D.30. Charles Rogers to Horatio Paul, 6 January 1755.

72. John Dyer, 'The Fleece' (1757) in *The Poetical Works of Mark Akenside and John Dyer*, ed. Rev. Robert Aris Willmot (London, 1855), part 2, p. 100.

73. *A Catalogue of the Genuine and Entire Collection of Scarce and Curious Shells, Fossils, Petrefactions, Ores, Minerals, insects, Books relative to Shells and Fossils, and some fine Cabinets, of the Eminent Collector Mr. Arthur Pond . . .* (London, Langford's, 18–24 May 1759), priced copy in B.M., Add. MS 23725, ff. 30–44.

74. See Ch. V above.

75. *A Catalogue of the ... Italian and other Pictures of Mr. Arthur Pond* bound in B.M., Add. MS 23725, ff. 22, 24 lot 71 (1st day), lot 69 (2nd day).

76. Vertue, *Note Books* 3, p. 105.

77. B.M., Add. MS 23725, f. 6. Obituary from the *London Daily Advertiser* (11 September 1758).

78. *DNB*, s.v. Pond, Arthur.

79. B.M., Add. MS 23724, ff. 119, 133–82; see also Ch. IV n. 19.

80. Ibid., 124, 150, 171, 173, 178 (Batt); 113, 120, 162 (Raymond).

81. Ibid., ff. 143, 144 (Raymond); 127, 128 (Price).

82. *A Collection of Prints, in Imitation of Drawings, from the following celebrated Masters ... by Charles Rogers, Esq.* (London, 1778).

83. Miles and Simon, *Thomas Hudson* (1979), not paginated. Hudson introduced Reynolds to the auction market. Reynolds was also a friend of Rogers, painted his portrait, and allowed him to include examples from his collection in his *Prints in Imitation of Drawings*.

84. W.T. Whitley, *Artists and their Friends in England*, 2 vols. (1928, reprint New York, 1968) 1:123–5.

85. Plymouth, City Museum, Cottonian Collection. Transcripts of Letters, D.22. Charles Rogers to Horatio Paul, 21 January 1754.

86. P.R.O., PROB 11/841, Will of Arthur Pond.

87. Annotated copies of the sales catalogues of the painting and shell collections (worth £495.19.6 and £665.6.0 respectively) are bound into B.M., Add. MS 23725, ff. 21–8, 30–44. In his *Anecdotes of Painting ... (1760–1795)*, p. 204, Horace Walpole quoted the price of £1400 for the print collection. The drawings sold for £1214.1.6. *A Catalogue of the Genuine, Entire and Valuable Collection of Drawings of that Eminent Painter and Collector, Mr. Arthur Pond ...* (London, Langford's, 25 April–3 May 1759), priced copy in Philadelphia, Museum of Art, Library.

NOTES TO CHAPTER VII

1. Robert Dossie, *The Handmaid to the Arts*, 2 vols. (London, 2nd ed., 1764).

2. Richard Godfrey, *Printmaking in Britain* (New York, 1978), p. 24.

3. George Vertue, *Note Books*—Index, *Walpole Society*, vol. 29 (Oxford, 1940–2), s.v. Vertue, George; *London Daily Advertiser*, no. 798 (21 August 1733).

4. Ulrich W. Hiesinger and Ann Percy, eds., *A Scholar Collects: Selections from the Anthony Morris Clark Bequest* (exhibition catalogue, Philadelphia, Philadelphia Museum of Art, 1980–1981), pp. 106–8. The full title of the *Recueil* is *Recueil d'estampes d'après les plus beaux tableaux et d'après les plus beaux dessins qui sont en France ...* (Paris, 1729). Pond's series of prints has been catalogued by H.M. Hake, 'Pond's and Knapton's Imitations of Drawings', *Print Collector's Quarterly* 9 (1922), pp. 324–49; however, Hake confuses the *Imitations* with the *Caricatures*, a later, separate series. They are distinguished in B.M., Add. MS 23725. Papers illustrative of the works of Arthur Pond, Engraver & Painter, including particulars of various kinds left by him at the time of his decease & the sale catalogues of his effects 1745–1759, ff. 61–71. A complete bound set of the *Prints in Imitation of Drawings* is held at New Haven, Yale Center for British Art, Department of Prints and Drawings (Rare Books, uncatalogued). The volume also includes a few prints not by Pond.

5. B.M., Add. MS 23724. Arthur Pond. Journal of Receipts and Expenses 1734–1750, ff. 22, 23 (Davis), 9, 15–17, 21, 25, 38 (Pennock). 'Pennock' was probably William Pennock, a wood, copper, and seal engraver located at the Tobacco Roll in Panier Alley, Newgate Street in 1709. He is known to have illustrated the frontispiece to a collection of songs entitled *Bacchus and Venus* (n.d.). Ambrose Heal, 'The Trade Cards of Engravers', *The Print*

Collector's Quarterly 14, no. 3 (July 1927), plate 1, pp. 218, 240; Hanns Hammelman, and T.S.R. Boase, *Book Illustrators in Eighteenth-Century England* (New Haven and London, 1975), s.v. Pennock.

6. B.M., Add. MS 23724, f. 20. William Herbert is listed at the Bell in Gracechurch Street in *c.*1735 in George Vertue's memorandum book. He married Pond's sister-in-law Susannah Durnford on 18 July 1716, when both lived in the parish of St. Magnus. B.M., Add. MS 23095. Memorandum Book of George Vertue 1715-1751, f. 22; London, Guildhall Library, MS 11362. Register Book of Marriages, Baptisms and Burials of the United Parishes of St. Magnus the Martyr & St. Margaret New Fish Street from September 1712 to December 1812 (not paginated). B.M., Add. MS 23724, ff. 13, 20, 33; a member of the French papermaking family, Josias Johannot and his wife Mary lived in the parish of St. Magnus between 1731 and 1737, when births of their three children are recorded in the registers. In 1741, Johannot, listed as a stationer at St. Paul Cray near St. Mary Cray in Kent, began to insure his dwelling, stock-in-trade, and outbuildings used for papermaking. The value of his properties rose from £300 in 1741 to £1200 in 1748. Guildhall, MS 11362 (not paginated), entries of 6 February 1731, 26 September 1733, 11 December 1737; Guildhall, MS 11936, Sun Fire Insurance Company Policy Registers, 1710-*c.*1900, vol. 59, no. 88182 (8 July 1741); vol. 82, no. 112030 (30 April 1748).

7. B.M., Add. MS 23724, ff. 6, 7, 9, 10, 17, 18, 20, 24-28, 39.

8. *London Daily Advertiser*, no. 1247 (27 January 1734, O.S.); no. 1303 (2 April 1735); no. 1617 (2 April 1736); no. 1929 (21 March 1736, O.S.).

9. Pierre-Jean Mariette, 'Abécédario de P.J. Mariette et autres notes inédites de cet amateur sur les arts et les artistes', 6 vols., *Archives de l'art français*, vols. 2, 4, 6, 8, 10, 12 (Paris, 1857-8), 4: 353-4.

10. Seymour Slive, *Rembrandt and his Critics 1630-1730* (The Hague, 1953), p. 152, n. 2.

11. Jonathan Richardson, *An Essay on Prints* (Strawberry Hill, 1792), p. 263; John Baptist Jackson, *An Enquiry into the Origins of Printing in Europe* (London, 1752), p. 35.

12. H.R. Plomer, *A Dictionary of the Printers and Booksellers who were at work in England, Scotland, and Ireland from 1726 to 1775* (Oxford, 1932), p. 148; John Nichols, *Literary Anecdotes of the 18th Century; Comprizing Biographical Memoirs of William Bowyer ... and Biographical Anecdotes of a Considerable Number of Eminent Writers and Ingenious Artists*, 9 vols. (London, 1812-15), 2:277-9.

13. *London Daily Advertiser*, no. 2254 (15 April 1738). According to Vertue, low prices had been an attractive feature of the 'Houbraken Heads' (Vertue, *Note Books* 1, *Walpole Society*, vol. 18, Oxford, 1929-30, pp. 4-5).

14. B.M., Add. MS 23724, f. 45.

15. Vertue, *Note Books* 6, *Walpole Society*, vol. 30 (Oxford, 1951-2), p. 196.

16. B.M., Add. MS 23724, f. 133; Ralph Strauss, *Robert Dodsley, poet, publisher and playwright* (London, 1910), pp. 165-6.

17. For example, *London Daily Advertiser*, no. 3439 (27 January 1742).

18. B.M., Add. MS 23724, ff. 10, 12, 14, 15, 26, 29, 31, 37, 43.

19. For published listings of the *Caricatures* see n. 3. above. A complete set is preserved in V. & A., Department of Prints and Drawings, E4961-1902 to E4981-1902 and E2366-1938. H.R. Hicks, 'Caricatures by Pietro Leoni Ghezzi (1674-1755) engraved by A. Pond (1705-1758)', *Apollo* 42, no. 246 (August 1945), pp. 198-200, is brief and misleading.

20. *Recueil de Testes de caractères & de Charges dessinés par Léonard de Vinci Florentin & gravées par M. le C. de C.* (Paris, 1730); Philadelphia, Free Library. John Frederick Lewis Collection of Engravers' Letters, vol. L-M, f. 83.

21. Henry Fielding, *Joseph Andrews* (1742, reprint New York, 1977), preface.

22. William Hogarth's engraving *Characters & Caricaturas* was first published in 1743 as a subscription ticket for *Marriage à la Mode*, then reissued as a single print in April of that year. Sean Shesgreen, ed., *Engravings by Hogarth* (New York, 1973), no. 49.

23. William Hogarth, *The Analysis of Beauty, Written with a view of fixing the fluctuating ideas of taste* (1753) ed. Joseph Burke (Oxford, 1955), p. 22.

24. The two plates—'Some heads of Women Caricatures (mr Fouquier's plate)'—were in Pond's shop in 1758. Impressions from them are preserved in the British Museum, Department of Prints and Drawings, Collection of Political and Personal Satires, no. 2590, no. 2845. B.M., Add. MS 23725, f. 57; Frederic George Stephens, *Catalogue of Prints and Drawings in the British Museum. Division I. Political and Personal Satires* 4 vols. (London, 1870–83), vol. 3, part 2, cat. nos. 2590, 2845, pp. 469, 634.

25. E. Harris, *The Townshend Album* (exhibition catalogue, London, 1974), p. 3.

26. A complete set is preserved in the British Museum, Department of Prints and Drawings, 1977.u.19–1 through 44. Pond's initial payments to Chatelain and Vivares in B.M., Add. MS 23724, ff. 66, 77–80, 84, 85, 87–9; for paper, ff. 89–91.

27. Charles Knapton's death is recorded in P.R.O. PROB 6/118. Grants of Administration for Middlesex, October 1742. Pond's name first appears on No. VI of the *Landscapes* published 25 October 1742.

28. Joseph Strutt, *Biographical Dictionary of Engravers, with an Essay on Engraving*, 2 vols. (London, 1785–6), s.v. Chatelain.

29. Francis Vivares had his own shop at the Golden Head in Porter Street, near Leicester Fields in 1749, but he had been active in the retail trade since 1744. He moved to Great Newport Street in 1750 where he lived for the rest of his life. *London Daily Advertiser*, no. 4149 (4 May 1744); no. 5745 (3 June 1749); Ian Maxted, *The London Book Trades 1775–1800. A Preliminary Checklist of Members* (Folkestone, 1977) s.v. Vivares. J.S. Muller arrived in England in 1744, was hired immediately by Pond, and began to issue his own prints—not very successfully—almost immediately. By 1748 he was the proprietor of the Golden Head at the corner of St. James Street, Long Acre. *London Daily Advertiser* no. 4207 (11 July 1744); no. 5482 (8 August 1748). John Wood, a student of Chatelain, became a landscape specialist and worked frequently for John Boydell. E. Bénézit, *Dictionnaire critique et documentaire des Peintres, Sculpteurs, Dessinateurs et Graveurs . . .*, 3rd ed. (Paris, 1976), s.v. Wood, John.

30. Information communicated by Sheila O'Connell, British Museum.

31. See note 26, above.

32. This was standard practice in quality print shops. 112 of the proof prints, 'most of 'em touched upon by Mr. Pond for the Ingraver', were still in his house when inventory was taken in 1758 (B.M., Add. MS 23725, f. 55).

33. Vertue, *Note Books* 6:196.

34. *The Autobiography and Correspondence of Mary Granville, Mrs. Delaney*, ed. Lady Llanover, 3 vols. (London, 1861), 2:412; E. Einberg, *George Lambert 1700–1765* (exhibition catalogue, Kenwood, 1970), p. 18, cat. no. 21; in May 1745, Pond sold Robert Doughty a view of Greenwich, after the print from Tillemans Pond had published in 1744 (B.M., Add. MS 23724, f. 115).

35. Elizabeth Wheeler Manwaring, *Italian Landscapes in Eighteenth Century England* (1925, reprinted London, 1965), p. 79; Marcel Roethlisberger, *Claude Lorrain: the paintings*, 2 vols. (New Haven, 1961); Ann French, *Gaspard Dughet called Gaspar Poussin 1615–1675. A French landscape painter in seventeenth century Rome and his influence on British art* (exhibition catalogue, Kenwood, 1980).

36. The costs and receipts for Nos. X and XI of the *Italian Landscapes* are as follows. Costs: £20.18.0 (1744), £40.9.6 (1745), £37.5.0 (1746). Receipts: £63.2.0 (1745), £49.16.0 (1746), £23.7.0 (1747). B.M., Add. MS 23724, ff. 103–46.

37. Henry Wilder Foote, *John Smibert, Painter* (New York, 1969) p. 87.

38. Pond's dealings with Joseph Sympson, Sr. began in February 1739, broke off at the end of 1740, and resumed in January 1745 (B.M., Add. MS 23724, ff. 60, 81, 112); Henry Overton was probably a relation of the printseller John Overton. He first appears in the

Journal in February 1745 but, like Sympson, may have purchased from Charles or Elizabeth Knapton before then (*London Daily Advertiser*, no. 1240 (18 January 1734, O.S.); B.M., Add. MS 23724, f. 113). Mary Overton took over the Fleet Street shop after her husband Philip's death in February 1745, and she bought steadily from Pond from March 1745 to April 1748 (*London Daily Advertiser*, no. 4465 (26 February 1745); B.M., Add. MS 23724, ff. 113–51). John Tinney, an engraver, insured his London printshop in 1745 and began buying from Pond several months later (Guildhall, MS 11936, vol. 73, no. 102383 (21 May 1745); B.M., Add. MS 23724, f. 120).

39. B.M., Department of Prints and Drawings, 1871-8-12-3928 through 3931, 1949-10-8-196. The first print after Pannini's *Inside of the Pantheon* was published by L. P. Boitard in London in 1738 (1949-10-8-195).

40. B.M., Add. MS 23724, ff. 111–181.

41. John Dyer, 'The Ruins of Rome', in *The Poetical Works of Mark Akenside and John Dyer*, ed. Rev. R. A. Willmot (London, 1855), part 2, pp. 25–40.

42. Foote, *Smibert*, p. 91.

43. B.M., Add. MS 23724, ff. 111–71.

44. William Hogarth, *The Analysis of Beauty* (1753), ed. Joseph Burke (Oxford, 1955), plate 10.

45. The author has not yet located a complete set of these prints as published by Pond (they were reissued by John Boydell in 1774). In order of publication, they are: *Landscape with Boors Merrymaking* (collection of Peter Delmé) by an unknown engraver after Teniers (March 1744); *View from One-Tree Hill, Greenwich* (Earl of Radnor) by J. Wood after Peter Tillemans (August 1744); *Landscape with Apollo Flaying Marsyas* (Earl of Leicester) by J.S. Muller after Claude Lorrain (June 1747); *Landscape with Dancing Figures* (Pamphili Palace, Rome) by J. Mason after Claude Lorrain (February 1748); *Storm: Jonah and the Whale* (Humphrey Edwin) by Vivares after Nicholas and Gaspard Poussin (September 1748); *Landscape with Figures* (Henry Hoare) by J. Mason after Claude Lorrain (October 1749); *Moonlight* (Christopher Batt) by Vivares after Aert van der Neer (March 1751); *Firelight* (Henry Hoare) by J. Wood after Rembrandt (1751). For the later history of the *Storm*, see Anthony Blunt, 'Landscape by Gaspard, Figures by Nicholas', *Burlington Magazine* 117, no. 870 (September 1975) 677–9.

46. Vivares's imitations of the *Roman Antiquities* are advertised in the *London Daily Advertiser*, no. 4901 (4 November 1746).

47. *Sayer & Bennet's Catalogue of Prints for 1775* (reprint, London, 1970).

48. Vertue, *Note Books* 3, *Walpole Society*, vol. 22 (Oxford, 1933–34), p. 156.

49. B.M., Add. MS 23724, ff. 111–82. Income from print sales dropped from £98.13.0 in 1745 to £27.15.0 in 1750. Sales records indicate that most prints were sold within three months of publication, then went at a rate of two or three a month thereafter.

50. Vertue, *Note Books* 6:199.

51. Robert Sayer took over Mary Overton's business in 1748–9. He began to buy prints from Pond in November 1748 and several months later announced that he had become proprietor of the shop 'late P. Overton's' in Fleet Street. He went on to become London's leading printseller after John Boydell. B.M., Add. MS 23724, f. 157; *London Daily Advertiser*, no. 5634 (12 February 1749). Peter and Elizabeth Griffin went into business in *c.*1747, when their first ad appeared in the *Daily Advertiser*; Peter died in 1749 and his wife continued selling prints at the same address. Their patronage of Pond began in October 1747 and continued at least through November 1750. *London Daily Advertiser*, no. 5259 (20 November 1747); no. 5875 (November 1749); B.M., Add. MS 23724, ff. 144–81.

52. *DNB*, s.v. Boydell; Godfrey, *Printmaking*, pp. 43–4, 46–8.

53. *Memoirs of Mrs. Laetitia Pilkington, Wife to the Rev. Mr. Pilkington*, 3 vols. (London, 1748, 1749, 1754), 2:240–1.

54. See chapter IV, above.

55. William Hogarth illustrated Samuel Butler's *Hudibras* in 1726; it was the first series of prints to display his comic and narrative skills. Highmore's success came with his plates for *Pamela* in 1744; Hayman's with his designs for Sir Thomas Hanmer's lavish edition of Shakespeare (1744).

56. B.M., Add. MS 23084. Vertue. MS Notebook, ff. 68–9.

57. The publication schedule can be worked out from the Knaptons' notices in the *Daily Advertiser*. The subscription opened in August 1733, the first 'heads' appeared in December, but the last set of four were not published until June 1736. *London Daily Advertiser*, no. 784 (4 August 1733); no. 904 (22 December 1733); no. 1671 (4 June 1736).

58. *London Daily Advertiser*, no. 798 (21 August 1733) (DuBosc); no. 1240, (18 January 1734, O.S.), (Overton).

59. Ibid., no. 1033 (22 May 1734); no. 1087 (24 July 1734).

60. Ibid., no. 1615 (31 March 1736); no. 1879 (2 February 1736, O.S.).

61. B.M., Add. MS 23084, ff. 68–9.

62. Vertue, *Note Books* 3:62, 79.

63. Oxford, Bodleian Library, MS 1009. Thomas Edwards, Letter Book 1738–1742, pp. 73, 89–90.

64. The most complete collection of these drawings for the heads and surrounds belongs to the Ashmolean Museum, Oxford. See David Blayney Brown, *Ashmolean Museum Oxford. Catalogue of the Collection of Drawings*, vol. IV. *Earlier British Drawings* (Oxford, 1982), cat. nos. 1480–1506.

65. An early imitation executed by the Gravelot-Houbraken team for a competing publisher appeared in 1738. This was followed by another set of Vertue portraits for a rival publication, 'The Chronological Historian'. There followed the Pond portrait of *Anson* with a decorated border designed by Gravelot's pupil Charles Grignon. A typical notice from 1746 reads, 'This Day is publish'd (Price 6 d.) Neatly engrav'd and embellish'd after Houbraken's Taste, the Portrait of his Royal Highness the Duke of Cumberland ...' *London Daily Advertiser*, no. 2261 (24 April 1738), no. 2836 (26 February 1740, O.S.), London, National Portrait Gallery, Guthrie Room, s.v. Anson, George; *London Daily Advertiser*, no. 4701 (16 January 1746).

66. *London Daily Advertiser*, no. 3713 (13 December 1742); no. 3767 (14 February 1743).

67. B.M., Add. MS 23724, ff. 134, 143.

68. John Perceval, first Earl of Egmont, *Diary*, 3 vols., *Historical Manuscripts Commission*, vol. 31 (London, 1920, 1923) 2:299.

69. Horace Walpole, *Anecdotes of Painting in England (1760–1795)*, eds. Frederick W. Hilles and Philip B. Daghlian (New Haven and London, 1937), pp. 202–3.

70. Richard Walter, *A Voyage round the World in the Years MDCXL, I, II, III, IV by George Anson* (London, 1748); a later edition (ed. Glyndwr Williams, London, 1974) suggests that much of the writing was actually done by Benjamin Robins.

71. A print of the sea lions on Juan Fernandes was advertised as early as September 1744. Pond later adapted the design for his own illustration. *London Daily Advertiser*, no. 4341 (21 September 1744); Walter, *Voyage* (1748), plate 19, opposite p. 122.

72. B.M., Add. MS 23724, f. 120.

73. Ibid., ff. 120–60.

74. Hiesinger and Percy, *A Scholar Collects*, pp. 111–12, 120.

75. B.M., Add. MS 23724, ff. 146, 152, 154 (Watkins), 120, 132, 145, 149, 153 (Anson).

76. *London Daily Advertiser*, no. 5949 (2 February 1750). The project was known as *English History Delineated*.

77. B.M., Add. MS 23725, f. 57.

78. Philadelphia, Free Library, Lewis Collection, vol. A–B, f. 116. The letter from Nicholas Blakey to R. Dodsley suggests that Ravenet coordinated the efforts of some of the artists and publishers. See David Alexander and Richard T. Godfrey, *Painters and Engraving: The*

Reproductive Print from Hogarth to Wilkie (exhibition catalogue, New Haven, 1980), p. 23, cat. no. 35.

79. A complete set with text is in the Department of Prints and Drawings, Yale Center for British Art, New Haven. The decision to abandon the series seems to have been taken by April 1752, when the same set of six prints was listed as 'The Antient History of England' with no reference to the larger project or a forthcoming sequel. The six plates were acquired by Robert Sayer and reissued by his firm in 1778; the later edition is at the B.M., Dept. of Prints and Drawings, 1855-6-9-1825 through 1830. *London Daily Advertiser*, no. 6638 (6 April 1752).

80. Nichols, *Literary Anecdotes* 2:277-9. On the verge of bankruptcy in 1755, the Knaptons were estimated to have stock valued at £30,000 and debts of £20,000.

81. Strauss, *Robert Dodsley*, passim.

82. Godfrey, *Printmaking*, pp. 43-5.

NOTES TO CHAPTER VIII

1. B.M., Add. MS 23725. Papers illustrative of the works of Arthur Pond, Engraver & Painter, including particulars of various kinds left by him at the time of his decease & the sale catalogues of his effects 1745-1759, f. 50.

2. Sir Joshua Reynolds, *Discourses on Art* (1769-1790), ed. Robert R. Wark (London, 1966), p. 43.

3. Jonathan Richardson, *Two Discourses* (London, 1719).

4. Horace Walpole, *Anecdotes of Painting in England (1760-1795)* eds. Frederick W. Hilles and Philip B. Daghlian (New Haven and London, 1937), p. 204. Walpole seems to mean by the term 'balance' that England exported £60,000 worth more than had been brought in.

5. William Hogarth, *The Analysis of Beauty. Written with a view of fixing the fluctuating ideas of taste* (London, 1753); *Anecdotes of William Hogarth, written by himself*, ed. J. B. Nichols (London, 1833).

6. Ilaria Bignamini has suggested that Hogarth was fighting to impose his own ideology on the art world, although she neglects to bring out his less altruistic side. See *William Hogarth: Nationalism, Mass Media and the Artist* (exhibition cat., Vancouver Art Gallery, November 29, 1980-January 4, 1981).

7. Reynolds, *Discourses*, pp. 223-4.

8. That series was *Industry and Idleness* (1747).

BIBLIOGRAPHY

MANUSCRIPTS

LONDON, BRITISH MUSEUM.

Add. MS 23724. Arthur Pond. Journal of Receipts and Expenses 1734–1750.

Add. MS 23725. Papers illustrative of the works of Arthur Pond, Engraver & Painter, including particulars of the property of various kinds left by him at the time of his decease & the sale catalogues of his effects 1745–1759.

Add. MS 23084. George Vertue. Notebook.

Add. MS 23089. George Vertue. Notebook.

Add. MS 23095. George Vertue. Memorandum Book 1715–1751.

Add. MS 29867. Emanuel Mendes da Costa: Anecdotes and Notices of Collectors.

Add. MS 39167. Rules and Regulations of St. Luke's Club.

Add. MS 39167 B. [George Vertue]. Minutes of the 'Virtuosi of St. Luke'.

Add. MS 19929. Memorandum Book of John Bullfinch 1701–1728.

LONDON, GUILDHALL LIBRARY.

MS 11361. Parish Register of St. Magnus the Martyr 1557–1720 (Baptisms and Burials).

MS 11362. Register Book of Marriages Baptism & Burials of the united parishes of St. Magnus the Martyr & St. Margaret New Fish Street from September 1712 to December 1812.

MS 11936. Sun Fire Insurance Company Policy Registers, 1710–c.1900.

MS 17833. Register Book of the Parish of St. Katherine Coleman. London from 25 March 1666 to 13 September 1741.

MS 17834. Register Book of the Parish of St. Katherine Coleman. London from the 13 September 1741.

LONDON, PUBLIC RECORD OFFICE.

PROB 6/118. Grants of Administration for Middlesex.

PROB 11/767. Will of John Pond of London Bridge, Surgeon.

PROB 11/835. Will of John Durnford, Citizen and Pinmaker of London.

PROB 11/841 (Middlesex). Will of Arthur Pond.

IR 17. Index of Apprentices Names in the Apprenticeship Books of the Inland Revenue Department, 1710–1762.

State Papers Foreign, SP 85. Walton Letters, Rome.

LONDON, VICTORIA AND ALBERT MUSEUM.

MS 86.00.18–19. [Richard Houlditch, Jr.]. Sale Catalogues of the Principal Collections of Pictures (One Hundred and Seventy one in number) Sold by Auction in England within the years 1711–1759 the greater part of them with the Prices and Names of Purchasers.

OXFORD, BODLEIAN LIBRARY.

MSS 1007–1012. Thomas Edwards. Letter Books 1720–1756.

PHILADELPHIA, FREE LIBRARY.

John Frederick Lewis Collection of Engravers' Letters.

PLYMOUTH, CITY MUSEUM AND ART GALLERY.

Cottonian Collection.

PUBLISHED SOURCES

Adair, Virginia and Adair, Lee, *Eighteenth Century Pastel Portraits*. London, 1971.

Adams, C.K., *A Catalogue of the Pictures in the Garrick Club*. London, 1936.

Adhémar, Jean, *La gravure originale au XVIIIe siècle*. Paris, 1963.

——, 'L'enseignement par l'image', *Gazette des Beaux-Arts*, 6th series, vol. 97 (February 1981), pp. 53–60.

Akenside, Mark, and Dyer, John, *The Poetical Works of Mark Akenside and John Dyer*. ed. Reverend Robert Aris Willmot. London, 1855.

Alexander, David, and Godfrey, Richard T., *Painters and Engraving: The Reproductive Print from Hogarth to Wilkie* (exhibition catalogue). New Haven, 1980.

Allen, R.J., *The Clubs of Augustan London*. Cambridge, Mass., 1933.

An Alphabetical List of the Royal Society (printed broadsides). London, 1724–58.

Altick, Richard D., *The Shows of London*. Cambridge, Mass., and London, 1978.

Ames, Joseph, *A Catalogue of English Heads: or, an Account of about Two Thousand Prints Describing what is peculiar to each; . . .* London, 1758.

Antal, C.F., *Hogarth and His Place in European Art*. London, 1962.

Ariso, Ferdinando, *Gian Paolo Panini*. Rome, 1961.

Atherton, Herbert M., *Political Prints in the Age of Hogarth: A Study of the Ideographic Representation of Politics*. Oxford, 1974.

Atkinson, Thomas, *A Conference between a Painter and Engraver*. London, 1736.

Bacou, Rosaline, *Le Cabinet d'un Grand Amateur P.-J. Mariette 1694-1774* (exhibition catalogue). Paris, 1967.

Baker, C.H. Collins, and Baker, Muriel I., *The Life and Circumstances of James Brydges First Duke of Chandos Patron of the Liberal Arts*. Oxford, 1949.

Bannerman, W. Bruce, ed., *The Parish Registers of Sanderstead, Co. Surrey*. London, 1908.

Barber, Mary, *Poems on Several Occasions*. London, 1734.

Basan, P. F., *Dictionnaire des graveurs, anciens et modernes depuis l'origine de la gravure; avec une notice des principales éstampes qu'ils ont gravés*. Paris, 1768.

——, *Catalogue raisonné des differens objets de curiosités dans les sciences et les arts, qui composoient le Cabinet de feu Mr Mariette Controlleur général de la Grande Chancellerie de France . . .* Paris, 1775.

Baugh, Daniel A., *British Naval Administration in the Age of Walpole*. Princeton, 1965.

deBeer, G.R., *Sir Hans Sloane and the British Museum*. London, 1953.

Bénézit, E., *Dictionnaire critique et documentaire des Peintres, Sculpteurs, Déssinateurs et Graveurs . . .*, 3rd ed. Paris, 1976.

Benjamin, Lewis S. (pseud. Lewis Melville), *Lady Suffolk and Her Circle*. Boston and New York, 1924.

Bettagno, Alessandro, *Caricature di Anton Maria Zanetti*. Venice, 1969.

Bignamini, Ilaria, and Danzker, Jo-Anne Birnie, *William Hogarth: Nationalism, Mass Media and the Artist* (exhibition catalogue). Vancouver, 1980-1.

Birch, Thomas, *The Heads of Illustrious Persons of Great Britain, engraven by Mr. Houbraken, and Mr. Vertue, with their Lives and Character*. 2 vols. London, 1743.

——, *The History of the Royal Society of London for improving of Natural Knowledge, from its first rise*. London, 1760.

Bleakley, Horace, *Ladies Fair and Frail: Sketches of the Demi-Monde during the 18th Century*. New York, 1919.

Blunt, Anthony, 'Landscape by Gaspard, Figures by Nicolas', *Burlington Magazine*, vol. 117, no. 870 (September 1975), pp. 607-9.

Bodart, Didier, 'Pier Leone Ghezzi, the draftsman', *Print Collector*, vol. 7, no. 31 (1976), pp. 12-31.

Boyce, Benjamin, *The Benevolent Man: A Life of Ralph Allen of Bath*. Cambridge, Mass., 1967.

Brown, David Blayney, *Ashmolean Museum Oxford. Catalogue of the Collection of Drawings*, vol. IV. *Earlier British Drawings (. . . before c. 1775)*. Oxford, 1982.

Bruand, Yves, 'Hubert Gravelot et l'Angleterre', *Gazette des Beaux-Arts*, 6th series. vol. 105 (1960), pp. 35-44.

Bryan's Dictionary of Painters and Engravers. 1816, revised ed. New York, 1903-5.

Burke, Joseph, *English Art, 1714-1800*. Oxford, 1976.

Calendar of Marriage Licenses issued by the Faculty Office 1632-1714. ed. George E. Cokayne and Edward Alexander Fry. *The Index Library*, vol. 33. London, 1905.

Campbell, R., *The London Tradesman*. 1747, facsimile ed. New York, 1969.

Carritt, David, 'Mr. Fauquier's Chardins', *Burlington Magazine*, vol. 116, no. 858 (September 1974), pp. 502-9.

Catalogue of the Superb and Entire Collection of Prints, and Books of Prints, of John Barnard, Esq. of Berkeley Square, deceased, . . . London, Thomas Philipe, 1798.

A Catalogue of the Genuine and Entire Collection of Valuable Prints, Bound and Unbound, of Christopher Batt, Esq.; Late of Kensington, Deceas'd . . . London, Langford, 1756.

A Catalogue of Maps, Prints, Copy-Books, &c. From off Copper-Plates, Printed for John Bowles at the Black-Horse in Cornhill, London. London, 1764.

A Catalogue of the extensive and capital collection of Prints, of the Rt. Hon. the Earl of Bute, deceased . . . London, Hutchins, 1794.

A Catalogue of the extensive, valuable, and superb Collection of Prints, Books of Prints, Drawings, and Miniatures, selected from various Cabinets ... of Charles Chauncy, M.D. F.R.S. and F.S.A. and Nathaniel Chauncy, Esq.; his Brother. ... London, Greenwood, 1790.

A Catalogue of the Curious Collection of Prints and Drawings of Mr. Andrew Hay; By him purchased from the Most eminent and valuable Collections in France. ... London, Christopher Cock, 1738.

A Catalogue of A curious Collection of Italian, French, and Flemish Prints and Drawings, By the most Eminent Masters ... collected abroad by Mr. Andrew Hay and Mynheer Wilkins of Amsterdam. ... London, Christopher Cock, 1740.

A Catalogue of the Well-known, Valuable and Magnificent Collection of Drawings, Prints and Books of Prints, of Thomas Hudson, Esq. London, Langford's, 1779.

A Catalogue of the Genuine and Entire Collection of Italian and other Pictures of Mr. Arthur Pond, Late of Great Queen-Street, Lincoln's-Inn Fields, Deceas'd. London, Langford, 1759.

A Catalogue of the Genuine, Entire, and Valuable Collection of Drawings of that Eminent Painter and Collector Mr. Arthur Pond, Late of Great Queen-Street, Lincoln's Inn Fields, Deceas'd. London, Langford, 1759.

A Catalogue of the Genuine and Entire Collection of Scarce and Curious Shells, Fossils, Petrefactions, Ores, Minerals, Insects, Books relative to Shells and Fossils, and some fine Cabinets, of the Eminent Collector Mr. Arthur Pond. ... London, Langford's, 1759.

A Catalogue of the Genuine, Entire and Well-known Collection of Etchings and Prints by Masters of the Greatest Eminence, Purchased by Sir Edward Astley, Bart. of Mr. Arthur Pond. London, Langford's, 1760.

Catalogue of the Extensive Cabinet of Capital Drawings by the Greatest Masters of All the Schools ... collected with Superior Judgment by Charles Rogers, Esq. F.R.S. and S.A. ... London, Thomas Philipe, 1799.

Catalogue of the Capital and Extensive Collection of Prints, and Books of Prints, of Charles Rogers, Esq. F.R.S. S.A. Deceased: ... London, Thomas Philipe, 1799.

[Caulfield], *Memoirs of the celebrated persons composing the Kit-Cat Club; with a prefatory account of the origin of the association.* London, 1821.

Chancellor, E. Beresford, *The History of the Squares of London Topographical and Historical.* London, 1907.

Chase, Isabel, *Horace Walpole: Gardenist.* Princeton, N.J., 1973.

Clark, Anthony M., 'Pier Leone Ghezzi's Portraits', *Paragone*, vol. 14, no. 165 (1963), pp. 11-21.

Clifford, Timothy, Griffiths, Anthony, and Royalton-Kisch, Martin, *Gainsborough and Reynolds in the British Museum* (exhibition catalogue). London, 1978.

Coates, A.W., 'Changing Attitudes to Labour in the Mid-Eighteenth Century', *Economic History Review*, 2nd series. vol. 11 (1958-9), pp. 35-51.

Cochrane, Eric, *Florence in the Forgotten Centuries 1527-1800.* Chicago and London, 1973.

Cockayne, George Edward, *The Complete Baronetage ...*. 5 vols. Exeter, 1900-9.

——, *The Complete Peerage of England, Scotland, Ireland ... extant, extinct or dormant.* 13 vols. London, 1910-59.

Coke, Lady Jane, *Letters from Lady Jane Coke to her friend Mrs. Eyre at Derby 1747-1758.* London, 1899.

Coleman, D.C., *The British Paper Industry 1495-1860.* Oxford, 1958.

A Complete Guide to All Persons who have any Trade or Concern with the City of London and Parts adjacent. London, J. Osborn, 1740.

Croft-Murray, Edward, *Decorative Painting in England 1537-1837.* 2 vols. London, 1970.

Cruickshanks, Eveline, *Political Untouchables: The Tories and the '45.* New York, 1979.

Cust, Lionel, and Colvin, Sidney, *History of the Society of Dilettanti*. London, 1898.

Dance, S.P., *Shell Collecting: an illustrated history*. London, 1966.

Darby, William, *Dulwich, A Place in History*. Dulwich, 1967.

Davis, Rosemary, *The Good Lord Lyttelton: A Study in Eighteenth Century Politics and Culture*. Bethlehem, Pa., 1939.

Delaney, Mary Granville, *The Autobiography and Correspondence of Mary Granville, Mrs. Delaney*. ed. Lady Llanover. 3 vols. London, 1861.

Dickson, P.G.M., *The Financial Revolution in England: A Study in the Development of Public Credit 1688-1756*. New York, 1967.

The Directory: containing an alphabetical list of the names and places of abode of the Directors of Companies, Persons in Public Business, &c. London, Kent, 1736.

Dobai, Johannes, *Die Künstliteratur des Klassizismus und der Romantik in England*. 2 vols. Berne, 1974.

D'Oench, Ellen G., *The Conversation Piece: Arthur Devis and His Contemporaries* (exhibition catalogue). New Haven, 1980.

Dossie, Robert, *The Handmaid to the Arts*. 2 vols. 2nd ed. London, 1764.

Draper, John W., *William Mason: A Study in Eighteenth-Century Culture*. New York, 1924.

——, *Eighteenth-Century English Aesthetics: A Bibliography*. 1931. reprint, New York, 1968.

Dumesnil, M.J., *Histoire des plus célèbres amateurs français et de leurs relations avec les artistes . . . Pierre-Jean Mariette 1694-1774*. Paris, 1856.

Dunbar, Janet, *Peg Woffington and her world*. London, 1968.

Edwards, Edward, *Anecdotes of Painters, who have resided or been born in England, with critical remarks on their productions*. 1808. reprint, London, 1970.

Edwards, Thomas, *The Sonnets of Thomas Edwards*. Introduction by Dennis G. Donovan. Los Angeles, 1974.

Eidelberg, Martin, 'Watteau Paintings in England in the Early Eighteenth Century', *Burlington Magazine*, vol. 117, no. 870 (September 1975), pp. 576-81.

Einberg, Elizabeth, *The French Taste in English Painting during the first half of the 18th century* (exhibition catalogue). Kenwood, 1968.

——, *George Lambert 1700-1765* (exhibition catalogue). Kenwood, 1970.

Englefield, W.A.D., *The History of the Painter-Stainer's Company of London*. London, 1923.

Esdaile, Katherine A., *The Life and Works of Louis Francois Roubiliac*. London, 1928.

Essex, English Record Office, *Georgian Essex*. Chelmsford, Essex, 1963.

Evans, Joan, *A History of the Society of Antiquaries*. Oxford, 1956.

Fielding, Henry, *Joseph Andrews*. 1742. New York, 1977.

——, *The Covent Garden Journal*. . . . 1752. New Haven and London, 1915.

Fielding, Sarah, *Adventures of David Simple in search of a faithful friend*. London, 1744.

Finberg, H.F., 'Canaletto in England', in *Walpole Society*, vols. 9, 10. Oxford, 1921-2.

Foote, Henry Wilder, *John Smibert, Painter*. New York, 1969.

Foote, Samuel, 'Taste; A Comedy, in two acts As performed at the Theatre Royal, Drury Lane', in *The Works of Samuel Foote, Esq.* 3 vols. 1830. reprint, New York, 1974.

Ford, Brinsley, ed., 'The Letters of Jonathan Skelton written from Rome and Tivoli in 1758', in *Walpole Society*, vol. 36. Oxford, 1956-8.

——, 'Thomas Jenkins, Banker, Dealer and Unofficial English Agent', *Apollo*, vol. 99 (1974), pp. 416-25.

Foss, Michael, *The Age of Patronage: The Arts in Society 1660-1750*. London, 1971.

Fowler, John, and Cornforth, John, *English Decoration in the Eighteenth Century*. Princeton, N.J., 1974.

French, Anne, *Gaspard Dughet called Gaspar Poussin 1615-1675. A French landscape painter in seventeenth century Rome and his influence on British art* (exhibition catalogue). Kenwood, 1980.

Friedman, Winifred H., *Boydell's Shakespeare Gallery*. New York and London, 1976.

Fry, E.A., *Index to Marriages from the Gentleman's Magazine*. Exeter, 1922.

Geikie, Sir Archibald, *Annals of the Royal Society Club. The Record of a London Dining-Club in the Eighteenth and Nineteenth Centuries*. London, 1917.

George, Mary Dorothy, *Catalogue of Political and Personal Satires Preserved in the Department of Prints and Drawings in the British Museum*. 5 vols. London, 1934-54.

Gilboy, W., *Wages in Eighteenth Century England*. Cambridge, Mass., 1934.

Girouard, Mark, 'Coffee at Slaughter's—English Art and the Rococo, Part 1', *Country Life*, vol. 139, no. 3593 (13 January 1966), pp. 58-61.

——, 'Hogarth and His Friends—English Art and the Rococo, Part 2', *Country Life*, vol. 139, no. 3593 (27 January 1966), pp. 188-90.

——, 'The Two Worlds of St. Martin's Lane—English Art and the Rococo, Part 3', *Country Life*, vol. 139, no. 3596 (3 February 1966), pp. 224-7.

——, *Life in the English Country House*. New Haven and London, 1978.

Glover, Richard, *Leonidas, a poem*. London, 1737.

Godber, Joyce, 'The Marchioness Grey of Wrest Park', *Bedfordshire Historical Society*, vol. 47 (1968).

Godfrey, Richard T., *Printmaking in Britain: A General History from its Beginnings to the Present Day*. New York, 1978.

Goodison, W., *Fitzwilliam Museum, Cambridge: Catalogue of Paintings, vol. 3 (British School)*. Cambridge, 1977.

Graves, Algernon, *The Society of Artists of Great Britain 1760-1791; The Free Society of Artists 1761-1783*. London, 1907.

——, *Art Sales from early in the 18th Century to early in the 20th Century*. 3 vols. 1921. reprint, New York, 1970.

Gray, Thomas, *Correspondence of Thomas Gray*. ed. Paget Toynbee and Leonard Whibley. 3 vols. Oxford, 1935.

Grean, Stanley, *Shaftesbury's Philosophy of Religion and Ethics. A Study in Enthusiasm*. Ohio University Press, 1967.

Greater London Council, *The Parish of St.-Giles-in-the-Fields*. 2 vols. *Survey of London*, vols. 3, 5. London, n.d.

——, *The Parish of St. Anne Soho*. *Survey of London*, vol. 34. London, 1966.

Greenwood, J.E.C. (pseud. Francis Askham), *The Gay Delavals*. London, 1955.

Gunnis, Rupert, *Dictionary of British Sculptors*. rev. ed. London, 1964.

Hake, Henry M., 'Pond's and Knapton's Imitation of Drawings', *Print Collector's Quarterly*, vol. 9 (1922), pp. 324-49.

Hamilton, Henry, *The English Brass and Copper Industries to 1800*. London, 1926.

Hammelman, Hanns, and Boase, T.S.R., *Book Illustrators in Eighteenth-Century England*. New Haven and London, 1975.

Harley, Rosamund D., *Artist's Pigments c.1600-1835*. London, 1970.

Harris, E., *The Townshend Album* (exhibition catalogue). London, 1974.

Harris, Rose, *The Conversation Piece in Georgian England* (exhibition catalogue). Kenwood, 1965.

Harris, Thaddeus Mason, *Biographical Memoirs of James Oglethorpe, Founder of the Colony of Georgia, in North America*. Boston, 1841.

Haskell, Francis, *Patrons and Painters: A Study in the Relations Between Italian Art and Society in the Age of the Baroque*. New York, 1963.

——, and Penny, Nicholas, *Taste and the Antique: The Lure of Classical Sculpture 1500-1900*. New Haven and London, 1981.

Hawcroft, Francis W., 'The Cabinet at Felbrigg', *The Connoisseur*, vol. 141 (May 1958). pp. 216-19.

Hayes, John, 'British Patrons and Landscape Painting—Eighteenth-Century Collecting', *Apollo*, vol. 83 (1966), pp. 188-97.

Heal, Ambrose, 'The Trade Cards of Engravers', *Print Collector's Quarterly*, vol. 14 (July 1927).

——, *The London Furniture Makers from the Restoration to the Victorian Era*. London, 1953.

Herrmann, Frank, ed., *The English as Collectors*. London, 1972.

——, *Sotheby's: Portrait of an Auction House*. London, 1980.

Herrmann, Luke, *British Landscape Painting of the Eighteenth Century*. London, 1973.

Hicks, H.M., 'Caricatures by Pietro Leoni Ghezzi (1674-1755) engraved by A. Pond (1705-1758)', *Apollo*, vol. 42, no. 246 (August 1945), pp. 198-200.

Hiesinger, Ulrich W., and Percy, Ann., eds., *A Scholar Collects: Selections from the Anthony Morris Clark Bequest* (exhibition catalogue). Philadelphia, 1980-1.

Hogarth, William, *The Analysis of Beauty. Written with a view of fixing the fluctuating ideas of taste* (1753). ed. Joseph Burke. Oxford, 1955.

——, *Anecdotes of William Hogarth, written by himself*. ed. J.B. Nichols. London, 1833.

Holloway, Owen E., *French Rococo Book Illustration*. New York, 1969.

Holmes, Sir Charles, 'Neglected English Masters', *Burlington Magazine*, vol. 60, no. 351 (June 1932), pp. 300-7.

Hudson, Derek, and Luckhurst, Kenneth W., *The Royal Society of Arts 1754-1954*. London, 1954.

Hughes, Helen Sard, *The Gentle Hertford Her Life and Letters*. New York, 1940.

Hunt, Reverend William H., ed., *The Registers of St. Paul's Church, Covent Garden, London, vol. 1—Christenings 1653-1752*. London, 1906.

Hutchison, Sidney C., *The History of the Royal Academy 1768-1968*. London, 1968.

Ilchester, Earl of, and Langford-Brooke, Elizabeth, *The Life of Sir Charles Hanbury-Williams*. London, 1929.

Ingamells, John, 'Andrea Soldi-I', *Connoisseur*, vol. 185 (March 1974) 192-200; 'Andrea Soldi-II', *Connoisseur*, vol. 186 (July 1974) 178-85.

Ingamells, John, and Raines, Robert, 'A Catalogue of the Paintings, Drawings and Etchings of Philip Mercier', in *Walpole Society*, vol. 46. Oxford, 1976-8. pp. 1-70.

The Intelligencer: or Merchant's Assistant. . . . London, 1738.

[Jackson, John Baptist], *An Enquiry into the Origins of Printing in Europe*. London, 1752.

Jacob, Hildebrand, *Of the Sister Arts; an Essay*. London, 1734.

Jaffé, Michael, *Cambridge Portraits from Lely to Hockney* (exhibition catalogue). London, 1978.

Jamot, Paul, 'Watteau Portraitiste', *Gazette des Beaux-Arts*, 5th series, vol. 4 (November 1921). pp. 257-78.

Johnson, Samuel, *The Idler and the Adventurer*. ed. W.J. Bate, John M. Bullitt, and L.F. Powell. New Haven and London, 1963.

Johnston, Elizabeth, 'Joseph Highmore's Paris Journal, 1734', in *Walpole Society*, vol. 42. Oxford, 1970.

Kent's Directory for the Year 1742. London, 1742.

Kerslake, John F., 'The Richardsons and the Cult of Milton', *Burlington Magazine*, vol. 99, no. 646 (January 1957). pp. 23-4.

——, *Early Georgian Portraits.* 2 vols. London, 1977.

Ketton-Cremer, R.W., *Thomas Gray: A Biography.* Cambridge, 1955.

Killanin, Lord, *Sir Godfrey Kneller and His Times, 1646-1723.* London, 1948.

Kirby, Joshua, *Dr. Brook Taylor's Method of Perspective made Easy, . . .* London, 1754.

Kitson, Sydney D., 'Notes on a Collection of Portrait Drawings Formed by Dawson Turner', in *Walpole Society*, vol. 21. Oxford, 1932-3, pp. 67-104.

Kurz, Otto, 'Varnishes, Tinted Varnishes, and Patina', *Burlington Magazine*, vol. 104 (February 1962), pp. 56-9.

Lami, Stanislaus, *Dictionnaire des Sculpteurs de l'école française au dix-huitième siècle.* Paris, 1910.

Laurentius, Th., Niemeijer, Dr. J.W., and Ploos van Amstel, Jhr. G., *Cornelis Ploos van Amstel 1726-1798: Kunstverzamelaar en prentuitgever.* Assen, 1980.

Lewis, Alison Shepherd, 'Joseph Highmore: 1692-1780'. Ph.D. dissertation. Harvard University, 1975.

Lewis, Lesley, *Connoisseurs and Secret Agents in Eighteenth Century Rome.* London, 1961.

——, 'Philipp von Stosch', *Apollo*, n.s., vol. 85 (May 1967), pp. 320-7.

Lewis, W.S., *Horace Walpole.* New York, 1960.

Lillywhite, Bryant, *London Coffeehouses.* London, 1963.

Lipking, Lawrence, *The Ordering of the Arts in Eighteenth-Century England.* Princeton, N.J., 1970.

A List of the Society of Antiquaries, From 1717 to 1796: in chronological and alphabetical order. London, 1798.

Loche, Renée, *Jean-Etienne Liotard, Genf 1702-1789* (exhibition catalogue). Zurich, 1978.

Lugt, Frits, *Les Marques de Collections de Dessins et d'Estampes.* Amsterdam, 1921.

——, *Répertoire des Catalogues de Ventes Publiques intéressant l'art ou la curiosité.* 2 vols. The Hague, 1938.

McKendrick, Neil; Brewer, John; and Plumb, J.H., *The Birth of a Consumer Society. The Commercialization of Eighteenth-Century England.* London, 1982.

McKillop, Alan Dugald, *The Background of Thomson's Seasons.* Minneapolis, 1942.

Mariette, Pierre-Jean, 'Abécedario de P.J. Mariette et autres notes inédites de cet amateur sur les arts et les artistes', 6 vols. *Archives de l'art français*, vols. 2, 4, 6, 8, 10, 12. Paris, 1857-8.

Maxted, Ian, *The London Book Trades 1775-1800. A Preliminary Checklist of Members.* Folkestone, 1977.

Maxwell, Constantia, *The English Traveller in France, 1698-1815.* London, 1932.

Melton, James, 'Charles Rogers and his furniture—I, II', *Apollo*, n.s., vol. 72, nos. 430, 432 (December 1960, February 1961), pp. 36-40, 196-8.

Middleton, Conyers, D.D., *The History of the Life of Marcus Tullius Cicero.* 2 vols. London, 1741.

Miles, Ellen, 'Thomas Hudson (1701-1779): Portraitist to the British Establishment'. 2 vols. Ph.D. dissertation. Yale University, 1976.

Miles, Ellen, and Simon, Jacob, *Thomas Hudson 1701-1779 Portrait Painter and Collector* (exhibition catalogue). Kenwood, 1979.

Montagu, John (fourth Earl of Sandwich), attributed to, *A Voyage performed by the late Earl of Sandwich round the Mediterranean in the years 1738 and 1739. Written by himself . . . To which are prefixed, memoirs of the noble author's life, by John Cooke, M.A.* London, 1799.

[Mortimer, Thomas], *The Universal Director; or the Nobleman and Gentleman's True Guide to the Masters and Professors of the Liberal and Polite Arts and Sciences.* ... London, 1763.

Muilman, Teresa Constantia, *An Apology for the Conduct of Mrs. Teresa Constantia Phillips, more particularly that part of it which relates to her marriage with an eminent Dutch merchant.* ... London, 1748–50.

Musgrave, Sir William, *Obituary Prior to 1800.* ..., 6 vols., ed. Sir George Armytage. *Harleian Society*, vols. 44–9. London, 1899–1901.

Nichols, John, *Literary Anecdotes of the Eighteenth Century: comprizing biographical memoirs of William Bowyer, printer, F.S.A., and many of his learned friends.* ... 8 vols. London, 1812–16.

Nicolson, Benedict, and Kerslake, John, *The Treasures of the Foundling Hospital.* Oxford, 1972.

O'Donoghue, F.M., and Hake, Henry M., *Catalogue of Engraved British Portraits preserved in the Department of Prints and Drawings in the British Museum.* 6 vols. London, 1908–25.

Ogden, Henry and Margaret, *English Taste in Landscape in the Seventeenth Century.* London, 1955.

The Orrery Papers. ed. the Countess of Cork and Orrery. 2 vols. London, 1903.

Ozzola, Leandro. 'Gli editori di stampe a Roma nei sec. XVI e XVII', *Repertorium für Kunstwissenschaft*, vol. 33 (1910), pp. 400–11.

Parris, Leslie, *Landscape in Britain, c.1750–1850* (exhibition catalogue). London, 1973–4.

Paulson, Ronald, *Hogarth: His Life, Art, and Times.* 2 vols. New Haven and London, 1971.

——, *Emblem and Expression: Meaning in English Art of the Eighteenth Century.* Cambridge, Mass., 1975.

Perceval, John (first Earl of Egmont), *Diary.* 3 vols. *Historical Manuscripts Commission*, vol. 31. London, 1920, 1923.

Piggott, Stuart, *William Stukely, an eighteenth-century antiquary.* Oxford, 1950.

Pilkington, Laetitia, *Memoirs of Mrs. Laetitia Pilkington, Wife to the Rev. Mr. Pilkington.* 3 vols. London, 1748, 1749, 1754.

Piper, David, 'The Development of the British Literary Portrait up to Samuel Johnson', *Proceedings of the British Academy*, vol. 54. London, 1968.

Plomer, H.R., *A Dictionary of the Printers and Booksellers who were at work in England, Scotland, and Ireland from 1726 to 1775.* Oxford, 1932.

Plumb, J.H., *The Commercialization of Leisure in Eighteenth-Century England.* 1974.

Pope, Alexander, *The Works of Alexander Pope, Esq. In Nine Volumes Complete ... together with the commentaries and notes of Mr. Warburton.* London, 1751.

Popham, A.E., and Pouncey, Philip, *Italian Drawings in the Department of Prints and Drawings in the British Museum: The Fourteenth and Fifteenth Centuries.* 2 vols. London, 1950.

Pye, John, *The Patronage of British Art, an historical sketch.* London, 1845.

Pyke, E.J., *A Biographical Dictionary of Wax Modellers.* Oxford, 1973.

Raines, Robert, 'Peter Tillemans, Life and Work, with a list of representative Paintings', in *Walpole Society*, vol. 47 (Oxford, 1980).

de Rapin Thoyras, Paul, *The History of England.* Transl. Nicholas Tindal. London, 1732.

Redgrave, Samuel, *A Dictionary of Artists of the English School: Painters, Sculptors, Architects, Engravers and Ornamenters: with notices of their lives and work.* London, 1878.

Reed, Amy Louise, *The Background of Gray's Elegy: A Study in the Taste for Melancholy Poetry 1700–1751.* New York, 1962.

Reichel, Anton, *Die Clair-Obscur-Schnitte des XVI, XVII, XVIII Jahrhunderts.* Zurich, Leipzig, Vienna, 1926.

Richard Houlditch, Esq.; his particulars and inventory. ... London, 1721.

Richardson, Jonathan, *The Theory of Painting.* London, 1715.

——, *Two Discourses.* London, 1719.

——, *An Account of Some of the Statues, Bas-reliefs, Drawings and Pictures in Italy, &c. with Remarks.* London, 1722.

——, *An Essay on Prints.* n.d. in *The Works of Jonathan Richardson.* Strawberry Hill, 1792.

Rocheblave, Samuel, *Essai sur le Comte de Caylus. L'homme—l'artiste—l'antiquaire.* Paris, 1889.

Röthlisberger, Marcel, *Claude Lorrain: The Paintings.* New Haven, 1961.

Rogers, Charles, *A Collection of Prints, in Imitation of Drawings, from the following celebrated masters.* ... London, 1778.

Rouquet, Jean-André, *The Present State of the Arts in England.* London, 1755.

Royal Society, *The Philosophical Transactions of the Royal Society of London ... abridged.* vol. 8 (1735-43). London, 1809.

[Russell, John], *Letters from a Young Painter from abroad to his Friend in London.* London, 1748.

Schmid, Frederick, 'The Painter's Implements in Eighteenth Century Art', *Burlington Magazine*, vol. 108, no. 763 (October 1966). pp. 519-21.

Sedgwick, Romney, *The History of Parliament: The House of Commons 1715-1754.* 2 vols. London, 1970.

Sermoneta, Vittoria, Duchess of, *The Locks of Norbury.* London, 1940.

Sewter, A.C., 'A Portrait by Arthur Pond', *Burlington Magazine*, vol. 77, no. 449 (August 1940), pp. 63-4.

Shaftesbury, Anthony Ashley Cooper, third Earl of, *Characteristicks of Men, Manners, Opinions, Times.* 3 vols. 4th ed., London, 1727.

Shaw, James Byam, *Paintings by Old Masters at Christ Church Oxford.* London, 1967.

Shesgreen, Sean, ed., *Engravings by Hogarth.* New York, 1973.

Simpson, Frank, '*The English Connoisseur* and its sources', *Burlington Magazine*, vol. 93, no. 583 (October 1951), pp. 355-6.

——, 'Dutch Paintings in England before 1760', *Burlington Magazine*, vol. 95, no. 599 (February 1953). pp. 39-42.

Singh, F.D., *Portraits in Norfolk Houses.* ed. Edmund Farrer. 1928.

Slive, Seymour, *Rembrandt and His Critics 1630-1730.* The Hague, 1953.

Smart, Alastair, *The Life and Art of Allan Ramsay.* London, 1952.

Smibert, John, *The Notebook of John Smibert.* Boston, 1969.

Smith, John Chaloner, *British Mezzotinto Portraits.* 4 vols. London, 1883.

Smith, John Thomas, *Nollekens and His Times.* 2 vols. ed. Wilfred Whitten. London and New York, 1917.

Stampfle, Felice, and Bean, Jacob, *Drawings from New York Collections III: The Seventeenth Century in Italy* (exhibition catalogue). Greenwich, Ct., 1967.

Standen, Edith A., 'Studies in the History of Tapestry: Some Exotic Subjects', *Apollo*, vol. 113, no. 233 (July 1981) 44-54.

Steegman, John, *The Artist and the Country House.* London, 1949.

Stephens, Frederic G., *Catalogue of Prints and Drawings in the British Museum Division I. Political and Personal Satires.* vols. 1-4. London, 1870-94.

Stewart, J.D., 'Records of Payment to Sir Godfrey Kneller and his Contemporaries', *Burlington Magazine*, vol. 113, no. 814 (January 1971), pp. 30-3.

Stock, Julian, *et. al.*, *An Exhibition of Old Master and English Drawings and European Bronzes from the Collection of Charles Rogers and the William Cotton Bequest* (exhibition catalogue). London, 1979.

Strauss, Ralph, *Robert Dodsley, poet, publisher, and playwright*. London, 1910.

Strickland, Walter George, *A Dictionary of Irish Artists*. Shannon, 1969.

Strutt, Joseph, *A Biographical Dictionary of Engravers, with an Essay on Engraving*. 2 vols. London, 1785-6.

Sutherland, Lucy S., 'Samson Gideon: Eighteenth Century Jewish Financier', *Transactions of the Jewish Historical Society of England*, vol. 17 (1951-2), pp. 79-90.

——, *A London Merchant 1695-1774*. Oxford, 1962.

Sutton, Denys, 'The Roman Caricatures of Reynolds', *Country Life Annual* (1956), pp. 113-16.

——, 'Aspects of British Collecting Part I', *Apollo*, vol. 114, no. 237 (November 1981), pp. 298-339.

Talley, M. Kirby, 'Thomas Bardwell of Bungay, Artist and Author 1704-1767', in *Walpole Society*, vol. 46. Oxford, 1976-8.

Thomson, Mrs., *Memoirs of Viscountess Sundon, Mistress of the Robes to Queen Caroline.* . . . 2 vols. London, 1847.

Thomson, G. Scott, 'The restoration of the Duke of Bedford's pictures', *Burlington Magazine*, vol. 92 (1950), pp. 320-1.

Thomson, James, *James Thomson (1700-1748) Letters and Documents*. ed. Alan Dugald McKillop. Lawrence, Kansas, 1958.

Timbs, John, *Club Life of London, with anecdotes of the clubs, coffeehouses, and taverns*. London, 1866.

Travers, John, ed., *The Hamwood Papers of the Ladies of Llangollen and Caroline Hamilton*. London, 1930.

Trevor-Fawcett, J.E., *The Rise of English Provincial Art: Artists, Patrons, and Institutions outside London, 1800-1830*. Oxford, 1974.

de Tubières, Anne-Claude-Philippe (Comte de Caylus), *Recueil d'éstampes d'après les plus beaux tableaux et d'après les plus beaux dessins qui sont en France.* . . . Paris, 1729.

——, *Recueil de Testes de caractère & de Charges dessinés par Léonard de Vinci Florentin & gravées par M. le C. de C.* Paris, 1730.

The Universal Pocket Companion. London, J. and J. Fox, *et al.*, 1741.

Vertue, George, *Note Books*. 6 vols. *Walpole Society*, vols. 18, 20, 22, 24, 26, 29, 30. Oxford, 1929-52.

Walpole, Horace, *Ædes Walpolianae: or a Description of the Collection of Pictures at Houghton Hall in Norfolk.* . . . 1743. 2nd ed. London, 1753.

——, *Anecdotes of Painting in England; with some account of the principal artists . . . with additions by the Rev. James Dallaway, and Vertue's catalogue of engravers who have been born or resided in England*. 3 vols. London, 1876.

——, *Anecdotes of Painting in England: [1760-1795] With some Account of the principal Artists; and incidental Notes on other Arts*. ed. Frederick W. Hilles and Philip B. Daghlian. New Haven and London, 1937.

——, *A Catalogue of the Collection of Pictures of the Duke of Devonshire, General Guise, and the late Sir Paul Methuen*. Strawberry Hill, 1766.

——, *The Duchess of Portland's Museum*. New York, 1936.

——, *The Yale Edition of Horace Walpole's Correspondence*. ed. W.S. Lewis, *et al*. New Haven and London, 1942-74.

Walter, Richard, *A Voyage round the World in the Years MDCCXL, I, II, III, IV by George Anson*. London, 1748.

Walters, H.B., *The English Antiquaries of the Sixteenth, Seventeenth, and Eighteenth Centuries.* London, 1934.

Waterhouse, Ellis K., 'English Painting and France in the Eighteenth Century', *Journal of the Warburg and Courtauld Institutes.* vol. 15 (1952) pp. 122–35.

——, *Painting in Britain, 1530–1790.* 1953. 4th ed. London, 1978.

——, *The Dictionary of British 18th Century Painters in oils and crayons.* Woodbridge, Suffolk, 1981.

Watson, Francis, 'English Villas and Venetian Decorators', *RIBA Journal* (March 1954).

Westerfield, R.B., *Middlemen in English Business, particularly between 1660 and 1760.* New Haven, 1915.

Whitehead, P.J.P., 'Emanuel Mendes da Costa (1717–1791) and the *Conchology, or natural history of shells*', *Bulletin of the British Museum (Natural History).* Historical series. vol. 6, no. 1 (29 September 1977).

Whitley, William T., *Artists and their Friends in England.* 2 vols. 1928. reprinted, New York, 1968.

Wiggin, Lewis M., *The Faction of Cousins. A Political Account of the Grenvilles 1733–1763.* New Haven, 1958.

Williams, Ralph M., 'The Publication of Dyer's *Ruins of Rome*', *Modern Philology*, vol. 44 (1946–7), pp. 97–101.

——, *Poet, Painter, and Parson: The Life of John Dyer.* New York, 1956.

Wimsatt, W.K., *The Portraits of Alexander Pope.* New Haven and London, 1965.

Wolstenholme, Gordon, and Piper, David, *The Royal College of Physicians of London. Portraits.* London, 1964.

Woodbridge, Kenneth, *Landscape and Antiquity: Aspects of English Culture at Stourhead 1718–1838.* Oxford, 1970.

Wroth, Warwick, and Wroth, Arthur Edgar, *The London Pleasure Gardens of the Eighteenth Century.* London, 1896.

Wyndham, H.A., *A Family History 1688–1837. The Wyndhams of Somerset, Sussex and Wiltshire.* Oxford, 1950.

Yorke, Phillip (second Earl of Hardwicke), *et al.*, *Athenian Letters: or, the Epistolary Correspondence of an Agent of the King of Persia, residing at Athens during the Peloponnesian War.* 1737. London, 1798.

——, 'Journal of What I Observed Most Remarkable in a Tour into the North', *Bedfordshire Historical Record Society* (1968).

Yorke, Philip C., *The Life and Correspondence of Philip Yorke Earl of Hardwicke Lord High Chancellor of Great Britain.* 3 vols. Cambridge and Chicago, 1913.

Zanetti, Anton Maria, *Raccolta di varie stampe a chiaroscuro, tratte dai disegni originali di Francesco Mazzuola, detto il Parmigianino, e d'altri insigni autori. . . .* Venice, 1749.

INDEX